PRAISE FOR *God Is Not One*

"A powerfully written, paradigm-shifting book. How religious differences can be a bridge of cooperation rather than a bomb of destruction is one of the most important challenges of our era, and Prothero is as good a guide as you will find." —Eboo Patel, founder and executive director of Interfaith Youth Core and author of *Acts of Faith*

"To live together well in a globalized world, we need to know each other's faiths, learn to debate in a civil way about their truth claims, and above all, come to respect each other even when we disagree on what matters to us the most. A very much needed book!" —Miroslav Volf, professor, Yale University, and author of *Exclusion and Embrace* and *Allah*

"This book could well be the most highly readable, accurate, and up-to-date introduction to the world's major religions. Prothero faces the real differences among them squarely, but demonstrates how these differences can enrich, not prevent, dialogue and cooperation." —Harvey Cox, Hollis Research Professor of Divinity, Harvard University, and author of *The Future of Faith*

"An urgently needed and very nicely done corrective to politically correct nonsense." —Rodney Stark, author of *Discovering God*

"With his usual combination of wit, insight, and breezy prose, Prothero shows us that comparative religion can be both important and fun. *God Is Not One* is the ideal jumping-off point for anyone who wants a single book that captures the core ideals and values of the leading religious traditions." —Noah Feldman, Bemis Professor of Law, Harvard Law School, and author of *The Fall and Rise of the Islamic State*

"As Prothero shows us in this erudite and very wide-ranging study, the world's different faiths differ enormously in their essentials as well as their incidental manifestations. An elegant and thoughtful study." —Philip Jenkins, author of *Jesus Wars*

"With intelligence, wit, wisdom, and humor, Prothero has written an important and informative book, and a very entertaining read! Everyone will benefit from reading this book." —Pamela Eisenbaum, author of *Paul Was Not a Christian*

Praise for *New York Times* Bestseller *Religious Literacy:*

"Provocative and timely . . . combines a lively history of the rise and fall of American religious literacy with a set of proposed remedies based on his hope that 'the Fall into religious ignorance is reversible.'" —*Washington Post*

"Prothero is the kind of professor who makes you want to go back to college. . . . To describe Prothero as 'quick-witted' or his interests as 'interdisciplinary' wouldn't do him justice. [He] is a world-religions scholar with the soul of a late-night television comic." —*Newsweek*

"Compelling and persuasively presented . . . *Religious Literacy* is a critical addition to the debate about Americans' civic education, in particular the teaching of religion in public school." —*San Francisco Chronicle*

"Remarkable . . . an especially deft examination of the reasons for Americans' religious illiteracy." —*Washington Monthly*

"*Religious Literacy* presents a compelling argument for Bible-literacy courses." —*Time*

"This book is a must-read not only for educators, clergy, and government officials, but for all adults in a culture where, as Prothero puts it, 'faith without understanding is the standard' and 'religious ignorance is bliss.'" —*Publishers Weekly* (starred review)

New York Times Book Review Editor's Choice

Named a *Booklist* Top 10 Religion Book

Quill Book Award Winner

GOD IS NOT ONE

GOD IS NOT ONE

The Eight Rival Religions
That Run the World

Stephen Prothero

HarperOne
An Imprint of HarperCollinsPublishers

To my students

HarperOne

GOD IS NOT ONE: *The Eight Rival Religions That Run the World.* Copyright © 2010 by Stephen Prothero. All rights reserved. Printed in the United States of America. No part of this book may be used or reproduced in any manner whatsoever without written permission except in the case of brief quotations embodied in critical articles and reviews. For information, address Harper-Collins Publishers, 195 Broadway, New York, NY 10007.

HarperCollins books may be purchased for educational, business, or sales promotional use. For information, please e-mail the Special Markets Department at SPsales@harpercollins.com.

HarperCollins website: http://www.harpercollins.com

HarperCollins®, 🏠®, and HarperOne™ are trademarks of HarperCollins Publishers

FIRST HARPERCOLLINS PAPERBACK EDITION PUBLISHED IN 2011

Library of Congress Cataloging-in-Publication Data
Prothero, Stephen R.
God is not one : the eight rival religions that run the world / by Stephen Prothero. — 1st ed.
p. cm.
ISBN 978-0-06-157128-2
1. Religions. I. Title.
BL80.3.P76 2010
200—dc22 2009053372

20 LSC 30 29 28 27 26 25 24 23

Human goals are many, not all of them commensurable, and in perpetual rivalry with one another.

—Isaiah Berlin

CONTENTS

A NOTE ON DATES AND DIACRITICALS

Scholarly books on religion often use diacritical marks to indicate how a word is pronounced in Sanskrit or other sacred languages. In fact, use of diacriticals is a key way to signal one's scholarly bona fides. But diacritical marks are gibberish to most readers—is that a breve (˘) or a cedilla (¸)?—so I avoid them here except in direct quotations, proper names, and citations. If an "s" with a mark underneath or atop it is pronounced like "sh," then it appears here as "sh": the Hindu god Shiva instead of Śiva, the Hindu goal of moksha instead of mokṣa. Diacritical marks also present a barrier to the integration of non-Christian religious terms into English—a barrier that is better torn down than built up. One reason the Sanskrit term *nirvāṇa* made it into English dictionaries was its willingness to drop the macron over the a and the underdot accompanying the n. And Hindu scriptures such as the Mahâbhârata and the Râmâyana are already finding wide acceptance among English speakers without their respective circumflexes.

Religious Studies scholars also typically date events either as C.E. (Common Era) or B.C.E. (before the Common Era), in an effort to avoid the Christian bias inherent in A.D. (Anno Domini, "in the year of our Lord") and B.C. ("before Christ"). This is sleight of hand since these dates continue to mark events in relation to the life of Jesus whether or not those events are said to have occurred in C.E. or A.D. However, since the use of A.D. and B.C. indirectly imply belief in Jesus as both "Lord" and "Christ," I use C.E. and B.C.E. here. Muslims have their own calendar, which begins with the *hijra* ("flight" or "emigration") of Muhammad from Mecca to Medina in 622 C.E. So while this book appears in 2010 C.E., it is also being published in A.H. 1431.

At least since the first petals of the counterculture bloomed across Europe and the United States in the 1960s, it has been fashionable to affirm that all religions are beautiful and all are true. This claim, which reaches back to *All Religions Are One* (1795) by the English poet, printmaker, and prophet William Blake, is as odd as it is intriguing.[1] No one argues that different economic systems or political regimes are one and the same. Capitalism and socialism are so obviously at odds that their differences hardly bear mentioning. The same goes for democracy and monarchy. Yet scholars continue to claim that religious rivals such as Hinduism and Islam, Judaism and Christianity are, by some miracle of the imagination, essentially the same, and this view resounds in the echo chamber of popular culture, not least in Dan Brown's multi-million-dollar *Da Vinci Code* franchise.

The most popular metaphor for this view portrays the great religions as different paths up the same mountain. "It is possible to climb life's mountain from any side, but when the top is reached the trails converge," writes philosopher of religion Huston Smith. "At base, in the foothills of theology, ritual, and organizational structure, the religions are distinct. Differences in culture, history, geography, and collective temperament all make for diverse starting points. . . . But beyond these differences, the same goal beckons."[2] This is a comforting notion in a world in which religious violence often seems more present and potent than God. But is it true? If so, what might be waiting for us at the summit?

According to Mohandas Gandhi, "Belief in one God is the cornerstone of all religions," so it is toward this one God that all religious people are climbing. When it comes to divinity, however, one

is not the religions' only number. Many Buddhists believe in no god, and many Hindus believe in thousands. Moreover, the characters of these gods differ wildly. Is God a warrior like Hinduism's Kali or a mild-mannered wanderer like Christianity's Jesus? Is God personal, or impersonal? Male, or female (or both)? Or beyond description altogether?

Like Gandhi, the Dalai Lama affirms that "the essential message of all religions is very much the same."[3] In his view, however, what the world's religions share is not so much God as the Good— the sweet harmony of peace, love, and understanding that religion writer Karen Armstrong also finds at the heart of every religion. To be sure, the world's religious traditions *do* share many ethical precepts. No religion tells you it is okay to have sex with your mother or to murder your brother. The Golden Rule can be found not only in the Christian Bible and the Jewish Talmud but also in Confucian and Hindu books. No religion, however, sees ethics alone as its reason for being. Jews understand *halakha* ("law" or "way") to include ritual too, and the Ten Commandments begin with how to worship God.

To be fair, those who claim that the world's religions are one and the same do not deny the undeniable fact that they differ in some particulars. Obviously, Christians do not go on pilgrimage to Mecca, and Muslims do not practice baptism. Religious paths do diverge, Huston Smith admits, in the "foothills" of dogma, rites, and institutions.[4] To claim that all religions are the same, therefore, is not to deny the differences among a Buddhist who believes in no god, a Jew who believes in one God, and a Hindu who believes in many gods. It is simply to claim that the mathematics of divinity is a matter of the foothills. Debates over whether God has a body (yes, say Mormons; no, say Muslims) or whether human beings have souls (yes, say Hindus; no, say Buddhists) do not matter, because, as Hindu teacher Swami Sivananda writes, "The fundamentals or essentials of all religions are the same. There is difference only in the non-essentials."[5]

This is a lovely sentiment but it is dangerous, disrespectful, and

untrue. For more than a generation we have followed scholars and sages down the rabbit hole into a fantasy world in which all gods are one. This wishful thinking is motivated in part by an understandable rejection of the exclusivist missionary view that only you and your kind will make it to heaven or Paradise. For most of world history, human beings have seen religious rivals as inferior to themselves—practitioners of empty rituals, perpetrators of bogus miracles, purveyors of fanciful myths. The Age of Enlightenment in the eighteenth century popularized the ideal of religious tolerance, and we are doubtless better for it. But the idea of religious unity is wishful thinking nonetheless, and it has not made the world a safer place. In fact, this naive theological groupthink—call it Godthink—has made the world more dangerous by blinding us to the clashes of religions that threaten us worldwide. It is time we climbed out of the rabbit hole and back to reality.

The world's religious rivals do converge when it comes to ethics, but they diverge sharply on doctrine, ritual, mythology, experience, and law. These differences may not matter to mystics or philosophers of religion, but they matter to ordinary religious people. Muslims do not think that the pilgrimage to Mecca they call the hajj is inessential. In fact, they include it among the Five Pillars of Islam. Catholics do not think that baptism is inessential. In fact, they include it among their seven sacraments. But religious differences do not just matter to religious practitioners. They have real effects in the real world. People refuse to marry this Muslim or that Hindu because of them. And in some cases religious differences move adherents to fight and to kill.

One purpose of the "all religions are one" mantra is to stop this fighting and this killing. And it is comforting to pretend that the great religions make up one big, happy family. But this sentiment, however well-intentioned, is neither accurate nor ethically responsible. God is not one. Faith in the unity of religions is just that—faith (perhaps even a kind of fundamentalism). And the leap that gets us there is an act of the hyperactive imagination.

Allergic to Argument

One reason we are willing to follow our fantasies down the rabbit hole of religious unity is that we have become uncomfortable with argument. Especially when it comes to religion, we desperately want everyone to get along. In my Boston University courses, I work hard to foster respectful arguments. My students are good with "respectful," but they are allergic to "argument." They see arguing as ill-mannered, and even among friends they avoid it at almost any cost. Though they will debate the merits of the latest Coen brothers movie or U2 CD, they agree not to disagree about almost everything else. Especially when it comes to religion, young Americans at least are far more likely to say "I feel" than "I think" or (God forbid) "I believe."

The Jewish tradition distinguishes between arguing for the sake of victory (which it does not value) and "arguing for the sake of God" (which it does).[6] Today the West is awash in arguments on radio, television, and the Internet, but these arguments are almost always advanced not in service of the truth but for the purpose of ratings or self-aggrandizement or both. So we won't argue for any-one's sake and, when others do, we don't see anything godly in it. The ideal of religious tolerance has morphed into the straitjacket of religious agreement.

Yet we know in our bones that the world's religions are different from one another. As my colleague Adam Seligman has argued, the notion of religious tolerance assumes differences, since there is no need to tolerate a religion that is essentially the same as your own.[7] We pretend these differences are trivial because it makes us feel safer, or more moral. But pretending that the world's religions are the same does not make our world safer. Like all forms of ig-norance, it makes our world more dangerous. What we need on this furiously religious planet is a realistic view of where religious rivals clash and where they can cooperate. Approaching this vola-tile topic from this new angle may be scary. But the world is what

it is. And both tolerance and respect are empty virtues until we actually know something about whomever it is we are supposed to be tolerating or respecting.

Pretend Pluralism

Huston Smith's *The World's Religions* has sold over two million copies since it first appeared in 1958 as *The Religions of Man*. One source of its success is Smith's earnest and heartfelt proclamation of the essential unity of the world's religions. Focusing on the timeless ideals of what he calls "our wisdom traditions," Smith emphasizes spiritual experience, keeping the historical facts, institutional realities, and ritual observances to a minimum. His exemplars are extraordinary rather than ordinary practitioners—mystics such as Islam's al-Ghazali, Christianity's St. John of the Cross, and Daoism's Zhuangzi. By his own admission, Smith writes about "religions at their best," showcasing their "cleaner side" rather than airing their dirty laundry, emphasizing their "inspired" philosophies and theologies over wars and rumors thereof. He writes sympathetically and in the American idioms of optimism and hope. When it comes to religion, Smith writes, things are "better than they seem."[8]

When Smith wrote these words over a half century ago, they struck just the right chord. In the wake of World War II and the Holocaust, partisans of what was coming to be known as the Judeo-Christian tradition were coming to see Protestantism, Catholicism, and Judaism as three equal expressions of one common faith. Meanwhile, fans of Aldous Huxley's *The Perennial Philosophy* (1945) and Joseph Campbell's *The Hero with a Thousand Faces* (1949) were denouncing the longstanding human tendency to divide the world's religions into two categories: the false ones and your own. The world's religions, they argued, are different paths up the same mountain. Or, as Swami Sivananda put it, "The Koran or the Zend-Avesta or the Bible is as much a sacred book as

the Bhagavad-Gita. . . . Ahuramazda, Isvara, Allah, Jehovah are different names for one God."[9] Today this approach is the new orthodoxy, enshrined in bestselling books by Karen Armstrong and in Bill Moyers' television interviews with Joseph Campbell, Huston Smith, and other leading advocates of the "perennial philosophy."

This perennialism may seem to be quite pluralistic, but only at first glance. Catholic theologian Karl Rahner has been rightly criticized for his theory that many Buddhists, Hindus, and Jews are actually "anonymous Christians" who will make it to heaven in the world to come. Conservative Catholics see this theory as a violation of their longstanding conviction that "outside the church there is no salvation." But liberals also condemn Rahner's theology, in their case as condescending. "It would be impossible to find anywhere in the world," writes Catholic theologian Hans Küng, "a sincere Jew, Muslim or atheist who would not regard the assertion that he is an 'anonymous Christian' as presumptuous."[10]

The perennial philosophers, however, are no less presumptuous. They, too, conscript outsiders into their tradition quite against their will. When Huxley's guru Swami Prabhavananda says that all religions lead to God, the God he is imagining is Hindu. And when my Hindu students quote their god Krishna in their scripture the Bhagavad Gita (4:11)—"In whatsoever way any come to Me, in that same way I grant them favor"—the truth they are imagining is a Hindu truth. Just a few blocks away from my office stands the Ramakrishna Vedanta Society. Its chapel looks conspicuously like a mainline Protestant church, yet at the front of this worship space sit images of various Hindu deities, and around the room hang symbols of the world's religions—a star and crescent for Islam, a dharma wheel for Buddhism, a cross for Christianity, a Star of David for Judaism. When my friend Swami Tyagananda, who runs this Society, says that all religions are one, he is speaking as a person of faith and hope. When Huston Smith says that all religions are one, he is speaking in the same idiom.

I understand what these men are doing. They are not describing the world but reimagining it. They are hoping that their hope will

call up in us feelings of brotherhood and sisterhood. In the face of religious bigotry and bloodshed, past and present, we cannot help but be drawn to such vision, and such hope. Yet, we must see both for what they are, not mistaking either for clear-eyed analysis. And we must admit that there are situations where a lack of understanding about the differences between, say, Sunni and Shia Islam produces more rather than less violence. Unfortunately, we live in a world where religion seems as likely to detonate a bomb as to defuse one. So while we need idealism, we need realism even more. We need to understand religious people as they are—not just at their best but also their worst. We need to look at not only their awe-inspiring architecture and gentle mystics but also their bigots and suicide bombers.

Religion Matters

Whether the world's religions are more alike than different is one of the crucial questions of our time. Until recently, most sociologists were sure that religion was fading away, that as countries industrialized and modernized, they would become more secular. And religion is receding today in many Western European countries. But more than nine out of every ten Americans believe in God, and, with the notable exception of Western Europe, the rest of the world is furiously religious. Across Latin America and Africa and Asia, religion matters to Christians who praise Jesus after the birth of a child, to Muslims who turn to Allah for comfort as they are facing cancer, and to Hindus who appeal to the goddess Lakshmi to bring them health, wealth, and wisdom. And it still matters in Western Europe, too, where Catholic attitudes toward women and the body, for example, continue to inform everyday life in Spain and Italy, and where the call to prayer goes up five times a day in mosques from Amsterdam to Paris to Berlin.

But religion is not merely a private affair. It matters socially, economically, politically, and militarily. Religion may or may not move

mountains, but it is one of the prime movers in politics worldwide. It moves elections in the United States, where roughly half of all Americans say they would not vote for an atheist, and in India, which has in the *Hindutva* (Hinduness) movement its own version of America's Religious Right. Religion moves economies too. Pilgrims to Mecca and Jerusalem pump billions of dollars per year into the economies of Saudi Arabia and Israel. Sales of the Bible in the United States alone run roughly $500 million annually, and Islamic banking approaches $1 trillion.[11]

All too often world history is told as if religion did not matter. The Spanish conquered New Spain for gold, and the British came to New England to catch fish. The French Revolution had nothing to do with Catholicism, and the U.S. civil rights movement was a purely humanitarian endeavor. But even if religion makes no sense to you, you need to make sense of religion to make sense of the world.

In the twenty-first century alone, religion has toppled the Bamiyan statues of the Buddha in Afghanistan and the Twin Towers in New York City. It has stirred up civil war in Sri Lanka and Darfur. And it has resisted coalition troops in Iraq. In many countries, religion has a powerful say in determining what people will eat and under what circumstances they can be married or divorced. Religious rivalries are either simmering or boiling over in Myanmar, Uganda, Sudan, and Kurdistan. The contest over Jerusalem and the Middle East is at least as religious as it is economic or political. Hinduism and Buddhism were key motivators in the decades-long civil war that recently ravaged Sri Lanka. And religion remains a major motivator in Kashmir, where two nuclear powers, the Hindu-majority state of India and the Muslim-majority state of Pakistan, remain locked in an ancient territorial dispute with palpable religious overtones. Our understanding of these battlefields is not advanced one inch by the dogma that "all religions are one."

Toxic and Tonic

The beginning of the twenty-first century saw dozens of bestselling books in both Europe and the United States by so-called New Atheists. Writers such as Richard Dawkins, Sam Harris, Daniel Dennett, Christopher Hitchens, and Michel Onfray preach their own version of Godthink, aping the perennial philosophers by loading all religions into one boat. This crew, however, sees only the shared sins of the great religions—the same idiocy, the same oppression. Look at the Crusades, 9/11, and all the religiously inspired violence in between, they say. Look at the ugly legacies of sexist (and sexually repressed) scriptures. Religion is hazardous to your health and poisonous to society.

Of course, religion does not exist in the abstract. You cannot practice religion in general any more than you can speak language in general. So generalizing about the overall effects of religion is a hazard of its own. Nonetheless, the main thesis of the New Atheists is surely true: religion *is* one of the greatest forces for evil in world history. Yet religion is also one of the greatest forces for good. Religions have put God's stamp of approval on all sorts of demonic schemes, but religions also possess the power to say no to evil and banality. Yes, religion gave us the Inquisition. Closer to our own time, it gave us the assassinations of Egypt's president Anwar Sadat by Islamic extremists, of Israel's prime minister Yitzhak Rabin by a Jewish gunman, and of India's prime minister Indira Gandhi by Sikh bodyguards. But religion also gave us abolitionism and the civil rights movement. Many, perhaps most, of the world's greatest paintings, novels, sculptures, buildings, and musical compositions are also religiously inspired. Without religion, there would be no Alhambra or Angkor Wat, no reggae or Gregorian chant, no *Last Supper* by Leonardo da Vinci or *Four Quartets* by T. S. Eliot, no Shusaku Endo's *Silence* or Elie Wiesel's *Night*.

Political scientists assume that human beings are motivated primarily by power, while economists assume that they are motivated

primarily by greed. It is impossible, however, to understand the actions of individuals, communities, societies, or nations in purely political or economic terms. You don't have to believe in the power of prayer to see the power of religious beliefs and behaviors to stir people to action. Religion was behind both the creation of the Islamic Republic of Pakistan in 1947 and the founding of the state of Israel in 1948, both the Iranian Revolution of 1979 and the Reagan Revolution of the 1980s.

When I was a professor at Georgia State University in Atlanta, I required my students to read Nazi theology. I wanted them to understand how some Christians bent the words of the Bible into weapons aimed at Jews and how these weapons found their mark at Auschwitz and Dachau. My Christian students responded to these disturbing readings with one disturbing voice: the Nazis were not real Christians, they informed me, since real Christians would never kill Jews in crematories. I found this response terrifying, and I still do, since failing to grasp how Nazism was fueled by ancient Christian hatred of Jews as "Christ killers" allows Christians to absolve themselves of any responsibility for reckoning with how their religion contributed to these horrors.

After 9/11 many Muslims absolved themselves too. The terrorists whose faith turned jets into weapons of mass destruction—who left Qurans in their suitcases and shouted *"Allahu Akbar"* ("God is great") as they bore down on their targets—were not real Muslims, they said. Real Muslims would never kill women and children and civilians. So they, too, absolved themselves of any responsibility for reckoning with the dark side of their tradition.

Is religion toxic or tonic? Is it one of the world's greatest forces for evil, or one of the world's greatest forces for good? Yes and yes, which is to say that religion is a force far too powerful to ignore. Gandhi was assassinated by a Hindu extremist convinced that he had given too much quarter to Muslims when he agreed to the partition of India and the creation of Pakistan. But Gandhi's strategy of *satyagraha*, or nonviolent resistance, was inspired by religion too, deeply influenced by the Jain principle of *ahimsa* (noninjury) and

by the pacifism of Jesus's Sermon on the Mount. Yes, religion gave the United States the racist hatred of the Ku Klux Klan, but it also put an end to discriminatory Jim Crow legislation.

Today it is impossible to understand American politics without knowing something about the Bible used to swear in U.S. presidents and evoked almost daily on the floor of the U.S. Congress. It is impossible to understand politics in India and the economy of China without knowing something about Hinduism and Confucianism. At the dawn of the twentieth century, in *The Souls of Black Folk* (1903), W. E. B. DuBois prophesied that "the problem of the Twentieth Century is the problem of the color-line." The events of 9/11 and beyond suggest that the problem of the twenty-first century is the problem of the religion line.[12]

Koyaanisqatsi

What the world's religions share is not so much a finish line as a starting point. And where they begin is with this simple observation: something is wrong with the world. In the Hopi language, the word *Koyaanisqatsi* tells us that life is out of balance. Shakespeare's *Hamlet* tells us that there is something rotten not only in the state of Denmark but also in the state of human existence. Hindus say we are living in the *kali yuga*, the most degenerate age in cosmic history. Buddhists say that human existence is pockmarked by suffering. Jewish, Christian, and Islamic stories tell us that this life is not Eden; Zion, heaven, and Paradise lie out ahead.

Religious folk worldwide agree that something has gone awry. They part company, however, when it comes to stating just what has gone wrong, and they diverge sharply when they move from diagnosing the human problem to prescribing how to solve it. Christians see sin as the problem, and salvation from sin as the religious goal. Buddhists see suffering (which, in their tradition, is *not* ennobling) as the problem, and liberation from suffering as the religious goal. If practitioners of the world's religions are all moun-

tain climbers, then they are on very different mountains, climbing very different peaks, and using very different tools and techniques in their ascents.

Because religious traditions do not stay static as they move into new centuries, countries, and circumstances, the differences inside each of the world's religions are vast. Religious Studies scholars are quick to point out that there are many Buddhisms, not just one. And so it goes with all the world's religions. Christians align themselves with Roman Catholicism, Orthodoxy, and Protestantism, and fast-growing Mormonism may well be emerging as Christianity's fourth way. Jews call themselves Orthodox, Conservative, Reform, Reconstructionist, and secular. Hindus worship a dizzying variety of gods in a dizzying variety of ways. And as every American and European soldier who fought in Iraq and Afghanistan can attest, Shia and Sunni Islam are in many respects quite distinct.

While I do not believe we are witnessing a "clash of civilizations" between Christianity and Islam, it is a fantasy to imagine that the world's two largest religions are in any meaningful sense the same, or that interfaith dialogue between Christians and Muslims will magically bridge the gap. You would think that champions of multiculturalism would warm to this fact, glorying in the diversity inside and across religious traditions. But even among multiculturalists, the tendency is to pretend that the differences between, say, Christianity and Islam are more apparent than real, and that the differences *inside* religious traditions just don't warrant the fuss practitioners continue to make over them. Meanwhile, the worldwide Anglican Communion splinters over homosexuality, and in the United States hot-button issues such as abortion and stem-cell research drive Protestants into two opposing camps.

For more than a century, scholars have searched for the essence of religion. They thought they found this holy grail in God, but then they discovered Buddhists and Jains who deny God's existence. Today it is widely accepted that there is no one essence that all religions share. What they share are family resemblances—ten-

dencies toward this belief or that behavior. In the family of religions, kin tend to perform rituals. They tend to tell stories about how life and death began and to write down these stories in scriptures. They tend to cultivate techniques of ecstasy and devotion. They tend to organize themselves into institutions and to gather in sacred places at sacred times. They tend to instruct human beings how to act toward one another. They tend to profess this belief or that about the gods and the supernatural. They tend to invest objects and places with sacred import. Philosopher of religion Ninian Smart has referred to these tendencies as the seven "dimensions" of religion: the ritual, narrative, experiential, institutional, ethical, doctrinal, and material dimensions.[13]

These family resemblances are just tendencies, however. Just as there are tall people in short families (none of the men in Michael Jordan's family was over six feet tall), there are religions that deny the existence of God and religions that get along just fine without creeds. Something is a religion when it shares enough of this DNA to belong to the family of religions. What makes the members of this family different (and themselves) is how they mix and match these dimensions. Experience is central in Daoism and Buddhism. Hinduism and Judaism emphasize the narrative dimension. The ethical dimension is crucial in Confucianism. The Islamic and Yoruba traditions are to a great extent about ritual. And doctrine is particularly important to Christians.

The world's religious rivals are clearly related, but they are more like second cousins than identical twins. They do not teach the same doctrines. They do not perform the same rituals. And they do not share the same goals.

Different Problems, Different Goals

After I wrote *Religious Literacy: What Every American Needs to Know—and Doesn't* (2007), I received many letters and emails from readers confessing their ignorance of the world's religions and

asking for a single book they could read to become religiously literate. This book is written for them. It attends to the idiosyncrasies of each of the great religions: for example, Yoruba practitioners' preoccupation with power, Daoists' emphasis on naturalness, and Muslims' attention to the world to come.

At the heart of this project is a simple, four-part approach to the religions, which I have been using for years in the classroom and at lectures around the world. Each religion articulates:

- a *problem*;
- a *solution* to this problem, which also serves as the religious goal;
- a *technique* (or techniques) for moving from this problem to this solution; and
- an *exemplar* (or exemplars) who chart this path from problem to solution.

For example, in Christianity . . .

- the problem is sin;
- the solution (or goal) is salvation;
- the technique for achieving salvation is some combination of faith and good works; and
- the exemplars who chart this path are the saints in Roman Catholicism and Orthodoxy and ordinary people of faith in Protestantism.

And in Buddhism . . .

- the problem is suffering;
- the solution (or goal) is nirvana;
- the technique for achieving nirvana is the Noble Eightfold Path, which includes such classic Buddhist practices as meditation and chanting; and

- the exemplars who chart this path are *arhats* (for Theravada Buddhists), *bodhisattvas* (for Mahayana Buddhists), or *lamas* (for Vajrayana Buddhists).

This four-step approach is admittedly simplistic. You cannot sum up thousands of years of Christian faith or Buddhist practice in four sentences. So this model is just a starting point and must be nuanced along the way. For example, Roman Catholics and Protestants are divided about how to achieve salvation, just as Mahayana and Theravada Buddhists are divided about how to achieve nirvana (or whether nirvana is an "achievement" at all). One of the virtues of this simple scheme, however, is that it helps to make plain the *differences* across and inside the religious traditions. Are Buddhists trying to achieve salvation? Of course not, since they don't even believe in sin. Are Christians trying to achieve nirvana? No, since for them suffering isn't something that must be overcome. In fact, it might even be a good thing.

This book is addressed to both religious and nonreligious people. You don't have to believe in God to want to understand how beliefs in God have transformed individuals and societies from ancient Israel to contemporary China. And you don't have to be baptized into Christianity or married to a Muslim to want to understand the work that rituals do to the people who undergo and administer them. So this book is written for nonbelievers. But it is written for practitioners too, and for seekers on sacred journeys of their own. The spiritually curious searching for new questions or new answers will find plenty of both in the lives of the Hindus, Confucians, and Jews explored in this book. And even those who are settled in their religious (or nonreligious) ways should find opportunities to reimagine their religious commitments (or lack thereof) by comparing and contrasting them with different ways of being religious.

Much is missing here. Shinto is not covered. Neither is Jainism, Zoroastrianism, Wicca, or the Baha'i faith. Also neglected are new religious movements such as Rastafarianism and Scientology. But

the religion I most regret excluding is Sikhism. I am the adviser to Boston University's Sikh Association, and some of my best students have been Sikhs. I had to draw the line somewhere, however, and I drew it on this side of the world's 25 million or so practitioners of Sikhism.

Included in this book are the great religions of the Middle East (Judaism, Christianity, and Islam), India (Hinduism and Buddhism), and East Asia (Confucianism and Daoism). Also included is the Yoruba religion of West Africa and its diasporas. In textbooks on the world's religions, this tradition is often lumped in with Native American, Australian, and other African "primitive" or "primal" religions. But Yoruba religion is a great religion, too, claiming perhaps 100 million adherents and spanning the globe from its homeland in West Africa to South America, Central America, the Caribbean, and the United States.

Although these religions appear here in discrete chapters, none really stands alone. As Confucians are quick to remind us, no human being is an island, and as Jewish philosopher Abraham Heschel once wrote, "No religion is an island" either.[14] One of the great themes of world history is interreligious contact, and interreligious conflict, collaboration, and combination have only accelerated in recent times. So this book aims to present the eight great religions not in isolation but in contact, and comparison. You can learn a lot about your own religion by comparing it with others. As the German philologist and comparative religionist Max Müller famously put it, "He who knows one, knows none."[15]

Great Is Not Necessarily Good

Muslims have long insisted that only God is great. Still, this book refers to the world's major religions as great. What does this mean? First, it does not mean that they are good. For more than a generation, writers on religion have acted on the conviction that the way toward interreligious understanding was to emphasize not only the

similarities of the world's religions but also their essential goodness. This impulse is understandable. No fair-minded scholar wants to perpetuate stereotypes, often rooted in missionary polemics, about Islam as sexist, Hinduism as idol obsessed, or African religions as satanic. But it is time to grow out of this reflex to defend. After 9/11 and the Holocaust, we need to see the world's religions as they really are—in all their gore and glory. This includes seeing where they agree and disagree, and not turning a blind eye to their failings.

Since 1927, *Time* magazine has named a person of the year. Some of these men and women—Franklin Delano Roosevelt and Winston Churchill come to mind—have been great in the sense of good. But goodness has not been a requirement for *Time*'s editors, who try simply to identify the person who, "for better or worse, has most influenced events in the preceding year." (Hitler was *Time*'s choice in 1938, and Stalin in 1939 and 1942.) In selecting the religions for this book, I have not made any effort to separate the wheat from the chaff. I have simply tried to include religions that are both widespread and weighty—religions that "for better or worse" have been particularly influential over time and continue to influence us today.[16]

The world's religions appear here not in chronological order of their founding but in order of influence—from the most to the least great. But how do you determine greatness? Statistics obviously matter. Strictly by the numbers, Christianity and Islam, which together account for over half of the world's population, are the greatest; Judaism, with a mere 14 million adherents, is in last place by far. But another key factor is historical significance. On this score Judaism may well be the greatest, since it gave birth to both Christianity and Islam. In the end, however, the rankings presented here focus first and foremost on contemporary impact— to what extent each religion moves us and shakes us and sends us scrambling after words.

While researching this book, I asked friends and students which religion they thought was the most influential. I got back

a litany of possibilities, including communism. A strong case was made for Confucianism, which has been a prime mover behind the East Asian economic miracle of the last generation and is booming in China now that the government is promoting Confucian ideals as a supplement to (and a possible replacement for) dying Marxist and Leninist ideology. But Christianity and Islam are the two greatest religions today. They are the traditions that draw the atheists' ire. And they are the ones that are redrawing the geopolitical map.

The Greatest Religion

The case for Christianity's preeminence is compelling. In the United States, the most powerful country in the world, Christianity is the religion *par excellence*. The world's number one bestseller, the Bible, is the scripture of American politics, widely quoted in inaugural addresses and on the floor of the House and Senate. And the overwhelming majority of U.S. citizens call themselves Christians, as has every U.S. president from Washington on. In the wider world, however, there is no majority religion. In fact, no one religion claims more than a third of what is an intensely competitive global religious marketplace. So worldwide the question of greatness is not so cut-and-dried.

Nonetheless, Islam is the Muhammad Ali of the world's religions. Statistically, it is second to Christianity, but its numbers are growing far more rapidly. Over the last century, the Christian portion of the world's population has declined slightly—from 35 percent in 1900 to 33 percent today. And in Europe many of these Christians are nominal practitioners at best. Over this same period, Islam's numbers have skyrocketed—from 12 percent of the world's population in 1900 to 22 percent today.[17] According to the World Religion Database, Islam is growing 33 percent faster than is Christianity, largely thanks to high birth rates in Indonesia, Pakistan, Bangladesh, India, Egypt, Iran, and other countries where Islam

predominates.[18] So while Christianity's market share has stalled, Islam's is racing ahead at a breakneck pace.

Numbers aside, Islam is the leader of the pack in terms of contemporary impact. Many Christians render to Caesar what is Caesar's and to God what is God's, restricting their faith to the private realm. Muslims, by contrast, have never accepted this public/private distinction. Most see Islam as both a religion and a way of life. This way of life affects how they dress, what they eat, and how they invest, spend, and lend money. So the religious commitments of Muslims have a huge impact on the world around them.

Islam and Christianity are both missionary religions that have been competing for converts since the birth of Islam in the seventh century. As the modern age opened, Islam was ascendant, taking Constantinople in 1453 and rapidly expanding over the next few centuries across Europe and the Middle East into North Africa, India, and Southeast Asia. Over the last few centuries, however, and especially since the fall of the Ottoman Empire in 1918, Christianity has been ascendant, thanks to the economic, technological, and military might of the colonial powers of Europe and the United States. In today's postcolonial era, Muslims are again on the march, and in the news. In a world in which oil runs our cars, power plants, and (increasingly) our lives, the sheikhs of Saudi Arabia and other oil-rich Islamic nations hold extraordinary influence. Almost all of the world's political hot spots involve Muslims in some way. Finally, the impact that Islamic extremists in al-Qaeda and other jihadist organizations have had on contemporary life is incalculable. Their actions have redirected trillions of dollars in government budgets and transformed not only how we travel and wage war but also how we imagine the future of the planet. Islam, in short, is the globe's most-talked-about religion. It is no accident that journalist Christopher Hitchens has aimed his poison pen first and foremost at Islam. "*Allahu Akbar*," say the Muslim faithful: "God is great." "God is not great," says Hitchens. "Religion poisons everything."[19]

Muslims are now engaged in a historic conversation about the course they should chart into the modern world, not least about

the proper relationship between mosque and state. This conversation is by no means restricted to extremists, or to the Middle East. It is vibrant in Indonesia, whose Muslim population (the world's largest) has shown little interest in extremism. It is also lively in the West, where "Progressive Islam" is strong. There are over a thousand mosques in the United States, and politicians there are taking note of the political power of Muslims in swing states such as Michigan and throughout the Tri-State Region of Connecticut, New Jersey, and New York. In the United Kingdom, Muhammad (or Mohammed) is now the third most popular boy's name (just ahead of Thomas and Harry, and just behind Jack and Oliver).[20] Islam is also the fastest growing religion in Europe, which has seen the number of Muslims triple over the last thirty years.[21]

Sports and Salvation

In choosing the religions for this book and in ordering these rivals in terms of contemporary impact, I have obviously been influenced by my own biases. I have tried, however, to be fair. While in Jerusalem researching this book, I struck up a conversation with an elderly Muslim. When I told him I was writing a book on the world's religions, he looked at me sternly, pointed a finger in my direction, and instructed me to be honest. "Do not write false things about the religions," he said. Religious Studies scholars are rarely honest enough to admit this in person, much less in print, but we all know there are things that each of the world's religions do well, and things they do poorly. If you want to help the homeless, you will likely find the Christian Social Gospel more useful than Hindu notions of caste. If you want to find techniques for quieting the mind through bodily exercises, you will likely find Hindu yogis more useful than Christian saints.

But being honest also requires being true to these religious traditions themselves—by writing chapters to which adherents can say "Amen" and otherwise wrestling with the fact that in writing

about any religion, one is treading on dreams. While researching this book, I repeatedly came across respected scholars of Hinduism and Buddhism referring to "sin" and "salvation" as if these were Hindu and Buddhist concepts.[22] But these are Christian ideas, so when writing about Hinduism and Buddhism, I will not use them. For similar reasons, I will not refer to the Muslims' Paradise or the Buddhists' nirvana as heaven. Similarly, I do not assume here that scripture is as important to Hindus as it is to Protestants, or that it is used in a similar way. The Vedas are the Hindus' most sacred scriptures, but hardly any Hindu gives a fig about their content; as almost any Hindu can tell you, what matters are their sounds, and the sacred power these sounds convey. Neither do I assume, as many Protestants do, that religions are about faith and belief. Religions cannot be reduced to "belief systems" any more than they can be reduced to "ritual systems." Belief is a part of most religions, but only a part, and in most cases not the most important part. (You can be a Jew without believing in God, for example.) So while I will refer to Protestants as "believers" and to their religion as a "faith," I do not refer to religious people in general as "believers" or to their traditions as "faith-based."

There is a long tradition of Christian thinkers assuming that salvation is the goal of all religions and then arguing that only Christians can achieve this goal. Huston Smith, who grew up in China as a child of Methodist missionaries, rejected this argument but not its guiding assumption. "To claim salvation as the monopoly of any one religion," he wrote, "is like claiming that God can be found in this room and not the next."[23] It might seem to be an admirable act of empathy to assert that Confucians and Buddhists can be saved. But this statement is confused to the core, since salvation is not something that either Confucians or Buddhists seek. Salvation is a Christian goal, and when Christians speak of it, they are speaking of being saved from sin. But Confucians and Buddhists do not believe in sin, so it makes no sense for them to try to be saved from it. And while Muslims and Jews do speak of sin of a sort, neither Islam nor Judaism describes salvation from sin as its aim. When a

jailer asks the apostle Paul, "What must I do to be saved?" (Acts 16:30), he is asking not a generic human question but a specifically Christian one. So while it may seem to be an act of generosity to state that Confucians and Buddhists and Muslims and Jews can also be saved, this statement is actually an act of obfuscation. Only Christians seek salvation.

A sports analogy may be in order here. Which of the following—baseball, basketball, tennis, or golf—is best at scoring runs? The answer of course is baseball, because *runs* is a term foreign to basketball, tennis, and golf alike. Different sports have different goals: basketball players shoot baskets; tennis players win points; golfers sink puts. So if you ask which sport is best at scoring runs, you have privileged baseball from the start. To criticize a basketball team for failing to score runs is not to besmirch them. It is simply to misunderstand the game of basketball. So here is another problem with the pretend pluralism of the perennial philosophy sort: just as hitting home runs is the monopoly of one sport, salvation is the monopoly of one religion. If you see sin as the human predicament and salvation as the solution, then it makes sense to come to Christ. But that will not settle as much as you might think, because the real question is not which religion is best at carrying us into the end zone of salvation but which of the many religious goals on offer we should be seeking. Should we be trudging toward the end zone of salvation, or trying to reach the finish line of social harmony? Should our goal be reincarnation? Or escape from the vicious cycle of life, death, and rebirth?

Big Questions

Every year I tell my BU undergraduates that there are two worthy pursuits for college students. One is preprofessional—preparing for a career that will put food on the table and a roof overhead. The other is more personal—finding big questions worth asking, which is to say questions that cannot be answered in a semester, or even a

lifetime (or more). How do things come into being? How do they cease to be? How does change happen? How does anything stay the same? What is the self? Who (or what) is God? What happens when we die? As predictably as fall follows summer, incoming college students bring into classrooms big questions of this sort. Just as predictably, many professors try to steer them toward smaller things—questions that can be covered in an hour-long lecture, and asked and answered on a final exam. But the students have it right. At least in this case, bigger is better.

Before I came to describe myself as religiously confused, I thought I had the answers to the big questions. I now know I didn't even have the questions right. If, as Muhammad once said, "Asking good questions is half of learning," I was at best a half wit.[24] Today I try to follow the advice of the German poet Rainer Maria Rilke to "love the questions themselves," not least this one from the American mystic Walt Whitman:

> . . . what saw you to tell us?
> What stays with you latest and deepest? of curious panics
> Of hard-fought engagements or sieges
> tremendous what deepest remains?[25]

There are all sorts of reasons to try to become more religiously literate. One is civic. It is impossible to make sense of town or nation or world without reckoning with religion's extraordinary influence, for good and for ill. There are also personal reasons to cultivate religious literacy, including the fact that learning about the world's religions empowers you to enter into a fascinating, multi-millennial conversation about birth and death, faith and doubt, meaning and confusion. American philosopher Richard Rorty has called religion a conversation stopper, and who hasn't had the experience of a knock on the door and a conversation run aground on the rocks of dogma?[26] But religion also serves as a conversation starter. We human beings ask questions. We want to know why. Our happiness depends upon it (and, of course, our misery). To

explore the great religions is to stand alongside Jesus and the Buddha, Muhammad and Moses, Confucius and Laozi; it is to look out at a whole universe of questions with curiosity and awe; it is to meander, as all good conversations do, from topic to topic, question to question. Why are we here? Where are we going? How are we to live? Does God exist? Does evil? Do we?

When people ask me how I became a Religious Studies professor (it *is* an odd profession), I usually say that I discovered the study of religion just as I was losing the Christian faith of my youth, and that this discipline gave me a way to hang in with religious questions (which continued to fascinate me) without the presumption that any answers were close at hand. When, to paraphrase Saint Augustine, I became "a question to myself," even bigger questions called out to me, and my ongoing conversation with the great religions began.[27]

One of the most common misconceptions about the world's religions is that they plumb the same depths, ask the same questions. They do not. Only religions that see God as all good ask how a good God can allow millions to die in tsunamis. Only religions that believe in souls ask whether your soul exists before you are born and what happens to it after you die. And only religions that think we have one soul ask after "the soul" in the singular. Every religion, however, asks after the human condition. Here we are in these human bodies. What now? What next? What are we to become?

This book explores the different answers each of the great religions has offered to the different questions they have asked. It aims to demonstrate how practitioners have lived the biggest of the big questions and to suggest ways that each of us today might also live these questions, not least the deceptively simple yet complex question of how to become a human being.

Islam

THE WAY OF SUBMISSION

Most Europeans and North Americans have never met a Muslim, so for them Islam begins in the imagination, more specifically in that corner of the imagination colonized by fear. They see Islam through a veil hung over their eyes centuries ago by Christian Crusaders intent on denouncing Islam as a religion of violence, its founder, Muhammad, as a man of the sword, and its holy book, the Quran, as a text of wrath. Buddhism conjures up the Dalai Lama and his Nobel Peace Prize, but Islam conjures up Osama bin Laden and his assault rifle. So Islam is women imprisoned in black burkas in Pakistan, Taliban rulers in Afghanistan blowing up ancient statues of the Buddha, and Saudi hijackers armed with airplanes, annihilating thousands of innocents for God and for virgins.

Islam has been an on-again, off-again obsession of Westerners for centuries, and not only in the imagination. Muslims took Jerusalem from Christians in 637 c.e., Crusaders took it back in 1099, Saladin seized it on behalf of Islam in 1187, and the British recaptured it on behalf of Christianity in 1917. But Islam first burst into modern Western consciousness with the rise of the Ayatollah Khomeini during the Iranian Revolution of 1979 and the capture in Tehran of fifty-two U.S. diplomats who were held hostage for 444 days before being released in 1981. Since 9/11, Islam has been hotly debated worldwide. What role did Islamic piety play in motivating terrorists to hijack four jets and kill close to three thousand

people? Is Islam a religion of terror? Are Christianity and Islam now engaged in a clash of civilizations? Or do Muslims stand peaceably alongside Jews and Christians as siblings in one tripartite family of religions?

Unfortunately, this crucial conversation rarely advances beyond a ping-pong match of clichés in which some claim that Islam is a religion of peace while others claim that Islam is a religion of war. One side ignores Quranic passages and Islamic traditions that have been to justify war on unbelievers, while the other ignores Islam's just-war injunctions against killing women, children, civilians, and fellow Muslims (hundreds of whom died in the Twin Towers on 9/11). The reason for all this ignoring is our collective ignorance. We are incapable of reckoning with Islam because we know almost nothing about it. Still, when Americans are asked for one word that sums up Islam, "fanatical," "radical," "strict," "violent," and "terrorism" all spill from their collective imagination.[1] In Germany, Spain, and Great Britain, majorities believe there is a fundamental conflict between being a devout Muslim and living in a modern society.[2]

After 9/11 there was a rush to reconceive of the Judeo-Christian tradition as the Judeo-Christian-Islamic tradition. And Islam does share much with its predecessors. Jews, Christians, and Muslims are all "people of the book" who believe in one God who speaks to His people through prophets. In fact, the phrase "people of the book" is Islamic (*Ahl al-Kitab*), used to describe Jews and Christians as brothers and sisters in Allah. The scriptures of these three great religions also share many key concepts. Islam's most frequently cited articles of faith—belief in one God, angels, scriptures, prophets, Judgment Day, and destiny—can be found in Judaism and Christianity too. The Hebrew Bible, Christian Bible, and Quran also share the patriarch Abraham, who according to all three traditions is the progenitor of monotheism.

Yet sibling relations in this Abrahamic family are dysfunctional at best. In one of the iconic incidents of his life, his "night journey" from Mecca to Jerusalem, Muhammad is said to have prayed with

Abraham, Moses, and Jesus. But can Jews, Christians, and Muslims learn to get along in a similar fashion? Or are they destined to face off as bitter enemies in an internecine clash of civilizations? After 9/11, U.S. president George W. Bush and U.K. prime minister Tony Blair spoke repeatedly of Islam as a religion of peace, but revivalist Franklin Graham called Islam "a very evil and wicked religion," and televangelist Jerry Falwell denounced Muhammad as a "terrorist."[3] Muslim groups worldwide responded to 9/11 by denouncing its crimes as anti-Islamic and emphasizing Muslims' commonalities with Jews and Christians, even as Islamic jihadists proclaimed that Jews and Christians were unbelievers deserving of death in this life and eternal torment in the next.

The events of September 11, 2001, yanked conversations about Islam around to questions of war and terror. But any conversation about Islam must reckon with the word *Islam*, which is related to the term *salaam*, which means peace. Muslims greet one another with *"Salaam alaykum"* ("Peace be upon you") and respond to this greeting with *"Wa alaykum as salaam"* ("And upon you be peace"). The word *Islam* means "submission" or "surrender," however. So Islam is the path of submission, and Muslims are "submitters" who seek peace in this life and the next by surrendering themselves to the one true God. They do this first and foremost by prostrating themselves in prayer. "Are you prostrate or are you proud?" this tradition asks. *Masjid*, the Arabic term for mosque, literally means "place of prostration." And some who surrender to this practice develop a mark on their foreheads that the Quran refers to as a "trace of prostration" (48:29).[4]

Prayer

Five times a day, 365 days a year, for more than a millennium, Muslims have heeded the call to prayer going out from mosques and minarets in cities and towns scattered across the globe. This invitation, the *adhan*, is almost always done in Arabic, because according

to Muslims it was in Arabic that God delivered His final revelation, the Quran, to his final prophet, Muhammad. It varies a bit across the Muslim world and over the course of the day. Before dawn, for example, there is the reminder that "prayer is better than sleep." But this is the most common formulation:

> *God is great*
> *God is great*
> *God is great*
> *God is great*
> *I bear witness that there is no god but God*
> *I bear witness that there is no god but God*
> *I bear witness that Muhammad is the messenger of God*
> *I bear witness that Muhammad is the messenger of God*
> *Make haste toward prayer*
> *Make haste toward prayer*
> *Make haste toward success*
> *Make haste toward success*
> *God is great*
> *God is great*
> *There is no god but God*

Over one billion people—roughly one-fifth of the world's population—self-identify as Muslims, placing Islam second only to Christianity in terms of adherents. Like Christianity, Islam is typically classified as a Western religion, and Islam predominates in such Middle Eastern countries as Iran, Iraq, and Afghanistan. But most of the world's Muslims live in Asia. Indonesia has more Muslims (roughly 178 million) than any other country—three times as many as in Saudi Arabia, Afghanistan, and Iraq combined—and it is followed by three more Asian nations: India, Pakistan, and Bangladesh. Of the ten countries with the largest Muslim populations, only two (Egypt and Iran) are plainly in the Middle East. Three (Nigeria, Algeria, and Morocco) are in Africa (as is Egypt, of course). The remaining country (Turkey) straddles Asia, the

Middle East, and Europe.[5] The Central Asian states of Azerbaijan, Turkmenistan, Uzbekistan, Tajikistan, and Kyrgyzstan all have Muslim majorities. In Europe, Muslims form majorities in Albania, Bosnia-Herzegovina, and Kosovo, and there are small but rapidly growing populations across Europe and North America.

By some estimations, close to 20 percent of those who came to the United States as slaves were Muslims, but Islam first became visible there through the Nation of Islam (NOI), which recruited both activist Malcolm X and heavyweight boxer Muhammad Ali to its heterodox combination of black nationalism and Islam. After the death in 1975 of Elijah Muhammad, who had led the NOI since the mysterious disappearance of founder Wallace D. Fard in 1934, this organization moved under the leadership of his son W. D. Muhammad in the direction of mainstream Sunni Islam. After W. D. Muhammad disbanded the NOI, Louis Farrakhan revived it, but today the overwhelming majority of African-American Muslims in the United States are mainstream Sunnis rather than NOI members.

Islam's rapid growth in Europe has set off a series of controversies about free speech and the head covering for Muslim women known as the *hijab*. While France prohibits the hijab in public schools for reasons of church/state separation, Sweden allows it in the name of religious liberty. Meanwhile, relations between Muslims and non-Muslims are tense in many European countries. A recent survey found that a majority of adults in the Netherlands have an unfavorable view of Islam. Another survey found that most Muslims in Germany believe that Europeans are hostile to Muslims. Meanwhile, sizeable majorities of Muslims and non-Muslims alike report that relations between Westerners and Muslims are "generally bad."[6]

Islam also has a presence in American and European popular culture. While Buddhists are typically portrayed at the movies in a positive light—think *Kundun* and *Seven Years in Tibet*—Muslims almost always play the bad guys. There are some favorable portrayals—Omar Sharif's Sherif Ali in *Lawrence of Arabia* and Morgan

Freeman's Azeem in *Robin Hood: Prince of Thieves*—but action films especially tend to depict Muslims as people who do little more than pray and kill, and not necessarily in that order.[7]

I have never heard the *adhan* at the movies, but I have heard it ring out on four continents. Nowhere was it more striking than in Jerusalem, where it seemed to follow me wherever I went. I heard it while standing at the Western Wall. I heard it while sitting inside the Church of the Holy Sepulchre. I heard as I was walking through the Damascus Gate into the Old City's Muslim Quarter. In each case I was reminded of how intimate the Western monotheisms are in this most contested of cities—never out of earshot of one another—and of how Islam is a recited religion, spread throughout the centuries by speech and sound.

Muslims respond to this call (which nowadays is broadcast on television and online) in all sorts of ways. Some ignore it. Others heed it when the mood strikes. But the observant stop cooking and driving and working to step into sacred time at dawn, noon, midafternoon, sunset, and night. In preparation, they wash themselves of life's impurities; they turn to face Mecca, Islam's holiest city; they bow their heads; they say, "Prayer has arrived, prayer has arrived"; and they promise to pray "for the sake of Allah and Allah alone." Then they begin to saturate the air with sacred sound.

Muslims perform the ancient choreography of this prayer with their whole bodies—standing, bowing, prostrating, and sitting. Their hands move from behind their ears to their torsos. They bow forward at the waist, hands on knees, back flat. They stand up straight again. They prostrate themselves into a posture of total and absolute submission to Allah, planting their knees, hands, foreheads, and noses on the ground. They then rise to a sitting position and ticktock back and forth between sitting and prostration as their prayer proceeds.

You don't make this prayer up as you go along, chatting informally and familiarly with God as evangelical Protestants do. Muslims can, of course, call upon Allah for their own reasons, in their own words, and in their own languages. But the five daily prayers

of *salat* (said aloud at dawn, sunset, and night, and in silence at noon and in the afternoon) are repeated in Arabic precisely as they have been for centuries, starting with *Allahu Akbar*: "God is great." Worshippers then bless and exalt Allah above all pretenders. They call Muhammad His prophet and messenger. They ask for peace upon "the righteous servants of Allah." They offer blessings to angels. They ask Allah to bless "Muhammad and the people of Muhammad," just as God has blessed "Abraham and the people of Abraham."

They then recite the most common of Muslim prayers—the Lord's Prayer of Islam—which comes from the first and most popular *sura*, or chapter, of the Quran, known as the Fatiha:

> *In the name of God, the Merciful, the Compassionate.*
> *Praise belongs to God, Lord of all Being*
> *the All-merciful, the All-compassionate*
> *the Master of the Day of Doom.*
> *Thee only we serve; to Thee alone we pray for succour.*
> *Guide us in the straight path,*
> *the path of those whom Thou hast blessed;*
> *not of those against whom Thou art wrathful,*
> *nor of those who are stray. (1:1–7)*

The Five Pillars

In sixteenth-century Geneva, Protestant theologian John Calvin spun a complex theological web around two simple threads: the absolute sovereignty of God and the total depravity of human beings. Like Calvinists, Muslims go to great lengths not to confuse Creator and created. Glorying in the servility of human beings before Allah, they refer to themselves in many cases as "slaves" of the Almighty. But unlike Calvin, Muslims do not believe in original sin. Every human being is born with an inclination toward both God and the good. So sin is not the problem Islam

addresses. Neither is there any need for salvation from sin. In Islam, the problem is self-sufficiency, the hubris of acting as if you can get along without God, who alone is self-sufficient. "The idol of your self," writes the Sufi mystic Rumi, "is the mother of (all) idols."[8] Replace this idol with submission to Allah, and what you have is the goal of Islam: a "soul at peace" (89:27) in this life and the next: Paradise.

The Quran repeatedly states that the path to Paradise is paved with both faith and works—"those who believe, and do righteous deeds, for them await[s] . . . the great triumph" (85:11)—but Islam inclines toward Judaism and away from Christianity by emphasizing orthopraxy (right action) over orthodoxy (right doctrine). Here the technique that will take you from self-sufficiency to Paradise is to "perform the religion" (42:13). Over and over the Quran refers to "believers" and "unbelievers," as if belief were the master key to Paradise, yet it is *action* that divides these two groups: "Those who perform the prayer, and expend of what We have provided them, those in truth are the believers" (8:3–4). To be sure, Islam is a "way of knowledge"—a topic mentioned dozens of times in the Quran.[9] And there are Quranic passages that seem to champion belief over practice. "It is not piety, that you turn your faces to the East and to the West," reads one. "True piety is this: to believe in God, and the Last Day, the Angels, the Book, and the Prophets. . . ." But after this brief segue into orthodoxy, even this passage returns immediately to practice: ". . . to give of one's substance, however cherished, to kinsmen, and orphans, the needy, the traveller, beggars, and to ransom the slave, to perform the prayer, to pay the alms" (2:177). In short, the response that Allah demands from humanity is not so much belief as obedience. Yes, there is one God, but believing that is the easy part, since heaven and earth sing of Him unceasingly. The hard part is submitting to God. "The desert Arabs said, 'We believe,'" the Quran reads. "Say not, 'You have believed,' but rather say, 'We have submitted'" (49:14).

In Europe and North America, spiritual seekers expend much time and energy searching for practices tailor-made for their

unique personalities. Some gravitate to yoga or meditation, others to Taiji (Tai Chi) or chanting. In Islam, however, the core practices are prescribed in the so-called Five Pillars.[10] The metaphor here is architectural, and the image being conjured up is of a building with supports on four corners and at the center.

The central pillar supporting this building is the Shahadah: "I testify that there is no god but God, and Muhammad is the messenger of God." This profession of faith is repeated in the call to prayer and in the five daily prayers themselves. To become a Muslim, all you need to do is testify to this creed, proclaiming its two truths out loud, with understanding and intent, ideally in the presence of witnesses.

The four pillars supporting the corners of this building are *salat* (prayer), *zakat* (charity), *sawm* (fasting), and *hajj* (pilgrimage). Muslims interrupt both work and play to pray five times daily in the direction of Mecca. They stop to remember Allah in the mosque, at home, and in the workplace. But Muslims can also be seen putting down prayer rugs at taxi stands at London's Heathrow Airport and inside office buildings in Dubai.

Muslims are also required to give charity to the poor. Unlike tithing, the Christian practice of giving 10 percent of your income to the church, zakat is based on assets and goes to the poor. Typically, Muslims are obliged to give 2.5 percent of most of their assets (personal possessions such as homes, cars, and clothing are excluded) above a subsistence level known as the *nisab*.

Muslims observe sawm during the month of Ramadan, abstaining from eating, drinking, smoking, and sex from dawn until sunset, and reciting and listening to the Quran instead. Ramadan, which commemorates the coming of revelation to Muhammad, falls in the ninth month of the Islamic year, but because Muslims observe a lunar rather than a solar calendar, its dates migrate across the Gregorian calendar observed in the West. Ramadan concludes with Id al-Fitr, a fast-breaking festival that brings families together to eat, pray, and exchange gifts. The Clinton White House hosted an Id

al-Fitr celebration in 1996, and the first U.S. postage stamp with an Islamic theme—issued just days before 9/11/2001—commemorated both this festival and Id al-Adha, the feast celebrating the willingness of Ibrahim (Abraham to Jews and Christians) to sacrifice his son Ismail (Isaac in the Jewish and Christian scriptures).

Finally, assuming they are physically and financially able, all Muslims are obliged to go once in a lifetime on pilgrimage to Mecca. The hajj, which occurs every year during the last ten days of the twelfth lunar month, is open only to Muslims, who may add to their names the honorific "al Hajj" after fulfilling this duty. The hajj both celebrates and reinforces the unity of all Muslims, a unity symbolized by the fact that men on this pilgrimage wear similar white garments. The most celebrated and photographed activity of the hajj is praying at the Kabah shrine, the most sacred place in the Muslim world. All mosques contain a marker called the *mihrab* pointing worshippers in the direction of Mecca. But in Mecca itself each *mihrab* points in the direction of the Kabah shrine. According to Muslims, this most sacred of places, which includes a black stone believed to be a meteor, was built by Adam and rebuilt by Abraham. It was desecrated by polytheists who ruled Mecca during Muhammad's youth but was reconsecrated to the one true God after Muhammad and his followers took Mecca in 630 c.e.[11]

Jihad

Of all the terms used in the world's religions, none is as controversial as *jihad*. Jihad literally means "struggle," and Muslims have traditionally understood it to point to two kinds of struggles: the spiritual struggle against pride and self-sufficiency; and the physical struggle against the "house of war," namely, enemies of Islam. The second of these struggles calls for a variety of tactics, including preaching, teaching, and working for social justice. It may also include war.

Some apologists for Islam have tried to minimize the impor-

tance of jihad, and to insulate Islam from its extremists, by argu-
ing that, of these two struggles, the spiritual struggle is higher. A
Muslim merchant I met in Jerusalem took this argument further,
contending that jihad has nothing whatsoever to do with war
because jihad is nothing more than the personal struggle to be
good. "Treating me with respect is jihad," he said. "Not ripping
me off is jihad." The Quran, he added, never even mentions war.

But the Quran does mention war, and it does so repeatedly. One
Quranic passage commands Muslims to "fight," "slay," and "expel"
in the course of just two sentences (2:190–91), while another says
that fighting is "prescribed . . . though it be hateful to you" (2:216).
Whether it is better for a religion's scriptures to largely ignore war
(as the Christian New Testament does) or to carefully regulate war
(as does the Quran) is an open question, but there is no debating
the importance of the themes of fighting and killing in both the
Quran and Islamic law. So while it is incorrect to translate *jihad* as
"holy war," the plain sense of this struggle in both the Quran and
contemporary Islamic practice is both spiritual and military.

One of the challenges for practitioners of any religion is wres-
tling with elements in their tradition that have been used to justify
evil and then bending those elements back toward the good. Many
Christians ignore New Testament passages that blame Jews for the
death of Jesus. But because some Christians have used these pas-
sages to justify hatred, persecution, and murder of Jews, the chal-
lenge is to attend to these words with care and then to drain them
of anti-Semitic connotations. Similarly, the challenge for Muslims
is to attend to passages in the Quran that extremists have used to
justify unjust killing. Many Muslims are meeting this challenge.
To suicide bombers, they point out that the Quran condemns sui-
cide unequivocally—"Do not kill yourselves" (4:29)—and prom-
ises hell for those who do so. To those who kill women or children
or civilians, they point out that the Quran condemns mass murder
(5:32) and insists on proportionality (2:194). Since the seventh cen-
tury, Islamic law has been committed to vigorously defending the
rights of noncombatants.[12]

According to a recent survey, most Muslims in Nigeria, Lebanon, and Turkey refuse to accept the legitimacy of suicide bombings even in defense of Islam. Unfortunately, in each of these countries significant minorities (42 percent in Nigeria, 34 percent in Lebanon, and 16 percent in Turkey) believe that suicide bombing is justifiable. In the Palestinian territories, 70 percent of Muslims say that suicide bombings meet their criteria for justice.[13]

For all the emphasis on jihad among Islamic extremists and Western neoconservatives, you would think that this is one of Islam's central concepts. It is not. As the Shahadah intimates, the three keywords in the Islamic tradition are Allah, Muhammad, and the Quran. To see the world as Muslims see it, you need to look through these lenses.

Allah

Allah is the Arabic word for God, so Arab-speaking Muslims and Christians alike refer to God as Allah, which literally means "the God" (*al-ilah*). As the article *the* implies, this God is singular, and the word Muslims employ to underscore this singularity is *tawhid*, or divine oneness. Christians, of course, are monotheists, but theirs is a soft monotheism in which the one God appears as a Trinity: Father, Son, and Holy Spirit. Islamic monotheism is harder. Like Jews, Muslims reject the Christian and Hindu notion that God can incarnate in a human body. Muslims also join Jews in rejecting visual images of God on the ground that such images, which cannot possibly capture the reality of the divine, tempt us toward idolatry. God is, for Muslims, absolutely and totally transcendent—far beyond all human conceptions of Him. So while Western art has until modern times been preoccupied with the Christ figure, Islamic art has centered on calligraphy, and particularly on the Arabic letters of the Quran.

God's names are legion in the Quran. In the Bismillah, the oft-repeated phrase that introduces all but one Quranic sura (chap-

ter 9), Allah is referred to as All Compassionate and All Merciful. Elsewhere in the Quran, Allah is called Forgiving, Generous, Loving, Powerful, Eternal, Knowing, Wrathful, and Just. In one passage He is called "the Sovereign Lord, the Holy One, Peace, the Keeper of Faith, the Guardian, the Majestic, the Compeller, and the Superb" (59:23). Muhammad reportedly said that Allah has ninety-nine names. Some Muslim thinkers divide this list into feminine *jamal* names (of beauty) and masculine *jalal* names (of majesty). But unlike many Christians who think of God as male, Muslims worship a deity who is beyond gender—neither male nor female.

Given this emphasis on tawhid, it should not be surprising that the gravest mistake from a Muslim perspective is *shirk*. Often translated as "idolatry," *shirk* refers to any practice or belief that ignores the unity and uniqueness of God. Polytheism is shirk, but so is likening God to anything that is not God. It is shirk to take money, power, or nation as your ultimate concern. Muslims disagree about whether belief in the Christian Trinity is shirk or the lesser offense of *kafir* (unbelief), but by either name it must be avoided. Jesus is revered as a prophet in Islam; the calligraphy of the Dome of the Rock in Jerusalem includes every Quranic passage mentioning Jesus. Muslims insist, however, that Jesus was neither Savior nor Son of God. In fact, the purpose of the Dome of the Rock's inscriptions is to assert the truth of tawhid over against the falsehood of the Trinity. "There is no god but God. He is One. He has no associate," these inscriptions insist, adding that since Allah has neither partners nor children, we should "say not 'Three'." Or, as the Quran puts it, "Say: 'He is God, One, God, the Everlasting Refuge, who has not begotten, and has not been begotten, and equal to Him is not any one'" (112:1–4).

Muhammad

In a book called *The 100: A Ranking of the Most Influential Persons in History*, the top spot went to Muhammad (570–632 C.E.).[14] This was a controversial choice. Christianity has almost twice as many adherents as Islam, yet Muhammad was ranked ahead of Jesus (who came in second). How could this be?

First, Muhammad did more for Islam than Jesus did for Christianity. Jesus was a great religious teacher, but he left it to Paul (who is ranked sixth) to establish Christianity and spread Jesus's teachings. If Jesus wrote anything, nothing of His writing survives, while Paul is credited as the author of nearly half of the New Testament's books. In purely religious terms, Muhammad did the work of Jesus and Paul combined. He was both a charismatic and a bureaucratic leader. He founded Islam and, though Muslims insist he did not write the Quran, he was the prophet through whom this revelation came into the world. Today Muslims look to Muhammad as a model for their own lives. The Hadith, a scriptural collection of his sayings and actions second in authority only to the Quran, has long provided a basis for Islamic law. Whereas Christians ask, "What would Jesus do?" Muslims ask, "What would Muhammad do?"

Second, Muhammad was also a great political and military man—a legislator, diplomat, and general. Unlike Jesus, who never married, and the Buddha, who abandoned his wife, Muhammad accomplished all this while maintaining an extended family network that, upon his death, included nine wives. Muhammad was the only person ever to achieve this combination of spiritual and secular success. "He was," a Muslim admirer writes, "a religious teacher, a social reformer, a moral guide, a political thinker, a military genius, an administrative colossus, a faithful friend, a wonderful companion, a devoted husband, a loving father—all in one."[15] Obviously this is faith talking, but even outsiders can see that Muhammad was the vehicle for both a new religion and a new political and economic order. While Jesus refused the sword,

Muhammad led armies. While Jesus eschewed politics, Muhammad ruled over a vast empire that extended at his death over most of the Arabian Peninsula. Moreover, the scripture Muhammad brought into the world attends to more topics than the Christ-inspired New Testament. As much about society as it is about spirituality, the Quran speaks of prayer and providence, marriage and divorce, breastfeeding and menstruation, lending and law.

Given Muhammad's unprecedented accomplishments, it should not be surprising that some Muslims used to call their religion Mohammedanism. But this is going too far. While Christians worship Jesus as God, Muslims have always insisted that Muhammad was only a human being. There is one and only one Allah in Islam, and He does not take human form.

As scholar of religion Wilfred Cantwell Smith has observed, the closest parallel to Jesus in the Islamic world is not Muhammad but the Quran. For Christians, the gift God sent to the world is Jesus, who came in the form of a human body. For Muslims that gift is the Quran, which came in the form of the Arabic language. So Muhammad, who is traditionally said to be illiterate, is more like the Virgin Mary than like her son. Whereas the Word of God that is Jesus came into the world through the pure vessel of a woman who had never had sex, the Word of God that is the Quran came into the world through the pure vessel of a man who could neither read nor write. Reciting the Quran, therefore, is like partaking of the Christian Eucharist. It is how you incorporate the divine into your body.[16]

Born in Mecca and orphaned as a child, Muhammad was a forty-year-old merchant married to an older woman named Khadijah when God first came to him in a cave on Mount Hira outside of Mecca. In this place, where Muhammad was known to withdraw for prayer and contemplation, the angel Gabriel interrupted his idylls with a command to "Recite." Muhammad was terrified. But recite he did, from 610 until these revelations came to an end shortly before his death in 632.

Islam dates its origins, however, not from these recitations but

from the formation of the Muslim community in 622. In this year, Muhammad and his earliest followers fled from Mecca, where his criticisms of local polytheistic traditions were met with scorn, to Yathrib, now known as Medina. There they established the Muslim community, or *ummah*. Today this event, known as the *hijra* (emigration), marks the beginning of the Islamic calendar, which is itself marked by the letters A.H., meaning "in the year of the hijra."

After Muhammad's death—in 632 C.E. (or A.H. 10)—the tradition split into its two main branches, Sunni and Shia, over the matter of Muhammad's successor. But before the end of the seventh century this new religious movement had spread spectacularly—east across the remainder of the Arabian Peninsula, west into Egypt and as far as Tripoli, and north into Jerusalem and modern-day Iran, Iraq, and Afghanistan. By 750, when the Mayans were still building Chichen Itza, Muslims had advanced across North Africa into modern-day Spain and Portugal and extended their reach to the Aral Sea and the Silk Road city of Samarkind. At the dawn of the modern age, in the sixteenth century, three great dynasties pushed Islam to the pinnacle of its powers: the Ottoman dynasty, centered in Istanbul, extended from the holy lands of Mecca, Medina, and Jerusalem into Egypt, North Africa, Iraq, and southeastern Europe; the Safavid dynasty controlled modern-day Iran; and the Mughal dynasty lorded over modern-day India. This era of global dominance ended with the rise of the British empire in the nineteenth century and the dissolution of the Ottoman empire in 1918. The world lives today under the heavy impress of this historic upheaval.

Quran

As Islam spread and became a global religion, it remained rooted in Arabian culture—in its sacred cities of Mecca, Medina, and Jerusalem, and in the Arabic language of the Quran. Although

Christians vary widely in their views of biblical authority, it is a nearly universal article of Islamic faith that the Quran is the perfect, unaltered, and untranslatable word of God. It was written not by Muhammad but by Allah, who gave its words to an angel, who gave them to Muhammad, who recited them to companions (but never wrote them down himself). If you want to know how God sounds, here it is, verbatim. So the Quran is scripture only in Arabic (unlike in Christendom, translations do not count).

The word *Quran* means "recitation," and the first words revealed to Muhammad were, "Recite: in the Name of thy Lord who created, created the human being of a blood-clot" (96:1–2).[17] So unlike the Book of Mormon (said to be translated from gold tablets), this scripture was oral from the start and not written down until long after Muhammad's death. Today the Quran is, of course, a book. But only about 20 percent of the world's Muslims are able to read its Arabic, and even for them the Quran is, like the Vedas to Hindus, more about sound than about meaning. So, as in Muhammad's time, the Quran is recited today more than it is read. It goes forth to the world in waves of sound, and it is not unusual for children as young as the age of ten to memorize these sounds in their entirety. Those who do so acquire both special honor and a special name— *hafiz* (for males) or *hafiza* (for females). More than a people of the book, Muslims are a people "of the recitation"—*al-Quran*.

Muslims believe that the Torah of Moses and the gospel of Jesus were revealed by Allah through His prophets. They also believe that these scriptures have been corrupted and are no longer trustworthy. So while Christians adopted a version of the Hebrew Bible as their Old Testament, Muslims adopted neither the Jewish nor the Christian scriptures. According to Muslims, only the Quran is the perfectly preserved word of God, committed to memory during Muhammad's lifetime and later written down just as originally recited.

The Quran is a relatively short book. About as long as the Christian New Testament, it can be read in a single day. Unlike the New Testament, the Quran contains almost no storytelling. Its preoccu-

pations are doctrinal and legal rather than narrative. It comprises
114 suras, or chapters, each of which is named. The first sura is
called "The Opening," and the second is called "The Cow." As a
rule, suras are presented by length, from longest to shortest. The
Quran contains no formal divisions other than the suras them-
selves, but scholars divide these chapters into earlier "Meccan" and
later "Medinan" suras, depending on where they were revealed.
Where a given sura was revealed matters because of the Islamic
doctrine of abrogation, which states that later suras can overturn,
or abrogate, earlier ones.

Tibetan Buddhists claim that their tradition synthesizes the
wisdom of South Asia's Theravada Buddhism with the compas-
sion of East Asia's Mahayana Buddhism. Muslims make a similar
claim. While Judaism is about law, and Christianity is about spiri-
tuality, they say, the Quran combines the two. The Quran's earlier
(and often shorter) Meccan suras focus on spiritual matters, while
the later (and often longer) Medinan suras focus on social, political,
and economic matters such as marriage, war, and gambling. So
Islam is a way of life as well as a religion. The Quran tells Muslims
not just how to worship Allah but also how to lend money, divide
estates, enter into contracts, and punish criminals.

One of the Quran's most persistent social themes concerns jus-
tice and poverty. Reminiscent of Latin American liberation the-
ology's "preferential option for the poor," the Quran articulates a
preferential option for the weak, speaking out forcefully and fre-
quently on behalf of the blind, the lame, and the sick. The pious,
the Quran says, "give food, for the love of Him, to the needy, the
orphan, the captive" (76:8).

The Quran glories, however, not in this world but the next. More
than any other great religion Islam emphasizes life after death. In
fact, it is difficult to find a sura that does not address the afterlife.
Hundreds of verses detail the horrors of hell, the splendors of Para-
dise, the rewards awaiting martyrs, the mechanics of the resurrec-
tion, and the prophesies and procedures of the Day of Judgment.
Exactly what this all means, and how literally or metaphorically it

is to be taken, is up for grabs, but hell and Paradise are described in the Quran in far greater detail than hell and heaven in the Christian Bible. Hell is a place of fire and thirst, roasting skin and cactus thorns; Paradise is a garden of cool shade, comfortable couches, full-breasted virgins, abundant fruit, and, above all, rivers: rivers of water, of milk, of wine, and of honey.

Repeatedly the Quran warns of horrors to come for those who persist in their pride and refuse to submit to Allah. The words "warn" and "warning" occur dozens of times, Muhammad is described as "a warner" (38:4), and the Quran as a book sent down "to warn the evildoers" (46:12). Prophets repeatedly warn that there is no protector but Allah, yet these warnings go unheeded, and the prophets are accused of forgery and sorcery instead.

One of the core questions posed in the Quran is this: "There is no god but He; so how are you so turned about?" (39:6). What turns us about is not so much sin as forgetfulness. Socrates understood learning as recollection: the truths we think we are learning we are actually recalling from past lives. Muslims don't typically believe in reincarnation, but they too see learning as recollection. All of us are born Muslims, they argue. No baby imagines that she is self-created or self-sufficient. As we grow older, however, we "wax proud" (16:23) and forget our true nature. The Quran seeks to shake us out of this forgetfulness, to remind us of our radical dependence on God, and to offer us ways to practice humility. "What, will you not remember?" the Quran asks incredulously (45:23). "Be not as those who forget God" (59:19). So while the Quran is revelation and recitation, it is also remembrance—"a Reminder unto all beings" (68:52). Remember Allah, it says. Remember the prophets and the holy books. Remember to take care of the weak and the needy.

Jewish and Christian readers new to the Quran are often surprised to find that its cast of characters extends to Abraham, Adam, Cain and Abel, David, Goliath, Isaac, Ishmael, Israel, Jacob, Jesus, John the Baptist, Jonah, Joseph, Mary, Moses, Noah, Pharaoh, Satan, Saul, and Zachariah. Mary appears more often in the Quran

than she does in the New Testament. Nonetheless, the Quran differs radically from the Christian Bible. Here Adam sins, but this first sin is not imputed to the rest of us. So, as in Judaism, there is no doctrine of original sin and no Savior sent to earth to redeem us by dying.

On the question of relations between Muslims, Jews, and Christians, the Quran seems as conflicted as interactions among these groups were during Muhammad's lifetime. The Quran says its God is the same as the Christian and Jewish God—"Our Allah and your Allah is One" (29:46, Pickthal)—and Muslims are told to "dispute not with the People of the Book" (29:46). At least one Quranic passage seems to indicate that Jews and Christians will make it to Paradise: "Surely they that believe, and those of Jewry, and the Christians . . . whoso believes in God and the Last Day, and works righteousness—their wage awaits them with their Lord, and no fear shall be on them, neither shall they sorrow" (2:62). Many passages say that the Jewish and Christian prophets were sent by God, and at least two passages insist that "we make no division between any of them" (3:84 and 2:136).

Abraham, for example, is described as "a man of pure faith and no idolater," and it is written that "in the world to come he shall be among the righteous" (16:120, 122). But he will stand there as a submitter rather than a Jew, since "whoso desires another religion than Islam, it shall not be accepted of him; in the next world he shall be among the losers" (3:85).

Consigning Jews and Christians to hell is one thing, but speeding their arrival is another. Some of the Quran's so-called sword verses—"O believers, fight the unbelievers who are near to you" (9:123) and "Fight you therefore against the friends of Satan" (4:76)—seem not only to justify but also to command making war on non-Muslims. Another controversial verse commands Muslims to "slay the idolaters wherever you find them, and take them, and confine them, and lie in wait for them at every place of ambush," unless, of course, they convert: "If they repent, and perform the prayer, and pay the alms," then you can "let them go their way" (9:5).

Ethics is the dimension where the great religions converge most closely. But on the ethics of war the Quran and the New Testament are worlds apart. Whereas Jesus tells us to turn the other cheek, the Quran tells us, "Whoso commits aggression against you, do you commit aggression against him" (2:194). The New Testament says nothing about how to wage war. The Quran, by contrast, is filled with just-war precepts. Here war is allowed in self-defense (2:190; 22:39), but hell is the punishment for killing other Muslims (4:93), and the execution of prisoners of war is explicitly condemned (47:4). Whether in the abstract it is better to rely on a scripture that regulates war or a scripture that hopes war away is an open question, but no Muslim-majority country has yet dropped an atomic bomb in war.

After 9/11, many non-Muslims read the Quran for the first time. Some came away horribly conflicted. When I read the Quran (in translation) for the first time, I found it repetitive. I kept wishing for some sort of narrative arc. I strained for historical context. Still there were elements I loved. I loved the recurring short litanies of the names of Allah, which seemed to punctuate almost every sura, providing the reader with moments of rest and breath:

> *"and know that God is All-forgiving, All-clement"*
> *"and know that God is All-hearing, All-knowing"*
> *"and know that God is All-sufficient, All-laudable"*
> (2:235, 2:244, 2:267)

I found the notion of a religion designed to humble the proud thrilling. I also loved the Quran's habit of the question—"Do you not understand?" (2:44); "Have you not seen?" (31:20)—despite the fact, *because* of the fact, that these questions were rarely answered.

There were also specific passages I found beautiful in expression and sentiment: "Every man has his direction to which he turns; so be you forward in good works" (2:148); and "let thy Lord be thy Quest" (94:8). My favorite sura was this short, poetic one, called "The Forenoon":

In the Name of God, the Merciful, the Compassionate
By the white forenoon
and the brooding night!
The Lord has neither forsaken thee nor hates thee
and the Last shall be better for thee than the First.
Thy Lord shall give thee, and thou shalt be satisfied.
Did He not find thee an orphan, and shelter thee?
Did He not find thee erring, and guide thee?
Did He not find thee needy, and suffice thee?
As for the orphan, do not oppress him,
and as for the beggar, scold him not;
and as for thy Lord's blessing, declare it. (93:1–11)

Although I do not believe that this life is a mere dress rehearsal for the next—that "the present life is naught but a sport and a diversion" (6:32)—I was moved by passages about the "homecoming" Muslims believe they have waiting in God (24:42). Finally, I loved the challenge of this simple question, *the* question of Islam itself: "So have you surrendered?" (11:14). I must say, however, and with no small measure of regret, that I did not love the tactics the text employed to get me to answer this question in the affirmative.

One source of my disquiet is the way the Quran twists wrath around compassion so tightly that the former seems to strangle the latter. The Quran begins almost every sura with the reminder that Allah is merciful and compassionate, and repeatedly we are told that He is "All-forgiving to him who repents and believes, and does righteousness, and at last is guided" (20:82). But at least as often we are told of the horrors to come for "the inhabitants of the Blaze" (35:6). Repeatedly I read that Allah is watching me, that I should fear him, since he is both "terrible" (40:3) and "swift" in retribution (6:165), and that He will bring down fire on the unrepentant, the unbeliever, the unrighteous, and the boastful.

In short, the Quran reads like a fire-and-brimstone sermon from start to finish. The Arabic term for torment/punishment/chastisement appears hundreds of times. In fact, it is one of the Quran's

most frequently used words. So any reader will be warned over and over again of "a painful chastisement" (7:73), "a humbling chastisement" (22:57), "a mighty chastisement" (8:68), the "chastisement of the Fire" (7:38), and the "chastisement of boiling water" (44:48).

Given how much fear has driven Islamophobia in the modern West, it is troubling to keep bumping into fear mongering here. Yet as Jewish philosopher Abraham Heschel once wrote of the wrath and rage of the Hebrew Bible prophets, "Every prediction of disaster is in itself an exhortation to repentance."[18] Great reciters of the Quran are able to convey to their listeners how their warnings really *are* warnings, intended to guide us toward submission. Some Muslim thinkers have even suggested that hell may not be eternal—that eventually those who find their way there will be punished enough and be taken up into Paradise.

Of course, the Quran is not unique in telling us to fear God. There is a long history of fire-and-brimstone sermons in Christendom, and the Quranic term for hell, *Jahannam*, is itself derived from the biblical term *Gehenna*. What Bible scholar Phyllis Trible refers to as "texts of terror" abound in Judaism and Christianity too. "Do not I hate them, O Lord, that hate thee? And am I not grieved with those that rise up against thee?" reads Psalm 139:21. Elsewhere, the Bible commands the annihilation of entire peoples (Deuteronomy 20:16–18) and insists on gruesome executions for disobedient children (Deuteronomy 21:18–21), for relatives who entice you into worshipping other gods (Deuteronomy 13:6–10), for adulterers (Deuteronomy 22:22), for prostitutes (Leviticus 21:9), and for anyone who works on the Sabbath (Numbers 15:32–36).

Still, I found myself reeling as I read, gagging as it were on the plates of pus and draughts of boiling water promised to the unrepentant. Part of my distress was doubtless rooted in my upbringing on the Christian scriptures. I have been conditioned to turn down the volume when Jesus speaks of casting whole cities into hell (Matthew 11:23), and I no longer see (or feel) the "lake of fire" (Revelation 20:15) as vividly as did Michelangelo in *The Last Judgment* or Dante in *The Divine Comedy*. Still, I was discour-

aged to read so much of liars, evildoers, hypocrites, unbelievers, and idolaters. I must admit, though, that something in me found all this God-fearing refreshing. In the modern West there is so much cheap chatter about befriending God that the prospect of fearing God seems almost illicit. What German theologian Rudolf Otto once referred to as the *mysterium tremendum* has been squeezed out of divinity and with it the prophetic possibility of punishment for those who glory in injustice.

Given centuries of Christian criticisms of Islamic views of women, many will be surprised to come across passages that treat men and women equally: "Men and women who have surrendered, believing men and believing women, obedient men and obedient women, . . . for them God has prepared forgiveness and a mighty wage" (33:35). But there is no sidestepping the notorious passage from the "Woman" sura that permits husbands to beat their wives (4:34). Almost as discouraging are a series of verses that assume a male reader, as if this scripture were addressed not to all humanity but to men only:

> *If you fear that you will not act justly toward the orphans,*
> *marry such women as seem good to you, two, three, four; but*
> *if you fear you will not be equitable, then only one. (4:3)*
> *Your women are a tillage for you; so come unto*
> *your tillage as you wish. (2:223)*

Readers committed to interfaith dialogue may be particularly upset by a series of verses that tell Muslims to forgo non-Muslim friends. One of my Muslim friends interprets passages such as "O believers, take not Jews and Christians as friends" (5:51) historically, arguing that, when these recitations were revealed, Jews and Christians were often allied with tribes opposed to Muhammad, so befriending them was tantamount to treason. Things are different now, he says, and friendships between Muslims and non-Muslims are not only permitted but imperative. Another Muslim friend says that these passages do not refer to modern-day friendships at all

but to patron/client relationships of mutual protection. What these verses mean, she says, is "Don't take Jews and Christians for your protectors . . . don't expect them to have your back."[19]

Shariah

Of Ninian Smart's seven dimensions of religion, the most important in Islam is the legal dimension. In fact one way Islam tilts toward Judaism and away from Christianity is in its emphasis on law over theology. *Shariah*, which literally means the "right path," is the term Muslims use for law, and Shariah law, as it is referred to (redundantly) in the West, has been adopted in some measure in recent years in Iran, Sudan, Saudi Arabia, and other Islamic countries, including Afghanistan under the Taliban.

Historically, Muslims have not separated the sacred and the secular, so Shariah extends into all aspects of life—family, society, economics, and politics. It covers ritual and ethics, as well as criminal law, taxation, and public policy. This robust concept tilts toward the afterlife too, instructing Muslims not only how to live on Earth but also how to get to Paradise.

Fiqh, or interpretation of Shariah, is based on both the Quran and the Hadith, a secondary body of scripture comprising thousands of accounts of the words and deeds of Muhammad. These Hadith, which were gathered in the eighth and ninth centuries into six respected Sunni collections, cover both law in the secular sense of that term and ritual obligations. They extend to such seemingly mundane matters as the cut of Muhammad's beard and the foods he liked (honey and mutton) and disliked (garlic and melons). The Shia have their own Hadith literature, which also includes accounts of the lives of their Imams (leaders).

Not all Hadith are equally authoritative, however. Each comes with both a chain of transmission, known as the *isnad,* and content, known as the *matn*, and the authenticity of any given Hadith can be challenged on either basis. If the chain of oral transmission from

Muhammad to whomever recorded the Hadith is dubious—if one of the transmitters is unreliable, for example—it can be rejected. If its content contradicts the Quran, it can be rejected too. So Muslims disagree routinely over whether a given Hadith is authentic.[20]

Outsiders often imagine that Islamic law is unchanging and immutable, but Sunnis and Shias differ significantly on all sorts of legal matters, and Sunnis themselves recognize four major legal schools.[21] Like Roman Catholics, the Shia centralize religious authority, in their case in the Imam. Sunnis decentralize religious authority, placing it in the Muslim community as a whole. So it should not be surprising that Sunni legal views vary widely.

There has been much talk in the West of the *fatwa*, or legal opinion, since the Ayatollah Khomeini of Iran issued a fatwa against the novelist Salman Rushdie in 1990 and Osama bin Laden issued fatwas in 1996 and 1998 protesting the presence of U.S. military troops in Saudi Arabian holy lands. Beginning with the Quranic recitation to "slay the pagans wherever you find them," bin Laden referred in the latter fatwa to U.S. military activity on the Arabian Peninsula as "clear declaration of war on God, his messenger, and Muslims" and called the killing of Americans and their allies "an individual duty for every Muslim."[22] Few Muslims heeded that call. That is because a fatwa carries the force of law only to those who recognize the authority of the jurist who issues it, and traditionally fatwas *have* been issued by jurists, not by laypeople such as bin Laden. In 2005 Muslim clerics in Spain issued a fatwa condemning "the terrorist acts of Osama bin Laden and his organization al-Qaeda" as "against Islam."[23] Bin Laden, they found, is an apostate who follows not the Quran but a law of his own devising.

Sunni and Shia

As this fatwa slinging shows, there are many interpretations of Islam. There is no Muslim pope to issue infallible encyclicals, so Islam is a big tent theologically. There are fundamentalists and

feminists, legalists and mystics, progressives and moderates. But
the most basic division in the Muslim world pits Sunnis, who con-
stitute roughly 85 percent of the world's Muslims, against Shias,
who account for the remaining 15 percent.

Surviving a founder's death is a challenge for every new reli-
gious movement. Mormonism splintered in 1844 over the question
of Joseph Smith's successor, and the Hare Krishna movement was
thrown into chaos after the death of Swami Prabhupada in 1977.
Following Muhammad's death, Muslims split over this key ques-
tion of authority. A majority backed Muhammad's father-in-law
Abu Bakr as his successor. But a minority, insisting that Islam's
next leader share Muhammad's bloodline, backed the Prophet's
son-in-law Ali.

Those who supported Ali came to be called *Shiat Ali* ("partisans
of Ali"), or Shia for short. Those who supported Abu Bakr came to
be called Sunni (from *sunna*, which means tradition). The broader
and deeper disagreement concerned how the Islamic community
was to be led. The Sunni invested social and political authority in
a series of caliphs, reserving all-important religious authority for
the broader community. The Shia invested social, political, *and*
religious authority in their leader, whom they called the Imam.
The word *imam* means leader in Arabic, and among the Sunni
this term refers simply to the person who leads weekly congrega-
tional worship services on Fridays. But among the Shia, the Imam
(who must be descended directly from Muhammad) leads not just
a congregation but the entire Shia community and, according to
the Shia, is both sinless and infallible.

The Shia minority has split into various branches, most notably
Twelver Shi'ism, which predominates in Iran and southern Iraq,
and Ishmaili Shi'ism, which has a strong presence in India and
East Africa. Twelvers are the largest Shia group. They believe there
were twelve Imams, that the twelfth went into hiding ("occulta-
tion") in 873 c.e., and that this "hidden" Imam will return at the end
of times as a messiah figure of sorts, leading an apocalyptic battle
between the forces of good and evil. The smaller Ishmaili branch

split off in 765 c.e. over who would succeed the sixth Imam. While many supported the sixth Imam's son Musa, those who became the Ishmailis supported his son Ismail. Unlike the Twelvers, Ishmailis follow a line of Imams that extends to the present day.

Every religion is a "chain of memory," and a key link in this chain for the Shia is the martyrdom of Muhammad's grandson Husain at Karbala in Iraq in 680 c.e.[24] This time-turning event is remembered each year during the Muslim month of Muharram. On Ashura, the Muharram's tenth day, the faithful stage dramatic performances of Husain's death after the manner of Christian Passion Plays. In a practice reminiscent of the self-flagellation of Catholic Penitentes in the American Southwest, some men flagellate themselves to relive Husain's suffering. Although versions of this holiday are celebrated among the Sunni, and among non-Muslims on the islands of Trinidad and Jamaica, it is of particular import to the Shia, many of whom do their daily prayers with their foreheads pressed to a piece of clay from Karbala. During the Iranian Revolution in Shia-majority Iran, rebels chanted, "Every day is Ashura and every place is Karbala."

Islamism

Among recent developments in Islam, the scariest to Muslims and non-Muslims alike is the rise of Islamism, a radical form of politicized Islam that took the martyr tradition developed by Jews and adapted by Christians in a deadly new direction.

Islamism means different things to different people, but as the "ism" implies, it refers most widely to an ideology—an anti-Western and anti-American ideology applied to political ends by groups such as the Taliban in Afghanistan, Hezbollah in Lebanon, Hamas in the Palestinian territories, and, of course, al-Qaeda. Ideologically, the goal of Islamists is to purify Islam from the pollutions of modernity, not least the presence of U.S. military forces in Saudi Arabia and the presence of the State of Israel in the Middle East.

Politically, Islamists aim to create Islamic states (or a transnational caliphate) following their idiosyncratic version of Islamic law. The tactics used to achieve these goals vary but for some Islamists they include violence and even acts of terror such as suicide bombings.

If Islam is a religion, Islamism is a political project, revolutionary in aim, utopian in spirit, and radical in all senses of the term. Like other revitalization movements, Islamism seeks to move forward by going back—in this case to the example of early Islam, which the Taliban, for example, interpret as forbidding female education and employment. Although Islamists typically trace their views to the Quran and the beginnings of Islam, Islamism, like other forms of fundamentalism, is actually a modern invention, deeply influenced by the Western ideologies it seeks to oppose. The greatest intellectual influence on al-Qaeda itself is likely the Egyptian theologian Sayyid Qutb (1906–66), who urged his followers to fight a holy war against secularism, democracy, and the West. Islamism's heroes are so-called martyrs who, in violation of a clear Quranic prescription against suicide, blow themselves up for, among other things, promise of instant transport to Paradise. The villains are Israel and the "Great Satan," the United States, but Islamists also denounce as evildoers (and apostates) fellow Muslims who interpret Islam in a more mainstream manner.

Ultraconservative intellectual movements such as Salafism share much with Islamism but are distinguishable from and often antagonistic to it. Salafists seek to redirect their religious tradition back to the pure, primitive Islam of the earliest Muslims, who are known as *salaf*, or "pious predecessors." Their sneer word is *bidah*, which means innovation.

One form of Salafism, Saudi Arabia's official theology of Wahhabism, spread globally in the early twenty-first century as Saudi money flowed into new mosques worldwide. Wahhabism is based on the strict teachings of Muhammad ibn Abd al-Wahhab (1703–92), an eighteenth-century thinker who also opposed innovation but was obsessed with the problem of shirk. According to Ibn Abd al-Wahhab's uncompromising theology, both Christianity and Ju-

daism are shirk, as are Shi'ism and Islam's mystical tradition of Sufism. Ibn Abd al-Wahhab opposed the Shia practice of visiting the graves of Muhammad and his companions. He even destroyed some of those sacred sites. Like Salafism, Wahhabism is often referred to as puritanical, because of its strict legal code, its desire to purify its religious tradition from various pollutants, and its goal of returning to the purity of the earliest form of the faith. Like New England Puritans, who did not celebrate Christmas, Wahhabis do not celebrate Muhammad's birthday.

Islamists have latched onto the notion that we are witnessing a clash of civilizations between Islam and the Christian West, but what their activities really demonstrate is an intra-Islamic culture war—a clash between Muslims who believe that the Islamic tradition means what it says when it comes to not killing women and children, and Muslims who do not.

Progressive and Moderate Muslims

At the other end of the political spectrum is Progressive Islam, a new movement particularly strong in Europe and the United States. Progressive Muslims are staunch opponents of Salafism, Wahhabism, and Islamism, but they also criticize colonialism and imperialism. "Their task," writes Omid Safi, author of *Progressive Muslims* (2003), "is to give voice to the voiceless and power to the powerless."[25] Pluralists to the core, Progressive Muslims welcome multiple voices not only from within Islam itself but also from other religious traditions. Although they base their thought and action on traditional Islamic sources such as the Quran and the Hadith, they also draw on Latin American liberation theology, the nonviolent resistance of Martin Luther King Jr., and the critique of Orientalism by the secular humanist Edward Said.

Progressive Muslims believe that the struggle for justice lies at the heart of the Islamic tradition. They also believe that the better angels of Islam have always been on the side of the poor and the

weak, and that their tradition's ancient mandate to defend the defenseless compels them to struggle for gender equality and human rights. "At the heart of a progressive Muslim interpretation," writes Safi, "is a simple yet radical idea: every human life, female or male, Muslim or non-Muslim, rich or poor, 'northern' or 'southern,' has exactly the same intrinsic worth."[26]

One of the most controversial chapters in the short history of Progressive Islam came in New York City on March 18, 2005, when Amina Wadud, a professor of Islamic Studies at Virginia Commonwealth University, led a mixed-gender Friday prayer service of over one hundred worshippers. This was not the first breach of the tradition of male prayer leaders, but it was the first to set off a firestorm of international controversy. Muslim leaders worldwide denounced this action as a violation of Islamic law, but women imams have subsequently led Friday salat services and/or delivered the traditional Friday sermon in the United States, Canada, Spain, and South Africa.

Of all the Western criticisms of Islam, one of the most persistent has been that it is hostile to women. Muslims from Muhammad forward *have* historically seen gender as an essential rather than an accidental characteristic of human beings. ("The male is not like the female," reads the Quran [3:36]). So in mosques in which women are allowed (some forbid their entrance) men and women are typically separated. Sons usually receive inheritances twice as large as those of daughters, and in Islamic courts it usually takes two female witnesses to equal one male witness. Finally, although Muslim theologians describe God as beyond gender, the Quran refers to God exclusively as "He" when a third-person pronoun is needed.

Muslim feminism is not an oxymoron, however. Muslim feminists argue that the Quran and the Hadith, while patriarchal in many respects, represented at the time a quantum leap for women in terms of property rights, inheritance, divorce, and education. They also note that women have become heads of state in at least seven Muslim-majority countries.

And then there is the controversial practice of veiling. The hijab has been outlawed in some Muslim countries and is required in others. Most French citizens and a large minority of Americans believe that Islamic head coverings should be banned in their countries, and both countries have seen lawsuits over such matters as whether Muslim women have the right to wear head coverings when working at McDonald's or posing for a driver's license photograph. Although many Muslim women have taken off the veil as an expression of women's rights, many Muslim feminists choose to wear the veil as an expression of those same rights. The hijab has also become a symbol of Islamic identity, not unlike the *kippah* (head covering) for Jewish men.

Between fundamentalists and progressives there are hundreds of millions of moderate Muslims. Among Indonesia's 178 million Muslims, fundamentalism is fringe. Islamist parties have failed at the polls, and most Muslims there self-identify as moderate or progressive. Both of these groups favor democracy and the separation of mosque and state. Progressives there distinguish themselves from moderates by speaking out more forcefully for religious pluralism and women's rights and by drawing more generously on the thinking of intellectuals from Europe, Latin America, and the United States.

The Muslims I spoke with during a visit to Yogyakarta, a cultural and intellectual center of this vast island archipelago, were moderates and progressives. All were openly adapting Islam to local circumstances, mixing its ancient traditions with their own. And all scoffed at any notion of a clash of civilizations between Islam and the Christian West. Any clash that exists, they said, is between fundamentalists of all faiths and their progressive and moderate coreligionists. While in Indonesia, I didn't see a single woman covered from head to foot as is common in Iran and Afghanistan, and in the rural areas none of the women wore any head coverings at all. When I asked Zuli Qodir, a leader of a popular moderate group called Muhammadiyah, what Islam was all about, he waxed Jeffersonian. "Islam is justice," he said. "And equality. And democ-

racy." Another Muslim leader told me that "the essence of Islam" is "caring for the poor."

Religious pluralism is particularly prized in Indonesia, where the influences of Buddhism, Hinduism, and Christianity have wafted across its 17,000-plus islands for centuries. Why did God create the world? According to the principal of an Islamic school I spoke with, because God prefers multiplicity to unity—because "difference is good." Repeatedly, I was reminded that Muslims reject religious coercion—"There is no compulsion in religion" (2:256, Pickthal)—and that their "people of the book" category includes not only Jews and Christians but also Hindus and Buddhists.

Sufism, Drunk and Sober

It is tempting to imagine that the world's religions are what they teach or what they do—that Christianity is its creeds, and Judaism its law. But just as we humans are more than the sum of our thoughts or work, religious traditions cannot be reduced to their creeds and rituals. Inside each of the world's religions there are people who take it as their task to look beneath the surface of the Nicene Creed or the Five Pillars to something that is, as the English poet William Wordsworth put it, "far more deeply interfused." In Islam these people call themselves Sufis.

During a visit to Jerusalem, I spoke with a shopkeeper who turned out to be not only an expert salesman but also a lifelong Sufi. When I asked him about the importance of the Five Pillars of Islam, he shook his head "NO!" and, pointing an index finger uncomfortably close to my nose, insisted that Islam could stand up perfectly straight without any of the Five Pillars. Real Islam, he said, has nothing to do with law and everything to do with experience. It is about a heart-and-soul connection between the individual believer and God—the sort of crazy love that sets your whole being into dance. It needs no rituals, no rules, he said. In fact, rituals and rules only take us away from what is Really Real.

A similar point was made by the eleventh-century Sufi Ansari of Herat (in present-day Afghanistan), who in this short poem subordinated the Five Pillars to a higher calling:

> *Fasting is a way to save on food.*
> *Vigil and prayer is a labor for old folks.*
> *Pilgrimage is an occasion for tourism.*
> *To distribute bread in alms is something for philanthropists.*
> *Fall in love:*
> *That is doing something!*[27]

The ninth-century Persian Sufi Bayazid Bistami was equally skeptical of the ability of religion to take you to God. "The thickest veils between man and Allah," he wrote, "are the wise man's wisdom, the worshiper's worship, and the devotion of the devout."[28]

One of the distinguishing marks of Islam is its unequivocal rejection of the Christian traditions of celibacy, asceticism, and monasticism. Muslims often scratch their heads over why Jesus remained single, and marriage is enjoined in both the Quran ("Ye that are unmarried shall marry," 24:32) and the Hadith ("Marriage is my *sunnah* [exemplary practice]").[29] So monks who have withdrawn from the world usually come in for derision. Early Sufis, however, bucked this trend. The term *Sufi* comes from the term *suf*, which means wool. So Sufi means "wool wearer," which is to say someone who has opted for a simple life of contemplation and pious poverty along the lines of Christian monastics and their scratchy wool garments.

Sufism, which emerged in the eighth century, is a mystical tradition. Like other mystics, Sufis stress the experiential dimension of religion. Less patient than other Muslims, they don't want to wait until they die to experience the divine. Like Muhammad (the first Sufi, they say) in the caves of Mount Hira, they seek to "taste the *here* and the *now* of God." Or, as one Sufi poet puts it:

When the ocean surges,
don't let me just hear it.
Let it splash inside my chest!"[30]

Under the guidance of gurulike figures known as sheiks or *pirs*, and through institutions known as orders or brotherhoods, Sufis have experimented over the centuries with a variety of spiritual practices designed to crack the heart open to ecstatic experience of the divine. In keeping with the broader Muslim notion that the problem of self-sufficiency originates in forgetfulness, Sufis seek to keep God forever on their hearts, either by chanting His "beautiful names" or by sitting with these names in silence. Another Sufi practice is a Muslim analog to what Daoists call "free and easy wandering," and wandering Sufis played a major role in the spread of Islam to climes as far flung as Africa, India, and Southeast Asia.

Inside the Muslim world, Sufis are notorious for flirting with idolatry by imagining their spiritual quest as culminating in an annihilation of the self that is also a mystical union with God. While Muslim theologians and jurists tend to emphasize God's transcendence and distance, Sufis emphasize God's immanence and nearness, drifting along the way toward pantheism ("everything is God") and monism ("everything is One."). While other Muslims emphasize the radical qualitative distinction between God and human beings, Sufis emphasize the ways in which human beings resemble God, who is as near to them, as the Quran puts it, "as the jugular vein" (50:16). If Reality is one, then multiplicity is an illusion, and there is no real distinction between Creator and created. Because every place is equally sacred, you don't need to go to Mecca or a mosque to find God. In fact you don't need to travel beyond your own heart. Like modern-day evangelicals who have a friend in Jesus, Sufis call themselves friends of God.

To many Muslims, there has always been something deeply unsettling and even dangerous about the esoteric precepts and practices of the Sufis, since from the Sufi perspective so much of what

other Muslims see as desirable and even required is unnecessary at best and harmful at worst. While most Sufis claim to follow both the outer, legal path of Shariah and the inner, mystical path called *Tariqah*, critics claim they sacrifice the former at the altar of the latter. Wahhabis, for example, see Sufism as an invitation to both shirk and immorality. The great Persian Sufi Mansur al-Hallaj was executed as a heretic in Baghdad in 922 for saying "I am the Truth"—a line al-Hallaj understood to be articulating his union with God but his accusers took to be blasphemy (since Truth is one of the ninety-nine names of God).

In order to make some semblance of sense of this mystical path, insiders and outsiders alike have divided Sufis into two types: the sober and the drunk. If the medium for the sober Sufi is prose and the métier reason, the medium for drunken Sufi writers is poetry and the métier emotion. Sober Sufis include the Persian philosopher al-Ghazali (1058–1111) who, by conceding the importance of Shariah, brokered a peace between Sufis and those who accused them of heresy and immorality. Approaching the divine with awe, sober Sufis are ever aware of God's power and wrath—an awareness that keeps them closer to the straight and narrow than their more intoxicated kin. Drunken Sufis, by contrast, emphasize the mercy and beauty of God, approaching Him in love and ecstasy more than awe and fear. As a result, they worry less about their tradition's legal and ritual requirements. For some drunken Sufis, at least, the Five Pillars are incidental—the plastic bag you take home from the grocery store, and quite different from the real nourishment inside.

A classic example of the intoxicated type, the great Persian poet Rumi (1207–73) is beloved today by Muslims and non-Muslims alike. Thanks to popular English translations by Coleman Barks, he is now one of the best-selling poets in the West, and his work has been performed by celebrities such as Madonna and Philip Glass. Rumi's poetry is endlessly intriguing, and his admonition to "gamble everything for love" is a challenge of the highest order.[31]

Part of the attraction is the backstory: Rumi was a bookworm

and a scholar when he was visited by a wandering Sufi named Shams, who, depending on the storyteller, either burned Rumi's books or threw them into a pond. ("A donkey with a load of holy books," Sufis now say, "is still a donkey."[32]) Either way, Shams turned Rumi's life upside down, and for years the two were inseparable. Then Shams mysteriously disappeared, most likely the victim of murder. This tragic turn remade Rumi into one of the world's most prolific and beloved poets.

Another name for Sufism is *ihsan*, or "doing what is beautiful," and Rumi's poetry does just that. His poems overflow with longing for his friend Shams. "There is no salvation for the soul," he writes, "But to fall in Love."[33] Rumi insists, however, that the love between Romeo and Juliet, or Nicole Kidman and her latest leading man, is also love for and from the divine. When he writes, "In the house of water and clay this heart is desolate without thee; / O Beloved, enter the house, or I will leave it," he is longing for God *and* Shams.[34] Or, to be more faithful to Rumi's faith, he is speaking of a God and a man who only *seem* to be different beings.

From a vantage point where only God is Really Real, it makes no sense to distinguish Sunni from Shia or Muslim from Jew. So Sufis generally affirm that all religions are paths to the divine. But they are only paths, clumsy gestures toward what is unspeakable. Of course, Sufis acknowledge differences between Islam and other religions. But such is outer, inessential knowledge. From the perspective of inner, essential knowledge, all such distinctions fall away. "There was a time, when I blamed my companion if his religion did not resemble mine," wrote the Spanish philosopher Ibn Arabi (1165–1240). "Now, however, my heart accepts every form. . . . Love alone is my religion."[35]

As Rumi once explained, intelligence comes in two forms. There is the secondhand intelligence of a child's memorizing facts delivered through books and teachers—the sort of intelligence that will get you a job as a civil engineer or help you distinguish between the Five Pillars of Islam and the seven sacraments of Roman Catholicism. Wordsworth called this "our meddling intellect."[36] But there

is another kind of intelligence, a "second knowing," which springs from direct, personal experience of God—"a fountainhead / from within you, moving out."[37] This kind of knowing lies beyond the limits of everyday language and ordinary thought. So Sufis attempt to express it in other ways—in music and dance and in the elliptical language of mystical poetry, whose very words urge the reader to look beyond them to The Beyond.

One of the temptations of any religion is to mistake it for the Ultimate To Which It Points—to start to worship Christianity rather than Christ, for example. Sufis resist this temptation. What they crave is not Islam but Allah, not Paradise in the by-and-by but the presence of the divine here and now, not the secondhand report but the firsthand experience. When asked whether she even cared about Paradise, the Sufi poet Rabia of Basra famously said, "First the neighbor, then the house."[38]

So what does it mean to be religiously literate when it comes to Islam? Is it about external forms or inner experience? Does Islamic literacy mean knowing the Five Pillars and the Quran? Or being conversant in the distinctions between Sunnis and Shia? Surely it is all of these things. To understand the role of Islam in the world today, you need to understand its view of the problem of self-sufficiency and the solution of submission. You need to make sense of the goal of Paradise, and how that goal motivates human behavior. But as the Sufis remind us, there is a fluency beyond this basic literacy, and perhaps beyond even language itself. Perhaps, as Rumi and his Sufi kin seem to say, what matters is not knowing Islam but knowing Allah. Or is knowing beside the point? Perhaps to understand Islam is not to know but to feel—to feel God moving inside you like the energy that animates a dance.

Those of us who are not Sufis must be content with knowing that Islam is the greatest of the great religions. In terms of adherents, this tradition of mercy and justice and forgiveness and submission is growing far faster than Christianity. In terms of influence, it is controlling the worldwide conversation about the virtues and vices of religion. Islam is a key player in the Middle East and Asia and a

rapidly growing presence in Europe and North America. Assets in Islamic banks (which do not charge or pay interest) are, according to the International Monetary Fund, "developing at a remarkable pace."[39] Given the rapid development of Brazil, Russia, India, and China (BRIC), our oil-guzzling world seems destined, at least in the short term, only to be guzzling more, which means that the influence of the Islam-rich OPEC nations will only continue to rise. Meanwhile, Iraq and Iran and Afghanistan remain enigmas to anyone unable to reckon with the ancient division inside Islam between Sunnis and Shia. To presume that the conversation about the great religions starts with Christianity is to show your parochialism, and your age. The nineteenth and twentieth centuries may have belonged to Christianity. The twenty-first belongs to Islam.

Christianity

THE WAY OF SALVATION

Every Christmas Eve when I was a boy, my family would gather around the fire to hear my father read *The Christ Child* (1931). This children's book borrows its voice from the stories of Jesus's birth and youth in the New Testament gospels of Matthew and Luke. It borrows its images from the husband-and-wife team of Maud and Mishka Petersham, illustrators whose watercolors seem to spring off the page with the power and poignancy of miracle. The cover depicts Jesus in a manger in Bethlehem just after His birth. Oddly, both His mother, Mary, and her husband, Joseph, have gone missing, so the baby's only company is a drove of sheep and donkeys that seem to be hanging on His every breath with the sort of obsessive attention usually reserved for new parents (though apparently not these ones). This image is commanded by a bright yellow halo, which recalls an astronaut's helmet from the 1960s (John Glenn style), or so I thought as a boy. Out of this bubble, which fits snugly over Jesus's head, springs a series of bigger halos, bursting into the night sky with light like the sun.

Clearly there is something special about this kid, who doesn't seem to object when the wise men come bearing gifts no child has ever heard of (except, of course, for the gold). Eventually He will learn to feed and dress himself, to swing a hammer and pound a nail. He will ride on a donkey into Jerusalem, eat one last meal with His disciples, pray in the Garden of Gethsemane, be betrayed by a friend, endure a show trial, and be scourged, mocked, and

crucified. But this is a children's book, so the scariest it gets here is talk of animals sacrificed at the Jerusalem Temple and an image of Mary, Joseph, and their baby fleeing King Herod into Egypt and a jet-black night. Otherwise Jesus seems to have a pretty cushy childhood. He waxes strong in Joseph's carpenter's shop and manages to shake loose from his parents for a few days in the Big City, where he hangs with rabbis in the temple, both listening to them and asking them questions. But this good Jewish boy cannot shake His halo, which sets Him apart, marks Him as chosen wherever He goes—an intangible reminder of the tangible Incarnation.

One of the lies of the so-called New Atheists is that the religions are one and the same, but the diversity inside Christianity alone is staggering. In the days before orthodoxy had the power to cast out heterodoxy, the early Christian movement was a willy-nilly affair with a laundry list of soon-to-be heretics that stretched from Montanists and Manicheans to Gnostics and Ebionites, Donatists and Docetics, Arians and Nestorians. If Christians today have largely forgotten the creeds and catechisms, Christians in the first few centuries had not yet written them. Then as now, writes theologian Harvey Cox, there was "no central hierarchy, no commonly accepted creed, and no standard ritual practice."[1] Christianity was up for grabs.

For the most part, early Christians defined themselves theologically, depending on how they viewed relations with the Jews, the mix of divine and human natures inside Jesus, and family relations among the Father, Son, and Holy Spirit. Early Christians also gravitated toward competing styles of monastic withdrawal—from peripatetic and solitary desert monks (the term *monk* comes from *monos*, Greek for "alone") to the more settled and less ascetic monastic communities of the Benedictines. Among the many ways of being an ancient Christian was the extreme asceticism of Simeon the Stylite (390–459), the David Blaine of his time, who climbed atop a pillar in his twenties and stayed there for the rest of his life.

There have been efforts to rein in this diversity, to bring heretics to their senses and eccentrics like St. Simeon back to earth. The

Roman emperor Constantine (272–337), who converted to Christianity in 312, convened the first church council in 325 in Nicaea in modern-day Turkey in an effort to impose uniformity on Christendom. But "the one true church" was as elusive then as it is today.

Christianity is now so elastic that it seems a stretch to use this term to cover the beliefs and behaviors of Pentecostals in Brazil, Mormons in Utah, Roman Catholics in Italy, and the Orthodox in Moscow. Unlike Muslims, who have always insisted that the Quran is revelation only in the original Arabic, Christians do not confine God's speech to the Hebrew of their Old Testament or the Greek of their New Testament. In fact, while Muslims have resisted translating the Quran (the first English translation by a Muslim did not appear until the twentieth century), Christians have long viewed the translation, publication, and distribution of Bibles in assorted vernaculars as a sacred duty. The *Jesus* film, distributed by the evangelical student group Campus Crusade for Christ International, has been translated into over a thousand languages and viewed in more than 220 countries.[2] But Christianity has not just adapted to local tongues. It has taken on local beliefs and practices—from Confucianism in East Asia to spirit possession in Africa. Members of the popular Kimbanguist Church of Congo celebrate Holy Communion with sweet potatoes and honey rather than bread and wine. This strategy of accommodating local cultures is one of the keys to Christianity's global success, and one of the sources of its dizzying diversity.

I was raised in St. Peter's Episcopal Church on Cape Cod. Recently I have attended services at Bethel African Methodist Episcopal Church in Boston's Jamaica Plain neighborhood. Though separated by only sixty miles, these two congregations are worlds apart. St. Peter's is lily white and quiet piety. Bethel AME is African American and irrepressible ecstasy. You can set your watch by St. Peter's services, which never run over one hour, but worship at Bethel AME doesn't stop running until the Spirit gives out. At St. Peter's, bodies stay in pews and hands stay on laps, even when the organist tries to rouse them with a black spiritual. At Bethel

AME, parishioners are more rousable. They get up and go as the Spirit leads them, raising their arms to heaven as a live band plays praise songs. Yet both are Christianity. So is the Quaker meeting a few miles from my home in East Sandwich, Massachusetts—a dozen or so Friends (as Quakers are called), sitting in silence in old plaids and practical wool, warmed (sort of) by a wood-burning stove, trusting in what silence says as their predecessors have since this congregation formed in 1657.

But the Christianity of *The Christ Child*, and of my childhood, did not trust in silence. It was all about the doctrine of the Incarnation, which to me was as mysterious as adult life in general. According to this core Christian teaching, at the fulcrum of world history God took on the form of a helpless baby, born of a frightened young woman and held in the rough hands of a carpenter. "What if God was one of us?" asks the Joan Osborne pop song. Christianity responds, "He was!" One day He humbled Himself and became a human being, as if Pele or Michael Jordan had decided at the peak of his career to give up his power, prestige, and prosperity for a new life of swaddling clothes among mere mortals. Through the Incarnation, God creatively confused the sacred and the secular, investing the mundane comings and goings of everyday life with sacred import. So while Christianity has always been about salvation from sin, it is also about hallowing ordinary things.

Soft Monotheism and the Trinity

Every Sunday, in millions of churches around the world, Christians affirm this doctrine of the Incarnation by reciting the statement of belief carved out at Constantine's request at the Council of Nicaea in 325. Still accepted today by all three major branches of Christianity—Orthodoxy, Roman Catholicism, and Protestantism—the Nicene Creed is organized around the doctrine of the Trinity, with sections on God the Father, God the Son, and God the Holy Spirit.

Christians are monotheists, but theirs is a soft monotheism com-

pared to the hard monotheism of Jews and Muslims, who refuse not just to petrify God in graven images but even to imagine God in human form. The Christian tradition is replete with Jesus sculptures and Jesus paintings, which shout to the rooftops the good news that God has taken on a human body. So Christians see God as a mysterious Trinity: three persons in one godhead, or as novelist J. C. Hallman brilliantly put it, "triplets perched on the fence between polytheism and monotheism."[3] In the Nicene Creed they affirm "one God, the Father, the Almighty, maker of heaven and earth"; "one Lord, Jesus Christ, the only Son of God"; and "the Holy Spirit, the Lord, the giver of life." Of these three divine persons, Jesus gets the most ink. "For us and for our salvation," He comes down from heaven and is born a human being from the Virgin Mary. He is crucified, dies, and is buried. But after three days He rises from the dead and ascends to heaven. Some day He will return to earth "in glory to judge the living and the dead." This creed concludes with an appendix of sorts that affirms the divine inspiration of the Christian Bible, the unity of the Christian church, and the importance of the Christian initiation rite known as baptism. Its last line affirms the doctrine of the resurrection of the dead and looks forward to "the life of the world to come."

It is often a mistake to refer to a religion as a "faith," or to its adherents as "believers." As odd as this might sound, faith and belief don't matter much in most religions. Often ritual is far more important, as in Confucianism. Or story, as in Yoruba religion. Many Jews do not believe in God, and the world's Hindus get along quite well without any creed. When it comes to religion, we are more often what we do than what we think. Of course, there are churchgoers who baptize their children and partake of the bread and wine of Holy Communion without much regard for what it all means, but to be a Christian has typically been to care about both faith and belief. The major schisms in Christian history have been driven to a great extent by doctrinal disagreements, and Christians have had few qualms, at least until modern times, about rooting out heretics through institutions such as the Inquisition. Today the price of ad-

mission to the Christian family continues to be orthodoxy (right thought) rather than orthopraxy (right practice). "We believe," the Nicene Creed begins, and two hundred or so words later Christians the world over have summarized their collective faith.

Jesus (A Trilogy)

As the term *Christianity* implies, this faith revolves around the person of Jesus, whom Christians have traditionally regarded as Son of God, Savior, and Christ (from the Greek word for the Hebrew term *messiah*, the coming king who will remake the world). Although the Bible describes Him as "the same yesterday and today and forever" (Hebrews 13:8), Jesus means different things to different people in different times and places. Shifting with the cultural, political, and economic winds, images of Jesus are about as stable as the weather in Kansas's Tornado Alley. In the ancient world, He was the messiah in Jerusalem, a truth teller in Athens, and an emperor in Rome. In the United States, He has been black and white, gay and straight, liberal and conservative, a capitalist and a socialist, a pacifist and a warrior, an athlete and an aesthete, a civil rights agitator and a member of the Ku Klux Klan. Muslims embrace Him as a prophet, Hindus as an avatar, and Buddhists as a bodhisattva. So when Jesus asks, "Who do people say I am?" (Mark 8:27, NIV), there is no easy answer, either in His lifetime or in ours.[4]

For all Christians, Jesus represents the power of God in the world. Some emphasize His role as a teacher whose words and actions instruct us to care for the poor, liberate the oppressed, and build the kingdom of God. Others see Him as a miracle worker who heals the sick, casts out demons, and raises the dead. Still others embrace Him as the Savior whose suffering and death by crucifixion paid the price for human sin and offers us salvation. But there is no disputing the influence Jesus has had on world history. The Library of Congress in Washington, DC, holds more books about Jesus (roughly seventeen thousand) than about any other historical

figure—twice as many as the runner-up, Shakespeare. Worldwide, there are an estimated 187,000 books about Jesus in five hundred different languages.[5] Jesus even has a country named after him: the Central American nation of El Salvador ("The Savior").

Given its preoccupation with faith and belief, creed and catechism, it is tempting to pigeonhole Christianity as the doctrinal religion par excellence. But this is also a religion with a story. Christians refer to this story as the gospel. This term is used to describe the four gospels of the Christian New Testament (Matthew, Mark, Luke, and John), which, along with the Old Testament, the letters attributed to the apostle Paul, and some additional books, make up the Christian Bible. But the root meaning of the term *gospel* is "good news." When Christians spread the gospel, they are spreading this good news. And though they might do so by reciting Christian doctrines such as the sinfulness of human beings and the atonement for sins by Jesus on the cross, they are at least as likely to tell a story.

The stories Christians tell vary from community to community, and from individual to individual. But the narrative arc typically runs from sin to salvation. Ever since Adam and Eve and the Garden of Eden, human beings have committed sins. There is a catalog of these transgressions known as the Seven Deadly Sins: pride, envy, anger, sloth, gluttony, lust, and greed. But sin refers more generally to the human propensity toward wrongdoing and evil. According to the Bible, everybody sins—"If we say that we have no sin, we deceive ourselves, and the truth is not in us" (1 John 1:8)—and sins have consequences, including conflict with other people and separation from God. Sinners cannot be admitted to heaven or granted eternal life, and there is nothing they can do on their own to merit salvation from sin. But happily Christianity is a "rescue religion," and this rescue was made possible as Jesus was dying on the cross.[6] On that day, which Christians celebrate as Good Friday, a sinless Jesus took our sins onto Himself. Three days later, on what Christians celebrate as Easter, He demonstrated God's power over sin by rising from the dead. The "good news,"

therefore, is that anyone who hears this story, confesses her sins, and turns to Jesus for forgiveness can be saved. Or, as the Bible puts it, "the wages of sin is death; but the gift of God is eternal life in Christ Jesus our Lord" (Romans 6:23).

This basic story operates on three interlocking levels. There is the story of Jesus Himself, the God who is born in a manger in Bethlehem, wanders around the Galilee, and dies on a cross in Jerusalem. But this Jesus story is itself embedded in narrower stories of the role of Jesus in individual lives and a broader story of the role of Jesus in human history.

The narrower stories are often told as great reversals, dramatic tales of wretched sinners saved by the grace of a merciful God. Or, as the popular Christian hymn "Amazing Grace" puts it, "I once was lost but now am found, was blind but now I see." U.S. president George W. Bush was an alcoholic until a visitation by evangelist Billy Graham to his family home in Kennebunkport, Maine, began to turn his life around. Shortly thereafter, he professed his faith in Jesus and was "born again." When asked in a 1999 debate to name his favorite political philosopher, Bush said, "Christ, because he changed my heart." Those who come to Christ in a flash are referred to as born-again Christians, but there is a less flashy way to become a Christian: by being baptized as a child and doing what Christians do as an adult.

The broader Jesus story runs from creation to apocalypse— from the creation of the world "in the beginning" told in the first book of the Bible, Genesis, to the coming conflagration told in the last biblical book, Revelation. Like all religious people, Christians repress, remember, and retell their core stories selectively. They emphasize this episode at the expense of that episode, in keeping with their own biases and the preoccupations of their times. But most popular versions of this broader Jesus story focus on the Christian problem of sin and the Christian solution of salvation. God creates a man named Adam and a woman named Eve and sets them up in the Garden of Eden. Life is good until they disobey God, eating fruit that God has forbidden to them. As a result of this primordial

transgression, Adam and Eve are banished from the Garden, and sin, death, and suffering enter the human story. After things go from bad to worse, God destroys the world in a great flood, leaving the family of Noah and the animals he has squirreled onto his ark to repopulate Earth. God then makes common cause with the Israelites, choosing them as His people via Abraham and delivering His Law to them via Moses. But sin, death, and suffering continue apace, so God the Father sends His Son, Jesus, into the world to live and die as a human being and to rise from the dead. Through His death by crucifixion, Jesus pays for the sins of the world, allowing those who follow Him to enjoy eternal life with God. But the workings of God in human history will not be fully revealed until Jesus returns and the dead are called out of their graves and separated along with the living into the saved (who go to heaven) and the damned (who go to hell).

This biblical story is brilliantly encapsulated in a large cross made by the American outsider artist Preston Geter. This cross is whittled, totem style, out of two-by-fours and colored in vibrant house paints. Adam and Eve appear at the base, naked and entwined in the Garden of Eden, encircled by a snake and chomping lustily on a bright red apple. Next up from the bottom is Noah's Ark, followed by Moses holding the Ten Commandments over his head, Charlton Heston style. At the center of this sculpture is a tiny crib holding the baby Jesus. Next is the crucified Christ, his outstretched arms turning the entire sculpture into the form of a cross. At the apex is the resurrected Christ, his arms pointing up, ascending to heaven, showing us the way to God. In keeping with the traditional Christian view that Christianity fulfills Judaism rather than overturning it, this sculpture reinterprets events from the Hebrew Bible in light of the coming of Jesus, transforming the lives of Adam, Eve, Noah, and Moses literally into portions of the cross itself. Like the Jesus story, this cross comes with a personal challenge: Do you believe that Christ died to save you from your sins? Do you know that Jesus rose to demonstrate that death does not have the last word— that the one true God is a god of flourishing?

2.2 Billion Saved

Christianity began as a renegade movement of ne'er-do-wells fighting over to what extent their commitment to Jesus the Jew committed them to Jewish practices such as circumcision. This movement was little more than a burr in the side of the Roman Empire until Constantine, whose mother was a Christian, converted in 312, transforming Christians almost overnight from persecuted outsiders to persecuting insiders—from living under the thumb of a hostile power to being the thumb itself. While Constantine's predecessor Diocletian was the most bloodthirsty persecutor of Christians in Roman history, burning churches, forbidding Christian worship, and manufacturing martyrs, Constantine allowed Christians to operate freely throughout his empire. The Christian message of hope for the poor and heaven for the faithful resonated widely, and on the strong arm of Constantine it spread to the far reaches of Greco-Roman civilization and then to the wider world.

Today the Bible is the world's number one bestseller, Jesus is the world's most recognizable icon, and Christianity is the world's most popular and widely scattered religion; 2.2 billion people, or a third of the world's population, call themselves Christians, and the New Testament has been translated into over three thousand languages.[7] Christianity is the majority religion in Europe, Australia, and North and South America, and Christians enjoy majorities in roughly 120 countries—from Aruba, Belarus, and Canada to Zambia and Zimbabwe. Although the United States is widely celebrated as "the world's most religiously diverse nation," it has more Christians than any other country on Earth.[8] There are roughly 247 million Christians in the United States, followed by Brazil (170 million), Russia (115 million), China (101 million), and Mexico (99 million).

Because of its global reach and renegade roots, the unity Christians sought to achieve when Constantine convened the Council of Nicaea that produced the Nicene Creed has been elusive. The

Bible is shared by all Christians, but the Catholic Bible has seventy-three books (or, if Prophecy of Jeremiah and Lamentations of Jeremiah are published together, seventy-two) and the Protestant Bible only sixty-six. There are hundreds of different translations, which Christians interpret in various ways. And there are feminist Bibles, African-American Bibles, a New Testament for teenage girls called *Revolve*, and one for teenage boys called *Refuel*.[9] *Good as New* (2004), a hip British translation by the left-leaning Welsh Baptist John Henson refers to John the Baptist as "the Dipper" and Saint Peter as "Rocky," and advises sex-obsessed young people not "to marry" but "to have a regular partner."[10]

Christianity split into two main branches, Roman Catholicism and Orthodoxy, in the Middle Ages. The fault line between Latins and Greeks appeared in theological disputes in 1054, when emissaries of Pope Leo IX excommunicated the Patriarch of Constantinople and the Patriarch responded by excommunicating the emissaries. This breach became irreparable after Catholic armies seized Constantinople in 1204. Institutionally, the rub was the power of the pope or, more broadly, whether church authority should be centralized (the Catholic position) or decentralized (the Orthodox position). Theologically, the Greek East and the Latin West split over what now seems like a how-many-angels-are-there-on-the-head-of-a-pin question concerning the Trinity. Does the Holy Spirit proceed from the Father alone, as the Orthodox claimed? Or from both the Father and the Son, as Roman Catholics insisted?

Today Orthodoxy is led not by a pope but by patriarchs whose authority is confined to their own nations. So the Greek Orthodox and the Russian Orthodox, for example, run their institutions without outside interference. More than other Christians, the Orthodox emphasize religion's ritual dimension, celebrating Holy Communion in high style, typically with incense, sacred music, and colorful clerical vestments. Of all the senses, the Orthodox rely first and foremost on sight, engaging with the mysteries of the divine through icons of the saints. The Orthodox differ from Cath-

olics (who insist on clerical celibacy) by allowing parish priests to marry, but they mandate celibacy for bishops. Finally, while Protestants and Catholics tend to think of the Christian story in legalistic terms, focusing on the Crucifixion as a pardon of sorts, the Orthodox focus instead on the Incarnation and Resurrection and the possibilities that both portend for mystical communion with Christ.

Protestant Reformation

The next great split in Christianity came during the Protestant Reformation in sixteenth-century Europe, which is often dated to the moment in 1517 when a German Bible professor and Augustinian monk named Martin Luther nailed ninety-five arguments against the Roman Catholic Church to the door of the castle church in Wittenberg. This Reformation took up the all-important question of salvation or, to be more precise, the question of how to get it. Are Christians saved from sin by some combination of faith and works, as Catholics maintained? Or, as Protestants maintained, is *sola fides*, faith alone, sufficient to wipe away our sins and admit us to heaven?

As the term *Reformation* implies, most of the great Reformers—Luther (1483–1546) in Germany, John Calvin (1509–1564) in Geneva, Ulrich Zwingli (1484–1531) in Zurich—wanted to reform the Roman Catholic Church, not foment revolution. Inspired by Renaissance efforts to go back to the roots of things, they wanted to leapfrog the innovations of medieval Catholicism and return to the models of the early church. In the face of growing literacy and an expanding middle class, they wanted to conduct worship and read the Bible in local languages rather than the Latin mandated by the Vatican. They wanted to do away with the controversial practice of selling indulgences (chits of sorts to reduce punishment for sin). And they saw no reason why priests could not marry. But as they preached their key themes—"justification by grace through faith," "the priesthood of all believers," and *sola scriptura* (Bible alone)—

these Reformers became accidental revolutionaries. And when Catholics reaffirmed their traditions (in no uncertain terms) at the Council of Trent (1545–63), the schism was complete.

Protestants agreed with Catholics on the problem of sin and the solution of salvation, but the two sides disagreed on the techniques that would take you to this goal. In many ways, this historic debate reprised Hindu and Buddhist debates about whether the religious goal came through self-effort or other power. What is really required of us for salvation? Loving our neighbor and doing the sacraments? Or simply putting our trust in the saving power of Jesus? The Protestant/Catholic debate also turned on whether redemption was a gift (as Luther argued) or (as the Vatican insisted) an exchange of sorts in which through acts of penance believers paid down their sin debts. Here Catholics drew on their tradition and the Epistle of James ("So faith also, if it have not works, is dead in itself," James 2:17, Douay-Rheims) to argue that both faith and works were necessary. But Luther, who had struggled mightily to find assurance of his salvation only to discover that no combination of prayer, asceticism, and spiritual exercises could kill the "monster of uncertainty" that bedeviled him, argued for *sola fides* ("faith alone").[11] For as Paul had written, "He who through faith is righteous shall live" (Romans 1:17, RSV).

Like devotional Hindus, Protestant Reformers insisted that the religious goal could be attained by all who offered up their everyday activities to the divine. Not only monks and nuns have sacred vocations; ordinary people have callings too. If this appeal made Protestantism plausible, what made it spread was the printing press, which, combined with widespread literacy, made it possible for the first time in world history to get up a religious rebellion quickly and inexpensively. The French intellectual Régis Debray is exaggerating when he writes that "without the alphabet . . . there would be no God," but without the printing press there would be no Protestants.[12]

The Catholic Counter-Reformation reacted to Protestant attacks by reaffirming traditional doctrines on such matters as sin,

salvation, and (especially) the sacraments, and by establishing such groups as the Society of Jesus (Jesuits), whose founder, Ignatius of Loyola, famously pledged, "What I see as white, I will believe to be black if the hierarchical Church thus determines it."[13] But Catholics also developed their own version of Hindu devotionalism. At the Council of Trent, the Vatican affirmed the importance of interior piety by insisting that laypeople make confession at least once a year. In 1609, bishop of Geneva Francis de Sales wrote *Introduction to the Devout Life*, the first Catholic spiritual classic addressed to laywomen.

Lutherans, Calvinists, Anglicans, and Anabaptists

Because of the Protestants' insistence that all could (and should) read the Bible in their own language, by the light of individual conscience, and with minimal (if any) reference to tradition, Protestantism itself splintered. Today its four main branches are Lutheran, Reformed, Anglican, and Anabaptist.

The Lutheran branch, strong in Germany, Scandinavia, and the American Midwest, comprises followers of Martin Luther who formed denominations such as the Evangelical Lutheran Church in America and various state churches in Europe, including the Church of Sweden and the Church of Norway. Lutherans emphasize liturgy in their worship services, which are also characterized by the robust singing of hymns, some (such as "A Mighty Fortress Is Our God") written by Luther himself. Although Lutherans reject the Catholic doctrine of transubstantiation, which says that the bread and wine in Holy Communion are actually turned into the body and blood of Jesus, they argue for the "real presence" of Jesus at the Eucharist.

The Reformed branch includes Protestants influenced by John Calvin's beliefs in the absolute sovereignty of God, the total depravity of human beings, and the predestination of all people before birth either to heaven or to hell. Although Calvinism coalesced in

Scotland under the influence of Calvin's student John Knox (1514–72), history's most famous Calvinists were the Puritans who left England for New England in the seventeenth century and helped to turn Calvinism into the dominant religious impulse in colonial and early America. Reformed denominations include Presbyterianism, the leading Protestant body in South Korea.

The Anglican Communion comprises denominations that grew out of the notorious split of King Henry VIII (1491–1547) from the papacy in 1534—a split precipitated by, among other things, Henry's resolve not to let his marriage to Catherine of Aragon stand in the way of marriage to a hot young thing named Anne Boleyn. Anglican denominations include the Church of England and the Episcopal Church (United States). Traditionally strong in England and former British colonies such as Australia, the Anglican Communion is now particularly vibrant in Africa, which is home to more than half of the world's 80 million Anglicans. Anglicans, who see themselves as charting a middle path between Catholicism and Protestantism, are in many respects quite close to Catholics. They refer to their clergy as priests, commemorate the lives of the saints, and typically celebrate Holy Communion every Sunday. In *The Book of Common Prayer* (1549) and the King James Bible (1611), Anglicans produced documents whose prose did for modern English what Dante did for modern Italian, which is to say they gave it birth.

The term *Anabaptist* literally means "rebaptizer," but Anabaptists are defined more by their attitudes toward war and government than by their practice of adult baptism. The Amish and the Mennonites are among the Anabaptist "peace churches," whose members insist on the sharp separation of church and state. Mennonites and Amish alike seek to live simple lives amidst the hubbub of modernity, refuse to participate in war, and many maintain an old-fashioned agricultural lifestyle free of such modern amenities as automobiles and electricity.

The Protestant and Catholic Cosmos

There are many ways to make sense of Christianity's Protestant/
Catholic divide. Catholics constitute "the world's oldest continu-
ously functioning international institution," while Protestants are
the new kids on the block.[14] Catholics have a pope and the Vatican,
while Protestants have neither. But the central difference between
the two concerns how each populates the world with sacred power.

For Catholics, the cosmos is filled with people and objects satu-
rated with the sacred. You can access God by praying to the saints,
parading through the streets on their feast days, or going on pil-
grimage to churches named in their honor. Some of the more pop-
ular saints, who serve as Catholicism's exemplars, are: St. Francis
of Assisi, the founder of the Franciscan monastic order, who sought
God among the poor and in the church of sun and sky; St. Jude,
the patron saint of hopeless causes; and the Virgin Mary, whose
life Catholics celebrate on the feasts of the Annunciation, Immacu-
late Conception, and Assumption, and whose "Ave Maria" ("Hail,
Mary") prayer is at any given moment on the lips of millions of
Catholics worldwide (including football fans at the University of
Notre Dame). Catholics also access God through seven sacraments
performed by priests: baptism, confirmation, reconciliation (aka
penance or confession), Holy Communion, marriage, ordination of
priests, and anointing of the sick (aka last rites). The key moment
in the Catholic Mass comes when the bread and wine of the Eucha-
rist are transubstantiated into the body and blood of Jesus. Relics,
such as the Shroud of Turin (said to be the burial shroud of Jesus)
and the body of Saint Peter in St. Peter's Basilica in Vatican City,
also tap into the mystery of the divine. So does the Bible, though
in this tradition the Word of God must be interpreted in light of
church authority and tradition. (Unlike most Protestant Bibles,
Catholic Bibles come with explanatory notes.) Finally, Catholics
have a pope whose special powers have extended since 1870 to papal

infallibility, the ability to speak without error on matters of doctrine and morals.

Protestants empty this Catholic cosmos of saints and relics, which they see as superstitious. Their exemplars are ordinary "knights of faith," who according to the Danish theologian Søren Kierkegaard go back to Abraham himself. Of course, Protestants have heroes, such as civil rights leader Martin Luther King Jr. and German Nazi resister Dietrich Bonhoeffer, but they do not pray to them or celebrate their feast days. In fact, they criticize Catholics for allowing their devotion to Mary (whom Catholics claim was conceived without sin) to overshadow in some cases their devotion to Jesus Himself. Protestants also reject papal authority and typically refer to their clerics not as priests but as ministers or pastors. Though Quakers reject sacraments entirely, most Protestants reduce Catholicism's seven sacraments to two: baptism, a desert-born initiation rite, typically understood as both a dying and a rising, in which initiates are cleansed either by immersion in water or by having water sprinkled over them; and Holy Communion, a communal meal of bread and wine (or, in some cases, grape juice), also known as Eucharist, Lord's Supper, and Mass that harks back to the Last Supper Jesus shared with his disciples on the eve of His crucifixion. The key moment in Protestant worship services comes not when the bread and wine are shared but when the Bible is read to the congregation and the minister (who in this case can be a woman) interprets that text for the congregation. So while Catholics can get to God through saints and relics and popes and priests and sacraments and the Bible, Protestants get to God without intermediaries and read the Bible with God's guidance alone rather than through a net of papal authority and church tradition.[15]

One effect of these differences is that there is less room for female exemplars in the Protestant tradition. Though Catholicism, which does not allow female priests, is often criticized as sexist, it was Catholics who put angels' wings on women and gave us a litany of female saints, not least the Virgin Mary herself. Protestants

clipped these wings and demoted visionaries such as St. Hildegard of Bingen and martyrs such as St. Agnes to the status of mere mortals. Although Protestant themes seem to resonate with modern Western values such as liberty and equality, half of today's Christians are Catholics. A bit over a third (36 percent) are Protestants, one in eight (12 percent) is Orthodox.[16]

Christians identify less and less each year with labels of this sort, however. It is now rare to find a Presbyterian who can explain Calvin's doctrine of predestination or a Methodist who can explain the teachings on sanctification of Methodism's founders, John and Charles Wesley. And since the *aggiornamento* ("updating") of the Second Vatican Council (1962–65), Catholics have come closer to Protestants on many key issues, not least their view of the church as a "people of God" rather than a hierarchy of popes and bishops. Today many of the world's biggest churches are nondenominational, and many adherents to Christianity prefer to identify themselves simply as Christians rather than as Presbyterians, Methodists, or even Catholics.

Mormonism

Christians have also produced a parade of new denominations that do not fit into the three classic categories of Roman Catholicism, Protestantism, and Orthodoxy. Many of these, including the Seventh-Day Adventists, Jehovah's Witnesses, and Christian Scientists, are American products. The most successful of these mold breakers (also American made) is the Church of Jesus Christ of Latter-day Saints, now one of the world's fastest growing religious movements.

The LDS Church began in upstate New York in the early nineteenth century when evangelicals were getting up the string of revivals now referred to as the Second Great Awakening. In the midst of this swirl, a confused teenager named Joseph Smith Jr. (1805–44) was overtaken with the sort of afterlife anxiety that had

led Martin Luther to reject what he saw as the sacraments-for-salvation exchange of the Catholics. So he too turned to God for help, asking in this case which of the many Protestant denominations was true. None of them, God reportedly replied. Soon thereafter, an angel named Moroni told Smith of gold tablets buried in the fifth century in a hill not far from his home. Smith dug up the tablets, used two seer stones to translate their "Reformed Egyptian" into English, and published the results in 1830 as the Book of Mormon. In this book, Jesus travels to the New World after His resurrection and before His ascension, planting His true church in the soil of the Americas.

Mormons, as LDS Church members are popularly known, share affinities with Protestant groups, but they do not see themselves as Protestants, and many Protestants return the favor by refusing to see Mormons as Christians. While Mormons assert their bona fides as Christians by affirming their love of Jesus, many born-again Christians (in keeping with the Christian preoccupation with doctrine) claim that Mormonism veers too far away from traditional Christian creeds to qualify as Christian. Mormons often claim, for example, that God has a body, and that humans can become gods. At least until the 1890s, they saw Old Testament practices of polygamy and theocracy as a warrant for them to go and do likewise. Though Mormons view the Bible ("as far as it is translated correctly") as the Word of God, they also recognize three extrabiblical books as scripture: the Book of Mormon, Pearl of Great Price, and Doctrine and Covenants. Finally, Mormons believe in ongoing revelation, which allows their presidents to modify beliefs and practices via prophecy.

Widely persecuted from the start, the Mormons are a reminder that freedom of religion is a hope rather than a reality, even in the United States. In response to anti-Mormon bigotry and hostility, the Mormons moved westward from New York to Ohio and Missouri before settling in Illinois, where Smith was arrested, jailed, and then killed by a mob in 1844. Mormons migrated to their current home in Salt Lake City, Utah, under the direction of their

"American Moses" Brigham Young (1801–77). Though long seen as dangerously un-American, Mormons are now widely viewed as quintessentially American. The most popular American novelist of the early twenty-first century—Stephenie Meyer of *Twilight* series fame—is a Mormon. The HBO show *Big Love* features a Mormon family. And LDS members such as David Archuleta of *American Idol* are so inescapable on reality shows that some critics are starting to complain that Mormons have "colonized reality television."[17] Yet most of the 14 million members of the LDS Church now live outside the United States, and about a third of that figure call Latin America home—an extraordinary achievement given that the Mormons' dietary code (the Word of Wisdom) prohibits the drinking of coffee.[18]

The Evangelical Century

After the Reformation, the next great event in Christian history was the rise of evangelicalism in the nineteenth century and the rapid evangelization of what came to be known as the Christian West. In 1822, U.S. president Thomas Jefferson prophesied that Unitarianism—a form of Christianity that rejects the Trinity, viewing Jesus as a great moral teacher but not divine—would overtake the United States.[19] He was wrong. This task was allotted instead to evangelicals, who set out over the course of this "evangelical century" to Christianize both the United States and the world.

Historian David Bebbington has defined evangelicalism in terms of four distinguishing marks: Biblicism (an emphasis on the Bible as the inspired Word of God); crucicentrism (an emphasis on Jesus's redemptive death on the cross); conversionism (an emphasis on the experience of the "new birth"); and activism (an emphasis on preaching and performing the gospel).[20] In the early nineteenth century these characteristics coalesced into a movement. Thanks to great revivals in England and the United States, and to the heroic missionary efforts of Methodist circuit riders and Baptist farmer-

preachers, Anglo-America was rapidly missionized, and evangelicalism became the dominant religious impulse in the Protestant world.

Christianity is a missionary religion. Unlike Jews and Hindus, who do not typically seek to make converts, Christians have long heeded Jesus's "Great Commission" to "go and make disciples of all nations" (Matthew 28:19, NIV). Christianity started as a movement of Jewish reformers. Jesus was Jewish, as were His disciples, who came to affirm that He was the Messiah long awaited by the Jews. But Paul, a convert from Judaism, decided to preach his message of sin and salvation to Jews and Greeks alike. It was not necessary, he decided, for converts to Christianity to become Jewish. Christian men did not need to be circumcised, and Christian families could eat pork without shame. So the Christian movement set up outposts among Greek speakers in the places Paul's biblical letters would make famous (Corinth, Galatia, Ephesus, Philippi, Colossae, and Thessalonica).

In the nineteenth century, Christianity made a similar advance among English speakers, expanding even more rapidly than it had in the first Christian centuries. In 1800, less than one-quarter (23 percent) of the world's population was Christian. By 1900, that figure had jumped to more than one-third (34 percent). The most extraordinary growth came in North America, which saw the total number of Christians jump tenfold between 1815 and 1915. In the process, the portion of Christians among the overall U.S. population expanded from about 25 percent to about 40 percent. In Canada, the advance of Christianity was even more dramatic—from roughly one-fifth of the overall population to roughly one-half.[21]

But evangelicalism did not just change the quantity of Christians; it changed the quality of Christianity. As evangelicalism expanded its footprint, experience and the emotions trumped doctrine and the intellect. Though more Christians came to see the Bible as the inspired Word of God, fewer seemed interested in knowing what God had to say. Anti-intellectuals such as Methodist revivalist Peter Cartwright and "baseball evangelist" Billy Sunday boasted of their

homespun ignorance, and Christians embraced a Scarecrow faith, their hearts overpowering their brains. If Positivism was, in French philosopher August Comte's words, an "insurrection of the mind against the heart," evangelicalism was an insurrection of the heart against the mind.[22]

Evangelicalism is often confused with fundamentalism, and though each stresses conversion and champions "family values," they are actually quite different. While both call the Bible the Word of God, evangelicals tend to speak of its inspiration rather than its infallibility, so they do not join fundamentalists in reading it as a geological or historical textbook. Historian George Marsden has famously defined the fundamentalist as "an evangelical who is angry at something," and what fundamentalists are angry at is modernity.[23] Evangelicals are both more friendly to modernity and less shrill. They were early and ingenious adopters of many new communication technologies, from the radio to television to the Internet.

Today evangelicalism is visible in InterVarsity Christian Fellowship, World Vision, and other voluntary associations that cut across old denominational lines. Though U.S. evangelicals are widely associated with figures on the Religious Right such as James Dobson, founder of Focus on the Family, nineteenth-century American evangelicals were politically progressive, spearheading movements to abolish slavery and to give women the vote. Today a typical evangelical in the United States is opposed to abortion and gay marriage but tilts to the center and even the left on many other public-policy issues, including poverty and the environment. The Evangelical Left is represented most eloquently by Jim Wallis, who has led the Sojourners Community in Washington, DC, since its founding in the early 1970s.

The Pentecostal Century

If nineteenth-century Christianity belonged to evangelicalism, twentieth-century Christianity belonged to Pentecostalism, a Spirit-filled faith that in recent decades has steered the Christian ship away from the Greco-Roman West and in a southerly and easterly direction. Christianity continues to be seen as white and Western, and as of 1900 just under 80 percent of the world's Christians were Caucasian, and just over 80 percent lived in Europe or North America.[24] So when Catholic writer Hilaire Belloc wrote in 1920 that "The Church is Europe; and Europe is The Church," he was more or less right.[25] But sometime in the twentieth century, Christianity's center of gravity leaped across the Strait of Gibraltar—from Spain into North Africa.[26] Much of this migration can be credited to Pentecostalism, which was made in America but is now equally at home in Africa, Latin America, and Asia.

A decade or so ago I suggested that American religion seemed to be moving from transcendence to immanence—from a colonial era of God the Father to a Victorian era of God the Son to a new era of God the Holy Spirit. Today this shift seems to be occurring worldwide. Pentecostalism is relocating the divine from "out there" to "in here," and the Holy Spirit is finally getting its due.

An outgrowth of the Holiness movement within the Protestant denomination of Methodism, Pentecostalism takes its name from the story in the New Testament book of Acts in which the Holy Spirit, after Jesus's death, descended on His disciples during the Jewish holiday of Pentecost, and "all of them were filled with the Holy Spirit and began to speak in other tongues" (Acts 2:4, NIV). Pentecostalism's distinctive feature is baptism in the Spirit, an additional experience of grace after conversion often evidenced by ecstatic speaking in unknown tongues, or glossolalia. Pentecostal worship gives free reign to "gifts of the Spirit" such as speaking in tongues, prophecy, and faith healing. And its preachers know how to put on a good show. U.S. president Abraham Lincoln once

remarked that, when he sees a man preach, he likes "to see him act as if he were fighting bees."[27] Pentecostalism is replete with bee-fighting preachers.

Like fundamentalism, with which it is often confused, Pentecostalism is a twentieth-century invention. Unlike fundamentalism, which accents doctrine, Pentecostalism accents experience, insisting (over fundamentalists' fierce objections) that the miracles swirling around the early church in the book of Acts are still available to people of faith. Pentecostals also allow for direct communications from God that make fundamentalists and other scions of biblical authority queasy.

The distinguishing marks of Pentecostalism appeared around the globe—in Wales, Korea, and India—during the first few years of the twentieth century and popped up in Kansas in 1900. But Pentecostalism's origins are typically traced to April 1906 and a small black church on Azusa Street in Los Angeles. At a series of interracial revivals led by a one-eyed black Holiness preacher named William Joseph Seymour (1870–1922), Christians began to pray, sing, and speak in languages they did not recognize. Many believed that the "gifts of the Spirit" they witnessed at Azusa Street were signs that they were living in the "last days" when God had promised to "pour out my Spirit upon all flesh" (Acts 2:17, RSV)—a belief made compelling when San Francisco's Great Earthquake erupted in the midst of the bedlam. The Azusa Street revival, as it is now called, went on to exhibit for years the sort of sacred power that the Yoruba refer to as *ashe*. Thanks in part to articles in the *Los Angeles Times* denouncing the goings-on as a "Weird Babel of Tongues," people visited from across the United States and around the world, and, when they went home, they took this new form of Christian worship with them.[28]

Since the 1970s, Pentecostalism has boomed in the Catholic stronghold of Latin America, and many U.S. Hispanics have left Catholicism for Pentecostal churches. Pentecostalism is even growing in some of the world's most secular societies. On a recent trip to Toronto, I learned of a professor there studying Swedish Pente-

costalism. At first I thought this was a joke. "How many people does he study?" I asked. "Five?" But Pentecostalism is alive and well and living in, of all places, Sweden. Stockholm's thriving Filadelphia Church, the first Pentecostal congregation in Sweden, was until the 1960s the largest Pentecostal church in the world. The Word of Life Church in nearby Uppsala boasts Europe's largest Bible school.

Pentecostalism produced denominations such as the Assemblies of God (est. 1914) and "Sister Aimee" Semple McPherson's International Church of the Foursquare Gospel (est. 1927). It found institutional expression in Oklahoma-based Oral Roberts University (est. 1965) and in the U.S. television ministries of Jim and Tammy Bakker, Jimmy Swaggart, and Pat Robertson. Its spirit also animates many nondenominational congregations and the Charismatic Movement that energized Roman Catholics, Episcopalians, and Lutherans after World War II.

From its humble birth on Azusa Street in 1906, Pentecostalism has developed into the world's fastest growing Christian movement in part because, like the early Christian movement, it appeals powerfully to the powerless and the poor. Today over a quarter of the world's Christians (roughly 600 million souls) are Pentecostals or Charismatics—not bad for a tradition that wasn't even on the map at the start of the twentieth century.[29] Roughly half of Brazil's Christians are Pentecostals or Charismatics.[30] Pentecostalism is also popular in the United States, and in Guatemala, where two presidents have been Pentecostals. Other pockets of Pentecostal strength include Nigeria, the Philippines, China, Chile, Ghana, South Africa, and South Korea.

One source of Pentecostalism's success is its ability to address both thisworldly and otherworldly concerns. Another is its ability to abide simultaneously in the pragmatic present and the biblical past.[31] Like evangelicals and fundamentalists, Pentecostals view the Bible as the inspired Word of God, evangelize with gusto, and respond to the challenge of death by preaching personal salvation through faith in Jesus. But Pentecostals also attend to the

challenge of human flourishing by promising health and wealth
here and now. Especially in the Third World, they offer deliver-
ance from demons and witches, and their strict rules about drink-
ing, gambling, and womanizing have improved the lives of women
worldwide, while putting more disposable income in the pockets of
Pentecostal families.

Pentecostalism has been criticized as escapist, and in most coun-
tries it continues to be associated more with the "prosperity gospel"
(which says that Jesus calls us to be rich) than with the Social
Gospel (which says that Jesus calls us to help the poor). The fastest
growing denomination in Latin America is the Brazil-based Uni-
versal Church of the Kingdom of God. This church, which is now
also active in the United States and the United Kingdom, preaches
a "name it and claim it" theology that encourages believers to pray
not only to get their souls into heaven but also to put cars in their
driveways.

Though almost all U.S. Pentecostals side with Republicans on
bedroom questions such as homosexuality, premarital sex, and
abortion, many tilt toward the Democrats on other social and polit-
ical issues. In Brazil, Pentecostals tend toward the "center left."[32] In
Venezuela, they have a favorable view of socialist president Hugo
Chavez.[33] Inspired by Jesus's description of the poor as "blessed"
(Luke 6:20), "progressive Pentecostals" worldwide are working to
fight drug abuse, provide shelter for the homeless, feed the hungry,
staff day-care centers, counsel drug addicts, fight the AIDS epi-
demic, and provide microfinancing for entrepreneurs.[34]

Pentecostals also have a long history of embracing female clergy,
something Catholic and Orthodox churches continue to refuse to
do. Most of the kudos for ordaining women have accrued to liberal
Protestant denominations such as the Episcopalians, who elevated
Barbara Harris to the role of bishop in Massachusetts in 1989 and
selected Katharine Jefferts Schori as its national leader in 2006. But
Pentecostals have had female preachers from the start.

The unprecedented rise of this tradition of the dispossessed has
many hallmarks of a second Reformation. Whereas Luther lib-

erated Christians from what had become for many a tyranny of good works, Pentecostalism liberates Christians from the tyranny of belief, which, after the Enlightenment, has become a straitjacket for many. One of the smartest and most open-minded graduate students in my PhD program was a Pentecostal. In a seminar on great thinkers in the study of religion, he consistently surprised me by agreeing with many of the theories of Émile Durkheim, Sigmund Freud, and others. After I confessed my surprise at his openness to their critiques of traditional Christian doctrines, he told me that his faith did not hang on belief. It hung instead on the sort of intense, personal experience that cannot be denied. Another friend, just before answering the altar call at a black church in the American South, confessed to her preacher that she didn't really believe in Jesus. "Don't worry," he said, "you will." Her preacher was able to reassure her because in his congregation experience mattered more than doctrine. And experience is Pentecostalism's bread and butter—the experience of being inhabited by the awesome power of God.

Brown Christians

Just as historic as the rise of Pentecostalism is the related story of the browning of Christendom. Europe was the homeland of the old Christendom, and white was its color. But today the overwhelming majority (63 percent) of Christians live in Asia, Africa, or Latin America.[35] There are now more Catholics in the Philippines than in the homelands of the last two popes (Poland and Germany) combined.[36] And though Christianity was illegal in China as recently as 1970, there may now be more people in the pews on any given Sunday in China than in all of Europe.[37] The LDS Church epitomizes this global shift. Though many perceive Mormons as lily white—the faith of the pop singers the Osmonds and of former Massachusetts governor Mitt Romney—most Mormons live outside the United States. Roughly a third live in Latin America, and

the tradition is particularly strong in the South Pacific, where Mormons claim between a third and a half of the populations of the island nations of Samoa and Tonga.[38]

Since colonization benefited Christian missions, you would think that the decolonization process that set in after World War II—independence for India (1947), Indonesia (1949), Ghana (1957), and Nigeria (1960)—would have hurt and perhaps even crippled Christianity. But the withdrawal of European powers from outposts in Asia, Africa, and Latin America has instead bolstered Christianity. Most churches on these continents are now led not by foreign missionaries but by locals, and Bibles, prayer books, hymnals, and catechisms are all accessible in local languages.

Thanks in large measure to the global appeal of Pentecostalism, between 1900 and 2000 the portion of Christians in Nigeria, Africa's most populous country, skyrocketed from 1 percent to 45 percent, while growth in South Korea was almost as dramatic—from less than 1 percent to 41 percent. Over the same period, the Christian population in Asia jumped more than tenfold—from 27 million to 278 million. This all happened while Europe was rapidly dechristianizing, suffering losses not only in Christian market share but, more important, in the fervency of faith and the frequency of churchgoing. The portion of Christians among the overall population fell between 1900 and 2000 in Germany, Great Britain, Italy, Spain, and France. Today only 52 percent of European adults profess belief in God.[39]

The browning of Christianity may seem to be a new departure, but it is actually a homecoming. During its earliest centuries, Christianity was nearly as multicultural as Los Angeles today. Breaking beyond the bounds of the Roman Empire, the Christian movement spread in its infancy to Ethiopia and India. When Christianity gained insider status under Constantine, only one of its five church centers was in Europe (Rome). The others were in Asia (Constantinople, Antioch, Jerusalem) and Africa (Alexandria). Many of the greatest thinkers in the early church were Africans, not least Saint Augustine (354–430), the author of the world's first autobiography,

the *Confessions*, and the most influential Christian thinker between Paul and Martin Luther. In 500 c.e., two-thirds of the world's Christians lived in either Africa or Asia. Not until medieval times would the church come to be largely European.[40]

The "next Christendom" is making its home in Anglican churches in Uganda, Pentecostal churches in Korea, Catholic churches in Brazil, and Han house churches in China.[41] It is also visible in African independent churches, Spirit-filled congregations untainted by affiliations with the traditional denominations that cozied up to colonial regimes. Christianity is even browning in its old haunts. Some of the most visible pastors in the United States are African Americans, and Western Europe's largest congregation, the London-based Kingsway International Christian Centre (KICC), is a black church run by a senior pastor of Nigerian descent.

Jaws still drop in the United States over the magnificence of evangelical megachurches—Joel Osteen's Lakewood Church in Houston, T. D. Jakes's The Potter's House in Dallas, Rick Warren's Saddleback Community Church in Lake Forest, California— which often feature live bands, jumbotrons, basketball courts, espresso bars, and architecture that evokes your local shopping mall more than your grandmother's sanctuary. Neither the United States nor Europe, however, claims any of the globe's top twenty megachurches.[42] The biggest of the big congregations—all Protestant and many Pentecostal—are found in countries such as South Korea, Chile, Columbia, El Salvador, Nigeria, and the Ivory Coast.

Highlighting the fact that Christianity is now an Asian religion, South Korea has dozens of megachurches in Seoul alone. These megachurches include the planet's largest congregation, Yoido Full Gospel Church, which occupies a prime piece of real estate facing the National Assembly, a reminder of the rising political power of Pentecostalism in Asia and worldwide. This church has over 500 pastors and 800,000 members and draws over a quarter of a million parishioners (and gawkers) on an average weekend. But not all megachurches are Pentecostal, or even Protestant. The Cave Ca-

thedral, a sanctuary carved out of rock hard by a garbage dump in Cairo, Egypt, blasts praise, prayers, and preaching over its massive sound system every Sunday to twenty thousand or so Coptic Orthodox believers.

All this is to say that the face of Christianity is getting darker, epitomized not by Pope Benedict but by the South African Anglican archbishop and Nobel Peace Prize winner Desmond Tutu. Or, more precisely, by a not-so-famous woman in Brazil or China or the Democratic Republic of the Congo, since, as church historian Dana Robert has observed, the typical Christian today is "no longer a European man, but a Latin American or African woman."[43]

The most widely reproduced image of Jesus, Warner Sallman's *Head of Christ* (1941), depicts Jesus as a white man with blond hair and an aquiline nose—the sort of guy who, with a haircut and minus the beard, could represent Utah in the U.S. Senate. But this marshmallow Jesus now seems as out of date as Mr. Rogers. Today artists are increasingly portraying Jesus as Asian or African, and as a woman too. Just before the turn of the last millennium, the *National Catholic Reporter* sponsored a contest called "Jesus 2000" that challenged artists to produce a twenty-first-century Jesus. The winning entry, Janet McKenzie's *Jesus of the People*, depicted a character of indeterminate gender and race but with dark skin and thick lips suggestive of a Native-American or black Christ.

The expansion of Christianity into the Global South is not just changing the color of Christians, however. It is also changing the shape of Christianity itself. According to Harvey Cox, Christians now live in a "post-dogmatic" "Age of the Spirit" in which individual spirituality trumps institutional religion, creeds and catechisms are invoked more than they are followed, and "the experience of the divine is displacing theories about it."[44] Supernaturalism, chased out of many Global North churches by scientific theorems and philosophical arguments, is back in vogue. Faith healing, speaking in tongues, and even exorcisms are everyday occurrences in many of the world's fastest growing denominations. This new wave of Christianity is eminently practical, addressing social prob-

lems such as poverty via something like the "preferential option for the poor" of Latin American liberation theologians. But it preaches personal salvation at least as much. According to historian Mark Noll, Christians are becoming more entrepreneurial and less deferential to tradition. The new pattern is "self-starting, self-financing and self-spreading Christianity."[45]

Observers of American religion have long noted that Christians are now divided along political rather than denominational lines. People on the Catholic left have more in common with liberal Protestants than they do with traditional Catholics, and traditional Catholics have more in common with conservative Protestants than they do with liberal Catholics. Something similar can be said of global Christianity, which is divided into North and South. Christians in the Global South tend to be more theologically conservative than Christians in the Global North, where biblical criticism, evolutionary theory, and comparative religion have created a large cohort of theological liberals. Christians in Africa, Asia, and Latin America also tend to emphasize their faith's experiential dimension, while those in Europe and the United States emphasize its ethical dimension. American and European Christians incline toward the Social Gospel, which views sin and salvation in collective rather than individual terms and challenges the faithful to focus on thisworldly matters such as feeding the hungry and providing shelter for the homeless. Christians in Africa, Asia, and Latin America tend to preach the prosperity gospel and to focus on winning a ticket to heaven. Here angels and demons are no mere metaphors, and the supernatural is alive and well and testifying to its power.

This growing gap between Global North and Global South Christianity is on display in the paroxysms besetting the Anglican Communion. The presenting problem is homosexuality, more specifically the election of an openly gay bishop, Gene Robinson of New Hampshire. But the broader issue is the authority of the Bible, which by any literal reading must be said to oppose at least male homosexuality. (Nowhere is lesbianism plainly condemned,

or even contemplated.) What this controversy reveals is that Anglicans in Africa are worlds apart from Episcopalians in the United States. Of course there are liberals in the Global South, and conservatives in the Global North. In response to Robinson's election, about 100,000 U.S. conservatives left the Episcopal Church in 2009 to form the Anglican Church in North America. Nonetheless, the story of contemporary Christianity is turning into a tale of two churches, with the Global North yielding influence as rapidly as the Global South is seizing it.

Driving this browning of Christianity are two classic engines of religious change: births and conversions. The fastest growing churches are, not surprisingly, eagerly evangelistic, and their efforts are being augmented by family sizes in the Global South that dwarf those in the North. Much has been made of high birth rates in the Muslim world, but Christians are having children at similarly staggering rates in the Global South, especially in Africa. There is no way that Christianity can keep up the growth it posted in Africa in the twentieth century—from 9 million souls in 1900 to 355 million in 2000—but thanks to a combination of that old-time revivalism and old-fashioned population growth, Africa and Latin America alike should bypass Europe by 2025 in terms of professing Christians.[46]

Christianity and Islam

One of the great challenges of this increasingly global church is how to reckon with its Muslim neighbors. For most of Christian history, Jews were the Christians' closest conversation partners. Christianity was from the beginning an amalgamation of Hellenistic and Hebraic influences, and just how the two should be mixed has always stirred contention. But today Christianity and Islam are the world's greatest religions. Together Christians and Muslims account for roughly half of the world's population, and for more than half of the world's suicide bombers and drone attacks.

The history of Christian-Muslim relations is of course fraught.

Arab Muslims seized Jerusalem (which they call *Al-Quds*, "the Holy") in 637. Christians took it back in 1099, only to relinquish it to the Muslim hero Saladin in 1187. And so it has gone for the last millennia or so. There have been times when these two religious communities have lorded over distant empires, crossing paths only through pamphlet wars or military campaigns. There have been places, such as medieval Spain, where Muslims and Christians lived side by side without fear. Today, however, Islam and Christianity are again rivals, competing cheek by jowl for people, power, and public opinion. Africa is now fairly evenly split between Christians (47 percent of the population) and Muslims (41 percent), so a new Great Game is on there for the hearts and minds of the world's fastest growing populations. The other Great Game, played out on television, in newspapers, and online, pits Christians against Muslims on their respective ethics of war.

Widespread criticisms of jihad in Islam and the so-called sword verses in the Quran have unearthed for fair-minded Christians difficult questions about Christianity's own traditions of holy war and "texts of terror." Like Hinduism's Mahabharata epic, the Bible devotes entire books to war and rumors thereof. Unlike the Quran, however, it contains hardly any rules for how to conduct a just war. The Old Testament is replete with war, beheadings, and rapes. "I will make mine arrows drunk with blood," a vengeful God brags in Deuteronomy 32:42, "and my sword shall devour flesh." Elsewhere this same God is implicated in the mass murder of children, the genocide of entire peoples, even (in the case of the Great Flood) the extermination of almost the entire human race. The Psalms, read every Sunday in many churches, drip with vengeance, including a blessing that concludes Psalm 137 for whoever retaliates against the Babylonians by smashing their infants against the rocks. It is not just the Old Testament that is flesh devouring and drunk on blood, however. "I came not to send peace, but a sword," Jesus says (Matthew 10:34). And who in his right mind can defend Jesus when He responds to a Canaanite woman pleading for help for her sick daughter by calling the two of them "dogs" (Matthew 15:22–28)?[47]

Mystics and the "Negative Way"

With all this religious ammunition loaded and cocked and ready to fire, it might seem that a clash of Muslim and Christian civilizations is fated. But both Islam and Christianity have strong traditions of mystics whose experiences of the divine have led them to embrace people of other religions as fellow pilgrims in a mysterious journey toward the Ineffable and Indescribable. These mystics provide resources for Muslims and Christians interested in turning swords into ploughshares, or at least in keeping those swords in their sheaths.

Students of Christianity often learn far more about its philosophers than its mystics. There is, for example, the Catholic philosopher Thomas Aquinas (1225–74), who brought Aristotle into conversation with Christianity and famously defined the human person as a combination of body and soul that, though fragmented at death, would come together again at the resurrection. Aquinas also advanced a series of logical arguments for the existence of God that continue to be debated today. But like the other great religions, Christianity also has a mystical strain that, in the name of the mystery that is God, is skeptical of systematic theology and philosophy. Like contemporary Pentecostals, ancient and medieval mystics stressed experience over doctrine. The Orthodox hoped for *theosis*, or deification ("becoming by grace what God is by nature," writes Athanasius). Medieval Catholics such as Teresa of Avila (1515–82) sought union with God. But in any case Christian mysticism was about direct experience of the divine.

Though Christian mystics offer a genealogy of their practice that goes back to Paul's ecstatic encounter with Jesus and Jesus's intimacy with His Father, Christian mysticism really flowered in the Middle Ages and the Renaissance. Like Augustine, who famously asked God to grant him chastity and continence, "but not yet," Saint Francis of Assisi (1182–1226) was a wealthy playboy when he turned to a life of poverty and communion with God through

the glories of nature. Female mystics such as Julian of Norwich (1342–1416) reveled in the feminine aspect of God. Meister Eckhart (1260–1328) spoke eloquently of the *via negativa*, the "negative way" to a God who is beyond space and time and description and therefore can only be said to be, as Hindu thinkers put it, *neti neti* ("neither this nor that"). Even Aquinas admitted that "it is easier to say what [God] is not than what He is."[48]

It is of course a long and circuitous route from contemporary evangelicalism and Pentecostalism to medieval mysticism—from suburban megachurches and their confident sermons about how Jesus would vote to Meister Eckhart. But Eckhart and your average megachurch pastor are both engaged in the ongoing Christian conversation about creation and crucifixion, sin and redemption. What the pastor has on the mystic is the simplicity of his story: we are sinners, Jesus died for our sins, and we can achieve salvation if we have faith in Him. What the mystic has on the pastor is his awareness that sometimes things are not as simple as they seem. Sometimes Christianity cannot be captured in simple formulas of sin and salvation, faith and works. The mystic sees nothing scandalous or even odd about the fact that Mother Teresa of Calcutta went for years without being able to conjure up the presence of God. The mystic knows as well that doubt is always part of genuine faith. She knows that, because (as God puts it in Isaiah 55:8, NIV) "my thoughts are not your thoughts, neither are your ways my ways." So, for her, faith and doubt are always partners. Yes, the problem of Christianity is sin and the solution is salvation. Yes, you get to that goal through works or faith or both, by following the examples of the saints or of the more ordinary "knights of faith." But such simple formulas by no means put an end to the mysteries of Christianity's core symbols of God and Christ and Bible and Church. And the big question of death and flourishing, mortality and creativity, far from being answered by faith (or, for that matter, by doubt), abide instead.

Confucianism

THE WAY OF PROPRIETY

To many Westerners, Confucianism seems about as relevant as a fortune cookie. We probably know less about Confucianism than we do about any of the other great religions, and what we think we know we do not like. Confucianism is old-fashioned and formal. It is about empty rituals, banal aphorisms, antiquated etiquette, and otherwise maintaining the status quo—wives bowing before husbands, workers scraping before bosses, the masses endlessly deferring to governmental authority. Could anything be more antimodern (or antihuman) than that? Thanks to the Enlightenment and The Beatles, we celebrate the new and the young, while Confucius, a self-described lover of antiquity, commands us to commemorate our elders and the dead. In an age of Ashleys and Olivias, Confucianism seems to side with Berthas and Gertrudes. So when confronted with a choice between Confucians and Daoists, we side with the freedom, spontaneity, and naturalness of Daoism. If you google "Confucius," you have to wade through page after page of "Confucius says" jokes (many of them off-color and almost all with some error in grammar or syntax) before you arrive at any actual quotations from the man himself. Confucianism, it seems, is a joke.

Over the long haul of human history, however, Confucianism may have carried more clout than any other religion. Confucius is almost certainly one of the five most influential people in recorded history. And although Daoist classics are far more popular in the

West, the Analects, the authoritative collection of Confucius's words and deeds (the Confucian equivalent of Islam's Hadith), is among the world's most influential books. In fact, it has wielded more power over more people over more time than any other scripture, with the possible exception of the Bible. Before Socrates, Confucius told us that real knowledge is knowing the extent of your ignorance. Before Jesus, he gave us his own version of the Golden Rule: "Do not impose on others what you yourself do not desire." Before Wall Street crashed, he said, "The gentleman understands what is moral. The small man understands what is profitable." Before we fell in love with the romantic comedies of Hollywood (and Bollywood), he said, "Wheresoever you go, go with all your heart." And before President Bill Clinton was impeached, he asked, "If you fail to be conscientious and trustworthy in word . . . then can you be sure of going forward without obstruction even in your own neighborhood?"[1]

Observers once widely believed that Confucianism was, as German sociologist Max Weber argued, not just a barrier to economic development but a blockade.[2] Now that capitalism is booming in East Asia, however, many now see the invisible hand of Confucius guiding the post–World War II economic miracles in China, Japan, and Korea. Yes, Confucius valued learning over profit, and his emphasis on filial piety and loyalty may have promoted crony capitalism in Japan and elsewhere. But his emphasis on education has been a huge driver of recent economic development across East Asia, and Confucian values such as industriousness, thrift, family loyalty, duty, and respect for authority have propelled China to its current status as the world's top exporter, the leading buyer of U.S. debt, and a major trading partner with the United States, the European Union, and Japan.

Confucianism is an eighteenth-century Western European term for what the Chinese refer to as *Rujia*, or "School of the Scholars." The term *scholars* here refers to scholars of the so-called Five Classics that came to constitute the Confucian canon: the metaphysical Book of Changes (Yijing, or I Ching[3]), a divination manual that

provides readings of human events through sixty-four randomly produced hexagrams; the historical Book of Documents, a collection of historical records and speeches of the great sage rulers of early Chinese dynasties detailing the virtues of governing by virtue; the poetic Book of Odes, the oldest anthology of Chinese poetry; the social Book of Rites, describing proper etiquette and rituals and envisioning society as a beloved community of mutual cooperation; and the historical Spring and Autumn Annals, documents from Confucius's state of Lu that underscore the centrality of collective memory in creating a stable society.[4]

Of these Five Classics the most celebrated in both China and the West today is the Yijing (I Ching). Perhaps that is because this endlessly intriguing book of divination doubles as a book of wisdom about chance and circumstance that reveals ancient secrets about how things are born, die, and change through the endless interaction of yin (feminine, shady, cold, hidden, passive, soft, yielding, Earth) and yang (masculine, bright, hot, evident, aggressive, hard, controlling, Heaven). Widely translated into English, the Yijing has traveled a long and winding road in European and America popular culture, influencing the television series *Lost*, the dances of Merce Cunningham, the novels of Philip Pullman, and the musical compositions of John Cage and Pink Floyd.

Confucianism is grouped today alongside Daoism and Buddhism as one of China's "Three Teachings." Unlike in the West where the jealous God of the jealous monotheisms (Judaism, Christianity, and Islam) dictates that people choose one and only one religion, in China the Three Teachings mix and mingle quite amiably. While Jews for Jesus is a misnomer to many Christians and almost all Jews, Daoists for Confucius and Confucians for the Buddha are thick on the ground in China. According to a popular Chinese saying, "Every Chinese wears a Confucian cap, a Daoist robe and Buddhist sandals."[5] Or, according to another, Chinese are Confucians at work, Daoists at leisure, and Buddhists at death. So if you were to phone random people in China and ask them, as American pollsters do, "What is your religion, if any?" almost ev-

eryone at the other end of the line would be hard-pressed to pick just one.

Confucianism may be just one of the Three Teachings, but more than Daoism or Buddhism or communism even, Confucianism gave us Chinese mores and the Chinese mind. Whether this bequest is a boon or a burden—the secret ingredient that gives Chinese civilization its special flavor, or the stench seeping out of China's dying feudal past—is open to debate. What is indisputable is the powerful role Confucianism has played in shaping Chinese thought, politics, economy, and society. For roughly two millennia, Confucianism was China's official orthodoxy, and its lessons on how to become human through education, ethics, and ritual were taught and learned for much of that time in Korea, Japan, and Vietnam. Confucianism's Five Classics were the core texts in Chinese schools beginning in 136 b.c.e., and for more than a millennia the only path to jobs in the vast civil service ran through exams on these scriptures. Thanks to the influence of a Song dynasty (960–1279 c.e.) reform movement known as Neo-Confucianism, Confucianism's Four Books—the Analects, the *Mencius*, the *Great Learning*, and the *Doctrine of the Mean*—replaced the Five Classics as the core texts in schools and on civil service examinations in 1313 c.e. This curriculum remained in place until 1905.

You no longer need to know what Confucius says to work for the Chinese government, but Confucian values such as reverence for antiquity, respect for education, deference to elders, and filial piety continue to influence profoundly how ordinary people act politically, conduct business, interact socially, and seek after harmony with Heaven, not only in China but throughout East and Southeast Asia. It is impossible to understand contemporary life in mainland China, Taiwan, Hong Kong, Japan, South Korea, North Korea, Singapore, or Vietnam without reckoning with the long shadow of Confucianism. The deference of the Chinese to the Chinese Communist Party is attributable in part to this Confucian sensibility, as is the success of China's factory-based export economy. Although the number of self-professed Confucians is quite small even in East

Asia, a Confucian sensibility runs through almost every Buddhist and Daoist there. And hundreds of millions of East Asian Shinto- ists, Christians, Muslims, and Marxists are deeply Confucian too. So are the Asian Americans of "model minority" fame who excel in school and workplace alike at least in part because of a reverence, bordering on faith itself, for Confucian values such as learning, hard work, and family. The United States is often described as the globe's only remaining superpower, but the supercharged Chinese economy holds over $1 trillion in U.S. government debt. So these two countries are partners in an intimate dance not only of lender and borrower but also of Christian and Confucian values. For all these reasons, Confucianism seems, despite its relative obscurity in the West, to stand among the greatest of the great religions, behind only Islam and Christianity and ahead of the remaining Three Teachings of Buddhism and Daoism.

Religion or Philosophy?

There is a nagging question, however, about whether Confucian- ism is a religion at all. Very few people in China think of it in these terms. For them Confucianism is a philosophy, ethic, or way of life. Only five religions are officially recognized by the Chinese government (Buddhism, Daoism, Roman Catholicism, Protestant- ism, and Islam), and Confucianism is not on the list. Confucianism has no formal religious hierarchy such as the Vatican, no official priesthood, and almost no congregational life. Confucian temples are dedicated to mere mortals. Its canonical texts are not said to be divinely inspired. And much of the ink in these texts is devoted to mundane matters such as good governance and profane genres such as the folk song. Here, making sense of ultimate reality takes a back seat to just making sense.

Like Buddhism, Confucianism can't seem to make up its mind about the religion thing. So it calls into question what we mean by religion and in the process helps us to see it in a new light. Confu-

cianism distinguishes itself from many other religions by its lack of interest in the divine. Its adherents do speak of an impersonal force called Heaven that watches over human life and legitimates the authority of rulers, and they have been known to revere the quasi-divine sage emperors of golden ages past. But they pay about as much attention to the creator God as your average atheist, and even less to formal theology. The Analects, which refer no fewer than eighteen times to an impersonal Heaven, do not once use personal terms for God popular in pre-Confucian China.

Confucians also respond to questions of death and the after-life with a yawn. British feminist philosopher Grace Jantzen has argued that religions are and ought to be at least as much about creation as about destruction—as much about flourishing in this world as about being saved from it in the next.[6] And while there is something odd about tapping this unabashedly patriarchal tradi-tion as an example of Jantzen's effort to overcome what she sees as a male preoccupation with death, there is no gainsaying the fact that Confucians do focus on human flourishing. Before Confucius, Chinese thinkers were more likely to speak of Heaven than Earth. After Confucius it was the other way around. To this day, Con-fucians are preoccupied with humans rather than gods, and with life before death rather than life after it. Their concerns are ethical rather than eschatological, practical rather than metaphysical. The purpose of rites is not to make it rain or save us from our sins but to knit us—dead and alive—into a beloved community. In Confu-cianism, even the cosmos asks after human life.

Rites for the dead are by no means neglected by Confucians, however. Like Jews, who see burying one's parents and saying Kad-dish prayers for them as one of the prime ways to observe the com-mandment to honor fathers and mothers, Confucians extend the obligations of filial piety beyond the grave. In fact, they see rites for deceased ancestors, including venerating those ancestors in tablets in home shrines, as key expressions of filial piety. But when asked to speculate about spirits, gods, and the afterlife, Confucius always directed the conversation back to human beings and this life:

Chi-lu asked how the spirits of the dead and the gods
should be served. The Master said, "You are not able
even to serve man. How can you serve the spirits?"
"May I ask about death?"
"You do not understand even life. How
can you understand death?"[7]

If the philosopher and theologian Paul Tillich was right to define religion in terms of "ultimate concern," whatever "religion" there is in Confucianism takes place here and now in this world of pain and overcoming. The earth is our home, Confucians have always insisted, and now is our time. We need not wait for some coming utopia. Our focus should be on actions in this world and particularly on social relations—the rites, etiquette, and ethical actions that make social harmony possible.

This might make the Confucian project sound secular, but it makes more sense to see it as a thisworldly religion—an attempt to find the sacred hidden in plain sight in the profane or, as the contemporary Confucian thinker (and a former teacher of mine) Tu Weiming puts it, "to regard the everyday human world as profoundly spiritual."[8] If religion is about the sacred as opposed to the profane, the spirit as opposed to matter, the Creator as opposed to the created, Confucianism plainly does not qualify. But perhaps what we are to learn from this tradition is not that Confucianism is not a religion but that not all religious people parse the sacred and the secular the way Christians do.

There is a persistent, unexplored bias in the study of religion toward the extraordinary and away from the ordinary. In the United States this bias manifests in a strong attraction (even among scholars who are atheists) toward hardcore religious practitioners—people who are slain by the Spirit and speak in tongues—for whom religion arrives as rupture rather than continuity. This bias leads us to see evangelicals as more "religious" than liberal Protestants, Orthodox Jews as more "religious" than Reform Jews, and Confucians as hardly "religious" at all. But there is nothing irreligious

about the Confucians; it is our categories of analysis that are confused. If we listen to Confucians in their own voices and on their own terms, we will see how religion can incarnate in very different forms.

Unlike Christianity, which drives a wedge between the sacred and the secular—the eternal "City of God" and the temporal "City of Man"—Confucianism glories in creatively confusing the two. There *is* a transcendent dimension in Confucianism. Confucians just locate it in the world rather than above or beyond it. The closest Confucians get to Western notions of a transcendent and "wholly other" God is the notion of Heaven (tian), which, while impersonal, nonetheless seems to have a will. But transcendence is always to be found here and now in human history and in human bodies themselves. What we refer to as the sacred and the secular are from the Confucian perspective forever trespassing upon and interpenetrating each other—"immanent transcendence."[9]

For all these reasons, Confucianism can be regarded as religious humanism. Confucians share with secular humanists a single-minded focus on this world of rag and bone. They, too, are far more interested in how to live than in plumbing the depths of Ultimate Reality. But whereas secular humanists insist on emptying the world of the sacred, Confucians insist on infusing the world with sacred import—on seeing Heaven in humanity, on investing human beings with incalculable value, on hallowing the everyday. In Confucianism, the secular is sacred. Or, as Tu Weiming puts it, "The Way of Heaven is immanent in human affairs."[10]

Of all the religious dimensions, Confucians care the least about theology. Confucians traditionally speak of God about as comfortably as do French politicians, and the notion of a transcendent Creator calling the shots from on high is as foreign to Confucianism as Confucianism is to most Western readers. Confucians do affirm, however, that our human nature comes from Heaven, that the good life is a life lived in accordance with this nature, and that a good state carries out the Mandate of Heaven.

Also overshadowed in Confucianism is the mythological di-

mension so highly cultivated in Hinduism and the experiential dimension so prized among Sufis. But Confucians care deeply about religion's other dimensions: the institutional, the material, and, most centrally, the ethical and the ritualistic. In fact, one of the hallmarks of Confucians is their conviction that ethics and ritual are inextricably intertwined. So while Confucianism is doubtless a bit of an odd offspring of the family of religions, it is in the family nonetheless.

Perhaps the most important DNA Confucianism shares with other members of the religion family is its faith in individual transformation. A friend of mine once remarked that there are really only two ways to change fundamentally who you are: Christian conversion and psychoanalysis. But Confucians believe their tradition, too, can fundamentally change a person. Each of us can become fully human. But because virtue needs a neighbor, this project is by no means in our hands alone.

A recent review of a New Agey book by a self-professed medium complains that much that passes for spirituality today "encourages self-involved people to become more self-involved." New Agers speak incessantly about how we are all related, yet all too many of them live inside a bubble of "self-regard," writes the reviewer Gordon Haber. "I've never heard of anyone visiting a psychic in order to learn how to be more generous with other people."[11] You can say what you want about Confucianism, but it doesn't have this problem. Whereas Daoists see society as a barrier to human flourishing, for Confucians, social life is essential. As Tu Weiming has written, "self-transformation . . . is a communal act."[12] We become human by becoming social.

Overcoming Chaos through Character

Confucianism emerged in the midst of a particularly chaotic period in Chinese history. The Zhou dynasty (1046–256 B.C.E.) was in turmoil, and China was breaking into fiefdoms waging bloody

war after bloody war. So it should not be surprising that harmony became the all-consuming goal. Different Chinese schools had different strategies for wresting order out of chaos. Realists sought harmony through the forces of law, punishment, and arms. Mohists sought harmony through undifferentiated universal love. Daoists retreated into nature in the name of spontaneity. But Confucians charted a different path. To the Realists they said that force would produce only resentment. To the Mohists they said that love would end war only in utopia. And to the Daoists they said that retreating from society into yourself was selfish and irresponsible. The Confucian strategy was to engage, engage, engage—to entwine yourself in the hustle and bustle of politics and society, and especially in ethics and ritual. Unlike religious traditions that focus on the relationship between the individual and the divine, Confucianism focused on relationships among individuals—on morality, yes, but also on etiquette, ritual, and propriety. We are neither born nor raised in isolation, Confucians observed, and only through interactions with other human beings do we become fully human.

One of Confucianism's key insights is that self-cultivation and social harmony are not at odds. Like modern-day evangelicals, Confucians say that if you want to change society, you first need to change individuals. But is this really possible? Confucians have always had a faith, bordering on fanaticism, in the ability of human beings to improve and even perfect themselves. You can change. Each of us can become the Confucian exemplar—a *junzi*, or "exemplary person" (also translated as "profound person," "noble man," "gentleman," and "superior man")—whose influence and example have the power to improve society.[13] In short, each of us can flourish and by flourishing bring order and harmony to society and cosmos alike.

But how can this be accomplished? In a word: education, which for Confucius was more about building character than about acquiring knowledge. In keeping with Confucius's epithet, "The First Teacher," Confucians have always stressed self-cultivation through education. We can improve ourselves and our society

by studying ancient classics, by emulating the sages, by learning proper etiquette and rituals, and by practicing the virtues. So job one in Confucian education is not learning a trade but learning to be human. Human beings are learners, and as we learn we become more ourselves. This cannot be done alone, however. Children need parents; students need teachers; spouses and friends need one another.

In a seminar I taught on wandering in the world's religions, my students got into a heated debate about whether it was better to wander alone or together—a debate that quickly turned into a conversation about whether humans are solitary or social creatures. Are we made and sustained in isolation or in relation? The Enlightenment notion of the self as an independent free agent makes no sense from the Confucian perspective of the interdependence of all things. Just as Confucians say no to the secular/sacred divide, they creatively confuse the boundaries between self and society. The self is *not* an isolated atom, they insist, but the center of a vast web of relationships with family, community, nation, and world. Without this complex ecology of overlapping networks of mutual obligations, there may be an ego, but there is no self.

Although unapologetically communitarian, Confucianism is not opposed to self-cultivation. In fact, self-cultivation is essential to the Confucian project. Confucians insist, however, that we become ourselves, and transform society, through others. The path to social harmony runs through human flourishing, and human flourishing is made possible through right relations with other human beings.

These relations are, according to Confucians, hierarchical by necessity. As John Winthrop, the first governor of the Massachusetts Bay Colony, was about to disembark from his ship, the *Arabella*, and transform himself and his passengers into New Englanders, he spoke of the importance of knowing your place and staying in it. "God Almighty, in his most holy and wise providence, hath so disposed of the condition of mankind, as in all times some must be rich, some poor, some high and eminent in power and dignity, others mean and in subjection," Winthrop said. The New World's

wilderness was wild enough without the anarchy of social climb-
ing. Here rich would stay rich, and poor would stay poor, but all
would be "knit together in this work as one man."[14] Confucians,
too, see hierarchy as an essential ingredient of social harmony.

When asked what he would do first if called to administer a
state, Confucius said he would start by rectifying names. The
phrase *rectification of names* actually points to two principles: first,
things should be called what they really are; second, things should
conform to what they are called. "Let the ruler be a ruler, the sub-
ject a subject, the father a father, the son a son."[15] Much disharmony
and disorder in a society, Confucius argues, comes when people
either do not know their roles or do not act in keeping with them.

Confucians typically break down these roles into Five Relation-
ships: ruler/subject; parent/child; husband/wife; elder brother/
younger brother; and friend/friend. Each of these Five Relation-
ships is supposed to be characterized by two-way mutuality and
reciprocity rather than one-way obedience. Parents and rulers are
to care for their children and subjects, while children and subjects
owe loyalty and respect to parents and rulers.

Just as important as the Five Relationships are the Five Virtues:
human-heartedness; justice; propriety; wisdom; and faithfulness.
Careful cultivation of these Five Relationships and Five Virtues
is supposed to produce social order, but according to Confucians
these relationships and virtues also produce fully human beings.
Here, too, it takes a village.

Confucius

Confucius (from Kung-fu-tzu, or "Master Kung": 551–479 B.C.E.)
is often described as Confucianism's founder, but he regarded
himself as a transmitter of ancient truths rather than an inventor
of new ones. He lived his remarkable life during China's Age of
the Hundred Schools and, in global terms, during the Axial Age

in which Socrates and the Hebrew prophets walked the earth at roughly the same time as the Buddha.

Biographical details about the life of Confucius are hard to come by, but it is widely agreed that he was born in 551 B.C.E. in Qufu in the state of Lu (in today's Shandong province) to a family of little means. He responded to the death of his father, and the poverty it produced, by plowing himself into his studies. Renowned when young as a polymath—China's Jefferson—he used his expertise in ritual, archery, charioteering, calligraphy, mathematics, poetry, history, and music (he played a stringed instrument called the zither) to set himself up as the first private teacher in China. His instruction, which focused on the Five Classics, aimed at character building and self-cultivation. Like Socrates, he taught through conversation, and his students reported that he was particularly good at posing the provocative question.

Confucius is typically credited with editing and writing portions of the Five Classics, but the work people most associate with him, the Analects (literally, "conversations") was put together by his students. In the Analects, Confucius identifies chaos as the human problem and order as the solution. The techniques he employs to move from sickness to cure are ethics and ritual.

Confucius taught each of his students to try to become a junzi ("exemplary person") by learning to cultivate *ren* ("human-heartedness") and *li* (ritual/etiquette/propriety). The purpose of education in his view was not to turn out workers who could turn out widgets but to empower students to transform themselves into complete human beings—people who both understand and embody the virtues.

Confucius also tried to become a player in politics, but his efforts in this arena would not bear fruit until long after his death, when in the Han dynasty (206 B.C.E.–220 C.E.) Confucianism became the state orthodoxy. As his efforts in politics and education indicate, Confucius was neither an ascetic nor a contemplative. He liked to fish, hunt, and sing. He was an aficionado of the arts. And he en-

joyed a good drink and a good meal. Married with children, he was a practical person who, according to one of the most celebrated passages in the Analects, had by the age of seventy attuned duty and desire into one clear voice.

Confucius died in his early seventies, under circumstances that to a lesser man would surely have been disappointing. Although he is said to have earned the loyalty of thousands of students, he was a failure in politics. So it should not be surprising that his last words ring with resignation bordering on bitterness: "No intelligent monarch arises; there is not one in the kingdom that will make me his master. My time has come to die." Confucius's voice was both stronger and more poetic a few days before his death, possessed of both more yang and more yin. Looking out over Tai Shan, one of China's most sacred peaks, he said:

> *The great mountain must crumble;*
> *The strong beam must break;*
> *And the wise man wither away like a plant.*[16]

Although sacrifices are offered in his name every day in Confucian temples across the world, Confucius is remembered as neither a saint nor a miracle worker. Some Daoists revere him as a god, but he has never been deified by Confucians. Just as Theravada Buddhists remember the Buddha as a pathfinder rather than a deity, Confucians see Confucius as a great moral teacher. They even debate whether he ever achieved the standing of sage (an honorific he never claimed for himself). However, Confucius was by acclamation an exemplary student and teacher who looked to the past, especially to the ancient sage ruler the Duke of Zhou, for lessons on how to cultivate character and secure peace. Ever humble, he claimed he was doing nothing more than faithfully passing down the teachings of greater thinkers. "I have transmitted what was taught to me without making up anything of my own," Confucius said.[17] In this sense the role he plays in Confucianism is more like Muhammad, who transmitted the Quran to Muslims, and Moses,

who transmitted the Law to the Israelites, than like founders such as Jesus or the Buddha, whose own insights formed the basis for their respective scriptures.

But Confucius was also a transformer who helped to redirect the ancient Chinese culture he plainly revered from a hierarchy of birth to a hierarchy of merit. He accepted students who were not able to pay him with anything other than dried meat and grati-tude—his greatest student was a commoner—and he insisted that it was possible for anyone, not just the high born, to cultivate the virtues and become a sage. So while there were transmitters such as Moses and Muhammad in this man, there were also transformers such as Jesus and the Buddha.

Human-Heartedness and Propriety

What teachings, then, did Confucius transmit, and transform? How did he mix the old and the new in responding to the chal-lenges of an age in which, as the Book of Poetry puts it, "there is no end to the disorder"?[18]

Any answer to these questions must begin, as did Confucius himself, with learning. For Confucius, studying the Five Classics was essential. But this study then needed to be put into motion, translated from thought to action. The point of learning was to produce virtue and propriety—to turn yourself into a junzi, an ex-emplar who exhibits the virtues, knows his social roles, performs the rituals, and otherwise traverses the Way of Heaven. While the tendency to reduce Christianity to its ethical precepts is a modern invention, ethics has always stood at the heart of the Confucian project, and at the heart of Confucian ethics is the virtue of ren, which perhaps more than any other quality exemplifies the exem-plary person. Mentioned over one hundred times in the Analects, the term *ren* has been variously translated as humaneness, human-ity, benevolence, altruism, love, and compassion, but it is perhaps best rendered as "human-heartedness."[19] Its Chinese character

combines the image of "human being" with the image of "two,"
so *ren* refers to right relations among people. Before Confucius, it
was believed that only sage rulers and other elites could cultivate
this virtue. But Confucius held it out as a possibility for all human
beings and as the last, great hope for social harmony and political
order. Virtue, he argued, was the foundation of civilization, and
the foundational virtue was ren.

One of Confucius's chief rivals, Mo-zi, argued on behalf of the
so-called Mohists that human beings should extend their human-
heartedness to all regardless of relation. In other words, he antici-
pated Jesus's emphasis on agape love, which, seeing no distinction
between friend and enemy, seeks to love all equally. But Confucius,
far more concerned about "family values" than was Jesus, said that
ren should be cultivated first and foremost inside the family.

Filial piety matters in Judaism, but honoring your parents is
even more central to Confucianism. The opening lines of the
Analects refer to filial piety as the "root" of ren.[20] Of the Five
Relationships, the first each of us learns (or fails to learn) is that
between parent and child. It is in this relationship that we take
our first baby steps away from self-centeredness and toward moral
excellence. Families teach us how to be human, how to follow and
to lead. If families are well ordered, human interactions will be
harmonious, and if human interactions are harmonious, society
will be harmonious too.

But how are we to cultivate this human-heartedness? How might
the lessons of empathy and fellow-feeling learned in the family
move out into the wider world? In a word, *li*. Before Confucius, *li*,
which literally means "to arrange in order," referred fairly narrowly
to ritual. But with Confucius and his followers it became a multi-
functional term referring as well to etiquette, customs, manners,
ceremony, courtesy, civility, and propriety.

Li is so crucial to Confucians that the Chinese sometimes refer
to Confucianism as *lijiao*, or the religion of li. Today li means doing
the proper thing in the proper way under any given set of circum-
stances—to act, in short, in keeping with the Way of Heaven. Li

stands alongside ren as one of the two key concepts in Confucius's thought, since both ren and li contribute to both self-cultivation and social harmony. But whereas ren is inward and subjective, li is outward and objective—ren put into practice.

An exceedingly broad concept, li comprises both ritual, as in how to perform a wedding, and ritualized behavior, which is to say manners, etiquette, and even body language. When U.S. president Barack Obama met Her Royal Highness Queen Elizabeth II at Buckingham Palace just a few weeks after his 2009 inauguration, he gave her an iPod—a widely criticized gaffe that demonstrated a severe lack of li. Li also governs proper behavior toward parents: "When your parents are alive, comply with the rites in serving them; when they die, comply with the rites in burying them."[21] It also extends to such seemingly mundane matters as how to look, listen, speak, and move: "Do not look unless it is in accordance with the rites (li); do not listen unless it is in accordance with the rites; do not speak unless it is in accordance with the rites; do not move unless it is in accordance with the rites."[22] Li is to ask tactfully about your parent's health. It is to stand up straight. It is to seek wealth within the rules. It is to allow your teacher to speak first. It is to treat a guest with hospitality. It is to put the arrow to pride.

In keeping with the Doctrine of the Mean, li includes avoiding extremes in both thought and behavior, taking your pleasures in moderation, and otherwise following the balanced and harmonious Way of Heaven. It is to incline yourself toward listening rather than speaking (the character for *sage* in Chinese is a large ear and a small mouth). It is to eat slowly, to pour tea just so, to avoid slurping your soup. Knowing what to wear at a wedding, or a funeral, is li. Being considerate of others—not blasting your boombox on the subway or cutting into line at the cinema—is li. In sum, li is to make space for reverence in all things, treating seemingly ordinary interactions as if they were sacred ceremonies.[23]

Just as Muslims look to Muhammad as an example of how to live a human life, Confucians look to Confucius. When Confucians read the Analects, they consider not only what Confucius

said but also what he did—how he "presented gifts, taught, ate, visited a temple, or how he performed simple mundane acts."[24] All of these things cultivate our human-heartedness and in the process act as the social glue that creates and sustains social order. It is li that turns an ordinary person into a superior person. It is li that makes society run smoothly, harmonizing Heaven and humanity.

There is a longstanding (and ongoing) chicken-and-egg debate among Confucians about whether li or ren is more foundational. Does li cause ren? Or does ren cause li? There is widespread agreement, however, that these are the Confucian tradition's two central concepts, so perhaps the middle way is to see them as part and parcel of each other—two sides of the same coin. Li is how ren expresses itself in the world. But ritual and propriety in turn makes us more human-hearted. Together li and ren produce harmony in the individual, the society, and the cosmos.

If Confucius sounds like a moralist, he was. His preoccupation was how to live. He believed that human nature is moral, so to become moral is to become ourselves. But there was a touch of the mystic in him too. Like Socrates, he was both humble and intelligent enough to recognize the limits of his own wisdom. Confucius once defined knowledge like this: "When you know a thing, to recognize that you know it, and when you do not know a thing, to recognize that you do not know it."[25] And on at least one occasion he seemed to bow in reverence to silence. After he confessed a preference for silence over speech, a worried student asked him what his fellow students would have to pass down if he refused to speak. Apparently silence had not struck Confucius yet, because he replied, "Heaven does not speak, yet the four seasons run their course thereby, the hundred creatures each after its kind, are born thereby. Heaven does no speaking."[26]

Mencius and Xunzi

Following Confucius's death, the Confucian conversation was dominated by two great competing thinkers, Mencius and Xunzi, who played in their tradition the roles that the dueling rabbis Hillel and Shammai would play a few centuries later in Judaism. Although Mencius is often referred to as an idealist, and Xunzi as a realist, this assessment begs the question that consumed them both: are human beings basically good? This question mattered because the entire Confucian project hung on the possibility of human improvement; its goals of social harmony and political order could not be reached if humans could not be improved. But could they? And if so, how? Mencius (371/2–c. 289 B.C.E.) famously argued that human beings are originally good. We do good because we are hardwired to do so. And when we do evil, it is nurture, not nature, that short-circuits the good. Where is the person, Mencius asks, who, when he hears a child crying at the edge of a well, will not try to prevent him from falling in? Each of us harbors feelings of compassion, which breed benevolence; feelings of shame, which breed dutifulness; a sense of courtesy, which breeds propriety; and a sense of right and wrong, which breeds wisdom. To become human, we do not need to grasp after something outside and beyond ourselves. The germs of humanity are within.

Rejecting what he saw as Mencius's naive optimism about human nature, the third-century-B.C.E. thinker Xunzi argued that human beings are basically wicked—"grasping, hungry, egotistical bastards."[27] In the Analects, Confucius had argued that government worked better by shame than by punishment: "Guide them by edicts, keep them in line with punishments, and the common people will stay out of trouble but will have no sense of shame. Guide them by virtue, keep them in line with the rites, and they will, besides having a sense of shame, reform themselves."[28] Xunzi disagreed. In this world of greed and envy and hate, our wickedness needs to be spanked out of us. Education doesn't cultivate our nature; it changes it. Only

through strict laws and severe punishments can humans learn to subdue their private passions in service of the public good (and their own). So whereas Mencius used gentle botanical metaphors of nurture and growth to describe our education to the human-heartedness already planted within us, Xunzi relied on harder metaphors from the workshop—metal shaped by hammering into a sword, wood bent by steam into a bow—to describe how the example of the junzi could emerge out of something so unvirtuous.

Neo-Confucianism, New Confucianism, and Boston Confucianism

After Confucius, Mencius, and Xunzi, the big three in the first Confucian wave, the influence of Confucianism rose and fell like a bell buoy on the Yellow Sea. Confucius never was able to win political friends and influence powerful people during his lifetime, and both Mencius and Xunzi were personae non grata under the short-lived Qin dynasty (221–207 B.C.E.). China's first emperor, a ruthless Machiavellian besotted by Legalist preoccupations with punishment and power, wanted nothing to do with Confucius's insistence that rulers treat their subjects like loving fathers treat their respectful sons. So he ordered the burning of Confucian books and the execution of Confucian scholars. During the Han dynasty, however, Confucianism had its Constantine moment, ascending in 136 B.C.E. from a persecuted movement to the official state orthodoxy and becoming the dominant intellectual impulse in China. Under the Han, the Five Classics became required reading for Chinese students, and a Confucian education became the ticket to employment in the vast Chinese bureaucracy.

Confucianism lost ground to both Daoism and Buddhism in the Tang dynasty (618–907 C.E.) but was revived in the Song dynasty (960–1279 C.E.), when under the moniker of the "School of Principle" (Neo-Confucianism to Westerners) it once again became China's preeminent intellectual impulse.

Two key developments put the "neo" in Neo-Confucianism. First was the willingness of Neo-Confucians to steal shamelessly from Buddhism and Daoism. Just as Muslims had rejected the asceticism of Christian monks, Neo-Confucians resisted the ascetic impulses of Buddhist and Daoist monastics. But they borrowed from the other Three Teachings various spiritual practices, including a meditative discipline known as "quiet sitting." For these Neo-Confucians, cultivating reverence stood shoulder-to-shoulder with pursuing wisdom in Confucian education, which now included a wide array of mental, physical, and spiritual practices: "book reading, quiet sitting, ritual practice, physical exercise, calligraphy, arithmetic, and empirical observation."[29]

The second key development rearranged the Confucian canon. Under the direction of Zhu Xi (1130–1200), Confucianism's foremost Song-dynasty thinker, Neo-Confucians now saw the "Four Books" rather than the Five Classics as the starting point for learning. From the fourteenth century until the twentieth, the Analects, Mencius, the Great Learning, and the Doctrine of the Mean would constitute the basis for China's civil-service examinations. The cumulative effect of this reorientation was to direct greater attention to the sorts of metaphysical and spiritual questions that Confucius shooed away but were the bread and butter (or, in this case, the rice) of Buddhists and Daoists.

Neo-Confucians distinguished themselves from Buddhists and Daoists, however, by their continued emphasis on ethics and history and by their continued commitments to reason and humanism. While the spirituality of the Daoists directed them out of this world, all the leading thinkers in this formative period of Neo-Confucianism were also political officials.

Some find antecedents for the philosophy of American pragmatism in the next great Neo-Confucian after Zhu Xi, Wang Yang-ming (1472–1529). Previous Confucians had creatively confused the sacred and the secular, Heaven and humanity. Wang Yang-ming did the same for thought and action. You don't really know something unless you act on it, and you can't really act on it unless

you know it, he insisted. "Knowledge is the beginning of action, and action is the completion of knowledge."[30]

For much of the twentieth century, Confucianism was left for dead. The centuries-old tradition of Confucian civil-service exams came to an end in 1905, and official state sacrifices to Confucius were discontinued in 1928. In the years immediately following the formation of the People's Republic of China in 1949, there was some talk of integrating communism and Confucianism. But the political drama of the Cultural Revolution cast Confucius as the villain. Its anti-Confucian campaign of the 1970s attacked the "four olds" (Confucian culture, ideology, customs, and habits) in the name of the "four news" (proletarian culture, ideology, customs, and habits). Communist Party officials denounced Confucius as the "number one hooligan" and indicted Confucianism of all sorts of high crimes and misdemeanors against the new Marxist-Leninist creed of Chairman Mao.[31] Taking a page out of the playbook of the anti-Confucian Qin dynasty of two thousand years earlier, the Red Guard seized and burned Confucian books and smashed the statue of Confucius at the Confucian temple in his hometown of Qufu. What was once the heart and soul of Chinese civilization was recast under the communists as a feudal affront to progress, an antimodern system of superstition, and a reactionary instrument of sexism and class oppression.

Today the Confucian star is rising once again in China. Confucian Studies programs are springing up at universities across the country. Confucius is being quoted by Communist Party officials, not least by China's president Hu Jintao, whose slogan, "To build a harmonious society," is based on a saying by Confucius ("to aim always at harmony").[32] And *Confucius from the Heart*, a sort of Chicken Soup for the Confucian Soul by the media professor (and media darling) Yu Dan, has sold more than ten million copies.[33] Pro-Confucian momentum is so strong in China today that some are beginning to imagine that Confucianism could soon replace Marxist-Leninism as the official state ideology. This fantasy of the Chinese Communist Party morphing into another sort of CCP

(the Chinese Confucian Party) is doubtless still far off, but millions of students across China are now reading the classics of Confucius and Mencius alongside (and in some cases against) the classics of Marx and Mao.

Accompanying this popular revival is a more philosophical resurgence called New Confucianism. Some observers are describing this new development as Confucianism's third wave, cresting unlike the first wave of the first millennium and the second wave of the second millennium and not just over China but across the globe. Taking aim at the stereotype of Confucianism as fixed and fossilized, New Confucians insist that, just as Confucius transformed the traditions he inherited, they have the right and the responsibility to transform Confucianism itself. According to my BU colleague John Berthrong, New Confucians attempt "to be faithful to the core teachings of Confucianism but to state them in modern, universal terms, and in dialogue with world cultures."[34] More specifically, New Confucians seek to bring the ancient wisdom of their tradition to bear on such current challenges as science, liberalism, democracy, and human rights, and to purge that tradition of sexism and patriarchy along the way. Popular in China, Taiwan, Hong Kong, and the United States, New Confucianism insists that while Confucianism has much to learn from the West (including Western philosophy and comparative religion), the West has much to learn from Confucianism. In their ongoing dialogue with Western philosophers and theologians, New Confucians are happy to laud liberty, fraternity, and equality, but they insist on adding community to the mix.

The New Confucians are also trying to gestate an authentically Confucian feminism. In books such as Chenyang Li's *The Sage and the Second Sex*, they look back to the mothers of Confucius and Mencius as inspirations and construct their ethics around the egalitarian relationship of friend and friend rather than the hierarchical relationship of ruler and subject.[35] They also observe that, while Plato and Aristotle debated whether women were fully human, the earliest Confucians always acknowledged that women could become not only junzi but also sages. Perhaps the greatest resource

for Confucian feminism is the early Chinese cosmology of yin and yang, which insists that the feminine and the masculine are complementary and ever interpenetrating each other.

One manifestation of this New Confucianism is referred to as Boston Confucianism, because its leading advocates are Tu Weiming of Harvard and Robert Neville and John Berthrong of Boston University. In an ironic proof of the Confucian sense (shared with the Hebrew Bible) that there is nothing new under the sun, Neville and Tu are in many respects reprising the debate between Mencius and Xunzi. Neville, a United Methodist minister who describes himself as a Confucian Christian, has served as the Dean of BU's School of Theology and as its university chaplain. In keeping with his Christian heritage, he echoes Xunzi both in his understanding of the sinfulness of human beings and in the key role played by li in disciplining this wickedness. Tu, by contrast, echoes Mencius in his understanding of humanity's essential goodness. So while Neville traces the root of the Confucian project to Xunzi's keyword of *li*, the keyword for Tu, who, like Mencius, focuses more on inner cultivation than ritual, is *ren*. What these two men share, however, is the conviction that there is no reason for Confucianism to restrict itself to China, or even to Asia. Confucianism successfully migrated from China to Japan and Korea and Vietnam. Why can't it take up residence in Boston too?

The Tigers of Mount Tai

I must admit that I have never been much of a fan of Confucianism, which has long managed to both intrigue and horrify me. Like most Americans, I revel in individual freedom and rebel against the rhetoric of duty and obligation, particularly when that rhetoric comes from voices outside my own head. I don't traffic in bumper stickers, either on my car or in my thinking, but if I did I'd be far more likely to display a bumper sticker reminding me to question authority than one reminding me to respect it. I ask my students, even my undergraduates, to refer to me by my first name.

And I am not alone. The United States was born of rebellion to authority, and Europeans and Americans alike are endlessly suspicious of received truths. We are encouraged to think outside the box, to praise "mavericks," to march to Henry David Thoreau's paeans to nonconformity. When it comes to marriage or death, we refuse the cookie-cutter ceremonies that satisfied our grandparents, writing our own vows and asking for our ashes to be scattered at our favorite golf course or baseball diamond. What could be squarer for generations brought up on the Beats and the hippies and the *Daodejing* than the stuffy propriety of Confucianism?

So it should not be surprising that we find much to commend in the short stories of Lu Xun (1881–1936), a critic of Confucianism who has been celebrated as the father of modern Chinese literature. Lionized by Chairman Mao as "the chief commander of China's cultural revolution," Lu Xun preferred down-and-dirty vernacular Chinese to the high-flying literary Chinese of elites, and he condemned in no uncertain terms the "man-eating" superstitions of Confucian culture as a multimillennia assault on individual freedom.[36] Confucianism was in his view injustice, oppression, and conformity masquerading as morality.

Though I am not and have never been a communist (except during the week I fell under the spell of Marx's *Das Kapital* in college), I share Lu Xun's view that Confucianism's so-called Three Bonds (ruler over subject, father over son, husband over wife) are authoritarian and sexist. Yes, subjects, sons, and wives were told that they had both a right and an obligation to correct their rulers, fathers, and husbands when they overstepped the boundaries of virtue, but how often did that actually happen? The character for *wife* in Chinese includes a broom, and Confucianism did little to overturn the received wisdom that girls were little more than domestic-servants-to-be. Many New Confucians emphasize the mutuality rather than the hierarchy in male/female relationships, and Confucianism does share with feminism a focus on human flourishing here and now. But it must be admitted that this is an exceedingly difficult tradition to redeem on feminist grounds.

I also share Lu Xun's suspicions of the mechanisms of duty, not because I am opposed to feeling and fulfilling obligations but because I know from experience how duties can drown a person to the point where he is no longer recognizable to either himself or others. I thrill to rituals of reversal—Holi in India, Mardi Gras in New Orleans, and Purim in Israel—that turn the world upside down. And I have a deep and abiding romance with the New England institution of the town meeting, a ritual of reversal itself in which for at least one night a year the subjects are the rulers, and the rulers the subjects.

Still, I must admit that of all the great religious leaders I have studied over the years, Confucius has grown on me the most. Individualism is one of the glories of modern Western civilization, but one of its evils is our cult of narcissism. Like the Buddha, Confucius saw the ego as a weapon of mass destruction that horribly distorts our ability to see things as they really are and kills by flattery along the way. So Confucius redirected our collective attention from the solitary individual to the person in community. Like the Buddhist practice of *metta* meditation, which instructs practitioners to breath out compassion on self and others, Confucius and his followers seek to instill in us ever widening circles of empathy—to self, yes, but then to family, community, nation, humanity, and Heaven. Perhaps because he came from modest means himself, Confucius repeatedly insisted that our measure has nothing to do with wealth or rank and everything to do with achievement and virtue. In politics, he was no egalitarian. But neither was he a tyrant. His insistence that we defer to those who know more than we do—what Berthrong characterizes as "the education of the unwise by the wise"—is not all that different from President John F. Kennedy's administration of and by the "best and the brightest"—a Confucian Camelot.[37]

I am also drawn to Confucius's call to speak truth to power, a call amplified by Mencius's brave insistence that subjects have the right to rebel against any ruler who by virtue of his lack of virtue has lost the Mandate of Heaven. In the modern West, we tend to associate Confucianism with a rubber stamp to govern-

mental authority—with President Nixon's naked assertion, in his interview with British journalist David Frost, that, "When the president does it, that means it is not illegal." But there is a reason why Confucius could not land a real government job. He insisted on virtue not only in subjects but also in rulers. While Confucius did say that subjects were to respect and obey their rulers, he also said that rulers should care for their subjects like loving fathers care for their sons. Good government, he said, depended on trust even more than on prosperity or military might, and trust could not be earned, or kept, except under cover of virtue.

As bloody causes continue to produce bloody effects in the Middle East, Confucius's rebuke to the Realists who sought social harmony through arms comes powerfully to mind. Force from on high, he argued, will only bring resentment from below. What greater proof of this theory is there than the multitude of resentful Islamists who line up each day to blow themselves up in Iraq and Afghanistan?

One of the most famous stories of the life of Confucius has him riding by Mount Tai (in Shandong province) when he encounters a woman consumed by grief. A disciple of Confucius learns that the woman, who is bent over her son's grave in anguish, has experienced not one loss but three. Her husband's father, her husband, and now her son have all been killed by a tiger. The ever-practical Confucius asks her why she has not moved to some safer place. "There is here no oppressive government," she explains, prompting Confucius to turn to his disciples and remark, "My children, remember this. Oppressive government is fiercer than a tiger."[38]

As a citizen in a country increasingly obsessed with rules, I also find Confucius's virtue ethics refreshing. All too often we try to force the round pegs of a general rule into the square hole of our particular circumstances. So while it is easy to stereotype Confucians as blind followers of unbendable rules of etiquette and propriety, Confucians have, in fact, long understood ethics as more art than science—a form of life rather than a set of hard-and-fast rules. While rules-based ethics claims to be universal and abstract, Confucian ethics is

by admission situational and concrete. What to do when you see an in-law—one whom you are forbidden by the rule book of propriety to touch—floating past you in a river and about to drown? Break the rule, and save the life, says Mencius. The virtuous thing to do in any situation is what the human-hearted person would do. The goal of Confucian ethics is to turn yourself into such a person.

During a recent graduation weekend, a newly minted doctor and I were chatting at the PhD "hooding" ceremony where dissertation advisers confer PhDs on their students. As we waited in all our medieval regalia to be summoned to the dais, he and I were taking in the li of it all, trying to figure out (among other things) whose hands we should shake, and when. So I couldn't help but laugh when a student who had written her dissertation on Confucianism botched the whole thing up, doing an oddly informal 360-degree turn to shake the hand of the associate dean—something no one else had done all day—and gumming up the proceedings in the process. Later I teased her about it. "I would think a student as steeped in Confucianism as you wouldn't have messed up the ritual," I said. "Ah," she replied with a knowing smile, "but when the sage does it, it is not messing up."

Finally, I must confess that Confucius is my professional hero. I have spent almost all of my adult life in academia, as either a student or a teacher. How could I not revere this man whose first words in the Analects speak of learning as a pleasure, whose birthday is celebrated as Teachers' Day in Taiwan, and whose faith in education ran so deep that he helped to construct a whole civilization around it?

Academics in the United States have a secret romance with France, where intellectuals somehow manage to reel in big salaries *and* get the pretty girls (or handsome guys). But Confucius outdid even the French in living (and loving) the life of the mind (and heart). And he did more to elevate the profession of teaching than anyone else on any continent in any age. He believed what every good teacher must believe: inside every one of us are the seeds of improvement and perfectibility, but these seeds needed to be cul-

tivated in order to bear fruit. Ren and li were to him the antidotes to chaos and disorder. But this cure could only be administered through education.

Confucius has been rightly described as conservative, but the sort of critical thinking he embodied epitomizes the liberal mind. Yes, he looked to the past for inspiration. As he himself said, however, he looked to what was old in order to find out what was new.[39] And he was determined to look at each question from many angles, including the ever-shifting angle of the new. "A noble mind can see a question from all sides without bias," Confucius said.[40]

For all his achievements in teaching and learning, however, Confucius never lost his intellectual humility. He never claimed he was divine. He never claimed he was a sage. He never even claimed he was a junzi. When asked whether he had ascended to the level of the junzi, he offered only a litany of the ways he had fallen short:

> There are four things in the Way of the profound person, none of which I have been able to do. To serve my father as I would expect my son to serve me: that I have not been able to do. To serve my ruler as I would expect my ministers to serve me: that I have not been able to do. To serve my elder brother as I would expect my younger brothers to serve me: that I have not been able to do. To be the first to treat friends as I would expect them to treat me: that I have not been able to do.[41]

Confucius provides a model, therefore, not of a fully realized human being but of someone ever striving to become more human-hearted—a model we can emulate instead of simply revere.

Becoming a Human Being

Over the centuries, Confucianism has become increasingly religious, particularly through its interactions with Buddhism and Daoism. But it remains extraordinarily thisworldly. So while it is

one of the most influential of the great religions, it is also the least religious of them. Or is it? Perhaps the final judgment to come out of our conversation with Confucius and those who have revered and reinterpreted him is that there are many different ways to be religious.

The Western monotheisms tell us that religion is a zero-sum game. You need to pick one, and you would do well to choose on the basis of what each religion can do for you at death. But among the many things Confucius and his followers seem to be saying is that perhaps the point of religion is not so much the by-and-by as the here and now. Perhaps human flourishing and social harmony are sufficiently lofty goals for any religion. Perhaps the greatest questions the great religions have to answer concern how to become a human being.

The contemporary American poet-farmer Wendell Berry has argued that we become human by participating in a "beloved community," which he defines as "common experience and common effort on a common ground to which one willingly belongs." American storytelling, Berry observes, is replete with examples of sensitive individuals overrun by overbearing communities (think Hester Prynne of *The Scarlet Letter*) and therefore of solitary individuals justifiably on the run from this overbearance (think Huck in *The Adventures of Huckleberry Finn*). But only in community, he argues, is it possible to become fully human. Only in the midst of community propriety (and impropriety), community goods (and evils), can we experience "our partiality and mortality" and our many connections to place and past, the quick and the dead. Berry defines himself as a Christian rather than a Confucian, but he comes closer to the Confucian spirit than any English-language fiction writer I know. These words—"living is a communal act"— were written by Berry. But they sound like a "Confucius says."[42]

Hinduism

THE WAY OF DEVOTION

At the beginning of any new venture, Hindus call upon Ganesha, the elephant-headed god of good fortune, lord of thresholds, and remover of obstacles. India is a land of wild diversity—religious, cultural, regional, social, linguistic—and Hindus worship hundreds (at least) of different deities, but almost all Hindus pay homage to the fat and happy Ganesha, the most popular god in this god-besotted tradition. Devotees ask for his blessings when they enter a temple, start a new job, embark on a journey, open a new business, head off to college, begin married life, plant new crops, or start writing a book. Indian nationalists turned to him to remove the obstacle of the British, and in 1947 he obliged. Today stock traders chant his 108 names each morning before the opening of the Bombay Stock Exchange in Mumbai, where the annual festival to this god of health and wealth is celebrated with particular gusto.

If omnipresence is a characteristic of divinity, then Ganesha is the divinest of the gods. His image is inescapable in India, popping up in ancient temples and Bollywood films, and on T-shirts, mouse pads, wristwatches, comic books, greeting cards, necklaces, and tattoos. Almost every Hindu home has an image of this potbellied god of good luck, who is classically portrayed holding an axe to destroy obstacles, a rope to rescue devotees from their troubles, and a sweet cake representing the bliss of spiritual liberation. Though Ganesha has a surplus of arms (four, typically), he has only one

tusk, since he broke off the other to use as a pen to write down the Hindu epic, the Mahabharata.

Devotion to Ganesha is not confined to India, or even Hindus, however. It extends to Buddhists and Jains and far beyond the borders of the Indian subcontinent. One of the first traditional Hindu temples built in the United States—the Sri Maha Vallabha Ganapati Devasthanam in Flushing, New York—is dedicated to Ganesha (who is also known as Ganapati). A large framed rendering in cloth of this jolly god of prosperity, girdled by a snake and riding his customary mouse, adorns the entrance to Boston University's Department of Religion where I work, and a pen-and-ink Ganesha, his belly as plump as a Chinatown Buddha, greets visitors to my Cape Cod cottage.

Hinduism is an over-the-top religion of big ideas, bright colors, soulful mantras, spicy foods, complex rituals, and wild stories. One of the wildest of these stories concerns how Ganesha got his head. Like most everything in India, this story comes in different shapes and sizes, but one popular version goes like this: Once upon a time the goddess Parvati was lonely because her husband, Lord Shiva, was off with his buddies on yet another interminable hunting trip. So she created a son from the dirt and dead skin on her own body. One day she asked her son to stand guard over her privacy while she took a bath. When Shiva returned, he found a strange boy barring him from his own home. When Ganesha would not let him pass, Shiva in his rage (Hindu gods are not constrained by the virtues) cut off his head. When Parvati saw her son lying lifeless in a pool of blood, she was so possessed by rage of her own that she threatened to destroy the universe. So Shiva, the destroyer god who is better at taking lives than creating or sustaining them, turned for help to Brahma (the creator) and Vishnu (the sustainer). Brahma told Parvati that her boy could be revived if the head of another creature could be procured. So Vishnu found an elephant and cut off its head, which Shiva, in the world's first example of xenotransplantation, attached to the boy's body. Shiva then declared his resuscitated son the leader of his celestial armies,

and, honoring Parvati's demand, declared that from that moment forward worshippers should call on his son's name before beginning any new undertaking, including worship itself. In this way, Parvati's dutiful son came to be the guardian of thresholds. He also came to be called Ganesha, which combines the Sanskrit words *gana* (meaning gang) and *isha* (meaning lord) and refers here to Ganesha's status as lord of Shiva's celestial armies.

The Mathematics of Divinity

In 1858, German Indologist Max Müller wrote that "Hinduism is a decrepit religion, and has not many years to live."[1] Müller was wrong. Hinduism may be the oldest of the great religions, but it is also the third largest (after Christianity and Islam), with roughly 900 million followers, or about 15 percent of the world's population. Most Hindus live in India, the world's largest democracy, where roughly four out of every five people are Hindu. But during the first millennium of the Common Era, Hinduism spread throughout Southeast Asia. The Prambanan temple complex, dedicated to Brahma, Shiva, and Vishnu, was built in the ninth century on the island of Java in Indonesia, and Angkor Wat in Cambodia, now a Buddhist site, was built in the twelfth century by and for Hindus. Today Hinduism is the majority religion in Nepal, and Hindus number in the millions in Bangladesh, Indonesia, Sri Lanka, Pakistan, Malaysia, and the United States.

In the United States, Asian Americans are often seen as a "model minority" because of their successes in school and at work. Like any stereotype, this is part true and part false, but it fits American Hindus who run neck-and-neck with Unitarians and Jews when it comes to such markers of success as levels of higher education and per-capita income. Hindus run 40 percent of the high-tech firms in California's Silicon Valley.[2] Back in India, Hindus form the bulk of a rapidly industrializing economy that many predict will become the next China.

It is difficult to say what, if anything, all these Hindus have in common because, of all the great religions, Hinduism is the least dogmatic and the most diverse. Rather than repelling new influences, Hindus are forever absorbing them. Of course, no religion is uniform. Christians have their feminist theologians and their macho fundamentalists, their "smells and bells" Anglicans and their speaking-in-tongues Pentecostals. But Hindus take diversity to new heights. Hindus do have a shared scripture (the Vedas), a shared sacred symbol (Om), and a sacred center (Varanasi in North India). They have no founder, however, or current leader. They have no shared creed and no mechanism for excommunication. When American poet Walt Whitman wrote, "Do I contradict myself? / Very well then I contradict myself," he was channeling the absorptive spirit of Hinduism. It, too, is large; it, too, contains multitudes.

In the Western monotheisms, one is the holiest number, but Hindus worship many gods through many different paths (*margas*), disciplines (*yogas*), and philosophies (*darshanas*). Their deities appear as powerful kings, starving ascetics, brave monkeys, graceful dancers, blue-faced flute players, and impersonal stones. Some Hindus say that there is really just one god underlying these many manifestations. Others say that there are many gods but one is supreme. Still others say there are many gods and all are equal. Some Hindus even say there is no god whatsoever—that the gods are a by-product of our hyperactive imaginations. Hindus are also divided on just how the gods are present in the *murtis* (icons) bearing their names. In a dispute that resembles the divide between Catholics (who believe that bread and wine are transubstantiated in the Mass into the body and blood of Jesus) and Protestants (who believe that bread and wine are just symbols representing Jesus), some Hindus say that the divine resides in these images, while others say that these images are symbols pointing beyond themselves to divinity.

Tellingly, Hindus cannot even agree on what to call their religion, or whether it is a religion at all. One of the most common

claims among Hindus in the West is that "Hinduism is a way of life" rather than a religion. And many prefer to refer to that way of life not as Hinduism but as *Sanatana Dharma* (Eternal Law).

Because you typically become a Hindu by birth rather than conversion, Hinduism is, like Judaism, as much a people as a religion. The term *Hindu* originally conjured up a place—the ancient Indus River Valley—and the people who occupied it. During the Mughal Empire of the sixteenth to nineteenth centuries, this term referred to any non-Muslim, and, as late as the early twentieth century, Americans were referring to all immigrants from India (Hindu, Sikh, and Muslim) as "Hindoos." British Orientalists and Indian nationalists popularized the notion of Hinduism as a world religion distinct from Islam and Christianity in the Victorian era, but the word *Hinduism* (spelled Hindooism at the time) doesn't even appear in English until the 1790s, and its usage was not widespread until the latter half of the nineteenth century.[3] That is why it was possible in 1845 for the American Transcendentalist Ralph Waldo Emerson to locate the popular Hindu scripture, the Bhagavad Gita, inside the wrong religion—"the much renowned book of Buddhism," he called it.[4]

In the absence of some entity with the authority to magically transform one specific vision of what Hinduism ought to be into what Hinduism actually is, Hinduism is what Hindus do and think, and what Hindus do and think is almost everything under the sun. More than a term pointing to a unified religion, therefore, Hinduism is an umbrella term for the religious tradition that gave the world karma and reincarnation and yoga. Under Hinduism's sacred canopy sit a dizzying variety of religious beliefs and behaviors practiced in the wildly complex and contradictory subcontinent of India and its diasporas.

Samsara and Moksha

Although Hindus disagree on how to reach the religious goal, there is considerable consensus on both the human problem and its solution. The problem is *samsara*, which literally means wandering on or flowing by but in this context refers to the vicious cycle of life, death, and rebirth. We are born and die, and then we are born and die again. And so it goes for the cosmos itself, which flows equally endlessly through its own cycle of creation, destruction, and re-creation.

In the West, belief in reincarnation is growing rapidly. More than one out of every four Americans and Europeans believes that the soul takes on another body after death.[5] But for Westerners reincarnation is usually seen as a reward rather than a punishment: perhaps in your next life you can buy that Porsche or marry that hottie or land that six-figure salary. Hindus, however, have classically seen reincarnation as a problem rather than an opportunity: this world is a vale of tears, and whatever happiness we might cobble together here is transitory and impermanent. Even heaven is subject to the flux and frustrations of the iron law of samsara. It, too, was created and will be destroyed, as will whatever gods reside there. The Hindu goal, therefore, is not to escape from this world to some heavenly paradise, but to escape from heaven and earth altogether.

Hindus call this goal *moksha*, which literally means release and in this case refers to spiritual liberation—freeing the soul from bondage to samsara and its unsatisfactoriness. This is the closest Hinduism gets to the Christian notion of salvation. But to refer to moksha as salvation is incorrect, since the concept of salvation implies salvation from sin, and Hindus do not believe in sin and so harbor no desire to be saved from it. What needs escaping is not sin but samsara. And moksha, not salvation, is that escape.[6]

Hindus understand that not everyone will be able to attain this goal, or even to strive after it. So they recognize four different aims

in life. The first three are: *kama,* or sensual pleasure (as in the ancient sex manual the Kama Sutra); *artha,* or wealth and power; and *dharma,* or duty. But the ultimate goal is moksha. Some conceive of moksha as a loving union of the individual soul with a personal god. Others see it as a more impersonal merging of what Emerson called the "Over-Soul" into the ineffable essence of impersonal divinity. Still others visualize moksha as a place. Instead of the Christian heaven and its streets paved with gold, they imagine a paradise either at Vishnu's home in Vaikuntha or at Shiva's home in Kailasa.

One of the most fascinating conversations in the Hindu tradition concerns how to reach this religious goal. What are the techniques for moving from samsara to moksha? As they wrestled with this question, Hindus developed three very different yogas (literally "disciplines"). The first, developed by priests and described in the ritual scripture the Vedas, was *karma yoga*, or the discipline of action, which initially referred to ritual action and particularly to fire sacrifice. The second, developed by wandering sages and written down in the philosophical scripture the Upanishads, was *jnana yoga*, or the discipline of wisdom. The third, *bhakti yoga*, or the discipline of devotion, is now by far the most popular form of Hinduism. It affirms that neither priestly sacrifice nor philosophical knowledge is necessary for release from the bondage of samsara. All that is needed is love—heartfelt devotion to the god of your choosing.

Today when Westerners think of Hinduism, many think of Apu, the Kwik-E-Mart proprietor on *The Simpsons* television show, a worshipper of Ganesha and Shiva, and arguably the Western world's most celebrated Hindu. But the classic image is the Hindu holy man. In the nineteenth century, missionary reports, ship-captains' travelogues, and Oriental tales seared into Western consciousness images of crazy ascetics walking barefoot on hot coals, contorting their emaciated bodies into impossible positions, and swinging from metal hooks dug into their backs. In the 1960s and 1970s, however, this "race of knaves," as one French missionary called them, went from being reviled to being revered.[7] As the

counterculture traded in the "materialistic West" for the "spiritual East," Americans and Europeans fell in love with gurus such as the Maharishi Mahesh Yogi of Transcendental Meditation (TM) fame, who seemed to many baby boomers (not least The Beatles) the perfect antidote to the drab life of the corporate man in the grey-flannel suit. Today one of the stock scenes in *New Yorker* cartoons depicts Western seekers meeting Hindu holy men. In one, an emaciated mountaintop guru answers his visitor's question with a question: "If I knew the meaning of life, would I be sitting in a cave in my underpants?"[8]

This image of the Hindu holy man, still alive in movies and television commercials (and reinforced by books on Hinduism that focus on the mystical experiences of elites), drives the popular perception that Hinduism is an otherworldly path of self-denial in which simple *sadhus* trade in jobs and families for lives of meditation, yoga, celibacy, and other austerities. And this is how Hinduism began over 2,500 years ago—as an elite tradition of ascetics seeking to solve the problem of samsara through wisdom. But today Hinduism is far less exotic—a popular tradition of ordinary fathers, mothers, and children seeking moksha through nothing more extraordinary than love.

Indus Valley Civilization

Religions are often described as trees with roots, trunks, and branches. But geology rather than botany is Hinduism's metaphorical home ground. Imagine the Hindu tradition as layer upon layer of rocks of various sorts stacked on top of one another. In some places antediluvian granite pokes up to the surface, but in other places those ancient rocks are buried under the lava of relatively recent volcanic eruptions.

The most ancient layer in Hinduism's geology is Indus Valley civilization, a proto-Hindu culture that provides the barest glimpses of Hinduism as it is practiced today. The second layer is Vedic re-

ligion, a karma yoga path that takes its name from ancient ritual manuals called the Vedas. Next comes philosophical Hinduism, a jnana yoga path of wandering renouncers and their scriptures, the Upanishads. The fourth layer is devotional Hinduism, the bhakti yoga of the Hindu epics, a story-driven path tailor-made not for priests or holy men but for ordinary men and women for whom Hinduism is about inviting the grace and favor of the gods into everyday life. Modern Hinduism is the final layer. Here intellectuals from the nineteenth-century Hindu Renaissance and beyond struggle to bring Hinduism into conversation with Islam, Christianity, and the modern world.

Indus Valley civilization dates at least as early as 2500 to 1500 B.C.E., making its architecture nearly as old as the pyramids and its cities earlier than Athens and Rome. Excavations conducted in the early 1920s at Harappa and Mohenjo Daro, both in present-day Pakistan, have shown that Indus Valley civilization supported a vast population that may have stretched from the Himalayas to the Arabian Sea. We now know that this civilization was urban, technologically advanced, and literate. But because its script has not yet been deciphered, we do not know much about its religious beliefs and practices. As a result, it is unclear how much Indus Valley civilization contributed to Hinduism. Some find Hindu precursors in its art and architecture, which seem to provide evidence of ritual bathing and animal sacrifice. Might the figurines of full-hipped women unearthed by archaeologists be prototypes of Hindu goddesses? Might the images of a man in a yogalike posture surrounded by animals be a prototype of Shiva, who is worshipped today as both an ascetic and the Lord of Animals? Perhaps. But in the absence of a deciphered script that can explain how these figures were actually used, any connections remain speculative.

Vedic Religion

The second layer in the geology of Hinduism, Vedic religion, takes its name from the world's oldest holy books, the Vedas (from the Sanskrit term *veda*, meaning "knowledge"). Hindus divide their many scriptures into two categories: *sruti* ("that which is heard," or texts authored by divinity) and *smrti* ("that which is remembered," or texts authored by human beings). The Vedas fall into the higher category of sruti. Regarded as eternal, these Sanskrit texts are said to have been revealed to human beings through *rishis* (seers) and then compiled by the sage Vyasa.

Like the term *Torah* in Judaism, which refers in a narrow sense to the five books of Moses (Genesis, Exodus, Leviticus, Deuteronomy, and Numbers) and in a more expansive sense to the entire Hebrew Bible, the Vedas refer in a narrow sense to a collection of four books (the Rig, Sama, Yahur, and Arharva Vedas) and in a broader sense to sruti literature in general, which includes these four books plus three other classes of Vedic scriptures: the Brahmanas (Priestly Books), the Aranyakas (Forest Books), and the Upanishads (Secret Doctrines). The simplest way to make sense of these four classes of revelation (all written in Sanskrit) is to think of the Vedas as technical manuals instructing priests in the proper performance of rituals (including the hymns to sing and the mantras to chant), the Upanishads as philosophical dialogues speculating on the meanings of these rituals and the Ultimate Reality underlying them, and the Brahmanas and Aranyakas (texts that fall chronologically between the Vedas and the Upanishads) as mixtures of the two.[9] The oldest of these scriptures is the Rig Veda, a collection of 1,028 hymns composed over centuries but dating back to at least 1200 B.C.E. The latest, the Upanishads, were probably composed between 600 and 300 B.C.E., though they were not written down until the seventeenth century C.E.

The French philosopher Simone Weil once wrote that "the first of the soul's needs, the one which touches most nearly its external

destiny, is order."[10] So it is fitting that this first of religions begins by attacking the problem of disorder. Demons of chaos are always arrayed in a pitched battle with the gods, so family, community, and cosmos alike are forever collapsing into disarray. The aim is to create and sustain social and cosmic order, or what the Vedas refer to as *rita* (a cognate of the English word *right*). But this cannot be accomplished by human beings alone. So priests turn to the gods through ritual, and especially through fire sacrifice (*yajna*), the central preoccupation of the Vedas.

In Europe and the United States, most of us see calling order out of chaos as a political task to be undertaken by secular means: a democratic republic, perhaps, or a constitutional monarchy. But for most of human history creating and sustaining order has been a religious burden. Confucianism shares with Vedic religion the conviction that ritual is the glue that holds society together. But in the Chinese context rituals have been more secular and interpersonal—between rulers and subjects, parents and children. Here the transactions are between humans and gods. And fire sacrifice *is* transactional. Priests, who serve as Vedic religion's exemplars, feed the gods with animals, milk, grains, and other plants (including the intoxicant soma) in exchange for order and all that sustains it, including sons and cows and bountiful harvests and victories in war. Echoes of Vedic sacrifice can be heard today in the sacred fires that continue to burn in Hindu temples worldwide, in the *arati* ritual in which devotees wave a lighted lamp before a divine image, in marriage ceremonies where vows are always taken before a sacred fire, and in the practice of cremation, in which the impure corpse is offered to the gods for purification.

Hinduism's controversial system of caste may also have its origins in Vedic sacrifice. According to the Rig Veda's "Hymn of the Primeval Man," the world first appeared at the beginning of time when a Primeval Man (*purusha*) was offered to the gods as a sacrifice. Out of this dismembered corpse came horses, cows, and other animals, and the hymns and mantras of the Vedas themselves. From its mind came the moon, from its eyes the sun, from

its breath the wind, from its head the sky, and from its feet the earth, setting the cosmos in order. But this primeval sacrifice set society in order too. Its mouth became the priestly caste (*Brahmin*); its arms the warriors (*Kshatriya*); its thighs the merchants (*Vaishya*); and its feet the servants (*Shudra*).

In the polytheistic world of the Vedas, we find gods associated with the earth, sun, sky, water, wind, storms, and other forces of nature; gods associated with such principles as order and duty and such hopes as health and good fortune; and goddesses of night, dawn, sacred speech, and rivers. Vishnu is a minor Vedic deity, as is the mountain god Rudra, who will later metamorphose into Shiva. There is no single high god in Vedic religion, but the most important are Agni and Indra.

Agni is the god of fire (the English word *ignite* is a cognate) but in keeping with the ancient Indian theme of multiplicity, he is also associated with sacrifice, the sun, the sacred cow, and the inner fire in the belly (*tapas*) that will later be employed by renouncers but here is tied to sacrifice. Because fire rituals are viewed as transmissions between earth and heaven, Agni is, like Eshu in Yoruba religion, a messenger. And because these rituals take place in private homes as well as public places, he is also the god of hearth and home.

Indra, the god of war and weather (especially bad weather) is after Agni the most important in the Vedic pantheon. A stern rebuke to the Western presumption that gods, like Miss America candidates, must be models of virtue, Indra is, according to one scholar, "a ruffian from birth, an unfilial son, a lecherous youth, and a gluttonous, drunken, and boastful adult."[11] Huge, hard-drinking, hard-charging, and possessed of both Superman-style strength and NFL-style bravado, Indra is a take-no-prisoners warrior whose ingestion of the bottled courage of soma (both an intoxicant and a god) makes him fearless, and reckless, in battle. Although Indra's influence diminishes as Hinduism evolves, he puts in an appearance in the Bhagavad Gita as the father of the warrior Arjuna.

There is much controversy, with huge political implications, about how Hinduism per se emerges out of its Indus Valley and Vedic foundations. We know that Sanskrit, the language of the Vedas, is an Indo-European language that shares much with other members of the Indo-European family, including Greek, Latin, German, French, Spanish, and English. For example, *deva*, the Sanskrit term for god, is related to the English term *divine*, to *deus* in Latin, to *theos* in Greek, and even to the Greek high god Zeus himself, who shares with Indra (and Vajrayana Buddhism to come) a fancy for the thunderbolt. But we do not know where the Indo-European language family originated.

What is known is that Dravidian-speaking Indus Valley civilization abruptly gives way around 1500 B.C.E. to Aryan civilization, the Sanskrit language, and Vedic religion. Global shifts in climate may have played a part in the demise of Indus Valley civilization, but the traditional theory is that a people calling themselves Aryans ("Noble Ones") came across modern-day Afghanistan and conquered northern India by force. Other Aryans then moved into Iran and still others into Europe, taking their languages with them. This theory explains the linguistic parallels between Sanskrit, Persian, and many ancient and modern European languages. It also explains the importance in the Vedas of horses, animals notably absent from Indus Valley civilization yet very much a part of the Central Asian cultures of the time. But this "Aryan invasion" theory, advanced by Europeans as early as the nineteenth century, has come under sharp attack by champions of *Hindutva* (Hinduness), who view India as a "Hindu nation" rather than a secular state. Their theory says that Aryan culture was indigenous to the Indian subcontinent—there is an unbroken line of development from Indus Valley civilization to Aryan civilization to Vedic religion to Hinduism. Hinduism, in this view, is home grown and the homeland of the Indo-European language family is not modern-day Turkey but the Ganges plains.

Philosophical Hinduism

Though there may be continuities between Indus Valley civilization and Vedic religion, and there are certainly continuities between Vedic religion and Hinduism, Hinduism is a new religious creation—at least as different from its predecessors as Islam is from Christianity and Judaism. In philosophical Hinduism, the third layer in Hindu geology, some gods carry over from Vedic religion, but many new gods emerge, and gods that were once central become marginal, and vice versa. Ritual takes a backseat to philosophy, and mystics replace priests as the religious exemplars. The practical spirit of the world-affirming Vedas yields to a preoccupation with the afterlife. Most important, the central religious problem shifts from social and cosmic disorder to something far more familial and individualistic: the nature and destiny of the human soul.

The modern novel is obsessed with the self, more specifically with the problem of authenticity. In classics from *Don Quixote* to *The Catcher in the Rye* the hero is not the person who commands great armies or gathers great wealth but he (and, increasingly, she) who avoids the fate of the fake and the phony. But this is heroic only because it is so difficult. Today young people and adults in both Europe and the United States shuffle from day to day and year to year imprisoned in roles assigned to them by families, friends, and employers. But who am I really? What is my true self?

The Danish nuclear physicist Niels Bohr once wrote, "I go into the Upanishads to ask questions," and the Upanishads, the midwife birthing early Hinduism out of Vedic religion, ask these questions with even more urgency than Don Quixote or Holden Caulfield. Often ignoring and sometimes attacking the ritual obsessions of the Vedas, Hinduism's homeless sages preoccupied themselves with philosophy instead. As they wandered across the belly of India, they wrestled with great questions of life and death, creation

and destruction, and often with an individualistic twist. How did I come to be born? What happens when I die? What is my relationship with Ultimate Reality?

A product of the Axial Age, the Upanishads were compiled beginning in the sixth century B.C.E., a period of astounding religious creativity that gave the world not only Hinduism but also Buddhism and Jainism, Greek philosophy and the Hebrew prophets, Confucius and Laozi. The Upanishads introduced concepts such as karma and reincarnation that we now recognize as common coin not only of the Hindu tradition but also of human civilization. Philosophical Hinduism also introduced various meditative and yogic techniques designed to awaken liberating insight in practitioners willing to withdraw from the world into lives of celibacy and other austerities. These mystics, known as renouncers (*sannyasins*), became Hinduism's earliest exemplars. Although Hinduism now recognizes dharma (duty), artha (power), and kama (sensual pleasure) as legitimate aims of life, these renouncers saw moksha as the *summum bonum*, and turned their backs on wealth and power and sex and everything else that makes modern Western democracies tick. Convinced that the path to liberating wisdom was an extraordinary path requiring extraordinary means, these renouncers walked this path as *former* householders, leaving behind spouses and children and jobs in order to pursue moksha full-time.

There is a Jewish tradition of mourning for apostates—sitting shivah for them for seven days as if they were actually dead. In the Hindu tradition, renouncers die socially too. Their marriages are legally terminated, they no longer answer to their birth names, and the possessions they abandon as they go on their spiritual quest are distributed to their heirs. But what really distinguishes these renouncers from the priests who exemplified Vedic religion is not just their withdrawal from the dharma world of work and family but also their withdrawal from the karma world of fire and sacrifice. While Vedic priests trafficked in karma, or action, these new exemplars focused on jnana, or wisdom. Whereas Vedic religion

was a tradition of priests performing fire sacrifices in order to keep chaos at bay, early Hinduism was a tradition of renouncers cultivating knowledge in order to liberate themselves from samsara.

Some renouncers rejected the Vedas outright, but most did not. In keeping with Hinduism's absorptive sensibility, they reinterpreted Vedic sacrifice instead. Focusing on this ritual's inner meaning rather than its outer performance, they asserted that fire sacrifice happens not just on an altar but inside us too. They referred to their ascetic austerities as *tapas*, which means heat, and they came to believe that they could carry this sacred fire inside them wherever they went. And where they went was far and wide, wandering homeless and alone, never staying long in any one village except during the four months of the monsoon, subsisting (barely) at the margins of society, sleeping in mountain caves and at river banks, accomplishing nothing other than their own austerities, seeking nothing less than spiritual liberation.

These renouncers referred to themselves by many names: *sadhus* (holy men), *shramanas* (strivers), *munis* (silent ones), *parivrajakas* (wanderers), *bhikshus* (beggars). As a rule, they were homeless and celibate and begged for food. Some took vows of silence. Today the most notorious are the Nagas ("Naked Ones") who clothe themselves in nothing more than the ashes of cremation grounds. But the most audacious are the Aghoris, devotees of Shiva who have been known to eat excrement, drink urine, and use human skulls as begging bowls. All this was catnip to nineteenth-century missionaries and ship captains who saw in these practices further evidence of the superiority of Christianity to the inanities of "Hindooism." But these renouncers knew what they were doing: smashing social taboos in order to experience the mystical reality of nondual awareness. If everything is one, what is the difference between following social conventions and breaking them?

Together these renouncers gave the world a new understanding of the human being and a new diagnosis of the human problem. Because they were philosophers, everything turned for them on foolishness and wisdom. The problem was no longer chaos but

samsara. What got us into this mess was *avidya* (ignorance), so what would get us out would have to be *jnana* (wisdom).

This wisdom begins with the fact that we humans are essentially spiritual. Inside each of us, these philosophical Hindus argued, there is an unchanging and eternal soul. And we are that soul. But our souls are trapped in the prisons of our bodies and in the illusions (*maya*) these bodies are forever conjuring up. As long as we inhabit flesh and bones, we are destined to suffer. Yet death offers no release either because, after we die, we will be reborn in other bodies and repeat again and again the sorrowful cycle of life, death, and rebirth.

Whereas Vedic sacrifice was fueled by fire, this cycle is fueled by karma (literally, "action"), which used to refer largely to ritual action but refers here to moral action and its consequences. In the ethical monotheisms of Judaism, Christianity, and Islam, human beings are rewarded and punished for their good and bad deeds by a good and just God. In Hinduism, however, consequences follow from actions without any supernatural intervention. Just as, according to the law of gravity, what is dropped from a tree will fall to the ground, according to the law of karma, evil actions produce punishments and good actions produce rewards. Karmic law explains why human beings keep migrating from death to life and back again. When you die, you die with a combination of good and bad karma—*punya* (merit) and *papa* (demerit). If that were the end of it, however, justice would not be upheld, because there would still be good actions awaiting reward and bad actions awaiting punishment. Therefore you must be reborn into another body, and the cycle of samsara continues apace. The circumstances into which each of us is born, therefore, have nothing to do with luck. They are a result of the good and bad actions we took in our prior lives. Or, as the Shvetashvatara Upanishad puts it, we wander in the cycle of transmigration according to our deeds (5:7).

To end this wandering is moksha—liberation from ignorance, karma, and rebirth alike. But how to achieve this goal? According to philosophical Hinduism, moksha came not through the external

revelation of the Vedas but from within, not by the secondhand ministrations of priests but through your own efforts and by your own experience. But renouncers were not left entirely to their own devices. They accepted guidance from gurus. In fact, they insisted on it. The main method for the transmission of learning in early Hinduism was from guru to student. But what these gurus transmitted was not so much knowledge itself as techniques for arriving at that knowledge on your own.

Yoga is now a popular pastime in the West, employed by millions for such thisworldly aims as stress reduction and weight loss. But yoga in its original sense of discipline means "to yoke" one thing to another, and the things being yoked in the yogas practiced by philosophical Hindus were the self and reality, the self and divinity, the self and immortality. The secret knowledge that gurus whispered to those who sat at their feet was how to use body and breath to transport yourself from ignorance to wisdom, from illusion to reality, from humanity to divinity, from samsara to moksha.

Around the time the Upanishads were taking shape, Socrates gave the world his famous Allegory of the Cave: People imprisoned in this cave see only shadows cast on a wall before them, so they are forever mistaking appearance for reality. The renouncers of early Hinduism made a similar observation: the world is not as we see it; we are not who we think we are. Every day, we look at ourselves and the world through a veil of illusion called maya. To be wise is to lift that veil, to see self and world not as they seem to be but as they really are. And how they really are is one. Yes, human beings appear to be different from divinity, but appearances can be deceiving, and here they most certainly are, because once you drill down past the inauthentic to the authentic—past caste and job and gender and race and ethnicity and nationality and language group and height and weight and name and birth date and serial number—you will see that you, too, are divine. Our sense of separateness from God is but a shadow cast on the wall of the cave. The sacred is inside us. The essence of the human being is the same as the essence of divinity.

Hindus refer to the essence of the human being as *Atman*, which is typically translated as "self" or "soul." The essence of divinity they refer to as *Brahman*. And the liberating wisdom of Hindus who walk this jnana path is as simple and complicated as this: The individual soul is divine. The essence of each of us is uncreated, deathless, and immortal. Atman and Brahman are one and the same.

To know this is to achieve moksha. But it is not enough to believe in the Atman-Brahman equivalence. You must experience it. Neither book learning nor secondhand transmission will do. Shankara (788–820), considered by many to be the greatest Hindu philosopher, was emphatic on this point. Ritual cannot get you to moksha, he argued, but neither can yoga or philosophy or good works or scriptural study. "When a man has been bitten by the snake of ignorance he can only be cured by the realization of Brahman," he wrote. "A sickness is not cured by saying the word 'medicine.' You must take the medicine. Liberation does not come by merely saying the word 'Brahman.' Brahman must be actually experienced."[12]

In one of the Upanishads' most famous stories, a boy named Svetaketu has just returned home after years of studying the Vedas at the feet of his guru. He is an A+ student, filled to the brim with book learning, and proud of it. But his father, Uddalaka, is not so easily impressed. Have you ever pondered, he asks Svetaketu, how to "hear what cannot be heard . . . perceive what cannot be perceived . . . know what cannot be known?" But Svetaketu's training has taught him nothing of such mysteries. So one evening Uddalaka gives his son some salt and tells him to put it in a container of water. The next morning he asks his son to give him back the salt. But the salt has dissolved in the water. So Uddalaka tells him to taste the water. "How is it?" his father asks. "It is salty," the son replies. Atman and Brahman, the father says, are like that salt and that water.[13]

This dialogue concludes with one of the most famous quotations of philosophical Hinduism. "*Tat tvam asi*," the father tells his son: "You are that." Precisely what this simple formula means is, like

so many things in Hinduism, up for grabs. Clearly, Uddalaka is equating Atman and Brahman. But what does this mean? Some believe it means that Atman and Brahman are identical—the essence of the human being is the same as the essence of God. Others claim that Brahman and Atman are different but indivisible. There is no disagreement, however, about the importance of attaining this liberating wisdom by experience. In this classic story, the son does not just sit at the feet of his father. He tastes the water, and the salt, for himself.[14]

Devotional Hinduism

If you are confused at this point, you are not alone. This third geological layer of philosophical Hinduism is rock hard—both difficult to practice and difficult to understand. It requires extraordinary austerities and extraordinary insight. Historically, most renouncers have come from the upper castes, and almost all have been men. But what about the rest of us? By doing our duty both morally and ritually, we can accumulate good karma so that one day we might be reborn into circumstances conducive to a life of renunciation and release. But in the meantime the ultimate goal of moksha is out of reach. All we can hope for is the proximate goal of a better rebirth.

As Hinduism developed, ordinary people decided that this was not enough. Women and lower-caste men wanted to reach out and grab the brass ring of moksha. They wanted it in this lifetime, and they did not want to be forced to give up families and friends, sex and success to get it. So beginning around the time of Jesus, Hinduism moved in a more popular direction referred to today as *bhakti yoga* or the discipline of devotion. The quest for spiritual liberation shifted from a one-man drama of utmost seriousness to a playful musical with a colorful cast of thousands, and devotional Hinduism was born.

While the jnana-style Hinduism of the philosophers was ex-

pressed in Sanskrit in the difficult disputations of the Upanishads and embodied in the austerities of wandering ascetics, this fourth layer in the geology of Hinduism was expressed in vernacular songs, poems, dramas, and dances, and embodied in heartfelt worship of one's chosen deity. Instead of controlling their bodies and emotions through meditation and yoga, devotional Hindus let both bodies and emotions go. Instead of sneering at the body as a prison, they celebrated the body as a temple of their chosen god. When it comes to revelation, wrote the fifteenth-century North Indian poet Kabir, Sanskrit is like the still water of the well, while vernacular languages such as Tamil, Hindi, Bengali, and Marathi are like the living water of an everflowing stream.

Philosophical Hindus had understood God as something beyond our ken—*nirguna Brahman*, God without attributes. The only words they were willing to attach to God were *sat* (existence), *chit* (consciousness), and *ananda* (bliss). Devotional Hindus, however, happily described their chosen deities as male or female, four-armed or eight-armed, wild or mild. And they worshipped their unapologetically personal divinity—*saguna Brahman* (God with attributes)—with relish.

As if to illustrate that no religion can live by philosophy alone, devotional Hindus emphasized their tradition's narrative dimension over its doctrinal and experiential dimensions. They recited intimate poems about their overflowing love of the god of their choosing. They sang *kirtans* (devotional songs) reminiscent of the praise songs so popular today in evangelical Christian circles. And they listened to epic stories of gods and heroes, conveyed through puppeteers, folk singers, and street-corner poets. Whereas renouncers spoke of Atman and Brahman and samsara and moksha, these artists and their audiences spoke of hunting and fighting and love-making. Their ecstasies were for this world.

The ecstasies of bhakti-style worship were particularly emphasized by the Hindu reformer Caitanya (1485–1533), whose singing and dancing to Krishna live on today in the International Society of Krishna Consciousness (ISKCON, or the Hare Krishnas),

which sees Krishna not as one god among many but as the Supreme Lord of the universe. Another great figure in bhakti-style Hinduism was the seventeenth-century poet (and contemporary of Milton) Tukaram (1608–50), who gave voice to many of the great themes of this Hindu revolution in a short poem devoted to Narayana, another name for Vishnu. "I have been harassed by the world," he begins, "I am bound fast in the meshes of my past . . . I have no power, O God, to end my wanderings." After remarking on just how endless his wanderings are, he asks, "Who will finish this suffering of mine? / Who will take my burden on himself?" The answer, of course, is Narayana:

> *Thy name will carry me over the sea of this world,*
> *Thou dost run to help the distressed,*
> *Now run to me, Narayana, to me, poor and wretched as I am.*
> *Consider neither my merit nor my faults.*
> *Tukaram implores thy mercy.*[15]

As this poem demonstrates, one of the key transformations as Hinduism layered this way of devotion on top of its way of wisdom was a shift from self-help to other-help. One curiosity about early Hinduism is how little the gods were involved. Since the time of the Vedas all sorts of divinities have inhabited the Indian subcontinent. But philosophical Hinduism was functionally atheistic; while the gods existed, they were largely irrelevant to the task at hand. Moksha was something you achieved by yourself, not something handed to you from on high.

Over time, however, moksha became a product not of self-effort but of other power. In devotional Hinduism, samsara remains the problem and moksha the solution, but now the path to spiritual liberation is quicker and easier. Instead of relying on yourself, as jnana yoga practitioners did, you can get moksha through the mercy and grace of your chosen god. There is no requirement to renounce job and family and social life, or to work toward moksha for many lifetimes. As wisdom takes a backseat to love, release from the fetters

of karma comes as a gift, and it is given to men and women alike, and to people of all social ranks.

But moksha is not the only aim of this new, more egalitarian form of Hinduism. By the grace of your chosen deity, it becomes possible to win not only release from the cycle of suffering but also happiness here and now. Eminently practical and unapologetically thisworldly, devotional Hinduism addresses the full gamut of thisworldly concerns. Devotees ask their chosen gods to heal their arthritis, protect their harvest, and guide their loved ones through rites of passage—birth, marriage, childbirth, and death. The point of this world is not simply to get out of it, but to prosper in it, and your family with you.

This way of devotion is rooted in the hugely popular Mahabharata and Ramayana epics, which were in process as the Common Era began, but bhakti yoga did not spread widely until the seventh century in South India and the twelfth century in North India. Once it got traction, however, this devotional approach quickly outran the philosophical approach of the Upanishads, becoming India's most popular path to the divine.

Muslim rule came to India during the Mughal Empire of the sixteenth to nineteenth centuries, and Christian rule arrived with the British Raj of the nineteenth and twentieth centuries, but Hinduism's way of devotion outran them both. Today there are a few million renouncers in India, but there are close to a billion practitioners of bhakti yoga. The notion that God is impersonal and ineffable is now confined to the rare philosopher. For everyone else God is personal, emotional, and even erotic. Hinduism today is a way of devotion.

The Trinity: Vishnu, Shiva, Mahadevi

Although the Hindu trinity is often said to consist of Brahma (the creator), Vishnu (the sustainer), and Shiva (the destroyer), Brahma is now a marginal deity, invoked far more often than he is wor-

shipped. Like the largely irrelevant watchmaker God of the Deists, he creates the world only to sit back and watch events unfurl. So the real trinity (or *trimurti*: "three forms") is Shiva, Vishnu, and the Mahadevi ("Great Goddess"), and the three main branches of bhakti-style Hinduism are Vaishnavism (worship of Vishnu), Shaivism (worship of Shiva), and Shaktism (worship of the Great Goddess, also known as Shakti).

Vishnu is best known for his ten avatars, or incarnations—as a fish, tortoise, boar, half lion/half man, dwarf, and then (in his human embodiments) as Rama, Krishna, the Buddha, and finally Kalki, the incarnation still to come. As Krishna, Vishnu is a hero of the Mahabharata, and as Rama he is the hero of the Ramayana.

Krishna is best known (and loved) for his mischievousness. Although he is a good god, he is also a trickster who loves to play a good prank. Krishna is often paired with a paramour such as Radha but is best remembered for his erotic encounters with the *gopis*, or cowherd girls. Krishna would serenade them on his flute, and they would fall under the lure of his mischievous grin, long black locks, peacock-feathered crown, lotus eyes, and deep-blue complexion. (The word *Krishna* literally means "black" or "dark," and Krishna is typically depicted with black or deep-blue skin.) In one classic tale, Krishna steals the clothes of the gopi girls as they are bathing naked in a river and then tricks them into exposing their beautiful bodies to him. In the Hindu tradition, a woman cannot be naked in front of any man except her husband, so he fixes things by marrying them all.

Famous among worshippers of Krishna, who was expert in all of India's sixty-four arts of love and according to some accounts enjoyed the affections of over sixteen thousand wives, is the *rasa lila*, the story of Krishna dancing with his gopi girls. In Sanskrit, *rasa* means emotion and *lila* means play, so this dance is about the play of emotions or, as it is sometimes translated, the "sweet pastimes" of Krishna. The story takes place at night as the gopis, upon hearing the sweet sound of Krishna's flute, sneak out of their houses to dance the night away—a night Krishna magically stretches into

billions of years. The rasa lila is now performed throughout the Hindu world, most famously in Vrindavan, a town in North India said to be Krishna's childhood home. These performances demonstrate that the gods are playful. In fact, the cosmos itself is seen by some Hindus as a lila or game of the gods.

Most Hindus today are uncomfortable with their tradition's eroticism. Many of my Hindu students refuse to see anything sexual whatsoever about the Shiva lingam that to Western eyes at least seems to unite quite explicitly the male and female sex organs—the phallus and the yoni. But there is no denying that Hindus have long cultivated a close connection between the love that passes between human beings and the love that passes between humans and gods. The sexually explicit sculptures at North India's Khajuraho temples and the sexually explicit instructions in the Kama Sutra testify to the fact that Hindus traditionally accepted sex not only as a fact of life but also as one of life's glories. Many see Radha's love for Krishna as a symbol of the union of lover and beloved, devotee and god. Some Vaishnavas do not worship just Krishna alone but Radha Krishna, the divine union of male and female. Either way, we are to love the god of our choosing with all the passion (and at least some of the eros) that Radha and her gopis lavished on Krishna.

Shiva puts a very different face on divinity than the mischievous grin of Krishna. Shiva literally means "friendly," and in recent years Hindus have gravitated toward pictures of him as a sweet and happy child. But traditionally Shiva has been associated with divinity's wilder side—as the destroyer in the trimurti and the inheritor of the awesome powers of the Vedic god Rudra ("Roarer") whose third eye can turn anything (and anyone) to dust. A bundle of contradictions, Shiva is wrathful and loving, male and female. Sometimes referred to as an "erotic ascetic," Shiva is both a solitary Himalayan yogin, dressed in tiger skin and smothered in ashes, and a no-holds-barred lover who in one record-breaking lovemaking session has sex with his wife Parvati for a thousand years.[16]

Shiva is often depicted in the West as the multiarmed dancer,

Nataraj, who dances inside the circle of samsara, holding both the drum of creation and the fire of destruction. In Bali, where he is the most popular of the gods, he resides at the center of the five directions, reconciling opposites and sustaining the balance so highly prized in Balinese culture. Shiva also has a special relationship with Varanasi, the North Indian sacred center famous for its *ghats*, or steps, along the Ganges, some for bathing ascetics, others for cremation. Here the other power of devotional Hinduism reaches its apex, because it is said that anyone who dies in this City of Shiva achieves moksha. At the moment of death, Shiva whispers the mantra of the crossing into your ear and you are released from rebirth.

Shakti is a term for the feminine energy animating all divinities, a Hindu analog to the Yoruba concept of *ashe*—the power to make things happen. Shakti is also a name for the Mahadevi, or "Great Goddess." This goddess appears in many forms, which are often classified into the auspicious and the terrific, the mild and the wild.

On the mild side are the Mahadevi's gentler incarnations as a consort of one god or another: Parvati the consort of Shiva, Radha the consort of Krishna, and Sita the consort of Rama. Lakshmi, another mild goddess (she is often paired with Vishnu), is particularly popular. Like Ganesha, she is associated with prosperity and good luck and adorns the walls of many homes and businesses. On the wild side are the Mahadevi's incarnations as a more independent and ferocious deity: unmistakeable Kali, goddess of cremation grounds and battlefields, with her necklace of skulls and her thirst for blood, and many-weaponed Durga who rides a tiger or lion and is fierce for righteousness. Invincible Durga emerges out of the combined powers of other gods to slay the buffalo demon of chaos they cannot kill themselves. After nine nights of carnage, she saves the world from its terrors by doing just that.

The Tantric tradition, a somatic philosophy and body of rituals (some sexual) that since the arrival of British prudery has served largely as an embarrassment to ordinary Hindus, typically worships the goddess Shakti. It sees the cosmos as a field for the

creative play of Shiva and Shakti and uses a variety of techniques (mantras, mandalas, and various meditative strategies, visualization techniques, and sexual rites, both real and imagined) to seek after spiritual liberation and thisworldly power. This hugely influential tradition is still a powerful force today not only in India but also in Tibet and Nepal and throughout East and Southeast Asia. Some revisionist scholars see it as the master key to unlocking the secrets of the Hindu tradition.[17]

Puja

Today Hinduism is best known in the West not via Vishnu, Shiva, and the Mahadevi but via yoga, which now seems to be on offer at almost every other street corner in cities from San Francisco to Paris to Berlin. In fact, much of what most Americans and Europeans know of Hinduism they have learned from their yoga teacher's impromptu comments on karma and reincarnation, Atman and Brahman. Hardly any of my Hindu students do yoga, however. What they do is go on pilgrimages to sacred cities, rivers, and mountains, and to places associated with the exploits of their chosen gods. As devotional Hindus, they also observe festivals, which, like the gods themselves, come in local and pan-Hindu varieties. Some of the biggest are Diwali, a festival of lights, and Holi, a spring festival of reversal when people of all ages and stations in life douse one another with water and colored powder. "My karma ran over my dogma," reads a bumper sticker popular among the "spiritual but not religious" set. That isn't quite how Hindus would put it, but in Hinduism doing your duty does take precedence over knowing your dogma, and right ritual (orthopraxy) is more important than right doctrine (orthodoxy).

The central ritual practice of my Hindu students, and of devotional Hindus worldwide, is puja. Like Vedic sacrifice, puja involves a food offering. In Vedic times animals were sacrificed, but today the offerings are usually vegetarian. If these offerings are made in

a temple, they are typically mediated by a priest. But they can also be given by ordinary people at a home shrine, with oil lamps and incense sticks lit in front of an icon.

The offering has been elevated to an art form in Bali, where *canang sari*, as they are called, can be seen almost everywhere—from hotel lobbies and shops to taxicabs and even motor scooters. These elegant offerings usually start with a four-sided palm-leaf basket, which is then adorned with flowers, rice, and a slice of banana or sugar cane. As they are strategically placed to align with the five sacred directions (north, east, south, west, and center), an incense stick is lit across the top, and the offerings are splashed with holy water. All this is a gift, a free expression of love to a given god. But it is also an exchange. Those who bring an offering to a temple take home with them *prasada*—the rice, fruit, sweets, and flowers offered by others to the gods and now offered by the gods (without regard to caste) back to worshippers. Devotees also hope to receive merit in return. "If one disciple soul proffers to me with bhakti a leaf, a flower, fruit, or water, I accept this offering of love from him," says Krishna in the Bhagavad Gita. "Whatever you do, or eat, or offer, or give, or mortify, make it an offering to me, and I shall undo the bonds of karma."

Religious rituals typically engage a wide range of the senses—the bells and smells of a Greek Orthodox Mass, the tastes of the Sikh langar meal. Hinduism engages the senses with all the subtlety of a professional wrestling match. Incense infuses the air. Brides sport bright red saris. Images of the gods are a riot of primary colors. Worshippers ring bells as they enter and exit temples, which ring out themselves in a cacophony of sacred mantras and profane chatter. In Balinese Hinduism each of the main gods is associated with both a cardinal direction and a color: Vishnu, north, black; Ishwara (another name for Shiva, but here a distinct god), east, white; Brahma, south, red; Mahadevi, west, yellow; with multicolored Shiva lording over the center. If you had to name a religion whose aesthetic diverged the farthest from Quaker simplicity, Hinduism would be it.

Hindu worship, however, is first and foremost about sight. Whereas Protestants go to church to hear the gospel reading and the sermon, Hindus go to temple to see and be seen—to gaze at their beloved gods and to be gazed at lovingly in return. Worshippers build up to this key moment in puja by circumambulating the temple itself and then the image of their god. Only then do they take *darshan* by engaging their deity in an intimate, eye-to-eye encounter. "When Hindus go to a temple, they do not commonly say, 'I am going to worship,' but rather, 'I am going for *darsan*,'" writes Harvard professor Diana Eck in her book on this "religious seeing." Not without reason have Eck and others referred to *darshan* as "the central act of Hindu worship."[18]

Hindu Storytelling: The Mahabharata

As much as ritual, however, devotional Hinduism is about stories. In fact, just as story and law are two sides of the same coin in Judaism, story and ritual are integrated in Hinduism. At Passover, Jews listen to the Exodus story and reenact it; in Hinduism's *Vrat Katha* tradition, Hindus listen to a story of a fast and then vow to fast themselves.

The key repositories of Hindu stories are the Mahabharata and the Ramayana. Although these epics are technically classified as *smrti*, and are therefore supposedly of secondary importance (to *sruti*), they are actually more influential among devotional Hindus than the Vedas. Classically, these stories, which take place in mythic time, have been handed down orally through parents or gurus or dancers or singers or puppeteers. Nowadays young people also learn them through comic books, television, or the Internet. When I was living in India in the late 1980s, almost everyone who had access to a television seemed glued to it each afternoon as a lavishly produced Hindi miniseries on the Mahabharata unfurled over ninety-four episodes.

The Bible has been billed as "The Greatest Story Ever Told,"

but the Mahabharata, which means "Great India," is at least as dramatic and far, far longer. At one hundred thousand verses and roughly 1.8 million words, it dwarfs the Bible, the *Iliad*, and the *Odyssey* combined. But the Mahabharata is also remarkable for its longevity. Composed between 400 B.C.E. and 400 C.E., the Mahabharata has been popular entertainment for roughly two millennia. Its scenes were carved into reliefs at Angkor Wat in Cambodia in the twelfth century, and in 1985 Royal Shakespeare Company director Peter Brook produced a nine-hour-long stage version that toured the world for four years to rave reviews before finding a second life in 1989 as a six-hour miniseries.

Duty is the Mahabharata's central preoccupation, but drama is its draw. Its scenes are the stuff of Shakespeare's plays and America's soap operas, combining heroism and holiness with betrayal, lechery, murder, adultery, and lust for both body and blood—all on a stage where gods and humans walked the same Earth.

The Mahabharata tells the story of a family feud that makes the troubles of *West Side Story* and *Romeo and Juliet* look like child's play. On the one hand there are the righteous sons of King Pandu, the Pandavas; and on the other there are the evil sons of a blind king, Dhritarashtra, the Kauravas. Both clans are descended from a king called Bharata (a term used today to refer to India itself). The start of this epic concerns the winning, losing, and dividing of a kingdom, but the first major plot point comes when the Kauravas win this kingdom in a dice game. As a result, the Pandavas are set to wandering, but it is agreed they can return after thirteen years to reclaim their kingdom from their cousins. Upon their return, however, the unrighteous Kauravas go back on their word. So a battle ensues that puts the charioteering of *Ben Hur* to shame. The deus ex machina arrives in the form of Krishna, who takes the side of the righteous Pandavas, who after eighteen days of carnage win a great victory.

Today the most beloved portion of the Mahabharata is the Bhagavad Gita ("Sacred Song"), a dialogue on the ethics of war that since the nineteenth century has functioned like something of

a Hindu New Testament—the Hindu holy book par excellence.
The central problematic of the Gita, as it is popularly known, is
dharma, a Sanskrit term variously translated as duty, law, justice,
truth, order, righteousness, virtue, ethics, and even religion. The
root of the word *dharma* is the Sanskrit term *dhr*, which means
hold or support, so dharma is whatever upholds cosmic order and
supports what is right.

The Gita gets going just as the bloodletting in the Mahabharata
is about to begin. As Arjuna of the Pandava clan approaches the
battlefield, a crisis of conscience comes over him. The householder
tradition of caste says it is Arjuna's duty to fight. He is, after all, a
Kshatriya (warrior). But householder ethics tells him not to kill his
kinsmen, and he knows that if he goes into battle, he will kill them
by the score. What is a dutiful Hindu to do?

In the Gita, Arjuna seems to be talking with his charioteer, but
his charioteer turns out to be Krishna in disguise. In this discussion
two great tectonic plates in Hindu history start to rub against each
other. Krishna offers a creative new synthesis of the devotional tra-
ditions of the householder and the philosophical traditions of the
renouncer—a synthesis that would determine the shape of popu-
lar Hinduism from this moment forward. Do your dharma and
fight, he tells Arjuna, but act without attachment to the fruits of
your actions. Renounce any desire for reward. Fear no punishment.
Devote your actions and their consequences alike to God. And re-
member that even the fiercest warrior cannot actually kill anyone,
since we are not our perishable bodies but our immortal souls.

As this dialogue continues, Krishna lays out for the first time
Hinduism's three different paths to moksha. In addition to the
karma yoga of ritual and ethical action (the sacrificial religion of
Vedic religion) and the jnana yoga of asceticism and renunciation
(the philosophical religion of early Hinduism), there is now a third
option: the bhakti yoga of love and grace (the devotional religion
of popular Hinduism). It is now possible to achieve the religious
goal of moksha by other power rather than self-effort, by entrust-
ing the fruits of your actions to the grace of God. "In whatever way

people approach me," Krishna tells Arjuna, "in that way I show them favor."

There are as many ways to read the Gita as there are ways to read the gospel of Mark or the book of Job. Most Hindus read it as a spiritual allegory of sorts. Like those Muslims who understand the concept of jihad to refer not to the outer struggle against flesh-and-blood enemies but to the inner struggle against spiritual temptations, most Hindus understand the lessons of the Gita to be spiritual rather than military (or even ethical): the real struggle is not for kingdoms and cash but for the liberation of your soul. Reformation-era Protestants championed the "priesthood of all believers." Everyone, they argued, is a priest. The Gita also blurred the distinction between householders and renouncers. We can all be renouncers of a sort, it argued—even women, servants, and outcastes. It was no longer necessary to choose between doing your duty and pursuing spiritual liberation. It was now possible to have both.

Hindu Storytelling: The Ramayana

Almost as popular as the Mahabharata is the Ramayana ("Story of Rama"). Here the central themes are more personal—not war and heroism and fidelity to the ethics of caste but love and longing and fidelity to the ethics of marriage. The Ramayana, which probably came into its current form between 200 B.C.E. and 200 C.E., extends to seven books and twenty-four thousand verses, making it far shorter than the Mahabharata but still about twice as long as the New Testament.

This scripture tells the story of a demon, a kidnapping, and the trials and tribulations of a virtuous prince named Rama and his faithful wife, Sita. The action begins when Rama's father banishes him on the eve of his coronation to fourteen years of wandering in the forest. There Sita (who insists on accompanying her husband into exile) is captured by the ten-headed demon king, Ravana, and

stolen away to his home in Lanka (now Sri Lanka), only to be freed through the cunning of the monkey god, Hanuman (who builds a bridge from India to Sri Lanka), the assistance of Rama's brother, Lakshmana, and the courage of Rama himself, who kills Ravana in battle. But this is not the end of the story, because no sooner is Sita liberated than Rama banishes her on suspicions of adultery. Sita in turn throws herself onto a funeral pyre but, like the burning bush of the Bible, she is not consumed, because Agni, the god of fire, knows she is innocent. So Rama and Sita are reconciled, and together they return to Ayodhya, where Rama reigns as king. But this is not the end of the story either, because after Sita becomes pregnant, Rama (who apparently has some trust issues) becomes suspicious once again, worrying this time that her offspring may not be his. So again he banishes Sita, who gives birth to twin boys at the hermitage of the poet seer Valmiki, to whom the Ramayana is traditionally ascribed. When the twin sons grow up, all can see that they are the spitting image of Rama, so innocent Sita is once again called home. This time Sita refuses, however, disappearing into the earth. As for Rama, he gives his earthly kingship to his sons and assumes his rightful place in the cosmos as the seventh incarnation of Vishnu.

Because it is revered not only by Hindus but also by Jains, Buddhists, and even Muslims, the Ramayana stands alongside the Bible, the Quran, and the Analects of Confucius as one of the four most influential books ever written. Originally told in Sanskrit, it has been retold over the centuries in many different languages and from many different perspectives. The *Sitayana*, for example, tells the tale from Sita's perspective, and *Sita Sings the Blues*, a humorous full-length animated feature film with a 1920s jazz music score, bills itself as "The Greatest Break-up Story Ever Told."[19] Diwali, the pan-Indian festival of lights, celebrates Rama's return to rule in the kingdom of Ayodhya. And one of India's greatest spectacles is the *Ram Lila*, a weeklong performance of the Ramayana staged annually in Ramnagar ("Rama's City") across the river from Varanasi. Like the Mahabharata, this story has been a magnet for alle-

gorical interpretations. Many Hindus see Sita as the soul captured by the body (Ravana) only to be rescued by God (Rama).

In 1987 and 1988, a Hindi version of the Ramayana was serialized in seventy-eight television episodes in India, and "Ramayana fever" afflicted some hundred million viewers. The success of this series led to a remake, also in Hindi, in 2008 and 2009. A more modest and condensed English-language version of this "spiritual tale of romance," billed as a cross between the *Odyssey, Romeo and Juliet*, and *Star Wars*, took to the stage in 2001 at the National Theatre in London.[20] And in 2006 Virgin Comics debuted a comic book series called *Ramayan 3392 A.D.* billed as "the greatest legend relived—a saga of duty, bravery, loyalty, revenge, and redemption."

In the Mahabharata and Ramayana and their contemporary retellings, we see the playfulness of Krishna and the bravery of Rama, but we also see the Hindu sensibility at work—its preference for stories over dogmas, its reveling in mystery and paradox, and its aversion to fixed boundaries and settled borders. At least for those who grew up under the impress of the Western monotheisms, the porous borderland in these stories between the animal, human, and divine worlds is striking. It is often remarked that Hinduism divinizes human beings, but as the epics demonstrate it also humanizes the gods. In Hindu temples and scriptures, we are miles away from the transcendent God of Judaism, Christianity, and Islam, who may have desires but is a stranger to need. Hindu deities are more like us. In this tradition, human beings need the gods, and the gods need human beings.

Modern Hinduism

The last layer in Hinduism's geology begins as a response to British and American criticisms of Hinduism as idolatrous and polytheistic—"a vast museum of idols," in Mark Twain's words, "and all of them crude misshapen, and ugly."[21] The British arrived in India in 1757 via the ministrations of the East India Company and

stayed for almost two centuries, until Indian independence in 1947. Modern Hinduism bent Hinduism's bhakti path in the direction of the Western monotheisms, and especially toward Anglo-American Protestantism. It also brought Hinduism into conversation with the Enlightenment—with science and reason, liberty and equality. Focusing more on the Upanishads than the epics, this movement accented the ethical and doctrinal dimensions of the religion over its ritual and narrative dimensions. In keeping with the ways and means of Victorianism, it downplayed Hindu eroticism, all but purging the tradition of Tantrism and creating generations of Hindus (including many of my students) who see nothing sexual in the phallus and yoni of the Shiva lingam. Modern Hinduism also aimed to undercut Christian missions by positioning Hinduism as a world religion equal (or superior) to Christianity. Also referred to as the Indian Renaissance, this movement had two main impulses, both visible in Indian religion and politics today.

The first impulse emphasized the unity of all religions. Its key figure was Ram Mohan Roy (1772–1833), a Brahmin from Bengal whose studies at a Muslim university and employment with the East India Company had familiarized him with Sufism, Unitarianism, and Deism. Under the auspices of the Brahmo Samaj, which he founded in Calcutta in 1828, Roy rejected bhakti-style polytheism as irrational and puja as "idol worship." There is only one God, he argued, and that God is beyond description. Therefore, no one religion has a monopoly on religious truth. All religions are flawed human efforts to capture the elusive divine. In ethics, Roy and the Brahmo Samaj argued against caste, child marriage, and widow burning. They even rejected karma and reincarnation as affronts to rationality and impediments to social reform.

Another modern Hindu multiculturalist was Ramakrishna (1836–86), who pushed the unity of all religions beyond theory to practice. Like Roy, Ramakrishna was a Brahmin from Bengal, but his interests ran to mysticism more than social ethics. Ramakrishna began his spiritual life as a Kali devotee. He later had visions of Krishna and Jesus and practiced his own versions of Christianity

and Islam. While reason had convinced Roy of the unity of all re-
ligions, for Ramakrishna it was experience. He knew all religions
were different paths up the same mountain because he had traveled
those paths himself and seen with his own eyes that each converges
at the same peak.

Ramakrishna's most famous pupil, Swami Vivekananda (1863–
1902) came to the United States as a representative at the World's
Parliament of Religions, held in Chicago in 1893. There he spoke
against Christian missions and for the unity of religions with a
combination of learning and humor (not to mention an elegant
Irish brogue picked up at missionary school) that shocked and de-
lighted his American audiences. He also spoke of Hinduism as a
world religion deserving of the same respect as Judaism and Chris-
tianity. In 1894 in New York City he established the Vedanta Soci-
ety, which in the early twentieth century was the largest and most
influential Hindu organization in the United States.

All of these men were influenced by Hinduism's Advaita Ve-
danta philosophy, whose emphasis on the one over the many led
them, first, to collapse Hinduism's many gods into one Brahman
and, then, to collapse the world's many religions into one religion.
Their influence can be seen today in best-selling books on religion
by Huston Smith and Karen Armstrong.

A second impulse of the Indian Renaissance had a very differ-
ent vision of India's religious character. Here the key figure was
Dayananda Saraswati (1824–83), who was born into a Brahmin
family in Gujarat and raised a Shaivite. Skepticism about the pro-
priety of worshipping the Shiva linga launched him, first, into life
as a sadhu and, later, a career as a Hindu reformer—the "Martin
Luther of India."[22] Through the Arya Samaj, which he established
in Bombay in 1875, he joined Roy and Ramakrishna in champi-
oning monotheism. But his distinctive emphasis was on purify-
ing Hinduism by returning to the Vedas. He rejected the epics as
myths and scorned popular practices such as puja and pilgrimage
as superstitious. Saraswati matters today because of his aggressive
nationalism. While Roy and Ramakrishna championed the unity

of all religions, and did so in English, Saraswati attacked Christianity and Islam and championed Hindi as the national language.

Hinduism Today

When I was in college and graduate school, my professors told me that Hinduism was a tolerant faith, ever absorbing foreign religious influences rather than seeking to exterminate them. It was this tradition, I was told, that gave us the maxim "Truth is one, the sages call it by different names." And its greatest exemplar was Mohandas Gandhi (1869–1948), who in the spirit of Roy, Ramakrishna, and Vivekananda labored not only for Indian independence but also for a multireligious India of Hindus and Muslims and Christians and more.

In addition to these multiculturalists, however, Hinduism has its militants—heirs not of Gandhi but of Saraswati. Critics call them fundamentalists, and Indian youth now call them "fundos." They call themselves champions of Hindutva ("Hinduness") who see India not as a multireligious nation but as a Hindu state that should be governed in the Hindi language and in keeping with Hindu beliefs and practices.

Giving the lie to the observation of American Transcendentalist Henry David Thoreau that "there is no touch of sectarianism" in Hinduism, these Hindu nationalists are sectarian to the core. Like America's Moral Majority, a largely Protestant group that tried to reach out to Catholics and Jews, Hindutva advocates claim to represent not only Hindus but also Jains, Sikhs, and Buddhists. But there is no doubting their opposition both to the secular values of India's Congress Party and to the Islamic values of India's Muslim minority, who from the Hindutva perspective are the illegitimate heirs of foreign invaders of the Hindu holy land.

Political Hinduism of this right-wing sort goes back to Saraswati and the Arya Samaj, but it did not become a force in Indian politics until the 1980s. Today this marriage of nationalism and

fundamentalism, often advanced in the name of Rama and at the expense of Muslims, Christians, and secularists alike, is represented by groups such as the RSS, or Rashtriya Svayamsevak Sangh (est. 1925), the VHP, or Vishva Hindu Parishad (est. 1964), and the BJP, or Bharatiya Janata Party (est. 1980). The BJP ran India's central government at the turn of the twenty-first century and remains a major force in Indian politics at both the national and state levels.

Although Hindu nationalism was not manufactured for export, it has found a foothold in both Europe and the United States, notably in some American chapters of the Hindu Students Association. In Sri Lanka, Hindu and Christian Tamils employed suicide bombers in a decades-long civil war that ravaged this island nation for over a quarter century beginning in 1983. But for the most part Hindus in the diaspora gravitate toward the multicultural impulse of modern Hinduism now associated first and foremost with Gandhi. If we divide contemporary Hindus, as sociologist of religion Prema Kurien has done, into "militant nationalists" and "genteel multiculturalists," almost all of my Boston University students fall into the latter camp.[23]

Hindus gained a foothold in the diaspora through organizations such as Vivekananda's Vedanta Society and the Self-Realization Fellowship of Swami Yogananda, whose *Autobiography of a Yogi* (1946) became a countercultural hit in the 1960s. Their religion first became visible in the West through the charismatic gurus who flocked to Europe and the United States in the 1960s and 1970s. Today it has set up shop in yoga studies throughout the West. Nonetheless, the heart and soul of Western Hinduism resides in the temples dedicated to Vishnu, Shiva, the Great Goddess, and Ganesh that now punctuate the skylines of almost all European and American cities. In these temples, the ancient beliefs and practices of India continue to push up through the various geological layers we call Hinduism, and devotees continue to call on the gods of their choosing to bring them happiness in this life and release from samsara in the world beyond.

Buddhism

THE WAY OF AWAKENING

Buddhism begins with a fairy tale. Unlike *Cinderella* or *Rocky*, however, this is no underdog fantasy of someone who has nothing and gains the whole world. In fact it is just the opposite—a story of someone who has everything and decides to give it all away.

It begins with a prince in a palace and a dim and distant sense that something has gone awry. The prince's name is Siddhartha Gautama, also known as Shakyamuni ("Sage of the Shakya Clan"). The time is the sixth century B.C.E.—the Axial Age of Confucius in China, Cyrus the Great in Persia, and Pythagoras in Greece. The place is Lumbini, the Bethlehem of Buddhism in the foothills of the Himalayas in what is now southern Nepal.

This prince's mother had died as he was taking his first breaths, so in his bones he knows suffering, but his father sees to it that life in the palace is whisked clean of dissatisfaction. Shortly after Siddhartha was born, a soothsayer had prophesied that he would be great in either politics or religion. His father was religious, but he was a practical man too. Determined to raise a Napoleon rather than a Mother Teresa, he went to great lengths to shield his son from anything that might upset his soul and set him to wandering.

Now a young man, this coddled prince enjoys what by all appearances is a life of champagne and caviar. Like Muhammad and Confucius, he lost a parent as a boy, but he has a beautiful house, a beautiful wife, and a beautiful son. All this beauty, however, cannot stop questions from bubbling up. He starts to ask himself,

"How did I get here?" And then he looks at the roads radiating out from his palace and for the first time allows himself to imagine where they might lead.

This future Light of Asia informs his father that he wants to see the real world. His father reluctantly agrees to send him on a tour outside the cozy confines of his sheltered life but orchestrates things as carefully as advanced planners for a prime minister's visit to Paris. The Champs-Élysées has been swept of homeless people, foreign minstrels, and other unpleasantness. But on this tour the Buddha-to-be sees a sick person. "What is that?" he asks his charioteer (because throughout his life he has been shielded from sickness). His charioteer tells him, "A sick person. Each of us falls ill. You and I alike. No one is exempt from sickness." On his second tour, orchestrated in even greater detail by his father, Siddhartha sees an old man. "What is that?" he asks his chari- oteer (because throughout his sheltered life he has been shielded from old age). His charioteer tells him, "An old person. Each of us gets old. You and I alike. No one is exempt from old age." On his third tour, Siddhartha sees a corpse. "What is that?" he asks his charioteer (because throughout his sheltered life he has been shielded from death). His charioteer tells him, "A dead person. Each of us dies. You and I alike. No one is exempt from death." On his fourth and final tour, Siddhartha sees a wandering holy man. "What is that?" he asks his charioteer (because through- out his sheltered life, which has included encounters with all sorts of beautiful and wealthy and powerful people, he has never seen such a man). His charioteer tells him, "A sannyasin, a wandering ascetic who has left behind spouse and family and job and home in search of spiritual liberation."

These four sights bring on the most momentous midlife crisis in world history. Looking at his life though the prism of the suffer- ing of sickness, old age, and death, Siddhartha decides that there must be more to human existence than profit, power, pleasure, and prestige. So at the age of twenty-nine he vows to "go forth from home to homelessness."[1] The next day, in an event now celebrated

as the "Great Departure" (and reenacted in ordination ceremonies the world over), Siddhartha allows his spiritual desires to override the duties of filial piety. He says good-bye to his father and wife and son, walks out of his palace one last time, rides to the border of what would have been his vast inheritance, shaves his head, takes off his fine clothes, and puts on the life of a wandering holy man.

In the Western religions, wandering typically arrives as punishment. It is the spanking you get after you eat the apple or kill your brother. But for Siddhartha wandering arrived as opportunity. For years he meandered around North India, studying with various yogis, experimenting with various body austerities, and otherwise searching for a solution to the problem of human suffering. As he whittled his body down to skin and bones—the opposite of the big fat plastic "Buddhas" of Chinatown fame—his renown as an ascetic grew, but his ability to focus on his spiritual goal diminished. The more he disciplined his body, the more often and more desperately it cried out for food and sleep. So he left his teachers and fellow students and decided to strike out on his own. Forging a "Middle Path" between hedonism and asceticism, he vowed to eat and sleep just enough to solve the problem of suffering.

At the age of thirty-five, after six years as a renunciant, he sat cross-legged under a tree in Bodhgaya in North India and vowed not to get up until he had stolen the secret of our everlasting wandering from rebirth to rebirth. Sensing trouble, Mara, the demon of sense pleasures, sent a Bangkok of distractions his way, but the Buddha-to-be would not be stirred by such trivialities. After forty-nine days, awakening came upon him. In one of the great moments in world history, he saw that all things are impermanent and ever changing. He saw how we suffer because we wish the world were otherwise. And through these insights he saw his suffering itself wander away. From that point forward he was the Buddha, which, like the term *Christ*, is a title rather than a proper name. In this case the title means not messiah but "Awakened One."

After his Great Awakening, the Buddha had a crisis of conscience. He knew that what he had achieved he had achieved alone,

by his own effort, on his own merit, and through his own expe-
rience. He knew that words fail. So how could he possibly teach
what he had learned to others? Wouldn't any instruction he might
offer be misunderstood? How could he speak without disturbing
the silence out of which his awakening had come? So this newly
minted Buddha considered withdrawing entirely from the world
of speech and society. He returned to his itinerant life, wandering
in silence for days. He finally decided, however, to try to help others
see what he had seen, experience what he had experienced, so that
they, too, might escape from "this sorrow-piled mountain-wall of
old age, birth, disease, and death."[2]

In a deer park in Sarnath, outside of Varanasi in North India, he
found five fellow travelers who had turned their backs on him after
he had decided to embark on the Middle Path. "Turning the wheel
of dharma," he delivered to them his first sermon: Buddhism 101.
At the heart of this sermon were the Four Noble Truths, which
compress the problem, solution, and techniques of Buddhism into
this quick-and-easy formula: life is marked by suffering; but suf-
fering has an origin; so it can be eliminated; and the path to the
elimination of suffering is the Noble Eightfold Path. Whether
these five holy men were converted by his person or by his words is
not known. But after the Buddha gave this pathbreaking sermon,
each of them decided to join his *sangha*, or community, and the
Buddhist mission was on.

For the next forty-five years, the Buddha wandered around the
Indian subcontinent, turning the wheel of dharma and gathering
monks and nuns into a motley crew of wandering beggars. To-
gether they bore witness to what has been described as "history's
most dangerous idea"—that human beings can solve the human
problem on our own, without recourse to God or divine revela-
tion.[3] In this way, Buddhism, the most psychological of the great
religions, joined Platonism, Jainism, Confucianism, and Daoism as
one of the great innovations of the Axial Age.

One of the distinguishing marks of the Buddhist tradition is its
emphasis on experience over belief. Buddhism never had a creed

or a catechism until the American convert Henry Steel Olcott decided in the late nineteenth century that any self-respecting religion needed both. This relative indifference toward religion's doctrinal dimension is rooted in the Buddha's celebrated refusal to speculate. Like his contemporary Confucius, who also inspired a new religion without relying on God or the supernatural, the Buddha was a practical man. He likened his teaching to a raft—"it is for crossing over," he said—and was forever passing his carefully chosen words through a colander of the useful.[4]

One of the most famous stories of the Buddha's life concerns a man who keeps peppering him with all manner of metaphysical puzzlers. Is the world eternal? Are body and soul one and the same? The Buddha responds to these questions with questions of his own. If you were shot with a poisoned arrow, would you waste time and breath by asking who shot the arrow, how tall he was, and of what complexion? Wouldn't you just pull the arrow out? Buddhism, he says, is about removing the arrow of suffering. Speculation only plugs more pain and poison into skin.

At the age of eighty this prince who had awakened ate a bad piece of meat placed in his begging bowl. He died of food poisoning in Kushinagar, India, not far from his boyhood home on the Nepalese border. Just before passing into what Buddhists refer to as *parinirvana* ("final nirvana"), he asked his followers not to grieve for him. Everything is characterized by transiency (*anicca*), he said. Everything that is born must decay and die. His reputed last words were, "Be lamps unto yourselves; work out your own liberation with diligence." His followers then cremated his body and distributed the remains as relics.

Since that time Buddhist pilgrims have been making the circuit of the four sacred places of the Buddha's life: Lumbini, where he was born; Bodhgaya, where he was enlightened; Sarnath, where he gave his first sermon; and Kushinagar, where he died. Along the way they pray to the Buddha not only for nirvana but also for help with the struggles of ordinary life, and they regale one another with miraculous legends of his past lives. These pilgrims used to go

on foot, sleeping under the stars or on monastery floors (or both), but now it is possible to go on first-class trains and air-conditioned buses, enjoying the amenities of luxury hotels.

When I was young, I did a budget version of this circuit myself and was particularly taken with Sarnath. One of the glories of India is that it is a land of hyperstimulation. If, as the Hebrew Bible puts it, "Wisdom crieth aloud in the streets" (Proverbs 1:20), you wouldn't know it in Mumbai or Calcutta, since a clamorous combination of cars, motorbikes, motorized rickshaws, buses, and bicycle bells push decibels in many Indian cities to jet runway levels. But the stimulation does not hyperactivate only the ear. India's images of the divine are riots of color. And its city streets are crowded almost to the point of impassibility. When I visited, Sarnath was a welcome respite from this blooming, buzzing confusion. While many of the world's sacred spaces have been overtaken by the jealous god of consumerism, Sarnath had yet to go over to the tourist side. The architecture of the stupas there was blessedly spare, reminiscent of the Native American funeral mounds scattered around the American South and Midwest. And the place was eerily, blessedly quiet, a fitting tribute to this way of awakening.

From Asia to America

Upon the death of the Buddha, who is often said to have lived between 563 and 483 B.C.E. but may have lived as much as a century later, much of Buddhism was literally a movement—a meandering collection of monks and nuns who imitated the Buddha's "no abiding place" lifestyle, supported only by the benevolence of lay followers willing to give them food in hopes of acquiring good karma and a better rebirth. But eventually more and more of these renunciants settled down into a vast network of wealthy and powerful patrons. In this way Buddhism became the first of the great religions to develop the institution of monasticism.

As the fairy tale of the Buddha yielded to the exigencies of his-

tory, Buddhism spread across much of the Indian subcontinent, thanks in part to its revolutionary rejection of the caste system and its indifference to the scriptures, ceremonies, and status of high-caste Brahmins. It moved north and east into Central Asia, along the Silk Road into China, and from there into Korea and Japan. It sailed south to Sri Lanka and Myanmar, and from there into the Southeast Asian archipelagos. It even hiked its way over the mountains to the sky-high plateau of Tibet. Buddhism spread not because it had a new holy book, like Islam, or a new god, like Christianity. In fact, early Buddhists refused to see the Buddha as divine and did not view his words as revelation. Buddhism spread because it had a story, a powerful new story about someone who, by waking up, had solved the problem of human suffering and found peace amidst the swirl.

Back in its homeland of India, Buddhism had its Constantine moment when the great emperor Ashoka (304–232 B.C.E.), shaken by a horrific battle that gave him a great victory in exchange for thousands upon thousands of deaths, converted to Buddhism and began to construct all over the subcontinent monuments to compassion, nonviolence, and religious tolerance. But India was a god-besotted place and not one to forsake divinity. So by the thirteenth century, Buddhism had all but died out in the land of its birth, a victim of the popularity of bhakti-style Hinduism and the powerful arrival of Islam.

Buddhism went West in the nineteenth century via books, artifacts, and people—through translations of Buddhist scriptures into European languages; through art collected by Buddhist sympathizers and deposited in places such as the Museum of Fine Arts in Boston; through converts, such as the Russian founder of the Theosophical Society, Helena Blavatsky; and through immigrants, particularly from China and Japan, to Europe and North America.

Today roughly 445 million people, or 7 percent of the world's population, are Buddhists, making Buddhism the world's fourth largest religion after Christianity, Islam, and Hinduism. The world's Buddhists are concentrated in South and East Asia and are

only minimally represented in Africa and Latin America. There are, at a minimum, 175 million Buddhists in China, and Buddhists form majorities in Thailand, Cambodia, Myanmar, Sri Lanka, Bhutan, Japan, and Laos. When it comes to monasticism, numbers are hard to come by. There may have been as many as one million renouncers in Tibet when China invaded in 1950, but monks are probably most numerous today in Thailand and Taiwan.

Buddhism's trend line, however, is down. At its peak, this tradition might have accounted for close to one-third of the world's population, but the twentieth century hit Buddhism hard. The rise of communism in China and North Korea, and of evangelical and Pentecostal Christianity in South Korea, were particularly devastating. Still, Buddhism is growing rapidly in Australia, New Zealand, and the United States, thanks to ongoing immigration from Asian countries, the enticement of a spirituality that doesn't hinge on the God proposition, and Buddhism's apparent compatibility with science, especially modern psychology and quantum mechanics. Buddhism has also benefited from the belovability of the Tibetan Buddhist leader and Nobel Peace Prize winner, the Dalai Lama, and from a series of 1990s films on Tibetan themes, including *Seven Years in Tibet* starring Brad Pitt, and *Little Buddha* starring Keanu Reeves.[5]

Of all the Asian religions, Buddhism has had the largest influence on European and American popular culture. Its beliefs and practices have made their way onto the television show *The Simpsons*, the movie *The Matrix*, a bestselling book by NBA coach Phil Jackson called *Sacred Hoops* (1996), and lyrics by the hip-hop group the Beastie Boys ("Bodhisattva Vow"). Buddhism has also long attracted the attention of Western intellectuals. The German philosopher Friedrich Nietzsche called Buddhism "a hundred times more realistic than Christianity," and the American Beat Generation hero Jack Kerouac devoted his novel *Dharma Bums* (1958) to Buddhist themes and in the process helped to set off the "rucksack revolution" of the 1960s.[6]

The largest of the three main Buddhist branches is the Maha-

yana ("Great Vehicle"), which predominates in Vietnam and in East Asian countries such as China, Japan, and Korea. The oldest is the Theravada ("Way of the Elders"), which is popular in South and Southeast Asia—in Thailand, Myanmar, Sri Lanka, and Cambodia. Tibet is home to the high-altitude Vajrayana "Diamond Vehicle," which also has a presence in Mongolia, Bhutan, Nepal, Russia, parts of China and Japan, and India, where the Dalai Lama has resided in exile since fleeing his homeland in 1959.

Although Buddhism is widely associated in the West with meditation, most Buddhists do not meditate. Their piety consists largely of bhakti-style devotion to various Buddhas and other supramundane figures. They worship these Buddhas in temples, pray to them at home, and go on pilgrimage to sacred sites associated with their exploits. Buddhism also plays the leading role in funerary rites in almost every society where it has a major presence. Because this tradition is associated with rebirth, families look to Buddhist monks when it comes to dying, funerals, and memorials.

Among the great religions, Buddhism runs in the middle of the pack in terms of contemporary influence, just behind Hinduism, which boasts more adherents, and just ahead of Judaism, which claims only about one practitioner for every thirty Buddhists worldwide.

From Suffering to Nirvana

Like Hindus, Buddhists trace the human problem to the karma-fueled cycle of life, death, and rebirth known as samsara. But Buddhists are more explicit about precisely why it is undesirable to wander from rebirth to rebirth. Rebirth is undesirable, they say, because life is marked by suffering. So the problem Buddhism seeks to overcome is suffering, which Buddhists refer to as *dukkha*. Its goal is nirvana, which literally means "blowing out" (as in the candles on a birthday cake) but in this case refers to extinguishing suffering.[7]

Buddhists use a variety of techniques to achieve this goal. Some chant. Some just sit. Some visualize their way into mandalas, or sacred maps of the cosmos. Some puzzle over mind benders called koans in an effort to frustrate the either/or mind and shock what remains into nondual awakening. But Buddhists are best known for the practice of meditation, even though it is not a common activity among laypeople. A Burmese friend who has been meditating for decades once described his practice as nothing more than "a chance to be idle." In our purpose-driven culture, however, doing nothing can be hard work.

Of all the styles of Buddhist meditation, the simplest is following your breath. I do this with my students in my introduction to religion courses, and it's something anyone can try at home. You find a comfortable place to sit and then just follow your breath—its going out, its coming in, and the subtle rests between its ebbing and flowing. In the process you might realize that this breath is forever changing, the end of the out giving rise to the start of the in, and the end of the in giving rise to the start of the out. You might also feel how the body breaths on its own—that you are not in control.[8]

Another popular Buddhist practice is *vipassana*, which is variously translated as "insight" and "mindfulness" meditation. Here, instead of your breath, you follow your feelings or thoughts or sensations. If you are bored, observe that you are bored. If your back aches, observe that your back aches. The aim of vipassana meditation is simply to be mindful of things as they are, to watch how all conditions arise and pass away, and so to observe, as German poet Rainer Maria Rilke put it, that "no feeling is final," and no thought or sensation either.[9]

Metta is another form of Buddhist meditation. *Metta* is often translated as "loving kindness," but it also means unconditional love—love without attachment or expectation of return. In this technique you begin by feeling metta for yourself. You move on to cultivating unconditional love for a friend. Then you feel metta for someone you neither like nor dislike, and then for someone you dislike or even hate. In the next stage you feel unconditional love

for yourself, your friend, the person to whom you are indifferent, and your enemy, treating them all as equally needful and deserving of loving kindness. Finally, you extend this feeling of metta to all beings everywhere in the world and beyond: "May all creatures be of a blissful heart."[10]

Though their techniques differ, Buddhists share certain core convictions. Whereas some Buddhists are deeply engaged in questions of rebirth and the afterlife, most follow their Confucian and Jewish counterparts in focusing on the here and now. They see suffering as the problem and nirvana as the solution. They trace suffering to "ignorant craving"—our tendency to mistake things that are changing as unchanging and then to cling desperately to their supposedly unchanging forms.[11] Or, as one Zen teacher puts it, "Suffering arises from wanting something other than what is."[12] This is a shocking departure from the teachings of Plato and the Upanishads, which promise happiness to those who discover and hold fast to what is unchanging and eternal.

But the most astonishing thing about Buddhism, and perhaps its greatest contribution to the conversation among the great religions, is its teaching that the thing we are *most* certain of—the self— is actually a figment of the imagination. Descartes said, "I think, therefore I am." Buddhists say if you think carefully enough you will see that you are not. According to Buddhists, the self (Cartesian or otherwise) does not actually exist.

You can take these words as a philosophical proposition to be proved (or disproved), but that wouldn't be very Buddhist of you, since Buddhists have insisted since the time of their founder that their teachings are true only insofar as they are useful. In other words, the point of Buddhist teachings is to reduce and eliminate suffering. So these teachings are aptly likened to vehicles—ferry-boats or rafts intended to take you from this island of suffering to the far shore of nirvana. If they can't do that, then we should throw them away, however "true" they may or may not be in theory.

Because it tends to analyze the human problem in terms of the individual, and to aim to solve that problem through withdrawal

from society, Buddhism has long been viewed by sociologists as pessimistic, apolitical, socially apathetic, and ethically inert—perhaps the most powerful evidence of Karl Marx's claim that religion is "the opiate of the masses." And there is some merit to this charge. Buddhists have traditionally focused on the individual more than society. I suffer because of how I view the world, not because of political or economic structures that oppress or impoverish me. At least until the twentieth century, Buddhists have been revolutionaries only in the realm of the individual mind.

Over the last generation, however, Buddhists have responded to such criticisms with "Engaged Buddhism," a term coined by the Vietnamese Zen Buddhist monk Thich Nhat Hanh (b. 1926) to refer to efforts to apply the Buddhist principle of compassion to social and economic problems such as poverty, war, injustice, discrimination, and environmental degradation. Engaged Buddhists in France and the United States, Vietnam and India are working to address the social roots of suffering through collective action. After 9/11, one of the most outspoken groups denouncing racial profiling of Arabs and Muslims were engaged Japanese-American Buddhists who, recalling the internment of almost all American Buddhists in internment camps during World War II, wanted to be sure that nothing like that happened to American Muslims. The Buddhist tradition, these Engaged Buddhists argue, is by no means just about personal spiritual growth.

Buddha, Dharma, Sangha

Like Christianity and Islam, Buddhism is a missionary religion. And converting is easy. All you have to do is recite the Three Refuges (or Three Jewels):

> *I take refuge in the Buddha.*
> *I take refuge in the Dharma.*
> *I take refuge in the Sangha.*

The term *sangha* means community. In early Buddhism this community was restricted to celibate monks and nuns. Laypeople did their thing at the margins, chiefly by giving food and clothing to monastics and receiving good karma in return. But they were not part of the sangha. Instead of reaching for the ultimate aim of nirvana, they hoped only for the proximate aim of a better rebirth. More recently, however, the notion of sangha has expanded to include nonmonastics. Today, if a Buddhist friend tells you she is going to her sangha, she means she is going to a meeting with her Buddhist friends. The Cape Sangha, near my Cape Cod home, is made up entirely of lay Buddhists.

The Buddha is just a human being in the earliest forms of Buddhism. Because of his vast storehouse of merit, he may be able to work wonders of clairvoyance and clairaudience, and even to fly, but he does not claim to be a god or savior. He is simply a pathfinder—someone who has experienced what Kerouac called "the Great Awakening from the dream of existence" and lived (for a while) to tell the tale.[13] So all he can show us is how to be human.

While other religious communities work hard to build up the authority of their founders, early Buddhists undercut the Buddha's authority. Their Buddha taught his listeners not to be seduced by the authority of any text, tradition, or teacher (even himself), but to discover for themselves how to live an authentically human life. Their Buddha also refused to designate a successor. After he died, he said, the teachings would be in charge. So there never would be a Buddhist pope.

The second of the Three Jewels, *dharma*, requires more explanation. In Hinduism, *dharma* means duty. Here it refers primarily to teaching (as in a "Dharma talk"). But *dharma* has also been translated as "the way it is," since Buddhist teachings aim at nothing grander than "to know things as they are."[14]

Buddhist teachings vary of course, but they often begin with the Four Noble Truths and the Noble Eightfold Path. Though widely considered to be the simplest doctrinal distillation of Buddhist teaching, the Four Noble Truths are anything but simple. In fact,

I never feel more challenged as a professor than I am when I am trying to explain these teachings.

The First Noble Truth observes that human existence is characterized by *dukkha*, or suffering. According to the European Values Survey, reincarnation belief is rising rapidly in the West: 29 percent of adults in the United Kingdom believe in reincarnation, as do 19 percent in western Germany, 21 percent in France, and 32 percent in Russia.[15] Many Westerners today welcome reincarnation as an opportunity to experience in the next life things they were unable to experience in this one. But for Buddhists reincarnation is literally a drag—a wheel full of friction and frustration. Yes, we can be happy. We can even be ecstatic. And there is joy along the way. Yet each of us, no matter how rich or poor or powerful or weak, is going to get sick, grow old, and die. Because nothing is permanent, nothing can permanently satisfy us. Because things change and pass away, everything and everyone we love will someday be no more. The happiness we experience is fleeting, and buried inside much of it is the sort of deep sadness that the Portuguese refer to as *saudade*.

The Second Noble Truth is more hopeful: suffering has an origin. Everything in this world is interdependent, linked in a great chain of cause and effect, so suffering must come from somewhere. Buddhists identify twelve links in this chain of "dependent origination" (*pratitya-samutpada*) but the key links are ignorance, thirst, and grasping. We suffer because we close our eyes to the way the world really is. We pretend we are independent when we are really interdependent. We pretend that changing things are unchanging. And we desperately desire the world and the people who populate it to be as we imagine it (and them) to be. And so we suffer when our spouses take up new interests, or when our favorite (and perfect just as it was) old-fashioned ice cream store puts up a ridiculous Web site with a stupid new logo, or when the brand new T-bird we are proudly driving home from the Ford dealership is hit by a rock thrown by a six-year-old kid who would go on to write this book (true story). We suffer because we desperately grasp after people, places, and things, as if they can redeem us from our suffering. We

suffer because we cling to beliefs and judgments, not least beliefs
in gods, and judgments that this friend or that enemy is morally
bankrupt. Today "you have changed" is an explanation one lover
gives to another as she is walking out the door. In Buddhism, "you
have changed" is a description of what is happening every moment
of every day.

The Third Noble Truth observes that, since suffering has a
cause, it can be eliminated. If we wake up to the way the world
really is, in all its flux and flow, and stop clinging to things that are
by their nature running through our fingers, then we can achieve
nirvana. But what is this "blowing out"? Nirvana is often described
in negative terms as the extinguishing of thirst, grasping, suffering,
greed, hate, delusion, and rebirth. More positively it is said to be
bliss, though a bliss that is beyond description, and peace, though
a peace that is beyond our ken. But nirvana is not some static place
you go to after death. It can be achieved in this lifetime.

The Fourth Noble Truth observes that there is a path to the
goal of nirvana. Like Confucianism's Doctrine of the Mean, this
Middle Path steers clear of the extremes of self-indulgence and
self-mortification. Also known as the Eightfold Path, it comprises
"right understanding, right thought, right speech, right action,
right livelihood, right effort, right mindfulness, right concentra-
tion."[16] Because this path has ethical, experiential, and doctrinal
dimensions, it is traditionally divided into three disciplines: ethical
conduct (right speech, right action, and right livelihood); mental
discipline (right effort, right mindfulness, and right concentration);
and wisdom (right understanding and right thought). In short, be
kind, be wise, be mindful.

Although all of the Four Noble Truths are described as teach-
ings, it is more faithful to the tradition to refer to them as observa-
tions, because none of this is dogma. Buddhism is a come-and-see
tradition. More than believers, its adherents are practitioners. Its
dharma is not divine revelation. And we are not supposed to accept
it just on faith. We are challenged to experiment with its teach-
ings, to see for ourselves whether what the Buddha said accurately

describes the world and (more to the point) whether its practices reduce our suffering.

No Soul, No Self

Of all the observations made by the Buddha, one is particularly vexing: we have no soul. Mormons say our souls existed before we were born, and almost all religions promise to preserve our souls after death. According to Buddhists, Hindus are wrong to locate the essence of the human person in the Atman, because the Atman does not exist. This core Buddhist teaching is called *anatta* (in the Buddhist language of Pali) or *anatman* (in Sanskrit), which in either case means "no soul." But that is only half of it (and the easy half), because according to Buddhists we have no self either. What we habitually refer to as "I" or "you," as if it were some unchanging essence, is actually nothing more than a conventional name attached to an ever-changing combination of separate parts called the five *skandhas*. When mixed together, these five "aggregates"—matter, sensations, perceptions, thoughts, and consciousness—create the illusion of "I" and "me." But this illusion is all there is to "myself."

One core text for this difficult teaching is a dialogue between the Buddhist sage Nagasena and a king named Menander. Like the rest of us, the king sees no reason to question anything as obvious as his own existence, but Nagasena is not so easily seduced by appearances. His argument for *anatta* hangs on an analysis of the king's chariot, whose existence the king sees no reason to question either. So Nagasena asks him, "Is the axle the chariot?" "No." "Are the wheels?" "No." "The frame?" "No." The chariot, Nagasena observes, is a composite made up of various things, just as a car today is composed of its frame and wheels and axles. The terms *chariot* and *car* are conventional designations, agreed-upon names for the coming together of various objects. So, too, is *I* a conventional designation for the coming together of this jangle of hair, head, hands, ideas, and emotions. Outside of such conventions,

however, no essence of "me" is to be found. The self is a charlatan; all memoir is fiction.

This may sound overly philosophical, and perhaps absurd, as if we have stumbled upon a metaphysics seminar for hypercaffeinated graduate students. Why should we care about this mumbo jumbo? Isn't the dharma supposed to be useful? Is there any practical payoff for denying something as undeniable as myself? Yes, Buddhists say. The false belief that "I" am some permanent, unchanging, independent essence unleashes all sorts of untold suffering. It gives rise to the ego, and then it gives the ego the reins, so we are dragged through each day by thoughts of "I" and "mine," obsessing over satiating the ego's insatiable cravings.

A few years ago an academic journal devoted an entire issue to one of my books. I was flattered, but when the issue arrived I had no desire to read it. I emailed a friend about my disinterest, which surprised me. "Of course!" she responded. "The only thing your ego does is say 'you're great' and 'you stink,' over and over again, in internally referential and self-perpetuating loops. . . . Any form of criticism is a version of 'you stink,' and any form of praise is another version of the same message, since 'you're great' implies you would stink if you weren't great in that way." The ego does more than tell baseball players they can't hit and professors they can't think, however. It endlessly trumpets its own existence—an activity toward which something that actually existed might not devote so much energy.

Confucianism says no to "I, me, mine" by denying the self's independence. We are not isolated atoms, Confucians say; we are interdependent webs of social relations. Buddhism goes a step further by denying any real self of any sort. Put an end to ignorance and grasping and suffering by putting the lie to the false self, it says. Or, as a poet put it:

> *Do*
> *Not*
> *Act*

From
Ego.
It is a sticky little
Mouse trap that
Begins
With
A
Wheel
Running us in
Circles.
Get off.[17]

Theravada and Mahayana

There is some question about whether Buddhism is a religion, but as with Confucianism this question reveals more about our own assumptions about religion than it does about Buddhism itself. Some who find Confucianism lacking on the God front try to reduce it from religion to ethics. With Buddhism the temptation is to reduce it to psychology, or therapy.

The earliest forms of Buddhism did not speak of God or stress the supernatural. They saw the Buddha as a human being. So if religion is about "belief in Spiritual Beings," as the classic definition by British anthropologist E. B. Tylor puts it, Buddhism was not in the religion family.[18] It wouldn't be very Buddhist of Buddhism to remain forever the same, however. And it did not. As a child of India, Buddhism inherited Hinduism's absorptive strategy. In India, it picked up most of the typical trappings of its religious kin, not least an elaborate pantheon of Buddhas and other spiritual beings with all the supernatural powers of Kali and Shiva. In Tibet it picked up some of the magic of the indigenous shamanism of Bon. And in China it adopted some of the naturalness, spontaneity, and simplicity of Daoism.

There was an early effort to fossilize the tradition, to set it in

stone. At its First Council, held hard by the Buddha's death in the fifth century B.C.E. or so, his followers agreed on a canon of the Buddha's teachings known as the *Tripitaka*, or "Three Baskets." At the Second Council, held about a century later, Buddhists split over a variety of matters, including how strictly monastic rules should be interpreted and enforced. This was Buddhism's Reformation, in the sense that it opened the door to the mad diversity that characterizes Buddhism (and Protestantism) today. This diversity is likely endemic to any tradition that subordinates "Is it true?" to "Does it work?" When new teachings or scriptures come along—and this tradition has produced both at a dizzying pace—Buddhists, rather than rejecting them as bastard children, adopt them as long-lost kin (assuming they can pass the pragmatic test of eliminating suffering).

The beginning of the Common Era was a period of extraordinary religious activity that saw the birth of Christianity, rabbinic Judaism, and bhakti-style Hinduism. This period also gave the world bhakti-style Buddhism, known today as Mahayana. *Maha* means "great" and *yana* means "vehicle" so *Mahayana* means "greater vehicle," and today it *is* the most popular Buddhist school. But in the beginning this name was a boast rather than a demographic observation. "I am the greatest," bragged heavyweight boxing champion Muhammad Ali. Mahayana Buddhists said the same thing. Much as Ali taunted Joe Frazier, they referred to their opponents as Hinayana, or "lesser vehicle." These opponents, however, disagreed, and one group that survives today is Theravada ("Way of the Elders").

Mahayana Buddhists claimed they were greater than Theravada Buddhists and their kin for many reasons, but one of their biggest claims to fame was their egalitarian bent. Theravada Buddhism was a monastic tradition. For Theravadins, the only way to achieve nirvana was to withdraw from the worlds of family, work, sex, and money into the celibate life of a monk or nun. For this reason, some refer to the Theravada path as "Monastic Buddhism."[19] The Mahayana branch also had its monastics, but here renunciation was

optional. Ordinary husbands and wives, employees and bosses expressed their devotion to new Buddhas by visiting new stupas and reading new scriptures. And though many of these laypeople contented themselves with the proximate goal of a better rebirth, some now began to hope for the ultimate goal of nirvana, without giving up on either love or worldly success.

Mahayanists attacked Theravadins on many grounds, but the blow that hit hardest was the accusation that their predecessors were selfish. Theravada Buddhism was all about individual enlightenment, Mahayanists argued. The Theravada exemplar was the *arhat*, who distinguished himself from the rest of humanity by wisdom (*prajna*) alone. So Mahayanists disparaged the arhat as smug, self-seeking, and self-centered. How could he cling to his own spiritual advancement when there was so much suffering among those he was leaving behind?

In a series of new scriptures, which they attributed to the Buddha but their opponents attacked as fakes and forgeries, the Mahayanists championed a new exemplar called the *bodhisattva*. This term literally means "awakening being," but the key virtue of this Mahayana hero is compassion (*karuna*). Instead of focusing selfishly on his own private nirvana, the bodhisattva uses his huge storehouse of merit to assist others. "All the suffering in the world comes from the desire for happiness for oneself," writes the eighth-century Indian poet-philosopher Shantideva in his *Guide to the Bodhisattva Path*. "All happiness in the world comes from the desire for happiness for others."[20]

Like Hinduism's jnana yogis, Theravada Buddhism's arhats stood in the self-help tradition. They, too, believed that the only way to get the religious goal was through one's own merit. So achieving nirvana was extraordinarily difficult. In India, the easier path of bhakti yoga developed inside Hinduism right around the same time the Mahayana path was first charted. As of the beginning of the Common Era, it was possible for Hindus to get moksha through other power rather than self-effort: if you are devoted to a god of your choosing, your god will do the heavy lifting. Ma-

hayana Buddhism worked in much the same way. With the rise of bodhisattvas, who walked and talked like Hindu gods, it became possible to get nirvana through outside assistance rather than self-reliance—through devotion to a bodhisattva, who would use his merit to take away your suffering. In this way it became much easier to achieve nirvana, and laypeople became fuller participants in the Buddhist community.

The bodhisattva is typically described as someone who has a crisis of conscience while standing on the threshold of nirvana. "How can I enter into nirvana when so many other beings are suffering?" he asks. And the compassionate answer is, "I cannot." So rather than renouncing the world, the bodhisattva returns to it, promising to postpone his own final nirvana out of compassion for others. This promise takes the form of the Bodhisattva Vow. Though this vow is different in different scriptures, it always includes a healthy dose of megalomania:

However innumerable sentient beings are, I vow to save them;
However inexhaustible the passions are, I vow to extinguish them;
However immeasurable the Dharmas are, I vow to study them;
However incomparable the Buddha-truth is, I vow to attain it.[21]

When I try to explain the psychology of the bodhisattva to my students, I describe the bodhisattva as someone standing on the front porch of nirvana, holding open the door while waving others into the party ahead of him, refusing to enter until everyone else has entered first. By introducing time and space into a situation that is said to be beyond both, this image may conjure up an unhelpful picture of a massive logjam at Buddhism's analog to the Pearly Gates. But it underscores the extent of the bodhisattva's compassion, patience, and resolve.

In addition to the bodhisattva, Mahayana Buddhists gave the world a radically new interpretation of the Buddha. While Theravadins saw the Buddha as a pathfinder and a human being, Mahayanists came to see him as eternal and omniscient—a supernatural

being who could answer prayers and reward devotion. Moreover, Mahayanists spoke not just of one Buddha, but of many—a vast pantheon of wonder-working Buddhas on call 24/7 to lavish grace and favor on ardent devotees. Eventually Mahayanists came to believe that trying to become an arhat was simply aiming too low. Why hope for anything less than Buddhahood itself?

The ready availability of meritorious Buddhas and bodhisattvas changed the playing field for laypeople seeking either the proximate goal of a better rebirth or the ultimate goal of nirvana. In the Theravada model, laypeople received merit from monks in exchange for food and clothing. And while that merit might help you to a better rebirth, it could never get you nirvana. In the Mahayana model, laypeople received merit from Buddhas and bodhisattvas in exchange for their devotion, and while that merit would likely only propel you to a better rebirth, it could also transport you to nirvana.

It is of course impossible to distill the many distinctions between Theravada and Mahayana Buddhism down to one thing, but the crux of it is that Theravada Buddhists think we awaken on our own, while Mahayana Buddhists think we awaken in relationship with others. Or, as Buddhist psychoanalyst Mark Epstein puts it, "we need partners in order to realize who we are."[22]

Zen and Other Ways to Blow Your Mind

With the emergence of the Mahayana school, Buddhism moved undeniably into the family of religions, since its vast (and growing) pantheon of bodhisattvas and Buddhas offered devotees all the grace and magic of other religions' gods. Just as bhakti Hindus could win moksha through the grace of Shiva or Krishna, Mahayana Buddhists could win nirvana through the grace of a Buddha or bodhisattva of their choosing. Many of these supramundane beings now have followings rivaling those of St. Jude or the Virgin Mary. The most popular bodhisattva, Avalokiteshvara, embodies compassion and, like Krishna, is said to come to earth repeatedly

to save people in peril. Known in Tibet as Chenrezig, he switches genders in East Asia, into the all-merciful Guanyin (in China) and Kannon (in Japan).

The most popular post-Gautama Buddha is the Buddha of Infinite Light—Amitabha in Sanskrit and Amida in Japanese—who is able to create out of his immeasurable storehouse of good karma a celestial abode of bliss—the Pure Land—that makes the Christians' heaven and the Muslims' Paradise look like Disneyland at closing time. This Buddha was popularized in Japan by Honen (1133–1212), the founder of the Jodo Shu (Pure Land) school, who promised that if you just chanted the name of the Amida Buddha— "*Namu Amida Butsu*"—he would issue you a one-way ticket to the "Western Paradise" or "Pure Land" from which nirvana is ensured. Nothing else was required. No meditation. No austerities. No study. All you had to do was demonstrate your devotion by chanting those three words, and the Amida Buddha would do the rest.

The epitome of this bhakti path of faith, grace, and devotion came a few decades later with Shinran (1173–1263) and his Jodo Shinshu (True Pure Land) school. This Japanese reformer said it wasn't necessary to chant the name of the Amida Buddha incessantly, as many of Honen's followers were doing. All that was needed was one sincere invocation. Today this other-power tradition is the most popular Buddhist school in Japan and has taken up residence in the United States as the Buddhist Churches of America.

Another Mahayana reformer from medieval Japan, Nichiren (1222–81/2), distinguished himself by the scripture he read rather than the Buddha he worshipped. Like Honen and Shinran, he was a chanter rather than a meditator. But his chant was to the Lotus Sutra: *Namu myoho renge kyo* ("Hail to the Marvelous Teaching of the Great Lotus"). Various Lotus Sutra schools emerged out of Nichiren's reforms, but the best known is Soka Gakkai International (SGI), a power-of-positive-thinking organization that has spread from Japan to Brazil, Singapore, and the United States, where it is the most racially and ethnically diverse of all American Buddhist organizations.

While many Mahayana schools echoed the Nichiren schools in organizing themselves around a scripture, one school did an end run around scriptures altogether. Popularized by Jack Kerouac and other Beat writers during the 1950s (though Kerouac himself was actually partial to the "Mind-Only" Yogacara school), Zen Buddhism takes its name from *dhyana* in Sanskrit, which became *Chan* in Chinese and then Zen in Japanese. Each of these words means "meditation," so Zen is a meditation school. Zen is best known, however, for two distinctive practices. The first, developed by the Soto Zen school, is *shikantaza*. In this deceptively difficult practice, you just sit. You don't try to follow your breath or to see into the nature of reality. You just sit idle for a time without thinking. ("Are you not thinking what I'm not thinking?" reads a *New Yorker* cartoon of two Zen monks in the lotus position.[23])

A second Zen practice, developed by the Rinzai Zen school, is the koan. A Zen master will pose a puzzle to a student: "What is the sound of one hand clapping?" Or "What was your face before your mother and father were born?" Or (my personal favorite), "What would the Buddha have said if there was no one to hear and no opportunity to teach?" The student will then try to offer a response that is genuine, spontaneous, and unrehearsed.

Zen grew out of the interaction of Buddhism with Confucianism and Daoism during the Tang dynasty in eighth-century China. Practitioners, however, trace their tradition back to the Buddha himself. Their oft-told tale speaks of an assembly of monks eagerly awaiting a discourse from the Buddha. When he arrives, however, he says nothing. He turns a flower in his fingers, he smiles, but he does not speak. Everyone is confused. Everyone, that is, except for one monk who smiles back, whereupon the Buddha announces that this monk had received his transmission—a teaching that is direct and ordinary, transmitted outside of words.

What intrigues me about the quest of Zen practitioners for *satori* (their term for moments of awakening that bring qualities of spontaneity and openness to everyday life) is how often these moments come in a flash of intuition. There is now strong evidence that

breakthroughs of many sorts—Eureka! moments for scientists and novelists alike—often arrive only after the rational brain has run into a brick wall. When you are out for a walk or a drive or just waking up or just going to sleep, the solution does an end run around your ordinary mind and pops into your head, fully formed. Apparently you need to wear out the left side of the brain so the right side can do its work. Or, to use language more native to the Buddhist tradition, you can't get to nonduality with the dualistic mind. You can't think your way to nirvana; it comes when you are out of your mind.

Emptiness

Another crucial development in Mahayana Buddhism was the teaching of *shunyata*, or emptiness. Whereas Theravada Buddhists had argued that the self was actually a composite (of the five skandhas) and therefore both fantasy and phantasm, Mahayana Buddhists took this argument one step further, contending that everything, including the five skandhas, is equally empty.

I can attest on the basis of two decades as a Religious Studies professor that this teaching is almost as hard to convey as no-self. Just as most of us prefer to live in the physical universe of Isaac Newton, untroubled by the unsettling truths of Einsteinian relativity, most of us are perfectly happy to accept existence as it appears without worrying about how it might actually be. But even those of us who want to see the reality rather than the shadow have a hard time wrapping our heads around the mind-bender of emptiness. And as if that isn't enough, there is the warning of the great second- and third-century Indian Buddhist philosopher Nagarjuna that garbling this doctrine can be hazardous to your health. "*Shunyata* misunderstood," he writes, "is like a snake grasped by the head."[24] So fair warning and beware.

The teaching of shunyata goes something like this: Since everything comes and goes in a great chain of cause and effect, nothing is independent; nothing exists on its own. There is no fire with-

out fuel, and fuels such as wood and natural gas cannot even be conceived of as "fuel" without the concept of "fire." The cottage where I live on Cape Cod may seem to be a very real and substantial "thing," but it was brought into being by (among other empty things) carpenters and roofers and shingles and nails (each of which is itself empty), and one day the effects of wind and rain (among other things) will rot it away. The same can be said of our opinions and beliefs, which also arise and fall in a great chain of cause and effect. Yes, things appear to have permanent, unchanging essences. But as much as we hate to admit it, nothing is really permanent, and everything is constantly changing. Yes, things appear to be unto themselves—this cup, that plate, this fork. But everything is made of something else and is always in the process of becoming something other than what it now appears to be. Before the fork was a fork, it was a sheet of stainless steel; before it was a sheet of stainless steel, it was iron, chromium, and other metals buried in rocks underground (though not, of course, conceived as such by the rocks nearby). And even this fork in my hand is only a "fork" among English speakers. In a culture of chopsticks unacquainted with Western place settings, it is simply an oddly shaped curio. "Form is emptiness," says the Heart Sutra, "and emptiness is form."[25]

For generations shunyata was seen in the West as pessimistic and nihilistic, perhaps because this term was routinely mistranslated as nothingness. But "emptiness is openness," as the American teacher of Tibetan Buddhism Pema Chodron puts it.[26] Shunyata should be understood first and foremost as a teaching of freedom rooted in experience:

> *Until we experience it,*
> *Emptiness sounds so*
> *Empty.*
> *Once experienced,*
> *All is empty by comparison.*[27]

To make this difficult teaching a bit more plain, Mahayana Buddhists speak of two truths: conventional truth with a small *t* and Absolute Truth with a capital *T*. From the perspective of Absolute Truth, everything is empty. Ultimately, there is no distinction between you and your best friend: each is radically interdependent; each is ever changing; each is impermanent. Ultimately, there is no unchanging essence to you or to me, just as there is no unchanging essence of chariot, car, house, or fork. Yet conventionally we speak of ourselves and these objects as if they were objects, as if we and they were independent, unchanging, and permanent, just as we speak of objects moving through space and time as if Newton's laws live even though we know that Einstein has superseded him and that many so-called objects are actually better described as waves. We do this because it is useful under most circumstances to speak in conventional terms. There is no chariot, says Nagarjuna, but that does not mean you cannot climb aboard and take it for a spin.

The oddest implication of emptiness is that we are all already Buddhas. It is the dualistic mind that sees Buddhahood as something different from us. Move into nondualistic awareness and you will realize that you have been a Buddha since birth. Here we may seem to be treading toward something like self-deification, or what the Hindus call God-realization. But if the Tibetan Buddhist teacher Sogyal Rinpoche is right, the point of shunyata may not be to transcend our humanity, but to inhabit it more fully. "You don't actually 'become' a Buddha," he writes, "you simply cease, slowly, to be deluded. And being a Buddha is not being some omnipotent spiritual superman, but becoming at last a true human being."[28]

One of the wonders of the ancient world (and Indonesia's top tourist attraction) is the ninth-century Mahayana temple at Borobudur in Java. When viewed from above, this temple looks like a mandala—a map of the cosmos that doubles as a map of the human mind. Every day devotees circumambulate and ascend it, moving symbolically through the world of craving, the world of forms, and finally entering the world of formlessness. All the while, tourists

snap photos incessantly and Indonesian schoolchildren practice their broken English with foreigners.

Even with the distractions, however, this remarkable temple is almost enough to turn you into a Buddha all by itself. As you ascend the six rectangular stories and three circular stories of this massive lava-rock monument, thousands of bas-reliefs carved in stone tell the story of the Buddha's life and illustrate the karmic law of cause and effect. At the top are seventy-two stupas. Stupas are structures that typically house some sacred relic, and, if you look carefully, you will see a stone statue of a seated Buddha inside each one. But in the center and at the highest point of this monument is an empty stupa—a wonderful gesture that recalls the empty chair for God so ubiquitous in Bali and, of course, the Mahayana teaching of emptiness itself.

Thunderbolt and Diamond

Vajrayana Buddhism, numerically the smallest of Buddhism's three paths, is often also called Tibetan Buddhism because, although it flourished elsewhere, it survived most visibly in Tibet. Vajrayana developed out of Mahayana in India in the sixth century and moved into Tibet in two great waves, first in the eighth century and again in the eleventh. There it made a great civilization that creatively combined Theravada-style monasticism, the study and contemplation of Mahayana texts, the magical and ritualistic traditions of Tantra, and the shamanistic beliefs and practices of the indigenous Bon religion. Vajrayana thrived in Tibet for centuries, until the Chinese invaded in 1950, eventually forcing the fourteenth Dalai Lama and his "Buddhocratic" government into exile in India.[29]

Vajrayana Buddhism enjoys a visibility in the West far out of proportion to its numbers, thanks to books and films trumpeting Tibet as an impossibly faraway Shangri-La, the inescapability of the Dalai Lama's trademark smile, and widespread sympathy for Tibetan underdogs in the face of Chinese rule. Tibetan Buddhist

monks are famous in Europe and North America for crafting out of colored sand intricate multicolored mandalas, which in this case include Buddhas in all nine directions (north, northeast, east, southeast, south, southwest, west, northwest, and center). These sand mandalas often take days to build but, in a grand demonstration of the Buddhist truth of impermanence, they are scattered to the wind (or into a river) shortly after they are completed.

Like Mahayana Buddhists, Vajrayana Buddhists are not immune from bragging about their beloved tradition. Robert Thurman, the first Westerner ordained a Tibetan Buddhist monk and now a Buddhist Studies professor at Columbia University, claims that this tradition creatively combines the best of Theravada monasticism and Mahayana messianism.[30] But there is also a boast in the name itself. *Vajra* means both "thunderbolt" and "diamond," so Vajrayana is the thunderbolt or diamond vehicle. Because it has the concentrated force of a thunderbolt, it presents the possibility of achieving Buddhahood extraordinarily quickly—in one lifetime. Because it can cut like a diamond, it is able to break through the Gordian knot of the dualistic mind to the nondualistic awareness of emptiness.

This third Buddhist vehicle also answers to a host of additional names: Mantrayana because of its use of mantras, or sacred chants; Lamaism because of its reverence for the lama (which means guru, or teacher); Esoteric Buddhism because many of its practices are passed down in secret from lama to student; and Tantric Buddhism, because some of its practices are derived from Tantra. One such practice is partaking of the "Five Forbidden Things"—meat, fish, alcohol, sex, and mystical gestures called *mudras*—an activity that seeks to break through the either/or mind to the nondualism of emptiness. Just as Chakrasambhara, the bodhisattva of compassion, and his consort, Vajrabarahi, merge into each other sexually, there is no ultimate distinction, Vajrayana Buddhists say, between meat eating and vegetarianism, between you and me, or even between nirvana and samsara.

The most widely read Vajrayana Buddhist text in the West is

the Tibetan Book of the Dead, which has been celebrated as a sci-
entific, spiritual, psychological, and humanistic text.[31] This funer-
ary manual, whose technical name (or one of them) is *Liberation
through Hearing in the Intermediate State*, guides the consciousness
of the deceased through the intermediate state (*bardo*) between
death and rebirth—a period Vajrayana Buddhists believe lasts for
up to forty-nine days. Its words are chanted, ideally by a lama, over
the corpse of the dying and the dead.

The afterlife journey described in this text begins with a terrify-
ing white light known as the Great Luminosity. Stay calm, you are
told. Don't be afraid. See the Great Luminosity (which some have
likened to the light reported by people who have had near-death
experiences) as nothing more than a projection of your own mind.
If you are able to do this, to see yourself and this light as one rather
than two different things, then you are liberated and will not be
reborn. But this is very rare. So most of us go on to the next stage:
a parade of ugly and wrathful Buddhas, followed by beautiful and
benevolent Buddhas. This time, we are told not to be too repelled
by or too attracted to any of these images. Don't fear them or love
them or run to or from them. Just understand each as a projection
of your own mind. If you are able to do this, to realize the empti-
ness of the distinction between yourself and these Buddhas, then
you are liberated and will not be reborn. But this, too, is rare. So
the overwhelming majority of us go on to the final stage, which
determines when and where we will be reborn. In this stage we
see various scenes of animals and humans having sex, and on the
basis of the good and bad karma we have accrued in past lives, we
insinuate ourselves into one of those scenes and are reborn into it.[32]

Beyond Buddhism

Quick-and-easy formulas are problematic in every great religion.
Have you really gotten to the heart of Islam if you perform the
Five Pillars? Or to the heart of Christianity if you say "Amen" to

the Nicene Creed? With Buddhism, quick-and-easy formulas are particularly suspect. To be sure, Buddhists have long been on the lookout for formulas that could get them to nirvana. And ritual has always played a major role in the tradition. But more than belief, Buddhism is about experience. And for the tradition's mystics, this experience lies on the far side not only of rites and creeds but also of language itself.

The teaching of emptiness is a teaching of freedom, not of nihilism or pessimism as so many western interpreters have imagined. There are reasons why the Buddha was often described as joyful and why the Dalai Lama seems inseparable from his trademark smile. One is that shunyata offers liberation from suffering. Another is that emptiness liberates us from enslavement to people, judgments, objects, and ideas, including the person of the Buddha and the institutions of Buddhism itself.

One beloved koan reads, "If you see the Buddha, kill the Buddha." Another Zen saying goes: "There is Buddha for those who don't know what he is, really. There is no Buddha for those who know what he is, really."[33] Each of these sayings warns in its own way against clinging to the Buddha. Why should clinging to the Buddha cause us any less suffering than clinging to God or self or boyfriend or political party or ideology or nation? But these sayings also make the broader point that anything that comes to you secondhand is worse than worthless; trust only what you yourself have seen to be true in your own experience.

Like "drunken" Sufis who laugh off the Five Pillars as baby steps on the road to Islamic adulthood, Buddhists who experience the mystery of emptiness recognize that ultimately all dualisms are figments of the ordinary mind, which is as binary as any computer. We should "hush the dualism of subject and object" and "forget both" because there is no essential distinction between lay and monastic, male and female, the bodhisattva who does the liberating and the person who is liberated.[34]

But emptiness does not just short-circuit the dualistic mind. It disables our penchant for judging others. When the habitual mind

sees someone do something other than what it would do, it judges. When it sees someone thinking something other than what it thinks, it judges. And when it sees someone worshipping some god other than its god, it judges again. According to shunyata, every creature in this jangle of judgments arises from a false dualism of right and wrong, true and false, good and bad.

Even the most basic Buddhist dualism—between the problem of samsara and the solution of nirvana—is, according to this tradition, ultimately unreal. The Four Noble Truths and the Eightfold Path are empty, too, as is Buddhahood itself. According to the Heart Sutra, "There is no ignorance, no extinction of ignorance."[35] And as Mahayana's master of paradox Nagarjuna wrote, "The Buddha never taught any doctrine to anyone."[36] So we should abandon attachments to every teaching and every practice. Oh, and don't forget that, according to the teaching of shunyata shunyata ("the emptiness of emptiness"), emptiness is empty too.

This may now sound not only pessimistic and nihilistic but also absurd. If there is no problem and no solution, what is the point? Is Buddhism just one big fat joke?

To say that there is no distinction between samsara and nirvana, however, is not to say that nirvana is impossible. It is to say that nirvana is inevitable. In fact, it is already here. To experience its bliss, all we need to do is to step out of the closed, either/or mind to the open heart of emptiness. Samsara is nirvana if you just accept things as they are. To say that there is no distinction between a Buddha and a dog is not to say that all you will get out of a Buddha is a sniff and a wag. It is to say that, if you see the world as it is, even a dog's scamper from his leash can lead you to bliss beyond bliss. What the experience of emptiness teaches, in short, is that there is nowhere to go, nothing to wait for. This is it. To borrow from the American writer John Updike, Buddhism serves "to give the mundane its beautiful due."[37]

In other words, everything written in this chapter resides in the realm of conventional truth rather than Absolute Truth. Stories about the Great Departure and the Great Awakening of the

Buddha are useful, but ultimately Buddhism is more about experi-ence than narrative. Exegesis of the Four Noble Truths and the Eightfold Path is useful. Descriptions of the problem of suffering and the solution of samsara, and of exemplars such as arhats, bo-dhisattvas, and lamas, may be useful, too, but they will not them-selves take you over to the far shore. Ultimately Buddhism is more about experience than doctrine. Here ultimate things lie beyond words, in the smile of the Buddha, and in his silence.

Yoruba Religion

In my introduction to religion courses I ask my students to invent their own religions. They form groups and dream up new religions. They then pitch their religious creations online and in class. After every group has had a chance to evangelize, everyone votes (with fake money in makeshift collection plates) for the new religion they like the best. Over the years my students have attacked this assignment with intelligence, humor, and creativity. One group invented ♪ism, a religion inspired by the grooves of rapper Tupac Shakur and the inscrutability of the artist formerly known as The Artist Formerly Known as Prince, which promised a posthumous "After-Party" for those who followed its injunction to "respect the rhythm." Another tried to convert us to The Congregation of Wisdom, which honors *Jeopardy!* phenom Ken Jennings as its patron saint. Meanwhile, Sertaism and ZZZ aimed not at salvation but at a good night's sleep.[1]

Many of my students' religious inventions were quite profound, however, and the one that moved me the most was Consectationism (from the Latin for "pursuit"). The goal of this religion is to find and follow your own purpose, or "Lex." And its ethic is simplicity personified: pursue your own Lex, and don't hinder anyone else from pursuing theirs. In their class presentation, modeled after evangelical Bible-camp skits, Consectationists offered revival-style testimonies about "The Sign of the Covenant," the sky-opening moment when each found his or her own Lex. Much of our sad-

ness and suffering, the students observed, comes from trying to live a life other than our own. So each of us should seek to discover our purpose and pursue it with passion and resolve.

Consectationism is, of course, make-believe, while Yoruba religion of West Africa and its diasporas is a venerable global tradition. But the heart of Consectationism lies surprisingly close to the heart of the religion of the Yoruba people. Here, too, each of us has a destiny we have somehow forgotten. Before we are reborn (the Yoruba affirm reincarnation), one of our souls (we have two or more, depending on who is doing the counting) appears before the High God Olodumare to receive new breath. Olodumare then allows us to choose our own destiny, which includes the day we will return to heaven, our personality, our occupation, and our own unique measure of good and bad luck. With birth comes forgetting, however. So we wander through life veiled from our true purposes, sidetracked by pursuits, in love and work, foisted on us by parents, friends, coworkers, and spouses. The antidote to this forgetfulness is to remember—to recover our destiny so we can do what we were created to do for ourselves, our families, and the world.

Happily, we are not alone in this task. There is a vast pantheon of superhuman beings, known as orishas (orixas in Brazil, orichas in Cuba), able and willing to help us live in harmony with our destiny.[2] There are a variety of techniques of divination that can bring the wisdom of these orishas to our ears. And there are specially trained priests and diviners, known as *babalawos* (if men) or *iyalawos* (if women), who through *Ifa*, the most venerable and venerated of these divination techniques, are able to help us recover our destiny, protect it through sacrifice, and fulfill it through action in the world. In fact, one of the first tasks of any parent is to take one's child to a diviner so that its destiny can be read and revealed.

Although *babalawo* means "father of secrets" and *iyalawo* "mother of secrets," diviners do not dispense any secret wisdom themselves. They know how to cast the sixteen palm nuts or the eight-half-seed-shells divining chain used to begin any consulta-

tion with a client. They have memorized at least a thousand Ifa verses—four for each of the 256 possible signatures (16 x 16) that the random casting of the palm nuts or divining chain produces. They chant a series of poems associated with each signature, or *odu*, including verses that prescribe the required sacrifice. But rather than oracles, these diviners are mediators between clients and orishas. So while the simplest way to understand what is happening when a client goes for a consultation is that the diviner is channeling the wisdom of the orishas to a human being, that is not quite right, since for the Yoruba, as for the ancient Greeks, wisdom is recalling what we already know within.

To understand Ifa divination, it is important to note how active the client is and how passive the babalawo. First, the client does not even tell the babalawo why she has come. She might have boyfriend troubles, or husband troubles, or both. She might be sick or be trying to decide whether to take a new job or move to a new town. She may be seeking prosperity or pregnancy or trying to fend off depression or loneliness. But her presenting problem is a mystery to him. Second, it is the client, not the babalawo, who decides which of the recited stories (typically at least four per signature) is appropriate to her conflict. What the babalawo brings to the table (or to the floor, actually, since this practice takes place with both babalawo and client firmly rooted to the earth) is a prodigious memory for the poems associated with each of the 256 signatures and an ability to chant the verses chosen by his client. But it is the client who does the choosing.

It should also be emphasized that the Yoruba put huge stock in the capacities of human beings. According to the Yoruba tradition, each human being has a physical body called *ara*. Each person also has at least two souls: one, called *emi*, associated with breath, and another, called *ori*, associated with destiny. The term *ori* literally means head, but in this context it refers to the spiritual center that chooses its destiny. This ori in each of us is animated by the same sacred power that animates the orishas: *ashe* (*ache* in Cuba and *axe*

in Brazil). So whatever channeling is happening in Ifa divination is happening between us and the orishas. It is also happening between the part of us that remembers and the part of us that forgets, which is to say between our more divine and our more human selves. Far from demanding our subservience, therefore, the babalawo is helping to call us back to our original selves, to recover the destinies we chose for this life before it began.

At the beginning of a reading, the babalawo touches the palm nuts to his client's ori. "You know the mystery," he says to the client. He then touches the palm nuts to the divining tray, which carries the image of the messenger orisha Eshu. "You know the mystery," he says to Orunmila (aka Ifa), the orisha of wisdom. And then he adds, "I know nothing." Ifa divination works not because the babalawo is superhuman but because the ori is itself a god within. As a Yoruba proverb goes, "The head [ori] is the greatest Òrìṣà."[3]

The Orishas

Yoruba religion varies widely across time and space—from the traditional practices of West Africa to the contemporary Yoruba-derived adaptations of Candomble in Brazil and Santeria in Cuba. And there are strong arguments for treating these adaptations as separate religions of their own—"rhizomes" of the Yoruba tradition that may be connected at the roots but, by virtue of new soils and new climates, have become distinct plants.[4] However, practitioners of these traditions are sufficiently closely connected—far more closely, in fact, than Mormons, Protestants, and Catholics—to be treated together here. And, together these Yoruba practitioners share the view that the human problem is disconnection and that the solution to this problem is to reconnect ourselves to our destinies, to one another, and to sacred power. This can be accomplished through the techniques of divination, sacrifice, and spirit/body possession, which in combination allow us to truly flourish as individuals and societies.

The Yoruba cosmos is awash in sacred power. There are malevo-
lent spirits, called *ajogun*, who can make your life a living hell if
you cross them. There are ancestor spirits, known as *egungun*, who
can get up and dance at festivals and, like the *ajogun*, are endowed
with ashe. But the powerhouses of ashe are the orishas. In this tra-
dition of communication and exchange between human beings
and the divine, devotees consult the orishas through the technique
of divination and feed the orishas through the technique of sacri-
fice. The orishas respond by listening to their devotees and making
things happen for them.

Orishas come in at least three overlapping types, running from
those who are plainly divine to those who might be better described
as superhuman. First, there are orishas who were present with
Olodumare at creation: Obatala, Eshu, and Orunmila. Second,
there are personifications of natural forces—Yemoja as the sea and
Oshun as the river—who flip the script of Christian incarnation
by becoming divine not by taking on a human body but by disap-
pearing into a river or hill. A third type comprises deified ancestors
who once walked the earth as mere mortals, such as the ancient
Yoruba king Oduduwa. These categories are not entirely separate,
however. Shango, the god of thunder and lightning, is also said to
be a former king of the great Yoruba kingdom of Oyo.

One of the most intriguing facets of the orishas is how inescap-
ably human they act. They have personalities and preferences, in-
cluding their own distinctive tastes in food, drink, and music. Like
Hindu gods, they marry. Unlike Hindu gods, they also divorce.
And they are far more passionate than the domesticated gods of
the Western monotheisms, where the divine temperament seems
almost Scandinavian by comparison.

The gaps between sacred and profane, spirit and matter, the su-
pernatural and the everyday, are at best hairline cracks in Yoruba
culture. The distinction between divinity and humanity is equally
fuzzy, since human beings carry the awesome power of ashe inside
them and orishas are by no means above even the basest human
emotions. Many orishas are adept at both creation and destruction.

The storm (and stormy) deity Oya, for example, brings both the abundance of irrigation and the devastation of floods. Orishas are sometimes compared to Greek gods for their foibles and fallibility, but the comparison is not quite apt, because the orishas suffer for their misdeeds, while it is quite common for Zeus and his friends to get off scot-free. Moreover, most orishas live in the earth rather than on mountains or in the sky (Shango and Olodumare are the notable exceptions).

So Yoruba religion is reciprocal—a system of communication and exchange between human beings and the divine mediated by a vast pantheon of powers (many of them former human beings) with one foot in the natural realm and the other in the supernatural. Here both sides speak and both sides listen. As in Hinduism, both sides give and both sides receive. Without the orishas to empower them, human beings would die. But without human beings to feed them, the orishas would die too. As a Yoruba proverb puts it, "If humanity were not, the gods would not be."[5]

Since Yoruba culture is oral by tradition, you might think that there would be an extensive iconography built up around the orishas. Not so. Classically, orishas are represented in shrines through natural rather than artistic objects: stones and herbs rather than paintings and statues. In the New World, the orishas were traditionally worshipped via images of the Catholic saints with whom they were identified. Only in recent decades have images of the orishas themselves started to circulate. This is because the Yoruba approach the divine largely through stories. If, as Régis Debray contends, "to lack a legend is also to lack dignity," then the Yoruba are a dignified people indeed.[6]

Yoruba stories can be found in the massive Ifa corpus memorized and chanted by babalawos. Here the orishas seem to be "one of us" rather than sacred in the sense of "set apart." In addition to the full range of human emotions, they exhibit a full complement of virtues and vices. Like the Hindu gods, they do not present themselves as either wholly good or wholly evil. They can be generous and petty, merciful and vengeful. They can harm as well

as heal. And so they challenge us not to eradicate evil but to balance it with good, and not only "out there" in the world but also inside ourselves (where good and evil coexist). This complexity has long troubled Christians, Muslims, and scholars alike, who all too often fail to see the lessons lurking underneath the orishas' moral failings, as if they have stumbled upon a double bill of *King Lear* and *Othello* and have nothing more to say than that Edmund and Iago don't seem to be proper gentlemen. Of course, Yoruba practitioners have no trouble unearthing these lessons, just as Shakespeare's audiences saw the complexities of human existence acted out on the Elizabethan stage. But the fact that the gods stumble and stir is one of Yoruba religion's glories. The Yoruba corpus, writes art historian Robert Farris Thompson, provides a "limitless horizon of vivid moral beings."[7]

Ashe is the key concept in Yoruba thought, and its central meaning is the awesome power to make things happen. But secreted inside this power is the equally awesome power to make things change. So to observe that the orishas change—to see that they are, to borrow from Karen McCarthy Brown, "larger than life but not other than life"—is not to find fault.[8] It is to praise them for drawing near to the human condition, for refusing to hold themselves above and beyond the rest of us. After all, the biblical God is only *said* to be good. He does evil things, or permits them, which for an omnipotent being is almost as bad, leaving believers scurrying to justify God's actions (or inactions). In Yoruba religion no such theological gymnastics are necessary.

While traveling in Bali, I was struck at how much could be (and was) made by Balinese Hindus of their vast system of correspondences of gods to the cardinal directions, to colors, to parts of the body, and to foods. The system of correspondences in orisha devotion is even more extensive. At least in the New World, the orishas are most famously associated with Catholic saints, but they are also associated with numbers, colors, emblems, virtues, herbs, clothing, jewelry, temperaments, land formations, bodies of water, parts of the body, days of the week, occupations, natural forces, drum beats,

songs, dance steps, foods they will not eat, and foods they cannot do without. To take just one example, Cuban devotees of Oshun associate her not only with Our Lady of Charity (the patron saint of Cuba) but also with love, rivers, gold, fertility, the lower abdomen, seduction, fans, seashells, brass, the color yellow, the number five, and pumpkins.

So Yoruba religion is not simply a system of communication and exchange between the divine and human realms. It is also a map to every mountain and valley of human experience, a system of signs and wonders out of which one can make meaning from seemingly small and unrelated things. One Candomble practitioner in Brazil refracted the television show *Gilligan's Island* through the prisms of two goddesses, Oxum (Oshun) and Iansa (Oya). To Candomble devotees, these two goddesses embody very different feminine forces—the "cool" coquette Oxum and the "hot" bombshell Iansa. But to this practitioner (and TV aficionado) Oxum was Ginger and Iansa, Mary Ann.[9] The net effect of this net of correspondences is to make everything, everyone, and everywhere potentially sacred. Every moment presents a possibility to reconnect with the orishas and, through them, with your destiny and the harmony that pursuing it brings.

Devotees disagree about just how many orishas there are. One reason the orishas are hard to count is that, like Hindu divinities, they answer to different names in different places, so it is often unclear when you meet a new orisha whether she really is a new acquaintance or someone you have already met under another name. The accounting traditionally runs to either 401 or 601—with the plus-one gesturing at the fact that in Yoruba culture there is always room for one more at the table. But one text speaks of 3,200, and some claim there is really only one divinity—that the "lesser" divinities we call orishas are all manifestations of the High God Olodumare.[10]

Keeping up with the orishas is easier in the New World than in West Africa, because in the transatlantic passage many orishas went missing. Most Brazilian and Cuban practitioners recognize

only one or two dozen orishas. Some whittle that pantheon down to the "Seven Powers" (typically four men and three women), which sounds helpful until you realize that, like the Ten Commandments, these *siete potencias* vary depending on who is reciting them.[11]

Orishas can be classified into male and female, sky and earth, hot and cool, forest and town. But Yoruba practitioners, in keeping with their strong preference for action over belief, do not typically worry themselves about such things. Neither do they fret about the afterlife. What really matters is how to get the orishas to intervene on your behalf in thisworldly matters of love, luck, and work. In order to do that, you need to get to know them—what they eat, what they wear, and how they sing and dance.

Olodumare

The Supreme Being for orisha devotees is Olodumare, also known as Olorun ("Owner of the Sky"), who rules the cosmos from on high. Like the God of Deism, Olodumare is as remote, distant, and difficult to approach as your steely great-grandfather. Unlike the God of Deism, he did not create the world, choosing to delegate that job to others.

Though practitioners will occasionally send prayers in his direction, they don't worship Olodumare directly. He has no temples, no liturgy, and no priests. He does not possess devotees in festivals. Although all sacrifices in some sense run through him, no one sacrifices to him directly. Like the abstract Hindu creator god Brahma, Olodumare is respected more than he is revered. When it comes to the day-to-day concerns that stand at the center of Yoruba religion, practitioners go to "lesser" agents for help. So Yoruba devotion focuses on them.

There is some disagreement about whether Olodumare was present at the creation of Yoruba religion or whether he is a relatively recent invention—a nod to the same monotheistic imperative that pushed Hindu intellectuals under British rule to shrink

the Hindu pantheon to one. There is also disagreement about whether the orishas are emanations of Olodumare or whether he is an abstraction of them. A parallel conversation concerns whether other orishas do the heavy lifting when it comes to answering prayers or whether those boons come from Olodumare himself (with the orishas acting merely as intercessors). Regardless of the details of the relationship between this sky god and these "lesser deities," Yoruba practitioners today speak of Olodumare as the chief source of power—"the supreme quintessence of *àshe*"—in a religious tradition that is all about power.[12]

Eshu

Of all the orishas, Eshu and Orunmila are the most important. In this religion of communication and connection between *orun* and *aiye* (heaven and earth), Orunmila the diviner delivers messages from above to humans, while Eshu the messenger delivers (or refuses to deliver) sacrifices from below to orishas and other spiritual beings. Without Eshu, interactions between heaven and earth would cease and human existence would spin into chaos. Though there is no priesthood devoted to him, images of Eshu can be found in almost every Yoruba home, and all shrines make at least a small place for him. That is because every sacrifice must include what gamblers call a rake for Eshu. If you don't feed him a little palm oil or tobacco (both personal favorites) at the beginning of a sacrifice, he won't have the energy, or the inclination, to do your bidding. For this reason Eshu is also known as Elegbara (or Elegba or Legba), which means "owner of the power" (of ashe).

Like Hinduism's Ganesha, Eshu is associated with crossroads, because as the holder of ashe he has the power to take almost any situation in whatever direction he pleases. Crossroads are important in many religious traditions. Jesus, of course, is remembered by the sign of the cross, and the most popular Hindu divinity, Ganesha, is lord of the crossroads. The crossroads is the meeting place of the natural and the supernatural, the visible and the

invisible, the known and the unknown. It is heads and tails, left and right, where power lines cross and sparks fly. Here two roads diverge, and we determine our destinies by choosing the road less (or more) traveled.

As the guardian of crossroads, Eshu clears the way for those who attend to him and puts up roadblocks for those who neglect him. He inserts uncertainty and unpredictability into a world otherwise governed by fate, and he then sits back and laughs at the chaos that follows. So Eshu is a trickster, too, an ambiguous figure—both policeman and troublemaker—whom Christians have long confused with the devil. The Yoruba divide their pantheon into two halves, which my former colleague Wande Abimbola refers to as "gods" and "anti-gods"—the orishas on the right, who represent benevolence, and the *ajogun* on the left, who represent malevolence. As someone who straddles the two, Eshu isn't above getting into a little mischief now and then. Or, as an Ifa verse puts it, "Death, Disease, Loss, Paralysis, Big Trouble, Curse, Imprisonment, Affliction. They are all errand boys of *Esu*."[13]

One of his most popular tales tells of Eshu stirring up trouble yet again. His colors are red and black, so he struts down the middle of the street with a trendy cap (impossible not to notice) colored red on one side and black on the other. People on one side of the street admire his fashionable red cap, but people on the other side of the street insist that his cap is black. The row that ensues (quite bloody in many versions) brings a wry smile to Eshu's lips, solidifying his role as a maker of mischief and disturber of the peace.

Today this messenger orisha is associated with the Internet, and with travel and transportation. If your car is hit at a crosswalk, or your hard drive wipes out all your emails, you may have crossed Eshu. But perhaps more than anything else, Eshu is associated with change. Every day we stand at a crossroads of some sort. It is Eshu whose provocations jerk us out of drift. He helps us find which way our destiny is calling us and gives us the courage to move forward in that direction.

Orunmila

As the mastermind behind Ifa divination, Orunmila (aka Orula and Orunla) is, according to some devotees, the "preeminent orisha" and "the cornerstone of Yoruba religion, metaphysics, and spirituality."[14] There is some disagreement about whether Orunmila, the orisha of wisdom, and Ifa, the orisha of destiny, are different people, or whether the two are just different names for the same ancient sage—the Yoda of orisha devotion.

Orunmila is the owner of the Ifa corpus, the great storehouse of wisdom of Yoruba mythology, philosophy, ethics, and theology. Because he was present at creation, Orunmila is said to know the destinies of humans and orishas alike. Given his omniscience, which includes the ability to predict the future, he is, according to many Yoruba, second only to Olodumare, though partisans of Eshu will dispute this interpretation. For some Yoruba practitioners, Orunmila, who is associated with harmony and stability, and his friend Eshu, who is associated with chaos and change, form, along with Olodumare, a sort of trinity. Although Orunmila is said to be short and very dark—"black as Ifa" is a common Yoruba saying—he is almost never represented in sculptures. That is because the spoken word is his métier. Although he will occasionally possess his priests in West Africa, he does not do so in the New World, where he is typically associated with St. Francis.

Oshun

Oshun, the "Ginger" of the Yoruba pantheon, is the orisha of rivers and sweet water, particularly of Nigeria's Osun River with which she is closely associated. She was the only female present at creation and the first to perform Ifa divination. In West Africa she is an orisha of fertility and childbearing, but in the New World she becomes something of a goddess of love. A great beauty, covered with brass bling and awash in husbands, lovers, and children, Oshun is the "Yoruba Venus" and the Shakti of the New World.[15]

But Oshun, whose beverage of choice is maize beer, is not all sweetness and light and grace on the dance floor. As with so many orishas, her power cuts both ways. Yes, she helps women in childbirth, but she's also good with knives and deadly poisons. Oshun is even more ruthless in love, however. She doesn't just play the field, she tears it up. She dumped Shango because he started to drink a beer she hated. She dumped Orishanla because he started eating snails. In the end, she tired of all the drama and got herself out of the love racket entirely by turning herself into a river.

One wonderful story about Oshun tells of Olodumare sending seventeen gods to order the earth. Only one of these orishas, Oshun, was female. So the male gods, who could count and thought that women were weak anyway, refused to involve her. She retaliated by withholding water from the earth. Without rain and rivers, crops could not grow, mothers could not drink, and babies could not nurse. So everything went to hell, and the old-boys' network went to Olodumare to gripe. But Olodumare would have nothing of it. He rebuked the male orishas for refusing to work with Oshun. So they apologized to her, and she accepted their apology, but only after they promised to respect her authority in the future.[16]

Obatala

Obatala ("king of the white cloth") or Orishanla ("great orisha") is the god of human creation who first fashioned clay into human form. Although Oshun is sometimes credited with human conception, it is Obatala who molds the stuff of the embryo into the shape of a human being. Obatala (Oxala in Brazil), the oldest and wisest of the orishas, is the quintessence of "cool," one of the central values in Yoruba culture. A model of the sort of patience that makes for peace, he has "the aesthetics of the saint."[17] As his name suggests, Obatala is associated with whiteness. His devotees dress in white and wear lead bangles. His temple walls are whitewashed, and he enjoys white fruits, white yams, white birds (especially doves), and

other white foods such as rice and coconuts (though, for the record, he does *not* like salt, or for that matter pepper).

The most commonly told story about Obatala (who also has a serious aversion to dogs) speaks of his getting drunk on palm wine while he was supposed to be creating the world. As a result, that job had to be taken over by Oduduwa, who used a five-toed chicken to spread sand over the water in all directions, as far as the eye could see. When Obatala woke up from his drunken stupor, he swore off palm wine not only for himself but also for his followers. When it came to making human beings, however, Obatala fell off the wagon. Botching this job, too, he created albinos, dwarfs, hunchbacks, and other physically deformed people, who to this day are sacred both to him and to the Yoruba—*eni orisha*, god's people.

Obatala also played a role in legitimizing the Cuban Revolution of 1959. On January 8, 1959, just days after Castro and his guerrillas took Havana, a white dove alit on his shoulder during his speech for national unity. The white dove symbolizes Christianity's Holy Spirit, but it also symbolizes Obatala, so in his first public act as leader of this new nation, Castro saw the support of both Catholicism and Santeria literally land on his shoulder.[18]

Ogun

Worlds apart from cool Obatala is hot Ogun, the orisha of iron. Ogun (Ogum in Brazil and Ogou in Haiti) has classically been associated with tool making, hunting, and war—the sword, the spear, and the soldier. Because he made the first tool, he is also the god of creativity and technology. In a wonderful example of the elasticity of Yoruba religion, Ogun came in the modern period to be connected not just with iron but with metals of all sorts. Today he is the orisha of both the locomotive and the speeding bullet, patronized by not only blacksmiths and barbers but also train conductors, auto mechanics, truck drivers, airline pilots, and astronauts. If you were injured in a car accident, you may have offended this orisha of creation and

destruction, who in the New World is worshipped as St. Peter, St. Anthony, and St. George.

Although Ogun put in an occasional appearance in the 1980s television series *Miami Vice*, his big moment in the Yoruba story came in primordial time. Kabbalistic Judaism speaks of a lonely God who creates humans in order to know and be known, love and be loved. In the Yoruba story human beings have already been created, but the orishas are lonely nonetheless because with the shattering of the original unity of the cosmos their realm has been cordoned off from the realm of us mortals. Eventually the orishas decide to reunite with human beings. But the abyss separating *orun* (sky) from *aiye* (earth) has been choked by chaotic overgrowth of cosmic proportions. So, try as they might, the orishas cannot make passage. At this point brave Ogun comes to the rescue. He snatches iron ore out of the primordial chaos and fires it into a tool powerful enough to whack his way across the abyss; in so doing, he clears a path for the other orishas to descend to earth behind him.

Ogun eventually made his way to Ire, in modern-day Nigeria, where he was lauded as "he who goes forth where other gods have turned." But soon he made a huge mistake. He went into battle while under the influence of palm wine, and in a drunken rage slew friends and foes alike. Although the people of Ire still wanted him to serve them as king—who better to administer justice than someone who was himself so intimate with injustice?—he was not so quick to forgive and forget. Withdrawing to the surrounding hills, he spent his time beating swords into plowshares as a farmer (and/or a hunter). He did not give up alcohol, however, and neither do his devotees. In another version of the story, Ogun turned his sword on himself after he saw what he had done and then disappeared into the earth. Either way, Ogun is one of the Yoruba's great tragic figures. The celebrated Nigerian Nobel laureate, poet, and playwright Wole Soyinka sees him as an embodiment of "Dionysian, Apollonian and Promethean virtues"—"the first actor . . . first suffering deity, first creative energy, the first challenger, and conqueror of transition."[19]

Ogun has been depicted largely as a god of violence and blood (his color is red), but like the bellicose Hindu goddess Kali he is also a god of justice who uses his pathbreaking abilities to uproot oppression. Praise songs refer to him as a "protector of orphans" and a "roof over the homeless," and in courts traditional Yoruba swear to tell the truth not by putting a hand on the Bible but by kissing iron.[20] Ogun's abilities in war, commitments to justice, and capacities of creative transformation have made him even more popular in the Americans than in Africa. He was a major figure in the drives for Cuban independence in 1959 and Nigerian independence in 1960. Some claim that in the Cuban Revolution Ogun mattered more than Marx himself.

Shango, Oya, Shopona, Yemoja, and Osanyin

Other important orishas include: Shango (also Xango and Chango), god of thunder and lightning—the "storm on the edge of a knife" according to one praise song[21]—and, in modern times, electricity, who also embodies virility and male sexuality; Oya (also Iansa), ruler of Ira, goddess of the Niger River, guardian of cemeteries, and owner of the wind, who sends strong gusts in advance of her husband Shango's storms ("Without her," it is said, "Shango cannot fight");[22] Shopona (aka Babaluaye, "Father, Lord of the World," and Obaluaye), god of smallpox and other contagious diseases (but also of healing), who walks with a limp but is so feared that many Yoruba treat him like Voldemort of Harry Potter fame, refusing to utter his name; Yemoja (aka Yemaja and Yemanja), goddess of the ocean and of motherhood, who while dancing sways her hips like the tides; and Osanyin, one-legged, one-eyed, one-armed god of healing herbs who speaks in a squeaky Pee Wee Herman voice and graces botanica signs from Havana to New York City.

Ashe

What makes these orishas orishas is power, which in Yoruba religion goes by the name of ashe. Ashe is often described in metaphors that yoke science and religion—as sacred force or superhuman energy or spiritual electricity. So ashe is akin to the life force that the Chinese call *qi*. The closest rendering into English of this term, which literally means "So be it," or "May it happen," is probably just "Amen." But the best definition comes from Robert Farris Thompson who calls it the "the power-to-make-things-happen."[23]

Yoruba practitioners recognize Ile-Ife, where the orishas created human beings and set the world in motion, as a center of ashe. Ashe also accumulates in Candomble and Santeria centers (*terreiros* and *casas*, respectively). But this same sacred power can be found as well in orishas, priests, diviners, chiefs, family heads, and ordinary human beings. It resides in "spoken words, secret names, thoughts, blood, beaded necklaces, ritually prepared clothing, earth, leaves, herbs, flowers, trees, rain, rivers, mountains, tornadoes, thunder, lightning, and other natural phenomena."[24] And it manifests in drumming and dance, poetry and song. Just as Hindus have been criticized for worshipping statues, the Yoruba have been criticized for worshipping rocks. But what the Yoruba approach with awe is not the rock but the sacred power that animates it.

In whatever form, ashe directs itself toward change. Because Yoruba religion is eminently practical, ashe is about having real effects in the real world—"as luck, power, wealth, beauty, charisma, children, and love."[25] Thompson's definition emphasizes the fact that ashe makes things happen. But ashe also makes things stop. Every time the palm nuts are cast and an odu is spoken, this tradition testifies to the possibility of growth, not least the possibility of new ways to embody ancient wisdom. Like the orishas themselves, however, ashe is not empowered only toward the good. Its transformative power can be (and is) used toward both good ends and bad.

It connects and disconnects. And when it comes to matters of life and death, ashe gives and ashe takes away.

A Global Religion

Books on the world's religions often include a chapter on "primitive," "preliterate," or "primal" religions, as if they were one and the same. All these religions really share, however, is a stubborn refusal to be crammed into the boxes constructed to fit more "advanced" religions. Stuffed into these chapters (which often fall at the end of the book) are all sorts of religious traditions that in many cases have far less in common with one another than do the "advanced" religions. As a result, these chapters often read like half-hearted apologies for the tendency of scholars (many of whom are trained in translating and interpreting scriptures) to gravitate toward religions that emphasize reading and writing over speaking and hearing. But the tendency to lump Australian and Native American and African religions with such lower-case religious phenomena as shamanism, totemism, and animism is driven by another, equally important bias. Just as considerations of black and white have dominated conversations about race in the United States, and considerations of Anglophone and Francophone have dominated conversations about culture in Canada, conversations about the world's religions have been dominated by the East/West divide. In BU's Department of Religion, our year-long introduction to the world's religions is split into Eastern and Western semesters. Unfortunately, this approach obscures and often renders invisible religions that do not fall easily along either side of the East/West divide.[26]

It should not be surprising, therefore, that while Yoruba language, culture, and art have been studied with care for a century or so, Yoruba religion has been either entirely neglected or dumped into that "primal" religions chapter in standard treatments of the world's religions. But the religion of Yorubaland and its diasporas

is its own thing, as distinct from the religion of the Sioux as Buddhism is from Islam. And it, too, is one of the great religions.[27]

Estimates of the number of Yoruba practitioners in West Africa vary widely but doubtless run into the tens of millions. Nigeria, the homeland of the Yoruba people, is Africa's most populous country, and the Yoruba, who can also be found in Benin, Togo, and Sierra Leone, are one of Nigeria's largest ethnic groups. According to Harvard professor Jacob Olupona and Temple professor Terry Rey, the Yoruba number about 25 million in West Africa alone.[28]

Islam and Christianity are now the dominant religions in Nigeria (with 45 percent of the population each), so most of the Nigerian population speaks reverently of either Muhammad or Jesus (or both), and there have been coordinated efforts among both evangelicals and Pentecostals to demonize Yoruba orishas. But even among the converted it is rare to find someone who has entirely banished Yoruba religion from her repertoire. Practitioners of Yoruba religion challenge cherished notions of what religion is and how it functions by refusing to choose between the orishas and Jesus or the orishas and Allah. Who says religion has to be a zero-sum game? Not the Yoruba, who feel quite comfortable seeing the priest on Sunday and the diviner on Monday. Instead of greeting foreign religions with the either/or of Aristotle, they greet them with the both/and of Eshu. As a result, Yoruba beliefs and practices survive not just on their own, among those who have rebuffed the advances of Islamic and Christian missionaries, but also inside Islam and Christianity, which Yoruba Muslims and Christians have stealthily transformed into distribution channels for Yoruba religious culture. Despite efforts by Muslim and Christian purists alike to root out the bugaboo of "syncretism," Muslims and Christians in Yorubaland (including ministers and imams) continue to go to Yoruba diviners and participate in Yoruba festivals. This creolization is particularly plain in Aladura Christianity, a Yoruba/Christian hybrid that traffics in the thisworldly powers of fervent and frequent prayer. In fact, the term *Aladura* itself attests to even

wider religious mixing among the Yoruba, since the word *adura* derives from the Arabic for intercessory prayer.

Yoruba religion is by no means confined to its African homeland, however. Yoruba-derived religions are also scattered across the African diaspora created by the transatlantic slave trade—in Brazil and Cuba, Colombia and Puerto Rico, Jamaica and Grenada, St. Kitts and St. Vincent, the Dominican Republic and Venezuela, Uruguay and Trinidad and Tobago. Yoruba slaves arrived by the millions in South America, the Caribbean, and the United States, as civil wars beset Yorubaland during the nineteenth century and victors sold off their spoils into slavery. These slaves had a huge impact on economic, cultural, and religious life in the Americas. "No African group," writes the pioneering Yoruba scholar William Bascom, "has had greater influence on New World culture than the Yoruba."[29]

In the New World, traditional African religions were denounced as "heathen" and often outlawed. Even drumming was prohibited in the seventeenth century in Haiti and severely restricted in later centuries in Brazil and Cuba. So Yoruba practitioners did what the Yoruba have been doing ever since their orisha of iron, Ogun, forged a path for the gods from heaven to earth: they adapted to difficult circumstances with courage and creativity. This was hard going in the United States, where the ratio of slaves to whites was low, the ratio of American-born to African-born slaves was high, and Protestant slave masters ruthlessly prohibited slave gatherings of any sort. But in Brazil and Cuba, which saw large numbers of Yoruba high priests, frequent arrivals of new slaves from the Old World, a high ratio of slaves to whites, a lingering slave trade (until the 1850s in Brazil and the 1860s in Cuba), and less slave owner opposition to dancing and drumming, Yoruba practitioners kept their religious traditions alive by marrying them to Catholicism. When ordered to cease and desist from the beliefs and practices of their ancestors, Yoruba slaves took their orishas underground and then resurrected them in the guise of the saints: Ogun as St. Peter; Yemoja as Our Lady of Regla; and Oya as St. Theresa. So

things changed, and remained the same. Praise songs to these orishas continued to be sung in the Yoruba language and to Yoruba rhythms, but for the most part devotion now went forward in the idioms of Catholicism and the grammars of Spanish, French, and Portuguese. The overall tale, however, is one of continuity. The list of elements of Yoruba religion that survived the horrors of the Middle Passage and slavery runs to divination, spirit/body possession, drumming, dance, initiation, reincarnation, spiritual healing, sacrifice, and, of course, orisha devotion itself.

Were slaves self-consciously conning religious and political authorities by cross-dressing the orishas as Catholic saints and then celebrating their exploits on these saints' feast days? Yes, says Soyinka. Their strategy was to "co-opt the roman catholic deities into the service of Yorùbá deities; then genuflect before them."[30] Some slaves may have been just that strategic, pretending to worship St. Peter when they were actually worshipping Ogun. But it is also possible that Santeria, Candomble, and their Yoruba-derived kin evolved in fits and starts, a marriage more of convenience than of cunning and camouflage. Though many practitioners today see the saints as masks put on the faces of orishas, others see orisha and saint alike as manifestations of the divinity that underlies and infuses each.

100 Million?

Today descendants of these slaves continue to preserve and practice the ways of their forebears under a variety of (dis)guises, including Santeria (literally "the way of the saints," also known as Lukumi and La Regla De Ocha) in Cuba; Candomble, Umbanda, and Macumba in Brazil; the Orisha Movement (aka Shango) in Trinidad and Tobago; Kele in St. Lucia; and, to a lesser extent, Vodun in Haiti.[31] Many whites and Hispanics without any blood ties to Yorubaland also participate in these traditions, and orisha devotees, who were once almost entirely poor, can now be found among the

middle classes. What these traditions share is a marriage to Catholicism plus fidelity to core techniques of orisha devotion such as divination, spirit/body possession, and sacrifice. This marriage has lasted because of the striking similarities between Roman Catholicism and Yoruba religion. Both operate in a cosmos with a Supreme Being at the top, human beings at the bottom, and a host of specialized intermediaries in between facilitating communication and exchange across the divine/human divide. And while intellectuals in both speculate about the afterlife, each is heavily invested at the popular level in everyday life. It is not beneath the orishas (or the saints) to care about our toothaches, our children, our promotions, or our lovers.

Because there are no central organizations of any sort for Candomble, Santeria, or their kin, there are no official numbers for adherents to Yoruba-derived religious traditions in the diaspora. The Yoruba penchant for secrecy makes even unofficial numbers elusive, and the stigma that these traditions are "primitive" and even "Satanic" keeps many practitioners under cover. Further complicating matters (and challenging deeply ingrained notions of how religion is supposed to work) is the fact that New World orisha devotees do not feel the need to choose between an identity as a Catholic and an identity as a practitioner of Candomble or Umbanda or Macumba or Santeria.

And then there is that small matter of what exactly we are trying to count. Those who have undergone initiations and had an orisha placed in their ori? If so, the numbers are admittedly quite small. Or those who have gone to diviners on matters of health, work, and love? If so, the numbers are quite large. Joseph Murphy, a professor in Georgetown's Department of Theology, writes that he has "yet to meet a Cuban of any social class or racial category who has not at least once consulted (or, more circumspectly, 'been taken to consult') an *orisha* priest/ess about some problem."[32]

This distinction may help make sense of the huge gap between census numbers for orisha devotion in Brazil and estimates thrown around by scholars. Yoruba religious traditions are particularly

strong in Brazil, which saw the largest slave migrations of any-where in the New World (about four million between the 1530s and the 1850s) and some of the largest ratios of slaves to free people. As the slave trade ended in the middle of the nineteenth century, slaves accounted for more than a third of Brazil's total population and enjoyed majorities in cities such as Rio de Janeiro and Salvador da Bahia. So orisha devotion in Brazil is "very pervasive"—"part of the popular culture, and the Brazilian way of life."[33]

Yet Brazil's 2000 census found only 128,000 people who self-identified as practitioners of Candomble and 397,000 who self-identified as practitioners of Umbanda.[34] How to reconcile these modest numbers with books that speak routinely of tens of mil-lions of adherents *each* for Candomble and Umbanda? Perhaps the census figures reflect those who practice Afro-Brazilian traditions quite apart from any Catholic identity, while the more generous estimates account for people with multiple religious identities—those who, while still on the Catholic rolls, nonetheless attend orisha festivals, consult orisha diviners, and "make ebo" (sacrifice).

Happily, there is some good data about the institutional di-mension of Candomble, which is the earliest, most resolutely African, and (census figures notwithstanding) most popular of the Yoruba-derived religions of Brazil. This data is particularly helpful in the northeastern state of Bahia, where orisha devotion is at least the equal of Catholic faith and probably its superior. Salvador da Bahia, this state's capital, has been called the "Black Rome" because of its Afro-Brazilian population and its Catholic piety. It is said that there are 365 churches in the city, one for every day of the year. Though this makes a good story, the figure is likely exaggerated. Either way, Candomble terreiros far out-number Catholic churches. Statewide, total terreiros skyrocketed from 67 in the 1940s to 480 in the 1960s to 1854 in 1989.[35] Today there are well over two thousand, and not all of them of the store-front variety. In fact, some resemble evangelical megachurches. Ile Axe Opo Afonja, a terreiro founded in 1910 and run in the early twenty-first century by the charismatic Mãe Stella de Oxóssi,

includes "a school, a daycare center, craft workshops, a clinic, and a museum spread across a multi-acre campus."[36] It attracts not just the down-and-out often associated with Afro-Brazilian religions but also prominent and well-to-do leaders in politics, business, education, and the arts.

One hundred million is the most commonly printed estimate for Yoruba practitioners worldwide, but total adherents—people who seek help from the orishas in some manner—probably top out at eight figures rather than nine. If Olupona and Rey are right, there are 25 million adherents in West Africa, making Yoruba religion the most widely practiced religious tradition on that continent after Islam and Christianity. Brazil, whose total population was 187 million in 2009, is home to at least another 10 to 25 million; Cuba (population 11 million) is home to at least two or three million more; and the United States has a few hundred thousand. Even by these conservative estimates, there are more adherents to Yoruba religion than there are Jews, Sikhs, Jains, or Zoroastrians, placing this tradition, on numbers alone, securely among the world's top six religions.[37]

Yoruba religion is not only great in terms of numbers and geographic reach, however. It is also great in the sense of ancient and monumental. In ancient Africa, the Yoruba, who organized themselves in towns run by a ruler (*oba*) who also served as a religious head, were among the most urbanized of peoples. By the ninth century C.E., their sacred capital of Ile-Ife was a thriving metropolis, and over the next few centuries Yoruba artists were creating objects of beauty out of terracotta and bronze that, according to Thompson, were the wonder of the West. Yoruba culture suffered through the rise of modernity under a combination of internal and external pressures, including foreign missions, colonialism, and civil war. Yet the Yoruba remain, according to Thompson, "creators of one of the premier cultures of the world."[38] And, I would add, of one of its premier religions. Just as the Bible has inspired the art of Bach, El Greco, and Toni Morrison, stories of the orishas have for centuries moved the hands and hearts of dancers, singers, novelists, painters, and poets in West Africa and beyond, including

Morrison herself, whose 1998 novel *Paradise* features a Candomble priestess and a goddess reminiscent of the Candomble water orisha Yemanja (Yemoja in Yorubaland).

Mãe Stella, Oyotunji, and Africanization

Not everyone is happy with this diffusion of the Yoruba religious impulse across the New World, of course. Many evangelicals and Pentecostals denounce orisha devotion as witchcraft, sorcery, and demon worship. Many Catholic priests see Santeria and Candomble as bastardizations of the true faith. A lawyer who tried to shut down a Santeria center in Miami called Santeria "a cannibalistic, voodoo-like sect which attracts the worst elements of society."[39]

Some Yoruba practitioners themselves see Santeria and Candomble as bastardizations. But rather than trying to purify their tradition of African superstitions, they are trying to decatholicize it. Like the Puritans of seventeenth-century England and New England, these reformers are intent on divorcing themselves from Catholic influences. But rather than looking to the Bible and the early Christian movement for models, they seek to restore the pristine traditions of the ancient Yoruba kingdoms.

In Brazil, the popular and powerful Bahian priestess Mãe Stella has challenged all Candomble practitioners to take off the fig leaf of the Catholic saints and worship African orishas in the open, without apology, guilt, or fear. Catholicism is no longer required, and Candomble is no longer outlawed, Stella reasons, so "the saints should be dumped, like a mask after Carnaval."[40]

Another effort to take orisha devotion "back to Africa" is Oyotunji African Village, which aims to re-create what it imagines to be a precolonial Yoruba kingdom in the contemporary American South. Located near Sheldon in rural Beaufort County, South Carolina, Oyotunji (the name means "Oyo Rises Again") was founded in 1970, but its roots go back to New York and the 1950s. Its founder, His Royal Highness Efuntola Oseijeman Adelabu

Adefunmi (aka Walter King, 1928–2005), established the Order of Damballah Hwedo Ancestor Priests in 1956 and the Shango Temple (later renamed the Yoruba Temple) in 1959, both as refuges for African Americans interested in wearing African clothes, taking African names, and living an African lifestyle.

Adefunmi, who was raised on the teachings and institutions of the pioneering black nationalist Marcus Garvey, encountered various forms of African religion on trips he took as a young man to Egypt and Haiti. In 1959 in Cuba he was initiated into the Santeria priesthood of Obatala. But in keeping with his "back to Africa" commitments, his community aimed to purify itself of New World influences. To that end, Adefunmi was initiated into the Ifa priesthood in Nigeria in 1972. On a later trip to Nigeria he was coronated an oba in Ile-Ife in 1981. Despite efforts to strip Catholic (and Protestant) masks off New World Yoruba practice, many influences from Santeria remain at Oyotunji. However, life at this twenty-seven-acre community has diverted from Cuban practice on the gender front, where since the 1990s women had access to the Ifa priesthood, a responsibility out of reach for them in Havana and its environs.

Life at Oyotunji has proved financially and culturally difficult for many, and the population has fluctuated as a result. The number of residents likely peaked at two hundred or so in the early 1970s and stood at a few dozen in the first decade of the twenty-first century.[41] Village residents, who rely heavily on Ifa divination to pursue their individual and collective destinies, have been led since Adefunmi's death in 2005 by his son, now known as Oba Adefunmi II.

The Africanization efforts of Stella and the Adefunmis have prompted an intriguing debate. Flipping the script on those who would decatholicize Santeria, some *santeros* and *santeras* (as practitioners are called) believe that Yoruba religion is actually purer today in Cuba than it is in West Africa, given how thoroughly Islam has penetrated Yoruba culture in its homeland.

Desi Arnaz and DC Comics

Though most Europeans and Americans know almost nothing about this great religion, over the last generation or so Yoruba religious traditions have come increasingly to international attention. In the 1950s, Cuban-American actor and musician Desi Arnaz sang repeatedly to the Yoruba orisha Babaluaye on the sitcom *I Love Lucy*, and in the wake of the Cuban Revolution of 1959 hundreds of thousands of Cuban refugees, many of them Santeria practitioners, flooded into the United States. Beginning in the late 1960s, Nigerian Afrobeat musicians such as Fela Amkulapo Kuti and King Sunny Ade toured the West, creatively translating the Yoruba aesthetic into idioms that lovers of rock and pop could understand. The popular Brazilian film *Dona Flor and Her Two Husbands* (1976) brought awareness of Candomble (the orishas come to the assistance of a grieving wife played by Sonia Braga) both to the Portuguese-speaking world and to millions who viewed it in subtitles in Europe and the United States. Black nationalism triggered a search for African roots buoyed by the Alex Haley book *Roots* (1976) and the twelve-hour television miniseries that followed. The Mariel boatlift of 1980, which brought over a hundred thousand Cubans to the United States, increased both the vitality and visibility of Santeria in the United States. A DC Comics series called Orishas debuted in 1990. Finally, a pathmaking U.S. Supreme Court case, *The Church of Lukumi Babalu Aye v. City of Hialeah* (1993), legitimated Santeria by ruling that efforts by local authorities in Hialeah, Florida, to outlaw animal sacrifice violated First Amendment guarantees of religious liberty. Since the 1990s, Yoruba religion has also taken to the World Wide Web, where sites such as Orishanet.org do what other religions do online—educate, aggregate, debate, and in some cases confuse. It is now possible to consult with a diviner through cyberspace.

For centuries Muslims and Christians have denounced Yoruba religion as superstition. In the 1970s and 1980s, this tradition was

further tarnished by a series of cult scares, epitomized by the 1987 Hollywood thriller *The Believers*, which equated Santeria with human sacrifice. More recently, a *Newsweek* story called Santeria practitioners "poultricidal zealots."[42] But this is an ancient religious tradition, nearly as old as Islam, which offers a profound diagnosis of the human problem, a practical solution, and a series of techniques (divination, sacrifice, and spirit/body possession) to reach its goal. Though it puts more truck in the oral than the written ("bookish" is pejorative here), Yoruba religion boasts a vast and sophisticated corpus of sacred stories, historical accounts, morality tales, poems, and proverbs that remind us of our individual and shared destinies, and promise to connect us with one another, with creation, and with the divine.

It should be noted that, while Yoruba culture is ancient, Yoruba identity is modern. Like the term *Hinduism*, which was a by-product of the arrival of the British in India, the term *Yoruba* is relatively recent, dating only to the early nineteenth century.[43] Before that time, Yoruba peoples identified not as Yoruba but with particular city-states or royal lineages, just as Hindus before the British identified not as Hindu but as speakers of particular languages, residents of particular regions, and worshippers of particular gods. While initially used by outsiders to refer to "Yoruba country" or "the Yoruba people," this term was eventually taken on as a badge of honor by the Yoruba themselves, first in the New World and then in West Africa, as former slaves began in the last half of the nineteenth century to return to their homelands with allegiances to a new, pan-Yoruba religion and culture rather than to particular city-states and royal lineages.

Elasticity

Like Hinduism, Yoruba religion rests on practice more than faith. In Yoruba the word *believer* (*igbagbo*) points to a Christian.[44] That is because Yoruba religion, more than a rigid belief system, is a

pragmatic way of life. Practitioners care far more about telling good stories and performing effective rituals than about thinking right thoughts. They greet religion's doctrinal dimension with indifference and demonstrate almost no interest in patrolling orthodoxy, or even in defining its borders. This is a tradition of stories, their interpretation, and their application in rituals and in everyday life—a "religion of the hand" rather than the head, in the words of a Candomble priestess from Brazil.[45]

Again like Hinduism, Yoruba religion is almost endlessly elastic, greeting foreign religious impulses with a yes rather than a no, adopting, adapting, and absorbing these impulses and reinventing itself along the way. As Christianity came to Yorubaland in the 1840s, and Islam centuries earlier, Yoruba religious traditions mixed with both. And as these reinvented Yoruba traditions sailed across the Atlantic to the Americas, practitioners reinvented them again, picking up not only Catholic influences but also the influences of religions indigenous to the Americas.

Soyinka describes this "accommodative spirit of the Yorùbá gods" as an "eternal bequest to a world that is riven by the spirit of intolerance, of xenophobia and suspicion."[46] Though in possession of a massive, multigenre oral corpus of sacred literature, Yoruba practitioners have resisted freezing it into dogma or revelation. Perhaps that is because this corpus consists largely of stories rather than Western-style theological argumentation. Or perhaps this corpus is as narrative and nondoctrinaire as it is because Yoruba practitioners couldn't be bothered to memorize dry theology. For whatever reason, the Yoruba exhibit the same flexibility in adapting their religious practices to new places and times that they exhibit in approaching their oral texts, which include—alongside the all-important divination poems—praise songs, prayers, proverbs, myths, incantations, folktales, and recipes for herbal remedies. "*Ifa*'s abiding virtue," writes Soyinka, is "the perpetual elasticity of knowledge."[47]

The Yoruba see the complex realities of the cosmos not as revealed from on high once and for all but as forever coming into

sight through an equally complex dance between humans and ori-shas. As a result, Yoruba practitioners are able to see these orishas as exemplars who abide inside the difficulties of human existence rather than lording over and above them, and to see their sacred texts "as no more than signposts, as parables that may lead the mind toward deeper quarrying into the human condition, its con-tradictions and bouts of illumination."[48]

Perhaps because it recognizes the contradictions and compli-cations of life on earth, Yoruba religion does not evangelize or anathematize. It has no pope, and its leaders have never gathered to squeeze Yoruba beliefs into a creed. "No excommunication is pronounced," Soyinka writes, "a *fatwa* is unheard of."[49]

Given all this freedom, what is shared across the elusive and elastic manifestations of Yoruba religion? In a word, practice. From Nigeria to New York, orisha devotees are practitioners more than believers. Their practice consists of various techniques for communication and exchange between human beings and orishas. These techniques aim at connection—narrowing the gap between the earthly and heavenly realms by calling on a series of mediators. The head of a family mediates between that family and its ances-tors. The chief of a town or city mediates between the townspeople and the orishas. The orishas mediate between human beings and Olodumare. The babalawo mediates between a client and the ori-shas. And Eshu mediates between human beings and the orishas.

Most succinctly, Yoruba religion sees the human problem as dis-connection. To be human is to be connected, but all too often we are disconnected from one another, from nature, from the orishas, and from the High God Olodumare. We are even disconnected from our destinies, alienated from our truest selves. Yoruba prac-tices seek to reconnect us across all these divides.

An African American sculptor named Lonnie Holley once lived in a modest home bumping up against the airport in Birmingham, Alabama, and throughout his property—on the ground, inside abandoned cars, and up in trees—he connected found-object sculptures with one another via a crazy patchwork of string, rope,

fishing line, and telephone cords that turned the entire landscape and everything in it into one interconnected and awe-inspiring piece of art. Yoruba religion also testifies profoundly to the power of connectivity. To our seemingly insatiable capacity to pretend that we are somehow independent atoms, Yoruba religion responds that human beings are connected to the divine, to animals, to plants, to inanimate objects, and to other human beings (both dead and alive).

As Christian missionaries flooded into West Africa in the nineteenth century, they taunted the Yoruba by insisting that "the dead do not speak."[50] This idea that society is for the living is entirely foreign to China, where the dead are very much alive—enshrined in ancestral tablets in the home and consulted on all sorts of important matters of business and the heart. But it is just as foreign to Yoruba culture, where the quick and the dead are connected through all sorts of stories and rituals.

It is difficult to summarize the key practices of any religion, particularly one as elastic as orisha devotion. But this task is even more difficult because of the penchant of Yoruba practitioners for secrecy. The key religious elite in this tradition in West Africa is the guardian of secrets, the babalawo. And, as Yoruba religion migrated to the New World, secrecy became only more important. Slaves were often prohibited from practicing African religions, so those committed to walking in the ways of their ancestors had no choice other than to sacrifice on the sly. Even today New World practitioners of Yoruba religions unveil their esoteric truths through a series of ascending initiations. Adherents play a game of reveal and conceal as seductive as *eros* itself, flirting with boundaries, resisting closure, and otherwise frustrating the desires of anyone wishing to package up its treasures in paper and bow.

While it is impossible to know everything that goes on inside a Candomble terreiro or Santeria casa, it is possible to generalize about the techniques Yoruba practitioners use to reconnect themselves with other human beings, with their ancestors, with the orishas, with their own destinies, and with the natural world. These

techniques include initiation, when you receive an orisha into your ori and in the process take on his or her ashe. But the most foundational practices in this "religion of the hand" are divination and spirit/body possession.

Ifa Divination

Ifa divination, which has been compared to China's Yijing (I Ching), is a consultation between a devotee and the orisha of wisdom and destiny Orunmila (aka Ifa). Orunmila is consulted via Ifa divination on important occasions such as births, marriages, and deaths, and whenever an orisha devotee is struggling with a conflict he or she wants to see resolved. Nothing like eternal salvation is at issue here. Yoruba practitioners do speak of a "good heaven" (*orun rere*) and a "bad heaven" (*orun apadi*). They also hope for reincarnation, which in this tradition is a good thing. (Cruel people and suicides are not reborn.) But the focus, as with Israelite religion, seems to be living long and well on earth rather than attaining immortality elsewhere. The presenting problems in Ifa divination are unapologetically thisworldly: sickness or lovesickness, bad fortune or bad blood. A daughter may be performing poorly in school. A grandfather may be dying. A mother may have trouble finding a job. It is also possible for entire communities to consult with babalawos, particularly in times of crisis. If the United States were a Yoruba nation, its leaders would have gone to Orunmila about the financial meltdown of 2008. From the Yoruba perspective, no difficulty is entirely secular. Each has its origin in an orisha who has been neglected, or perhaps in a witch or sorcerer, so each can be addressed by spiritual means.

Ifa divination begins literally in the hand, with a babalawo (or iyalawo) holding sixteen palm nuts or a divining chain vibrating with the power of ashe. The divining chain is quicker and more portable than the traditional palm nut method, and, for some, it doesn't carry the power or authority of the original. In the origi-

nal technique, the babalawo holds the palm nuts up to the ori of the client. He then shakes these nuts randomly from hand to hand until either one or two is remaining in the left. He does this sixteen times, in each case noting the results in the sand of his divining tray. He then repeats it another sixteen times, which enables him to arrive at one *odu* (signature) out of 256 (16 x 16) possible combinations. At this point, the babalawo, who has gone through rigorous multiyear training that includes memorizing in excess of a thousand Ifa poems, recites at least four stories for this odu, beginning with "Ifa says." The client decides which of these poems best fits his situation. The babalawo goes on to chant all the verses he knows for that story—the actions of the orishas, the consequences of those actions. The client then tries his best to apply these verses to his circumstances.

The consultation ends with a recommendation of a sacrifice of some sort. Generosity is a key virtue—the epitome of "cool"—in Yoruba culture, and to sacrifice is to show generosity to the orishas. Any given sacrifice is offered to a particular orisha, but a portion goes first to Eshu, who can be entrusted to deliver it only if he is cut in on the action from the start. Sometimes this offering is a blood sacrifice—a chicken, for example, which in almost all cases is then cooked and eaten. And animal blood is believed in this tradition to be particularly rich in ashe. But "making ebo" can also take the form of an act of charity or renunciation. Often what is sacrificed is a fruit or vegetable, or a drink of some sort. Yemoja, for example, enjoys duck, but she is also quite happy with watermelon. So like Yoruba religion writ large, Ifa divination is reciprocal. It begins with the orishas offering words of wisdom to a practitioner and ends with this practitioner offering a gift of some sort to the orishas: "May the offerings be carried, may the offerings be accepted," says the babalawo in salutation, "may the offerings bring about change."[51]

In the New World, Ifa continues to be practiced, but its nuances and complexities have given way in many locales to simpler and blunter oracular techniques. Priestesses are also fully integrated

into the divining ranks. In fact, the majority of the two thousand-plus Candomble terreiros in Bahia are run by women. Purists (and even elastic Yoruba religion has a few) deride these innovations as unwarranted, and the simpler techniques as baby stuff. But even in the New World divination continues to be regarded as the "essence of Yoruba philosophy and worship."[52]

Spirit (and Body) Possession

All religions make use of a wide variety of the senses, shaping the body in this direction or that for the purposes of prayer or penitence. It isn't just that we learn things through our bodies (though of course we do) but that we become and remain Muslims by prostrating in prayer, or Zen Buddhists by sitting in meditation. The Yoruba are particularly adept at putting religion in motion, however. Here spirit and matter dance cheek to cheek. Wisdom is embodied. There is no disembodied self that thinks beyond the confines of bone and breath. In traditional Catholicism, the saint is satisfied with the prayers of the faithful and an occasional candle lit in his name. But in Candomble and Santeria words and intentions are not enough; the orishas must eat and drink. So it should not be surprising that drumming and dance are religious practices. In this tradition, orishas enter into human life by possessing human bodies.

The orishas are associated with particular parts of the body, and therefore with particular illnesses. So it is possible in this tradition to trace illnesses not only to certain organs but also to the orishas who have afflicted those organs and therefore have the power to make them well. If you have come down with herpes in Cuba, it is likely Oshun who has stricken you. But the body is variously mapped across the Yoruba world. In Cuba, the warrior Ogun is associated with the legs, fiery Chango with the penis, and Elegba (aka Eshu) with the feet. In Brazil, Xango (aka Shango) is located in the chest, and whereas Ogun does get the left leg, the right leg

(and the penis) belong to Exu (the Brazilian analog to Eshu and Elegba).[53]

But the orishas are also recognizable in drumming patterns (slow for ancient Orunmila, fast for fiery Ogun) and dancing steps— Shango's kicks, leaps, high steps, and tumbles; Obatala's slow, cool walking; Babaluaye's erratic jerking (low and cramped, like a sick man). In fact, dance is so central to this religious tradition that some have referred to it as a "dancing religion." Some orishas never possess anyone. For example, Orunmila comes to earth solely through divination. But Ogun, god of war, dances in the sharp steps and aggressive postures of a warrior, his hands slicing the air on a sharp diagonal like a sword. Ochoosi the hunter pulls an arrow from his imaginary quiver, places it in his imaginary bow, and "reacts in a jerking undulation" from the force of the arrow's release. Shango "pulls energy from the skies toward his genitals," playing with his crotch, Michael Jackson–style. Oshun's movements are more lyrical and less staccato, flowing like the river she represents, sensuous and potent as sex itself.[54]

Yoruba trance dancing is often referred to as spirit possession, but that is not quite right, since the orisha possess both the body and the spirit of the devotee. Every word, gesture, and movement of someone who has "made the god" manifests the possessor rather than the possessed. Wande Abimbola has suggested that the appropriate metaphor here is to "climb," since most orishas (Shango is a notable exception) live inside the earth and come up through the ground to enter those they possess (feet and lower legs first).[55] The possessed also speak of being caught or grabbed. The most common analogy, however, is to a rider "mounting" a horse—an image that carries with it sexual connotations of a dominant male "mounting" a submissive female. In festivals and initiation rites the orishas "mount" and then "ride" devotees, possessing their bodies in dance and their spirits in trance.

There is a vibrant debate about how much (if at all) gender mattered in traditional Yoruba religion, but there is no debating how slippery and permeable the categories of male and female are for

Yoruba practitioners today.[56] While worshipping the orishas of their towns, the rulers of Idanre and nearby Owo cross-dress as women. In a festival to the goddess Oronsen, crowds praise their king as Oronsen's husband Olowo. Pointing to his fat belly, they also praise him for being pregnant—"the prolific banana tree which bears much fruit."[57] On feast days, men can dance as female orishas, and women can dance as male orishas. But even this distinction between "female" and "male" orishas is problematic, since the macho Shango is revered in Cuba as Saint Barbara, the goddess Oya is said to have been male at some point in the past, and the relatively obscure Brazilian orisha Logunede is said to spend half the year as a male hunter in the forest and the other half as a female enchantress in the river. It is also common for practitioners to switch genders when they reincarnate. Many Yoruba girls are called Babatunde ("Father Returns"), and many Yoruba boys are called Yetunde ("Mother Returns). Orishas also switch genders as they move from place to place. Like Buddhism's bodhisattva of compassion, who is male in India as Avalokiteshvara and female in East Asia as Guanyin, Oduduwa (aka Odua and Oduwa), the divine progenitor of all Yoruba kings, takes female form in northeastern Yorubaland and male form in its southwestern cities and towns. Perhaps because of this gender flexibility, many straight men in Brazil and Cuba refuse to become possession priests. They see being "mounted" as akin to playing the submissive role in a sexual encounter, so the possession priesthood in these countries is often filled by women and gay men.

New World Transformations

Many more changes came over Yoruba religion as it migrated to the New World. But these changes were only possible because the Yoruba religious impulse survived. One key to this survival is elasticity. If Yoruba religion had not bent under the unimaginable pressures of capture, passage, slavery, and emancipation, it would

undoubtedly have broken to pieces. But another source of the success of Yoruba religion is orality.

Judaism was born when Jews began to shift their sights, after the destruction of the Jerusalem Temple in 586 B.C.E., from temple rituals to textual interpretations. This historic transformation didn't just make Judaism as we know it, it made Judaism more mobile. Whereas temple rituals could only be performed by priests at the Jerusalem Temple, the Hebrew Bible could be interpreted anywhere by anyone who could read. Yoruba religion is similarly transportable and its authority similarly decentralized. In this case, however, authority lies in the oral corpus of Ifa divination rather than in the written text of the Hebrew Bible. "Book knowledge," writes UNESCO leader and Yoruba Studies professor Olabiyi Babalola Yai, "is devoid of àṣẹ."[58] So Yoruba religion was able to travel, first, inside West Africa and, later, across the oceans in the heads of diviners and the feet and hips of the god-possessed.

Some of the changes that came over Yoruba religion in the New World have already been mentioned. The orishas were whittled down from hundreds or thousands to dozens, and Ifa has largely (though not entirely) given way to simpler forms of divination. But there are other important differences between traditional Yoruba religion and the Yoruba-derived traditions of the Americas. Many orishas lost their associations with particular places and peoples in West Africa after they migrated to the New World. In West Africa only a chosen few, such as Ogun, Eshu, and Obatala, were truly pan-Yoruba deities. In the New World, however, almost all orishas serve devotees regardless of location. Some relatively unimportant West African orishas were promoted after transatlantic passage. The bow-and-arrow hunter Ochoosi is little known in his homeland but quite popular in Brazil, where in the Rio region he is identified with Saint Sebastian, whose iconography depicts him as shot full of arrows. Meanwhile, many orishas died in the Middle Passage, and many others withered away as slavery wore on. Agricultural orishas largely fell away in urbanized Brazil, though they continued to live and breathe (and eat) in Haiti. Another victim

of the transatlantic passage was ancestor worship. Slavery so thoroughly destroyed extended family networks that traditional ancestor devotion became next to impossible.

Another important transformation was the emergence of houses of worship for all orishas. One key difference between Indian and American Hinduism is that in India temples typically house just one god, whereas in the United States temples typically house many. Something similar happened as Yoruba religion crossed the Atlantic. In West Africa, shrines were typically associated with one particular orisha, who was in turn associated with one region or dynastic line. But in the New World, where resources were scarcer and devotees more widely scattered, Brazilian terreiros and Cuban casas typically housed all the orishas, or at least all the orishas with enough ashe to be remembered.

These and other efforts to preserve Yoruba religion by changing it can and should be seen as transformations. But in these transformations there is continuity too. Yoruba culture has traditionally been both elastic and accommodating. While Christians have long concerned themselves with keeping their faith pure by inoculating their doctrines against impurity, the Yoruba tradition has been happily mixing with "outside" influences for millennia. So the so-called syncretism of the New World was, and is, just more of the same.

Flourishing

There is an intriguing debate about the niche religion occupies in human psychology and society. Is religion's primary purpose to ward off the chill of death? Many believe this is the case—that religions rise and fall largely on how well they address the problem of mortality. But perhaps death and the afterlife are largely male concerns. After all, it is men who have done most of the killing in human history. Might it be that religion's primary purpose is to make sense not of death but of birth, not of destruction but of

creation? After all, the Jewish and Christian Bibles begin not with the deaths of Abraham or Jesus but with the creation of the world. Perhaps where religions really compete is on the question of how to flourish.[59]

In this debate, Yoruba religion comes down squarely on the side of human flourishing. There is discussion, of course, about reincarnation and about a good and a bad heaven. But the goal is not to be reborn or occupy some otherworldly paradise but to flourish here and now. Today Yoruba religion in both Africa and the Americas attempts to repair our lives and our world by reconnecting earth and heaven, human beings and orishas, and each of us with our own particular destinies and natural environments. This world can never be a paradise, because conflict is endemic to the human condition. Gods and "antigods" are forever at war, and we humans seem forever to be forgetting our destinies. But happily we can consult the orishas through divination, call them to our sides through sacrifice, and dance with them in our own bodies. Such resolutions of our conflicts are temporary, to be sure, and must be repeated. But with proper devotion to the orishas, say the Yoruba, we, our children, and our grandchildren can live long, healthy, wise, and prosperous lives.

Judaism

THE WAY OF EXILE AND RETURN

Judaism begins and ends with a story. If Christianity is to a great extent about doctrine and Islam about ritual, Judaism is about narrative. To be a Jew is to tell and retell a story and to wrestle with its key symbols: the character of God, the people of Israel, and the vexed relationship between the two.

This story has everything you could ever want in a good read. It has sex, deceit, love, murder, transgression, and tragedy of biblical proportions. It has some of the greatest characters in world literature, not least the adulterer and murderer King David and the capricious and irascible God of the Hebrew Bible. It even has a narrative arc—from garden to desert to city. The Jewish narrative is a story of slavery and freedom, of covenants made and broken and made anew. But above all else it is a story of a people banished and then called home—a story of exile and return.

The Hebrew Bible starts with God's creation of the world in seven days—six days of labor and one of rest. The conflict kicks in not long after creation with Adam and Eve and God and a serpent all wrapped around one another in the Garden of Eden. In this primordial society God lays down only one law: do not eat from the tree of the knowledge of good and evil. So, of course, Adam and Eve take a bite and are banished for giving in to temptation. In the Christian tradition, this violation infects all of humanity with a sin virus that can only be cured by the crucifixion of Jesus. Here it sets into motion the two great contrapuntal themes in the Jewish story:

a rhythm of wrongdoing, punishment, and exile; and a rhythm of covenant, breach, and new covenant. Because God is just, He punishes human beings for their wrongdoing, but because He is merciful, He extends to them the opportunities and responsibilities of a new relationship.

Later in this saga the action narrows and intensifies, shifting from the interactions of God and all humanity to the interactions of God and a particular people. In perhaps the most fateful deal in the history of the world's religions, God calls Abraham and his descendants to be His people and promises them a special land. To get there, however, they will have to wander, as will Moses, who after leading the Israelites out of slavery in Egypt will spend forty years in the wilderness hard by the Promised Land. The climax of this story comes on Mount Sinai when God delivers the Torah through Moses and by this new covenant offers a new way out of exile, a new path back home.

Like the term *dharma* in Indian religions, *Torah* is a wonderfully expansive term. Though typically translated as "law," it actually connotes "teaching" or "guidance." Torah refers in the first instance to the five books of Moses: Genesis, Exodus, Leviticus, Numbers, and Deuteronomy. Torah also means the entire Hebrew Bible, which Jews refer to not as the Old Testament but as the *Tanakh*, an acronym for its three parts: Torah (in the narrow sense of the five books of Moses), *Neviim* ("prophets" such as Isaiah and Amos), and *Ketuvim* ("writings," including Psalms, Proverbs, Job, and Song of Songs). Torah refers more broadly to the oral law, the interpretive tradition said to have been revealed alongside the written law to Moses on Sinai and now written down in the core texts of the rabbinic tradition: the Mishnah (c. 200 C.E.), the Jerusalem Talmud (fourth century C.E.), and the Babylonian Talmud (fifth century C.E.). Studying and debating the Tanakh and Talmud is Torah too. And according to a Jewish folk saying, "Even the conversation of Jews is Torah."[1]

So this religion of memory is about both story and law. Jews are a people who remember who they are by telling these stories and

by following this law. For them, law (*halakha*) and narrative (*aggadah*) are inseparable, two sides of the same coin. Anthropologist Mary Douglas once called the biblical book of Numbers "a law and story sandwich," but the same can be said of Judaism itself.[2] Here the task of human life is not to achieve enlightenment or moksha but "to walk humbly with thy God" (Micah 6:8) and in so doing to repair the world (*tikkun olam*).[3] This redemption is thisworldly, accomplished not in heaven but here on earth. And it comes by doing rather than believing. It is by practicing the 613 *mitzvot* (commandments) described in the Jewish scriptures that we bring holiness to our imperfect world. In this sense Judaism differs dramatically from Christianity, where faith is paramount. Whereas Christians strive to keep the faith, Jews strive to keep the commandments.

A few years ago, I asked an Orthodox rabbi ("teacher") which of these two elements was more important in Judaism: telling the story or following the law? "I give you a Jewish answer," he told me in his thick Brooklyn accent. "You can't have one without the other. Those who forget the law eventually forget to tell the story."

A Religion and a People

Judaism is both the least and the greatest of the great religions. Strictly by the numbers, it is by far the smallest. There are only about 14 million Jews worldwide, not much more than the population of Mumbai, India. The Jewish population in Israel, the sole country with a Jewish majority, is only about 4.9 million. More Jews—roughly 5.2 million—live in the United States, but no other country has a Jewish citizenry even approaching one million, and most people in the world have never met a Jew.

But this tiny religion has wielded influence far out of proportion to its numbers. It started a monotheistic revolution that remade the Western world. It gave us the prophetic voice, which continues to demand justice for the poor and oppressed (or else). It gave us stories that continue to animate political and literary conversations

worldwide: Adam and Eve in the Garden, Noah and the Flood, David and Goliath. Its grand narrative of slavery and freedom, exile and return, may well be, with all due respect to Christian narratives of the Passion of Jesus and Hindu narratives of Rama and Sita, the greatest story ever told. Judaism also stands at the crossroads of today's most vexing and volatile international conflict: the contest between Jews, Christians, and Muslims in the Middle East that some conservative Christians at least believe will usher in the end of the world.

In the United States, Jews are influential in politics, thanks in part to high voter turnouts among Jews and their strong presence in key electoral college states such as New York, New Jersey, and Florida. Although the White House has not yet seen a Jewish president, Jews have occupied seats in the U.S. Congress and on the U.S. Supreme Court far out of proportion to their numbers in the broader population. The same is true of CEO positions at Fortune 500 companies.

Jews have made their deepest impression on American popular culture. Sandy Koufax, perhaps the greatest left-handed pitcher in baseball history, brought attention to Judaism when he refused to pitch the opening game of the 1965 World Series for the Los Angeles Dodgers because it fell on the Jewish Day of Atonement known as Yom Kippur. Almost every major Hollywood studio was founded by Jews, as were NBC and CBS. Jews also made their mark on Broadway in musicals (George Gershwin, Irving Berlin, Stephen Sondheim) and plays (Arthur Miller, David Mamet, Wendy Wasserstein). Judaism gave the United States some of its most celebrated writers—from poet Allen Ginsberg to songwriter Bob Dylan to novelist Philip Roth—and some of its most celebrated buildings, thanks to architects Louis Kahn, Frank Gehry, and the master-plan architect for the new World Trade Center site in Lower Manhattan Daniel Libeskind.

More than any other American art form, comedy has been shaped by Jewish performers. There is a long tradition of Jewish humor about the absurdities of life and the hypocrisies of the high

and mighty (including God Himself). This tradition came to the United States via Ellis Island and was perfected in vaudeville, stand-up comedy, radio, and television. The history of American comedy is unimaginable without the Marx Brothers, the Three Stooges, Milton Berle, Jack Benny, Mel Brooks, George Burns, Woody Allen, Lenny Bruce, Jerry Lewis, Joan Rivers, Jerry Seinfeld, Sarah Silverman, and Jon Stewart. In fact, by almost any accounting, Jews, who make up less than 2 percent of the U.S. population, account for the vast majority of America's working comics.

This outsized influence is by no means limited to the United States, however. Fourteen of *Time* magazine's one hundred most important people of the twentieth century were Jewish, including film director Steven Spielberg, author Anne Frank, and person of the century Albert Einstein. Jews have done even better with the Nobel Prize, claiming nearly one-quarter of these honors since they were first awarded in 1901. Whenever anyone anywhere puts on a pair of Levi's, sips a cappuccino from Starbucks, spends a night in a Hyatt, powers up a Dell computer, or performs a Google search, they have a Jewish entrepreneur to thank.

You would think all this would be enough work for any one religion. Yet Judaism also managed to give birth to Christianity and Islam. (Jesus was an observant Jew.) So while Judaism itself commands the allegiance of only two out of every thousand human beings, its offspring account for one out of every two.

Judaism also stands apart for being both a religion and a people. The word *religion* comes from both *relegere*, to recollect, and *religare*, to bind together.[4] And the Jewish people do both, binding themselves to one another and to God through stories, law, and other modes of recollection.

It is sometimes said that Judaism is about ethnicity as much as religion, but that is not quite right, since Jews come from all sorts of different ethnic groups. There are Ashkenazi Jews of German and Eastern European descent (by far the largest group), Sephardic Jews of Spanish and Arab descent, and Ethiopian Jews of African descent. Like Hindus, however, Jews do function as an ethnicity of

sorts, bound together not so much by shared beliefs as by a shared sense of community. This solidarity is fostered by the observance of rituals and festivals that set Jews apart, but even the unobservant are still considered Jews. To say you are Jewish may mean that you believe in the God of Israel, attempt to follow His commandments, and study Torah. It may also mean that you come from a Jewish family. You can't be both an atheist and a Muslim, but a large minority of Jews do not believe in God.

Arguing for the Sake of God

Given this diversity, it should not be surprising that Judaism isn't easy to pin down. That there are as many Jewish opinions as there are Jews is a commonplace, but this estimate is understated. As an old adage goes, wherever you have two Jews there are always at least three opinions. No religion, of course, speaks with one voice. But Judaism is unusually cacophonous. More than any of the other great religions, its practitioners follow Rilke's admonition to "love the questions."[5] Only in Judaism is there a religious teacher principally famous for asking "Why?"[6]

If you ever stumble on a traditional yeshiva, a Jewish school for the study of sacred texts, the first thing you will notice is the noise. Students study in pairs in a large hall, often with wild gesticulations and hardly ever in hushed tones. They read aloud from this story or that law, and they argue even louder about the meanings. The yeshiva demonstrates that learning is valued in Judaism and that disagreements are a path to learning. Perhaps most important, it demonstrates that Jews revel in a good debate.

When yeshiva students are arguing with their partners, they are trying to get at the truth. According to a Hasidic saying, "If you are proved right, you accomplish little; but if you are proved wrong, you gain much: you learn the truth."[7] But these students do not necessarily assume that the truth is on one side or the other of their disputes, or even somewhere in between. The name *Israel* refers to

one who has wrestled with God (Genesis 32:28), and for millennia Jews have done just that. They have also wrestled with one another (including the pious dead) and with their own tradition's tensions between story and law, prophet and priest, exile and return, mercy and justice, movement and rest.

What is required in Judaism is not to agree, but to engage. According to Nobel Laureate Elie Wiesel, "If a Jew has no one to quarrel with, he quarrels with God, and we call it theology; or he quarrels with himself, and we call it psychology."[8] It was a Jew, Albert Einstein, who proved via the theory of relativity that even scientific observations depend on your perspective. Another Jew, American philosopher Horace Kallen, coined the phrase *cultural pluralism* and with it the metaphor of civilization as an orchestra in which differences in religion, language, and art can enhance social harmony rather than undermining it.[9] In what might seem like the cacophony of yeshiva training, Jews hear a symphony.

Jews record the commandments of God in two major scriptures, each as multivocal as the yeshiva itself. The Tanakh is a sprawling anthology of diverse genres, voices, and sources spanning roughly a millennium. It begins with not one but two different stories of creation. In its twenty-four books (two of which—Ruth and Esther—are named after women) we hear of God and angels, kings and commoners. We encounter proverbs, prophecies, love poems, hymns, theological history, wisdom literature, law, and apocalyptic visions.

Judaism's second major sacred text, the Talmud, is even more unruly. A vast tangle of various lines of argumentation, its two and a half million words don't just contain contradictions; they are designed around them, with a passage at the center of each page literally surrounded by competing interpretations. "Turn the pages," one rabbi says, "turn them well, for everything is in them."[10] In one of the great intellectual contests of all time, two rabbis, Hillel and Shammai, joust in this anthology of arguments over three hundred different issues. Hillel, who has been described as "Judaism's model human being," almost always gets the upper hand, which

is why the Jewish student center near my office is named Hillel House and not Shammai House.[11] But the Talmud does not simply record Judaism according to Hillel. It records Shammai's views too. So his words are also scripture. Or, as the Talmud reads in a passage that concluded three years of bitter debate between the School of Shammai and the School of Hillel, "Both are the words of the living God, but the law is in accordance with the view of the house of Hillel."[12]

Most human beings find ambiguity intolerable. Chasing after uncertainty and running away from contradictions, we squint when testing our eyes, determined to bring what is blurry into focus, as if our determination could make it so. Jews are trained not just to abide ambiguity but to glory in it. If, as Oscar Wilde wrote, "The well-bred contradict other people" while "the wise contradict themselves," the Jewish scriptures are wisdom personified.[13]

This wisdom echoes in the ways and means of the U.S. Supreme Court, which like the Talmud records dissenting opinions alongside majority decisions. It also lives on in a sixteenth-century text called the *Shulchan Aruch* (literally "Set Table"), the most authoritative collection of halakha (Jewish "law" or "way") after the Talmud. The main text of the *Shulchan Aruch* is written by a Sephardic Jew from a Sephardic perspective, but the glosses, which serve as the "tablecloth" (*mappah*) to the "table" set by the Sephardim, are written by an Ashkenazi scholar. The rabbinic tradition also animates the life and legacy of Sigmund Freud, one of the great Jewish thinkers of all time, who built his discipline of psychoanalysis on the insight that there are competing voices not only among individuals but also inside them. One of psychotherapy's tasks is to attend to these voices, and to find a way to live with the ambiguities and contradictions they conjure up.

On Converts and Creeds

So why does Judaism, which affirms one and only one God, abide so many different interpretations of the good (and godly) life? Why are Jews divided today into Orthodox, Conservative, Reform, Reconstructionist, and Humanist branches? Why, at the time of Jesus, were there already so many different types of Jews (Pharisees, Sadducees, Essenes, Zealots)? Why in the pages of the Talmud do Abbaye and Rava, two rabbis who are also fast friends, disagree so frequently, and so fiercely? Why does Judaism, more than any other religion, exemplify what poet e. e. cummings referred to as "whying"?[14]

To begin, Judaism is not a missionary religion. Although there have been times when Jews have attempted to make converts, for the most part Judaism has survived through inheritance, not evangelization. In fact, rabbis traditionally discourage conversions, rebuffing potential converts three times before agreeing to take them in. So there has never been a practical reason for Jews either to define their message to outsiders, or to stay on that message.[15]

In other words, Judaism has no real creed. Excommunications are exceedingly rare, and Jews have never tried to root out heretics by convening the equivalent of the Council of Nicaea or drafting the equivalent of the Nicene Creed.[16] The *Shema* does function as a creed of sorts, however. This formula, which is recited today in Jewish worship services and has lived for centuries on the lips of Jewish martyrs, begins with a clear affirmation of monotheism: "Hear (*Shema*), O Israel: the Lord our God, the Lord is One." It moves immediately from this doctrinal statement, however, to the ritual dimension: "And thou shalt love the Lord thy God with all thy heart, and with all thy soul, and with all thy might. And these words, which I command thee this day, shall be upon thy heart; and thou shalt teach them diligently unto thy children, and shalt talk of them when thou sittest in thy house, and when thou walkest by the way, and when thou liest down, and when thou

risest up. And thou shalt bind them for a sign upon thy hand, and they shall be for frontlets between thine eyes. And thou shalt write them upon the door-posts of thy house, and upon thy gates" (Deuteronomy 6:4–9). So even the *Shema* points beyond doctrine to practice, underscoring Judaism's affinity for doing over believing, orthopraxy over orthodoxy.

Orthodoxy was, of course, an obsession of the early Christians who wrote and enforced acceptance of the Nicene Creed. But Jews have rarely given in to the impulse to define and defeat heresy. In fact, Jews got along just fine without a statement of belief until Maimonides (1135–1204) proffered his "Thirteen Principles," but his quasicreed was controversial and not universally accepted.[17] So Judaism has always been more about practice than belief. What makes you a Jew is being born a Jew. What keeps you active is participating in the life of the Jewish community—showing up at synagogue, atoning for your sins on Yom Kippur, and honoring your parents by saying the Kaddish prayer for them when they die.

One reason defining orthodoxy and repelling heretics has never been a Jewish preoccupation is that Jews have long seen themselves not only as a people but as a people under threat. Other religions have founders who, by diagnosing the human problem in a new way and offering a novel solution, gather communities around them. With Judaism, however, the community itself was the starting point. The purpose of this tradition was not to solve the human problem but to keep a people together. Jews see themselves in collective terms, as a "holy nation" (Exodus 19:6) chosen by God. And why were they chosen? Not to believe something but to do something—to repair the world (*tikkun olam*). So Jews are knit together more by ritual and ethics than by doctrine.

Most fundamentally, however, Jews are knit together by memory. This memory speaks of one God who is personal but by no means should be understood as a human being. Unlike the Christian God who takes on a human body, the Jewish God stands above and beyond the world He created, which is to say that He is radically transcendent (though never without an immanent, and intimate,

dimension). Like Muslims, Jews emphasize the radical qualitative distinction between God and human beings. Unlike Christians, they typically insist that God is not to be depicted in human form or worshipped in "graven images." Although the *Tanakh* refers in places to God in almost embarrassingly human terms—He is said to have hands and eyes, to wrap Himself in a prayer shawl, and to put on phylacteries—Jews insist that God is beyond comprehension and description. Even writing the name of God is problematic for many Jews, who write the English word "God" as "G-d" in order to avoid disrespecting the divine when the paper on which that word is printed is thrown away. And so this tradition warns repeatedly against the temptation to confuse our opinions with the wisdom of God: "My thoughts are not your thoughts, neither are your ways my ways" (Isaiah 55:8).

Exile and Return

Given this emphasis on peoplehood, it should not be surprising that the problem in Judaism centers on the community rather than the individual. This problem is exile—distance from God and from where we ought to be. The solution is return—to go back to God and to our true home. The techniques for making this journey are two: to tell the story and follow the law—to remember and to obey.[18] As a Jewish friend once explained to me, the motivating tragedy in Christianity is the death of Jesus. If Jesus is the Messiah who is supposed to rule the world, why were the rulers of the world able to kill Him? The motivating tragedy in Judaism is exile. If God is all-powerful and we are God's people, why aren't we in our land? And what are we to do elsewhere?

The Jewish God is a "God of movement," and the Jewish people are forever on the move.[19] But their epic journey from garden paradise to desert wilderness to New Jerusalem is not yet complete, because the problem of exile is chronic. So the Jewish people live with hope for the place to which they are going, and with lamentations

over the places they have left behind. Some hope for a messiah (literally, "the anointed," which is to say, king), but this messiah has not yet come. Neither has the peace and prosperity his coming will usher in. So it is the job of the Jewish people to make things ready and to make things right—to "repair the world" and put an end to exile. However, until they complete this task (or the messiah does it for them), they live in the awkward middle space of almost and not yet.

The paradigmatic story for this pattern of exile and return centers on the destruction of the first Jerusalem Temple in 586 B.C.E. According to the Tanakh, after the death of Moses, who never made it to the Promised Land, Joshua led the Israelites into Canaan. King Solomon later built the Jerusalem Temple, which served as the sacred center of Israelite religion, the proto-Jewish tradition out of which Judaism as we know it would grow. Israelite religion (also known as biblical Judaism) was a priestly tradition focused on sacrifice. The fact that the prophets of the Tanakh fumed so furiously against its feasts and sacrifices as distractions from the real work of doing justice only indicates how central these temple-based practices had become. In 586 B.C.E., however, the Babylonians sacked Jerusalem and razed the temple. Or, as the prophet known as Second Isaiah put it, "Thy holy cities are become a wilderness, Zion is become a wilderness, Jerusalem a desolation. Our holy and our beautiful house, where our fathers praised Thee, is burned with fire; and all our pleasant things are laid waste" (Isaiah 64:9–10).

The Babylonians also trounced Judah, the southern kingdom that would later lend Judaism its name, and sent many Israelites into exile in Babylon (in modern-day Iraq). While in exile, these refugees were separated not only from their promised homeland but also from their monarchy, their sacrificial rites, and their God, who was said to reside in the temple's "Holy of Holies"—an inner sanctum so sacred it could be entered only by the High Priest and only on Yom Kippur. This exilic experience led to the development of the synagogue as a place of prayer and study and to the widespread adoption of portable practices such as circumcision that the

Israelites could take with them as they moved. This tragedy also led the Israelites to see that God's covenant with them was conditional. Yes, they were a people chosen by God, and that meant He would bless them if they walked in the path He had set before them. But it also meant that He would punish them if they deviated from that path.

After the Babylonians were themselves defeated in 538 B.C.E. by the Persian king Cyrus, the Jews (as the Israelites were now called) were allowed to return to Jerusalem and rebuild the temple. Most did not return. But those who did got to tell the story. They told their story in the five books of Moses, which were codified in the fifth century B.C.E. and read by Ezra—a Second Moses, some say— in Jerusalem's Second Temple, which was dedicated in 515 B.C.E. And the story they told was one of exile and return—a pattern that now provides, in the words of Judaic Studies expert Jacob Neusner "the structure of all Judaism(s)."[20]

This theme announces itself in the first chapters of Genesis, when the first three human beings are punished by exile—Adam and Eve for eating the forbidden fruit and Cain for killing his brother. It reappears in the story of Abraham who follows God's instruction to wander west from his home in Ur in Mesopotamia toward modern-day Palestine and, as God puts it, "unto the land that I will show thee" (Genesis 12:1). It surfaces again in the story of Moses, who leads God's people out of Egypt and across the Red Sea only to find himself wandering for forty years in the wilderness of the Sinai Desert. And Moses, of course, never arrives in the Promised Land.

In 70 C.E., all but the Western Wall of the Second Temple was destroyed by the Romans, and the Jews were sent once again into exile. Together these exilic experiences prompted a literature of longing and turned the Jewish community into a "people of the book." The book of Psalms gives voice to this longing, recalling a people who lay down by the rivers of Babylon and wept as they remembered Zion—a people who asked, as immigrants the world over continue to ask today, "How shall we sing the Lord's song in a

foreign land?" (Psalms 137:4). Tears also drop off the pages of the Talmud, where we encounter the figure of the messiah. With their people scattered from Egypt to Babylon, and the great kingdom of David a distant memory, the Jews begin to hope for a redeemer with the might to end their exile, to gather the Jewish people back home, and to make of that home a heaven on earth.

For roughly two millennia after the Romans destroyed the Second Temple, this theme of exile and return lived more in the imagination than on the land. The founding in 1948 of the state of Israel, whose Declaration of Independence speaks of a people "forcibly exiled from their land" yet never ceasing to "pray and hope for their return to it," brought this story down to earth.[21] Now it was possible, as it had not been for centuries, for Jews to live in and govern their homeland. As in the time of the Babylonian conquest, today some Jews choose to remain in exile—to make common cause with Moses the wanderer rather than David the settler, and even to reject the distinction between homeland and diaspora altogether. Others choose to make *aliyah*, namely, to put Israel under their feet instead of merely in their hearts. The temple has not been rebuilt, however. Though Orthodox Jews pray three times a day for its restoration, the land on which, according to Jewish tradition, it once stood now houses the Dome of the Rock, the world's oldest Muslim building. So Jews remain a "people of the book" rather than a "people of the temple."

This exile and return theme also leavens much Jewish art and literature. But its motifs of desire and fulfillment, dislocation and reconciliation, destruction and restoration resonate far beyond Judaism, in diasporic communities worldwide and wherever immigrants struggle to sing an old song in a new land. Exile and return is also acted out in Jewish families every year during the holidays and whenever the touchy topic of intermarriage arises. ("Is my Jewish daughter going into exile by marrying a Protestant?" "Will her children return?") It informs individual lives, making sense of our own dramas of God's concealing and revealing, our estrangements from God and homecomings to Him. After six million Jews died

at the hands of Hitler and the Third Reich in the Holocaust, many Jewish thinkers asked where God was when the Nazis turned on the gas chambers in Dachau and Auschwitz—whether God, too, had gone into exile. Throughout their history, however, Jews have refused to see their story merely through a lachrymose lens. While this tradition does give voice to longing for what was, and desire for what will be, it also speaks of celebrating life as it is right now: *L'Chaim* ("To life!").[22]

Liberation and Law

While Jews now live between exile and return, they also live between liberation and law. In the Exodus narrative, Pharaoh takes the Israelites into slavery in Egypt and murders their male sons. One of these sons, Moses, escapes due to the compassion of Pharaoh's daughter. As an adult, Moses returns to command Pharaoh to "Let my people go." When the hard-hearted Pharaoh refuses, God sends down ten plagues. Eventually, Pharaoh sees the errors of his ways and agrees to let the Israelites go. But as they are fleeing, he changes his mind, sending his armies after them. At the Red Sea, it looks as if Moses and the Israelites are trapped. But God parts the waters, allowing them to cross over into freedom. He then commands the waters to return, drowning the Egyptians.

This saga of enslavement and escape belongs to the Jews, of course, but also to the world. No other story has been more influential in the United States. The Pilgrims saw themselves as the New Israel, Europe as Egypt, and the New World as a wilderness in the process of becoming the Promised Land. Over successive generations, black slaves, Mormons, civil rights agitators, and feminists would read their experiences by the light of this freedom tale. It must not be forgotten, however, that it was in the midst of this liberation story that God laid down the law.

Throughout the Tanakh, God and human beings enter into sacred contracts called covenants. God makes universal covenants

with all of humanity through Adam and Noah. He later enters into particular covenants with the Israelites through Abraham and Moses. In these covenants, God promises blessings to those who follow His commandments and punishments to those who do not. The freedom won for the Israelites was not freedom to do whatever they wanted but freedom to become servants of God. So the climax of the Exodus story comes not at the far side of the Red Sea but atop Mount Sinai. Moses is both liberator and lawgiver. He inspires revolutions, but he also stands atop the U.S. Supreme Court building as the progenitor of the Western legal tradition. Similarly, the festival of *Shavuot* (Pentecost), which celebrates the giving of the Torah on Sinai, comes immediately after the festival of Passover. And after you have turned the last page of the book of Exodus, the book of Leviticus sets down the Torah in excruciating detail, with legislation regarding sacrifice and bodily discharges and male circumcision and atonement and idolatry and tattoos and prostitution and the Sabbath and food ways and male homosexuality (though not, it should be noted, lesbianism). And so, as memoirist Shalom Auslander puts it, "The Book of Freedom is followed by the Book of Submission. The Book of Possibility is followed by the Book of Do What I Say."[23]

Jews have divided their 613 mitzvot into positive commandments ("Thou shalt") and negative commandments ("Thou shalt not"). A more helpful division, however, is into ritual commandments (between the human being and God) and ethical commandments (between the individual and other human beings.) One of the distinctive features of Judaism is that its monotheism is ethical. God is not only all-powerful but also all-good, which is why Jews throughout history have kvetched at Him when He does not seem to live up to His own ethical standards. How can the Holocaust happen if God is really both omnipotent and good? Why do bad things happen to good people? For the prophets, ethics was central, and many Reform Jews have located the essence of Judaism in the Golden Rule. When asked to provide the first-century equivalent of a Twitter message on Judaism (by summarizing the Torah while

a student was standing on one leg), Hillel replied: "Do not unto others that which you would not have them do unto you. That is the entire Torah; the rest is commentary. Now go and study."[24]

As the litany of Levitical codes demonstrates, halakha (which is often translated as "law" but really refers to "way" or "path"—the Dao of Judaism) is not only about morality. It is also about how we should mourn, eat, and observe the Sabbath. In fact, most of the 613 mitzvot concern ritual rather than ethical life. Leviticus, for example, speaks primarily of ritual rather than ethical laws. Only chapter 19, which includes the admonition (delivered twice) to love the neighbor and stranger as yourself, attends to ethical laws, yet even there discussions of lying and stealing entangle themselves in discussions of beards and tattoos. So when Jews speak of observing the law, they are invoking not only the ethical but also the ritual dimension of religion.

Of all the ritual commandments, Judaism's dietary laws (*kashrut*) seem the oddest to outsiders. Almost all religious groups use food ways to distinguish themselves from their neighbors (halal rules in Islam, and vegetarianism for many Hindus), but observant Jews seem particularly strict when it comes to what they can and cannot eat. They consume only fish with scales and fins (so no eels or catfish), and they will not eat pork or birds of prey. Because meat and dairy cannot be mixed, many Jews have two separate sets of plates and flatware. Theories about the origins of these regulations abound. One, of course, is that they came from the mouth of God. Another is that kosher eating was God's health plan, saving Jews from trichinosis carried by pigs. Anthropologist Mary Douglas has argued that Jews do not eat lobsters and shrimp because these animals, which live in the ocean yet crawl on the ground, are category busters that frustrate the neat tripartite division in Genesis of animals of the earth, water, and air. According to Douglas, male homosexuality is outlawed for the same reason; it, too, is a conceptual anomaly.[25]

Jewish law can seem irrational to outsiders, and the way some Jews follow the law can seem obsessive and hypocritical at the same

time. For example, though it is not permitted to press an eleva-
tor button on the Sabbath (since the button operates an electrical
switch and is therefore considered work), some buildings with
Jewish residents have Sabbath elevators that stop automatically at
every floor. A more widely publicized example is the *eruv*. Jewish
law forbids carrying objects outside of the home on the Sabbath.
So it is impermissible to carry an infant to a neighbor's house or to
push your wheelchair-bound grandfather there. In order to allow
infants and infirm grandparents alike to enjoy the gift of *Shabbat*,
Jews devised a creative solution to this problem: "a magic schlep-
ping circle" called an *eruv*, which via wires between adjacent homes
creates a symbolic fence, turning what had been a public space into
a private one.[26] Since 2007, an eruv has covered most of Manhattan.
An "eruvitect" makes sure it remains in good working order, and
updates on its status appear regularly online.

These may seem to be cases of people circumventing the law.
But the real way to get around the law is simply to ignore it. In
these examples, there is great respect for the law, though there is
also much flexibility in interpreting it. Even observant Jews who
use Sabbath elevators refer to them as legal fictions, and, Judaism
being Judaism, there are debates about whether they are actually
halakhic.

When I was last in Jerusalem, a Jewish friend showed me around
the city. On two different days I offered to buy him ice cream. In
each case, because of the dietary requirement not to mix meat and
dairy, he had to recollect when he had last eaten meat (his com-
munity's rule was a three-hour wait). This may seem irrational,
but for him my offers appeared to engender Buddhist-style mind-
fulness, prompting him to be mindful of what he was thinking
about eating and of what he had eaten in the past and when. More
important, they prompted him to be mindful of God.

When Judaism Became Judaism

All this talk of Genesis, Exodus, and Leviticus may give the impression that Judaism is just about the Hebrew Bible. This impression is widespread among Christians, who often identify Judaism with what they call the Old Testament. Like Hinduism, which has its roots in the Vedas, Judaism has roots in the Tanakh. But the Tanakh describes a religion of priests and sacrifices that had already ceased to exist by the time this scripture was codified in the second century C.E. Judaism as we know it today developed between the time of the destruction of the First Temple by the Babylonians in 586 B.C.E. and the destruction of the Second Temple by the Romans in 70 C.E.

The destruction of the First Temple had provided the Israelites with a dress rehearsal of sorts for how to respond to the destruction of the second. In the wake of the Babylonian exile, Jews had developed the institution of the synagogue as a place for study and prayer. They had also started to collect the books that would constitute the Tanakh. These steps toward a more prayerful and portable religion accelerated after the destruction of the Second Temple. As the center of gravity of this tradition shifted from sacrifice to sacred texts during the first two centuries of the Common Era, the Israelite religion of priests performing rituals in the Jerusalem Temple gave way to a new religion of rabbis reading and interpreting texts in synagogues, and Judaism as we know it was born.[27]

The Tanakh was one of these texts, but as rabbis studied and debated its teachings, the fact that it could not serve as a comprehensive guide to Jewish life became plain. The Tanakh says almost nothing about such topics as marriage and contracts. It spells out neither when Shabbat begins and ends nor what sorts of labor it prohibits. So the rabbis got to the hard work of answering these questions, and the fruit of their labor was the Judaism of today.

Contemporary Jewish life is rabbinic. Its exemplars are rabbis. It centers on books rather than altars. It sanctifies the world not

through temple sacrifice but through words and deeds. These deeds constitute not just a religion but a way of being in the world—a way of cooking and eating and having sex and washing and speaking and working. This way of being is not restricted to any one place. And anyone can do it, not just priests. Jews today follow not only the Written Torah of the Tanakh but also the Oral Torah of the Talmud. In fact, very few of the 613 mitzvot prescribed for Jews today appear in the Tanakh itself. Most of them come from the Talmud, which serves as the textual heart of Judaism—"a masterwork," writes Elie Wiesel, "unequalled in Jewish memory."[28]

To refer to Judaism today is to refer to the "Judaism of the dual Torah" formed by rabbis in the first two centuries of the Common Era, deeply influenced by the Greeks and transformed, often quite radically, by successive generations of Jews.[29] To put it another way, Abraham and Moses were not Jews. Or, if they are Jews, they are Jews by adoption, integrated by an act of the imagination into a religion born long after they had died.

The Sabbath and Minor Holidays

One continuity between Israelite religion and rabbinic Judaism is Shabbat, or the Sabbath. Although this day comes once a week—from sundown on Friday to sundown on Saturday—it is the most important holiday in a tradition built around sacred time. Shabbat harks back to the dawn of time, both recalling and reenacting God's rest on the seventh day after making the world in the first six. It also commemorates the freedom from slavery described in the book of Exodus. Shabbat is the only holy day commanded in the Ten Commandments (which Jews refer to as the "Ten Words," since there are 613 commandments), and it is discussed and debated repeatedly in the Talmud, which prohibits thirty-nine different types of labor on this day of rest—from cooking and sewing to lighting a fire and putting one out.

Although outsiders often think of the Sabbath as prohibiting

work, what is actually prohibited are creative acts—mimicking the creativity God showed on the first six days. So each of the thirty-nine prohibited activities is a work of creation of some sort. Among outsiders, the Sabbath also conjures up images of "thou shalt nots": negative commandments against turning on appliances or driving a car. But observant Jews usually think about Shabbat in more positive terms—as entering a sacred place set apart by time. On Shabbat everything slows down. Families gather around the dinner table, lighting candles, saying special prayers, drinking wine, and enjoying a special kind of bread known as challah, often shaped into braided loaves.

Although Hanukkah is the only Jewish holiday many Europeans and Americans can name, it is actually one of Judaism's two minor festivals. Because it falls near Christmas and involves gift giving, it is often seen as a sort of Jewish Christmas. It actually commemorates the retaking of Jerusalem in the second century B.C.E. by Jewish rebels known as the Maccabees and their purification and rededication of the temple.

The other minor Jewish holiday is Purim. A raucous celebration that somehow recalls both Halloween and the Hindu celebration of Holi, Purim commemorates events recorded in the book of Esther in which the hero Mordecai foils a plot by the villain Haman to destroy the Jews. In a Purim sermon I heard once at the Wailing Wall in Jerusalem, an Orthodox rabbi spoke of driving into the city every day through an Arab section and greeting the people he saw there with joy rather than panic. He then urged his listeners to drink of wine and God until they could not tell the difference between enemies and friends, Arabs and Israelis, the cursed Haman and the blessed Mordecai.

Passover and Major Holidays

Perhaps more than any other religion, Judaism orders the world in time. Its three pilgrim festivals (traditionally celebrated in pilgrim-

ages to Jerusalem) commemorate key moments in the Jewish story: *Pesach* (Passover) for the exodus from Egypt; *Shavuot* (Pentecost) for the giving of the Torah to the Israelites on Mount Sinai; and *Sukkot* (Tabernacles) for the flight from Egypt into the wilderness. The other two major holidays are the High Holy Days of the New Year (Rosh Hashanah) and the Day of Atonement (Yom Kippur). Although these holidays are typically discussed in terms of sacred history and theology, they are also distinguished by their foods— apples and honey on Rosh Hashanah; stuffed vegetables on Sukkot; jelly donuts on Hanukkah; and matzo-ball soup on Passover.

Of these holy days, Passover is the most widely practiced.[30] Every spring, Jews gather around a dinner table for this festival of family and food. They eat. They drink. They sing. They ask questions and play at trying to answer them. They remember the sweetness of the Israelites' freedom march out of Egypt. They remember the bitterness of slavery and Pharaoh. And they remember the ten plagues. In the last of these plagues, aimed at the first son in every Egyptian family, the Israelites sacrificed a lamb and dripped its blood on their doorposts so that when the Angel of Death came he would see it and "pass over" their houses in peace. Celebrating the Seder fulfills the commandment to "tell thy son in that day, saying: It is because of that which the LORD did for me when I came forth out of Egypt" (Exodus 13:8). So like Judaism itself, the Seder is about both telling and doing, story and law.

The classic Seder food is matzo, unleavened bread prepared in large, flat sheets that snap when you break them. Matzo recalls the hurried flight from Egypt, when there was no time to allow bread to rise. So during the eight days of Passover leavened bread products are prohibited from Jewish homes. Other foods on the Seder table include: *maror*, a bitter herb that recalls the bitterness of slavery; and *kharoset*, nuts and apples ground up to resemble the mortar slaves used in their forced labor. There are also four glasses of wine, which are consumed at key moments during the Seder.

There is no faith prerequisite for participating in Passover. You do not have to believe in God. You do not even have to be Jewish.

For the past few years I have attended a Seder with friends in sub-urban New Jersey. When I was young, I went to ersatz Seders—odd affairs staged in church halls a few days before or after Passover by rabbis and ministers open to interfaith dialogue. But the ones I attend now are honest-to-goodness Seders—family and friends converging from near and far, preparing food, opening wine, and gathering on one of the first two nights of Passover week in a small home around a huge table to retell an ancient story. Every year the family patriarch begins by saying that this is not just ancient his-tory. To gather for Passover is to stand in a tradition of a people who have gathered for millennia to retell this story in their own languages and on their own terms. But if this story is not also our story, then it is not worth retelling, he says. "In every generation, each of us should feel as though we ourselves had gone forth from Egypt."

Passover festivities center on a reading of the Haggadah (liter-ally, "telling"), which recalls the story of the exodus of the Israelites from Egypt. Some Orthodox Jews insist on one official Haggadah. Other Jews revel in thousands of different versions, including the hugely popular "Maxwell House Haggadah" distributed by this coffee maker beginning in 1934.[31] When I was teaching at Georgia State University in Atlanta, I asked my students to read a feminist Haggadah, and some of them were upset that Jewish women were playing fast and loose with their tradition. But in this case play-ing fast and loose *is* the tradition. At the Seders I have attended in New Jersey, the family uses a Haggadah written by their daughter, which understands the Exodus story through the prism of the civil rights movement, with a heavy dose of Jewish mysticism thrown in for good measure.

Seders typically begin with lots of discussion and end with lots of singing, including a seemingly interminable rendition of *"Dayeinu,"* whose lyrics go through each and every miracle per-formed by God in leading the Israelites out of Egypt. An even longer folk song called *"Had Gadya"* ("One Little Goat") recalls the children's book in which a frog ran from a cat who ran from a dog

who ran from a pig who ran from a cow (and so on), only in this case a man buys a goat who is eaten by a cat who is bitten by a dog who is beaten by a stick which is burned by fire which is quenched by water which is drunk by an ox which is killed by a slaughterer who is killed by the Angel of Death who is himself done away with by "the Holy One, Blessed be He."

Life Cycle Rituals

Jews also observe rites of passage such as birth, adulthood, marriage, and death. Traditionally the first of these two passages were celebrated more for males than for females, through the bris, or circumcision ritual, and the bar mitzvah ("son of the commandments"). Many Jews now have naming ceremonies for female infants and bat mitzvahs ("daughter of the commandments") for twelve-year-old girls.

Jewish mourning practices include a seven-day period of sitting shiva in the home following a burial, Kaddish prayers for the dead, and a death anniversary remembrance called the *yahrzeit*. Jewish views of the afterlife are harder to summarize. In the Tanakh there is hardly any mention of life after death. Patriarchs live long, die natural deaths, and are buried by their kin (or, in the case of Moses, by God Himself), with no hint of any heavenly reward. Through the influence of Greek speculation on the immortality of the soul and with the rise of a Jewish tradition of martyrdom (itself influenced by Greek tragedy), Jews came to affirm the bodily resurrection—a doctrine that would play a huge role in the origins and development of Christianity and would later be enshrined in Maimonides's "Thirteen Principles." Nonetheless, Jewish thought has long downplayed the world to come. While many Reform Jews deny the bodily resurrection and many Orthodox Jews affirm it, almost all Jews agree that our focus should be on this life.[32] Even among the Orthodox there is less talk of the world to come than there is among most Muslims and Christians. A saying in the

Mishnah takes jabs at all sorts of theological speculation, conclud-
ing with a broadside at speculation about the afterlife. "Whoever
reflects upon four things would have been better off had he not
been born: what is above, what is below, what is before, and what
is beyond."[33]

Reform, Conservative, Orthodox

The only form of Judaism officially recognized by the State of Israel
is Orthodoxy. Elsewhere Jews have split into various branches. All
these branches tell the Jewish story of exile and return, and all re-
spect the authority of the Torah. They divide largely over how they
interpret and observe halakha. So while Christian denominations
distinguish themselves largely on the basis of faith and belief, these
branches differ more on ritual and ethics.

In the United States, there are three main Jewish movements:
Reform, Conservative, and Orthodox. Among American Jews who
belong to a synagogue, 39 percent affiliate with Reform, 33 percent
with Conservative, and 21 percent with Orthodox. Most American
Jews, however, do not belong to any synagogue at all.[34] The sim-
plest way to describe the differences between these three groups is
to say that each focuses on one key element in Judaism: the Reform
on ethics, the Orthodox on law, and the Conservative on tradition.

The Reform movement began in eighteenth-century Europe
and flourished in the United States, where it is now represented
by Hebrew Union College-Jewish Institute of Religion campuses
in Cincinnati, New York, and Los Angeles. Jews have tradition-
ally understood themselves as a people set apart, but the Reform
impulse is toward integration and assimilation. Pioneers in the
Reform movement wanted to be modern Germans or modern
Americans without ceasing to be Jews. So instead of Hebrew they
used vernacular languages in sermons and prayers. Some even held
Sabbath services on Sunday rather than Saturday and refused to
circumcise their sons.

The Pittsburgh Platform (1885), the classic expression of Reform Judaism, described the Hebrew Bible as "reflecting the primitive ideas of its own age" and spoke of Judaism as "a progressive religion, ever striving to be in accord with the postulates of reason." It rejected kashrut on the theory that only the moral laws of the Torah were binding. And because Reform Jews wanted to make whatever countries they were living in their homelands, this platform refused to see Jews as living in exile from their true home in Zion.[35] Today Reform Jews are more ritually observant, and virtually all of them are grateful for the Zionist movement that culminated in the State of Israel. But they continue to emphasize Judaism's prophetic tradition and its commitment to social justice, believing it is their job to repair the world by their own hands, not to wait for a messiah to do it. Reform Jews have pushed hard for gender equality, ordaining female rabbis, counting women as part of the minyan (quorum for prayer), and insisting not only on welcoming boys into adulthood via the bar mitzvah but also on initiating girls into adulthood via the bat mitzvah.

Orthodox Jews, by contrast, define themselves as defenders of Torah and tradition. They attempt to observe all the mitzvot, including kosher dietary laws. They accept only male rabbis, and their services are conducted in Hebrew. While Reform Jewish men rarely wear a yarmulke or *kippah* (head covering), many Orthodox men will not take more than four steps without one. And while Reform Jews allow men and women to mix in their temples, men and women are separated in the Orthodox *shul*.

Orthodox Jews are themselves separated into various groups. The Modern Orthodox, for example, are scrupulous in their observance of halakha, but they are much more open than other Orthodox Jews to modern life and modern ideas, including liberal-arts education. In the United States the Modern Orthodox are represented by Yeshiva University in New York, where it is common to see young men wearing blue jeans with traditional *tzitzit* (fringes) hanging out over them.

Hasidism is considered ultra-Orthodox, but when it began in

the 1730s in the shtetls of Eastern Europe, it was seen as liberal and even revolutionary because of its emphasis on the heart over the head. This movement was inspired by the Baal Shem Tov (1698–1760), a man beloved not so much for his book learning as for his heartfelt spirituality, his down-to-earth stories, and his unshakeable conviction that God is near to all of us, not just the intelligent and the learned. Today the Hasidim ("pious ones") testify to the presence inside Judaism of what Hindus call bhakti yoga, the discipline of devotion. Firm believers in divine immanence, the Hasidim attempt to commune with God always and everywhere, sensing His presence in activities as mundane as sleeping or tying your shoes. Characterized by full-throated and fully embodied enthusiasm—Judaism as joy—their services recall the ecstatic prayer of Pentecostalism and the danced religion of the Yoruba. The Hasidim revere a new Jewish exemplar, the *tzaddik* ("righteous one"), who is distinguished more by piety than by education. They invest in these tzaddiks, whom they also call *rebbes*, tremendous authority over their collective and personal lives, not unlike the guru figure in the Hindu tradition. The distinguishing mark of their movement, however, is their holy joy. "God desires the heart," the Talmud says, and the Hasidim seek to give God what He most desires.[36]

The beliefs and practices of Conservative Jews mark a middle path between Reform and Orthodox Judaism. Like Reform Jews, Conservative Jews are quite open to advances in modern thought, including Bible criticism. They are closer to Orthodox Jews when it comes to worship and law, respecting not only the ethical but also the ritual commandments as halakha, and worshipping in Hebrew. Women and homosexuals can be ordained in Conservative synagogues, however, and worshippers are permitted to drive to services on the Sabbath. Conservative Jews trace their origins to the founding, in 1886 in New York City, of the Jewish Theological Seminary, but their movement did not pick up steam until Solomon Schechter (1847–1915), a Cambridge University academic, came to the United States to lead JTS in 1902.

Much Jewish humor pokes fun at the differences between these

Jewish branches, with each joke taking aim at one group or another. One widely told joke takes a jab at the Orthodox for their obliviousness to modern life and at Reform Jews for their obliviousness to Jewish traditions:

> *A Conservative Jew living in a small city bought a new*
> *Ferrari. He wanted a rabbi to say a bracha (blessing) over*
> *it, but there were only two rabbis in town. So he went to the*
> *Orthodox rabbi. "Rabbi," he asked, "Can you say a bracha*
> *for my Ferrari?" The rabbi said, "What's a Ferrari?" So he*
> *went to the Reform rabbi. "Rabbi," he asked, "can you say a*
> *bracha for my Ferrari?" The rabbi said, "What's a bracha?"*

Reconstructionist and Humanistic Judaism

Two additional American Jewish branches are Reconstructionist and Humanistic Judaism. Reconstructionist Judaism, developed by Mordecai Kaplan (1881–1983) in New York City in the first half of the twentieth century, found institutional expression with the opening of Reconstructionist Rabbinical College in suburban Philadelphia in 1968. Following Kaplan's lead, Reconstructionist Jews rejected the notion of Jews as a chosen people and spoke of God only as an expression of the highest ethical ideals of human beings. From their perspective, Judaism was not a supernatural religion but an evolving civilization. Today Reconstructionist Jews are eager adapters of Jewish civilization to modern life. In keeping with their origins in the Conservative movement (Kaplan taught for over fifty years at JTS), they tend to be more traditional and observant than Reform Jews, speaking Hebrew in worship services, for example, and observing the full range of Jewish holy days. They distinguish themselves from the three leading U.S. Jewish branches, however, by viewing mitzvot as folkways rather than law. Like Reform Jews, they strive for egalitarianism in terms of both gender and sexual orientation. In fact, the first American bat mitzvah was held for

Kaplan's daughter Judith in 1922. Not surprisingly, there is also Jewish humor that pokes fun at Reconstructionist Judaism: At an Orthodox wedding, the bride's mother is pregnant; at a Conservative wedding, the rabbi is pregnant; at a Reform wedding, the bride is pregnant; and at a Reconstructionist wedding, both brides are pregnant.

Humanistic Judaism began in 1963 when Sherwin Wine (1928–2007), the "atheist rabbi," founded Birmingham Temple in suburban Detroit as a home for Jewish freethinkers.[37] Today its congregations celebrate Jewish culture and the power of the individual without invoking God, praying to God, or reading from the revelation of God. For Humanistic Jews, Judaism is first and last about ethics—doing "good without God." They reject the bris, or circumcision ritual, as sexist, preferring naming ceremonies for boys and girls alike. This group has strong affinities with Israel's kibbutz movement, which was built in the early twentieth century on secular and often antireligious foundations. One spokesperson is Harvard University's humanist chaplain Greg Epstein, a student of Wine and the author of *Good Without God* (2009). Although Humanistic Judaism is quite small—the International Federation of Secular Humanistic Jews claims only twenty thousand members—it expresses the sentiments of many more. According to a variety of studies, many Jews in both the United States and Israel are secular in the sense of either not being affiliated with any synagogue or not believing in God.[38]

Zionism and the Holocaust

Another Jewish impulse, Zionism (from Mount Zion, in or near Jerusalem), cuts across these movements. As nationalism overtook Europe in the nineteenth century, some Jews started to rethink their narrative of exile and return in more explicitly political terms. Jews had endured over the centuries a series of persecutions and indignities—from Egypt to Babylon to murder at the hands of

Crusaders in Jerusalem in 1099 to their expulsion from Spain in 1492 to the anti-Semitic tirades of the Protestant leader Martin Luther's *On the Jews and Their Lies* in 1543. The nineteenth century brought on a series of anti-Jewish pogroms in Russia and elsewhere, prompting a political push for a Jewish homeland, typically dated to the First Zionist Congress of 1897. There was some discussion of establishing a Jewish state outside of the Middle East, including in Argentina or modern-day Uganda, but advocates finally fixed on the biblical Promised Land.

The key figure in early Zionism was Theodor Herzl (1860–1904), a Viennese Jew whose secular arguments for a Jewish state proceeded on pragmatic and political terms. Many Orthodox Jews initially opposed Zionism, arguing that creating a Jewish state was the job of God and his messiah alone. Many Reform Jews joined the opposition because they wanted to engage fully in the lives of their respective countries, not separate themselves from their fellow citizens. The Holocaust proved to be the tipping point for the Zionist cause. Tapping into centuries of Christian anti-Semitism, including the claim that Jews were "Christ killers," Adolf Hitler and the Nazis killed six million Jews, roughly one-third of the Jewish population worldwide. Not long after the world learned of these horrors, the state of Israel was created, in 1948.

Feminist Theology

Judaism has also produced a vibrant conversation about the role of women in the Jewish community. Traditionally, Judaism has been the epitome of patriarchal religion. The biblical covenants were made with men and passed down through male circumcision. The minyan (quorum) required for certain religious activities has traditionally required ten male adults. Women were also exempted from the rabbinate and from many commandments. No wonder Jewish men have traditionally thanked God for three blessings: that they are not Gentiles, slaves, or women.

All this is changing, at least in non-Orthodox circles. Women joined the ranks of the rabbinate when Regina Jones of East Berlin was ordained in 1935. In the United States, Reform Jews ordained their first female rabbi in 1972, and Reconstructionist and Conservative Jews followed suit in 1974 and 1985, respectively. Even the Orthodox are loosening up. In Israel today Orthodox women are gradually breaking into the male monopoly of overseeing the certification of kosher food processing businesses. More important, Modern Orthodox women are now engaging in advanced Torah study, traditionally a central aspect of Jewish life.

Feminist theologians have done their best to retrieve examples of Jewish female leadership: Deborah the judge, prophet, and military leader described in the book of Judges; the Hasidic adept Oudil; and Israel's prime minister Golda Meir. These theologians speak of God in both the feminine and the masculine and invoke the memory not only of Abraham, Isaac, and Jacob but also of Sarah, Rebecca, Rachel, and Leah. But there is no pretending away the patriarchal history of Judaism. The term "texts of terror" now used to describe passages in the Jewish, Christian, and Muslim scriptures that condone violence, referred originally to texts in the Tanakh describing murder, rape, and other violence against women.[39] The Talmudic preference for males over females begins at birth. Or, as the Talmud puts it, "Happy is he whose children are sons and woe to him whose children are daughters."[40]

Kabbalah

Each of the great religions does certain things well and other things poorly. Buddhism is strong on the experiential dimension of religion and weak on the ethical dimension. Judaism is just the opposite. Because of their community focus, Jews (with the notable exception of the Hasidim) have not cultivated personal spirituality with the care or intensity that Buddhists have. Recently, many Jews hungry for spiritual experience have gravitated toward vari-

ous forms of Buddhist meditation. "Ju-Bus," as they are called, are attracted not only to the experiences these contemplative practices offer but also to the fact that they are delivered inside a tradition that does not have a jealous god. This same hunger for spirituality is also driving many Jews to tap into their own religion's experiential resources, including the mystical tradition known as Kabbalah.

A few years ago I was peppering a Jewish friend with questions about Judaism, and she was answering them patiently. After a while she blurted out, "You know I'm not Jewish, right?" This friend is one of the most Jewish people I know. Her mother is Jewish, her father is a rabbi, and her brother lives in Israel. She spent years studying Torah. She observes the commandments. She knows the blessings. And she embodies much of the best of the Jewish tradition. So why did she deny she is Jewish? Well, she was not really denying it. What she was telling me is that her experience of what we call God is bigger and more mysterious than anything the term *Judaism* might convey.

My friend is a mystic, though she would resist being put in that box too. But she has had experiences of God that most of the rest of us can only imagine, and she understands the Jewish tradition largely in light of Kabbalah. Because of the difficulties and dangers of this esoteric path, Kabbalistic study has traditionally been limited to married men advanced in both age and Torah study. Kabbalah had considerable influence in the medieval and early modern periods, but fell into decline during the reason-besotted Enlightenment. In recent years, Kabbalah has come into public view (and ridicule) because of the association of celebrities such as Madonna, David Beckham, Ashton Kutcher, Demi Moore, Lindsay Lohan, and Britney Spears with the Kabbalah Centre run in Los Angeles by Philip Berg. Kabbalah's roots, however, run much deeper than this pop Kabbalism. In fact, they run to thirteenth-century Spain and an Aramaic book called the *Zohar*. This sprawling text of many volumes is traditionally attributed to a second-century figure named Shimon bar Yochai, though the faithful claim that its tradi-

tions go back to Moses and Sinai and even to creation itself. Scholars say the *Zohar* was likely written by the man who claimed only to have "discovered" it: Moses de Leon (1250–1305) of Avila, Spain.

Kabbalism contains all sorts of esoteric speculation not only on God but also on numbers, letters, vowels, and consonants. Ultimately, God is said to be *Ein Sof*, which is to say endless and limitless and beyond mental grasping. But Ein Sof manifests in ten *sefirot*, or emanations—a view opponents say pushes Kabbalah perilously close to polytheism. Another key concept in Kabbalah is *Shekhina*, the feminine and immanent aspect of God, which according to Kabbalists complements and balances the more masculine and transcendent aspect of God emphasized in the Tanakh and Talmud. The Shekhina makes an appearance in the Talmud, where she is said to go into exile in Babylon with the Jewish people. In Kabbalah, however, she takes center stage.

According to Kabbalistic thought, before creation all was one. But with creation came multiplicity. In a sort of spiritual Big Bang, everything exploded out into the cosmos in fragments but with a spark of the divine tucked inside each. So creation is a broken but redeemable vessel. Our job is to reverse this primordial exile of the many from the One, to return the sparks inside us and inside everything around us to their original wholeness. This is accomplished by doing the commandments, which bring one closer to God and to the rest of the Jewish community. But mitzvot also operate on another plane, by helping to lure the Shekhina out of her own exile and back into union with the more masculine aspect of the divine. Kabbalists speak of this union as a marriage of God and the people of Israel, where the Shekhina plays the role of God's people in exile returning to their/her true home and repairing the world in the process.

Jewish Renewal

Judaism is often thought of as a closed community, and there are some for whom separation from the rest of the world is essential to Jewish life. A new movement, however, is eagerly adopting all sorts of outside influences into the Jewish family and giving them Jewish life. Jewish Renewal draws heavily on Kabbalah and Hasidism, but it was born with the counterculture in the 1960s, so from the start it was culturally and spiritually promiscuous, picking up this from feminism and environmentalism and that from Zen and Tibetan Buddhism. One early inspiration was Zalman Schachter-Shalomi (b. 1924), a Polish-born Orthodox rabbi and Holocaust survivor who taught for a time at the Buddhist-based Naropa Institute in Boulder, Colorado, and whose journey to India to meet the Dalai Lama was chronicled in Rodger Kamenetz's *The Jew in the Lotus* (1994). A key early expression was *The Jewish Catalog* (1973), a "do-it-yourself kit" for creative Jewish spirituality modeled after *The Whole Earth Catalog* (1968). This man and this book both aimed to launch Judaism from insularity to openness—to a more experimental and embodied spirituality that would embrace not only the outside world but also other religious traditions.

Rather than founding new synagogues and positioning themselves as a new denomination, advocates of Jewish Renewal organize themselves into *havurot* ("fellowships"), small communities of equals gathered for prayer, Torah study, and meditation. Jews have long seen study as worship; in Jewish renewal, study is meditation too. The term *havurah* carries the connotation of "friend," so these are fellowships of friends that actually share certain features with meetings of the Society of Friends (Quakers), including informal worship, casual dress, and an egalitarian spirit uncomfortable with hierarchy of any sort.

Practitioners of Jewish Renewal have been organized since 1993 into the Alliance for Jewish Renewal, but the spirit of this movement is better expressed in books such as Schachter-Shalomi's

Jewish with Feeling (2005) and Michael Lerner's *Jewish Renewal* (1994). Many American synagogues today have havurot inside them, providing a place for Jews with inclinations toward yoga or Sufism or Kabbalah under the sacred canopy of the synagogue itself. Although many advocates of Jewish Renewal speak easily of the Shekhina, the marriage they believe will renew the world is between Judaism and other spiritualities.

To critics, Jewish Renewal is "New Age Judaism," which is to say it isn't really Jewish at all. Just as Humanistic Judaism has gone over the deep end into agnosticism and even atheism, Jewish Renewal is missing the re-. Did not God Himself say, "[I] have set you apart from the peoples, that ye should be Mine" (Leviticus 20:26)? If so, who are we to transgress the boundaries of religions? Such criticisms neglect to remember how malleable the Jewish tradition has been over the millennia and how central this malleability has been to its survival. The notion of an unadulterated Judaism is as elusive as the notion of an unchanging Buddhism. Hasidism, for example, makes all sorts of claims to tradition, but it is a product of the eighteenth century, older than Protestant fundamentalism, no doubt, but no less a modern invention. The same is true of Orthodoxy, which was born in nineteenth-century Germany in response to Reform Judaism. The Jewish tradition has always been a dance, or perhaps a wrestle, between the old and the new. And it is this give and take that keeps it vital.

While Judaism is a tradition of story and law, what has kept it alive is conversation and controversy—the inquisitive spirit of the boys (and, nowadays, girls) in the yeshiva. How to tell the story? How to interpret the law? How to end the exile? Almost all religions provide opportunities for human beings to convince themselves of their own righteousness, to speak in the name of God, and even to go to war on God's behalf. This "blasphemy of certainty" is also rife among secularists who in their case have not God but science or the proletariat on their side.[41] Jews, both religious and secular, have done all these things, of course. Yet their tradition warns them repeatedly that their thoughts are not God's thoughts,

reminding Hillel that Shammai might be right about this and re-
minding Shammai that Hillel might be right about that. Because
only God really knows, the rest of us are free to wrestle, without
fear, with how to read a text or how to observe a commandment—
to turn learning into recreation and debate into play. If religion
without controversy is dead, Judaism may well be the liveliest of
the great religions.

Daoism

Modern life is purpose-driven. Though much of it is conducted in an office chair, it is nonetheless about speed and efficiency—"galloping by sitting."[1] Wandering, by contrast, is slow, unproductive, and open to surprises. If you have a destination, or even a plan, you aren't on a wander. Purposeless by design, wandering is closer to play than to work. It lets circumstance and desire take you where they will, and it doesn't sweat the outcome.

The Western monotheisms portray wandering as punishment—something you get after you bite the apple (Adam and Eve) or kill your brother (Cain). In Daoism (or Taoism[2]), however, wandering is opportunity rather than punishment. The Daoist hero Lu Dongbin was working his way toward marriage, employment, and success when, during a nap, he caught a glimpse of the future prison he was making for himself. He dreamed he was a rich and respected government official with many children and grandchildren until a scandal stole everything from him, scattering his family and leaving him a broken man. When he woke up, Lu decided to climb out of his hamster cage. After flunking China's imperial examinations, he made for the mountains instead. Eventually this dropout became one of Daoism's beloved Eight Immortals.

Whereas Christians and Muslims tend to view this world as a dress rehearsal for the world to come, "This is it!" is the Daoist mantra. Socially, Daoism represents a revolt of the land against the city, of China's rural south against its urban north. We are at home

on earth, and in our bodies. We are least ourselves when those bodies are stuck in the concrete of a city sidewalk. We are most ourselves when walking through the mountains. So it should not be surprising that Daoist scriptures portray wandering as freedom. To be lost in the maze of social conventions and ritual propriety, led around by the noose of norms and "the normal," is to be alienated from yourself, from other people, and from the environment. To lose yourself in mountains or valleys is to return to the origin of things, including your own nature. To "roam in company with the Dao," led only by intuition and desire and the innate curiosity of the child, is to discover who you really are—your natural spontaneity, vitality, and freedom.[3]

The first chapter of the Daoist classic the *Zhuangzi* (or *Chuang-Tzu*) is called "Free and Easy Wandering." It speaks of a sage who "could ride upon the wind wherever he pleased, drifting marvelously" for days at a time; another who could "go wandering in infinity"; another who "rides on the clouds, drives a flying dragon, and wanders beyond the four seas"; and yet another who "can roam in nonaction." Later chapters describe the sage as someone who "wanders beyond the dust of the mundane world" and speak of the wanders of emperors and even Confucius himself. According to Sinologist Victor Mair, who titled his *Zhuangzi* translation *Wandering on the Way*, wandering is "probably the single most important and quintessential concept" in this text. Mair adds that *yu*, which is usually translated as "wandering" but also means "playing," is a "term for that transcendental sort of free movement which is the mark of an enlightened being." This movement can be of the mind as well as the body. "Just ride along with things as you let your mind wander," writes Zhuangzi. "That is the ultimate course."[4]

The *Zhuangzi* itself is a ramble into the unexpected, the unpredictable, and the unknown—a piñata of paradox and parody and parable and wit, just waiting to be cracked open by childlike joy. Its lines tramp whimsically from this story to that without a care in the world about continuity, organization, or narrative arc. Having no way, it seems to chuckle, may take you to the Way itself.

This may seem impossible, irrelevant, and silly. How can a wander be purposeless on purpose? How can the archer hit her target without taking aim? Yet we know that too much aiming of a baseball, say, leads a pitcher to throw balls rather than strikes. As any Little League coach can tell you, a pitcher needs to throw without aiming. He needs to let go.

The Dao of Everything

Daoism is the least known in the West of Asia's great religions, yet in some respects it is the most widespread. Daoism is popular not only in its homeland of China, where it stands alongside Confucianism and Buddhism as one of the Three Teachings, but also across East and Southeast Asia—in Taiwan, Hong Kong, Korea, Japan, Singapore, and Vietnam. It has also made its way via immigration and popular culture to Australia, Europe, and the United States. In times of global warming and environmental degradation, Westerners are particularly attracted to the Daoist value of naturalness, which urges human beings to act in harmony with the natural world. The Daoist love of nature, and of mountains, is reflected in Chinese landscape painting, and its themes of simplicity, change, and nonconformity echo throughout Chinese poetry. Daoism has also had a profound impact on acupuncture, Chinese medicine, and *Taiji* (Tai Chi).

The Daoist classic the *Daodejing* (or *Tao Te Ching*)—also known as the *Laozi* (*Lao-Tzu*) after its reputed author—is the most widely translated book after the Bible and the second most influential book in Chinese history after the Analects of Confucius. Given the complexity of this text, it is hard to account for its popularity, though the fact that it is both brief and ambiguous means, as Mair writes, that "everybody can not only find in it what they want, they can find what they're looking for quickly."[5]

More than any of the other great religions, Daoism has benefited from a recent renaissance of scholarship by Chinese, Euro-

peans, and Americans alike. But Daoist immortals have ridden to the West on the wings of popular rather than academic culture. The *Buddhist Bible* (1932) that the Beat icon Jack Kerouac—the Lu Dongbin of 1950s America (Lu, too, had a weakness for women and alcohol)—carried around in his back pocket as he went "on the road" contained not only Buddhist but also Daoist texts. And Kerouac's Beat friends and the hippies that traipsed after them were influenced at least as much by Daoist commitments to naturalness, simplicity, spontaneity, and freedom as they were by Buddhism's Four Noble Truths. So while his fellow travelers were, in Kerouac's phrase, "Dharma Bums" they were also Daoist wanderers who through various techniques mimicked the ecstasies of ancient Chinese shamans, traveling to other worlds and coming back with wisdom (and stories) from spirits and gods.

Getting your fill of Daoism is even easier in your living room and at the movies than it is at your local bookstore. On the animated television comedy *The Simpsons*, Lisa helps her brother Bart compete in a miniature golf tournament by hopping him up with a cocktail of Daoist and Zen wisdom and wit. This same combination is on display in the *Kung Fu* television series (1972–75) and in popular films such as *The Karate Kid* (1984), *Teenage Mutant Ninja Turtles* (1990), and *Crouching Tiger, Hidden Dragon* (2000). Daoism also informs feng shui (literally "wind and water") and the "biospiritual" breathing exercises known as *qigong*.[6] Feng shui, which was originally used to position graves in keeping with the yin ("shady") and yang ("sunny") sides of cemetery hills, is now used in architecture and interior decoration in both East Asia and the West. The best known of Daoist qigong practices, Falun Gong, was banned in China in 1999.

The most important vehicles for the diffusion of Daoism worldwide are the thousands upon thousands of martial arts schools scattered throughout Asia and almost every town and city in Europe and the United States. In classes on Taiji, for example, children, adults, and senior citizens alike learn of key Daoist concepts such

as qi (chi) and the complementarity of the feminine yin and the masculine yang. More important, they come to embody them.

The West's infatuation with Daoism is most visible in the titles of hundreds of books, including many bestsellers, that begin with the magic words "Tao of" and cover almost every aspect of human life. There are "Tao of" books on cooking, eating, dishwashing, teaching, coaching, dating, dreaming, computing, writing, bathing, being, dying, and letting go. Sports-related books include *Tao of Surfing*, *The Tao of Golf*, *The Tao of the Jump Shot*, *Tao of Baseball*, *The Tao of Poker*, and *The Tao of Chess*. For academics, there are "Tao of" books on anthropology, psychology, politics, and statistics, as well as Fritjof Capra's hit, *The Tao of Physics*. For the spiritual or religious (or both), there is *The Tao of Islam*, *The Tao of Zen*, *The Tao of Jesus*, *The Tao of Christ*, and even a book (on Jewish mystic Martin Buber) called *I and Tao*. On such perennial subjects as sex and money and love and business, "Tao of" books abound. Elvis, Emerson, Muhammad Ali, Warren Buffet, Bruce Lee, and Willie Nelson all have "Tao of" books devoted to them. For animal lovers, there is *The Tao of Bow Wow*, *The Tao of Meow*, and even *The Tao of Cow*.

Of all the "Tao of" books, the one with the most jolting (and revolting) title is *The Tao of Poop*, though it may be of some comfort to know that this book's subtitle is *Keeping Your Sanity (and Your Soul) While Raising a Baby*. The most famous is Benjamin Hoff's *The Tao of Pooh* (1982), which puts Daoist truths on the lips of Winnie the Pooh and his friends. While introducing China's Three Teachings, Hoff tells his readers about a scroll depicting Confucius, the Buddha, and Laozi, all tasting vinegar. Confucius has a sour face, the Buddha has a bitter one, but Laozi is smiling, because life to him is as sweet as Pooh's beloved honey.[7] Much of this is silliness, of course. The movie *Tao of Steve* includes the immoral line, "I'm not looking for enlightenment, I'm just looking for a girlfriend." But the silliness is fitting, since Daoist sages seem to laugh far more often, and more lustily, than, say, Jesus or Paul did.

One reason Daoism is popular in the West is that Westerners know so little about it. This ignorance allows us to make it over in our own image, and because there are few card-carrying Daoists in Europe and the United States, these makeovers are hardly ever corrected by Daoists themselves. To be fair, Daoists have never really tried to systematize their thought. They have never banished their heretics or even identified them. Their canon of scriptures is both encyclopedic (well in excess of a thousand volumes) and contradictory. And they have never frozen their fluid teachings into dogma—fitting for a tradition that stands by change and creativity. Again like Hindus, Daoists are forever absorbing rather than repelling new influences. Their tradition is an endlessly elusive grab bag of philosophical observations, moral guidelines, body exercises, medicinal theories, supernatural stories, funerary rites, and longevity techniques that, more than any of the other great religions, defies definition. Daoism is, to be sure, a tradition of books, both holy and humorous. But it is also a tradition of sacred mountains and pilgrimages and festivals and wine and incense and hymns and sexual practices and alternative medicine and martial arts and meandering conversations and immortals who "wander in the mists" and "dance in the Infinite."[8]

Just how many of these wanderers and dancers there are is as elusive as Daoism itself. Because Daoism is one of China's Three Teachings, most Chinese feel free to do Daoist, Buddhist, and Confucian things without aligning themselves exclusively with any one tradition. Those who identify largely with Daoism typically refer only to priests and sages as "Daoists." Moreover, Daoist practitioners do not usually gather in congregations in which they can line up and be counted. So the accounting here is about as impossible as the defining. (The World Religion Database, which keeps tabs on adherents of other major religions, does not even try in this case.) Taiwan, which since the 1960s has seen a Daoist renaissance, has about ten thousand Daoist temples and perhaps six million Daoist practitioners.[9] The number of Daoists in China, where Daoism is also staging a comeback, is anyone's guess, since official govern-

ment statistics count only clerics. Though Daoism is often associated with hermits and rebels, the tradition's folkways have long attracted all social classes, including government officials, so most Chinese are influenced in some way by its teachings. This tradition is stronger, however, in China's rural south than in its urban north. A plausible estimate is 50 million in mainland China alone, though that figure could rise to well over 100 million if you count people who climb Daoist mountains, patronize Daoist temples, or light incense to Daoist immortals in their homes.[10]

Still, it must be said that Daoism's contemporary impact lies less in its numbers than in the power and diffusion of its ideas. Daoist influence can be found outside of Daoism per se in Neo-Confucianism and Zen Buddhism, but Daoism has not exerted the influence over East Asian civilization that Confucianism and Buddhism have. Its power has almost always been countercultural, and its influence today continues to be more in literature and the arts than in politics and economics. For this reason, it ranks well below both Confucianism and Buddhism in terms of contemporary impact.

Nurturing Life

Daoists have always been more attracted to the fluid than to the fixed, so Daoists disagree about almost everything, including the goal of their tradition. Some Daoists accept death as part of the natural order of things, while others seek to defy death by questing after immortality. Nonetheless, most Daoists agree that the highest value is life, so the highest practice is the art of nurturing life. The problem is that we let life slip away, either by not living it fully or by not living it for long. We wear ourselves down by selling ourselves into the servitude of customary ways of thinking and acting. The Daoist solution is to live life to the fullest—to enjoy good health in a vital body for a long life. So there are echoes here of the this-worldly orientation of Israelite religion, in which patriarchs such as

Abraham and Moses sought not heaven but to live a long life, die of natural causes, and be buried by their kin.

For some Daoists, this goal of human flourishing extends to a loftier goal: physical immortality. They seek to become immortals who feed on the wind, drink the dew, mount the clouds, and ride on dragons to the end of the earth (and beyond). But even these Daoists do not hope for (or fear) an afterlife. While the philosophers of ancient Greece affirmed a disembodied immortality of the soul after death, Daoists say that whatever immortality is available to us is to be found on earth and in this body.

Philosopher Grace Jantzen asserts that the great mystery at the heart of the great religions is not mortality but natality.[11] This certainly applies to Daoism, which is more about nourishing life than defeating death. For Daoists, flourishing is built into the nature of things. Like trees that are made to grow, humans are made to flourish. But this is only possible if we live in harmony with the natural rhythms of the Dao. Unfortunately, most of us live in accordance with the dictates of social conventions, moral rules, formal education, and ritual prescriptions. Such civilization is a vampire. Its artifice sucks the life out of us, depleting our qi (vital energy) and taking us to an early grave. We act intentionally, from the will rather than the heart. We think too much and intuit too little. We commit ourselves to dichotomies that are really distinctions without a difference, distinguishing between what we like and dislike, what is right and wrong, what is beautiful and ugly. And so we die a little each day.

All this attention to conventional thought and morals doesn't just kill individuals, however. It destroys social harmony, which is possible only when everyone does what they naturally do. While Confucians see etiquette and rituals as solutions to the world's ills, Daoists see both as causes of the human problem of lifelessness. The Dao has created things to change spontaneously and without warning. But the stuff of society—etiquette and ritual, language and thought—molds us, constrains us, freezes us. We build barriers, in our individual and our social lives, that chop what was

once a unified cosmos into smaller and smaller parts, separating us from one another and restricting "the free movement of the Dao." This fragmentation seduces human beings into seeing themselves as isolated atoms, distinct from one another and from the Dao. So we become foreigners in our own land, frenetic creators of a civilization that with every so-called advance cuts us off from the original harmony of the "pristine Dao."[12]

In other words, the Confucian project of actively cultivating such virtues as ren (human-heartedness) and li (ritual/etiquette/propriety) isn't just ineffectual; it is harmful, both to individual flourishing and to social harmony. What the Confucians see as self-cultivation is actually self-destruction. No wonder so many of the students of Confucius came to early ends: "Yan Hui died early, Ji Lu was dismembered and pickled in Wei, Zi Xia was blinded, and Ran Boniu contracted leprosy." Each sacrificed his nature—and his life—at the altar of the false god of social convention.[13]

Into all this trouble rides the sage. While the stuffy junzi ("profound person") served as the Confucian model, the spontaneous sage—also known as the "genuine person" (zhenren)—functions as the exemplar in the Daoist tradition. Unrestrained by social shackles, the sage acts authentically and spontaneously, without expectation or goal. His reliance on intuitive wisdom over book learning may make him seem foolish to outsiders. But by freely flouting social norms, he is able to crash through the life-sucking barriers that accrete around artifice and allow the life-giving Dao to move where it will. Only this Dao can nurture us back to life. And the sage embodies it, combining in his own body the vitality of the child and the potency of the mother.

The techniques Daoists employ toward this goal of nurturing life are meant to ensure not only that we are healthy and long-lived but also that the life we live is vital and genuine. Typically these techniques work by preserving and circulating our qi, balancing our yin and yang, and otherwise returning us to the creativity of the Dao. These techniques include "sitting and forgetting," "fasting of the mind," and "free and easy wandering." They also include di-

etary regimens, breath control, visualization exercises, purification rites, sexual practices, meditation techniques, and various physical exercises modeled after the movements of long-lived animals ("bear strides and bird stretches").[14] In outer alchemy, ancient Daoists experimented with metals such as cinnabar to create elixirs of immortality along the lines of the immortality plant sought by the title character in the Mesopotamian epic Gilgamesh. In inner alchemy, developed around the eleventh century C.E., the human body itself became the laboratory, and sages-to-be sought to create an "embryo of immortality" inside themselves by manipulating the "three treasures" of the human body: *qi* (vital energy), *jing* (sexual essence), and *shen* (spirit).[15]

All these techniques work by fostering union with the life-giving Dao, since vitality, longevity, and even immortality come only by living in harmony with the natural rhythms of things. I may be a father, a son, and a professor, but from the Daoist perspective none of these social roles captures who I really am. That is because I am a natural rather than a social being. So when I say this meeting is killing me or this party is death, I am speaking literally rather than metaphorically. The rituals and etiquette so prized by Confucians drain our vital energies and shorten our lives. Wandering in the mountains liberates us from the death-dealing details of everyday social life, infusing us with strength for the journey. Only by "getting the Dao" can we achieve the freedom and vitality of the sage.

As this goal of enriching and extending life implies, the experiential dimension is Daoism's forte. Rather than asking after truth, as did the Greeks, Daoism asks about where to go: what is the way to the Way? In fact, of all the great religions, Daoism may be the most allergic to doctrine. Whatever wisdom it holds it disseminates in parables and paradox and often in secret. Its core intuition is that there is a natural way, called the Dao, which at any given moment we can work with or against. To be fully human is to dance with this Dao, moving in rhythm with its core values of naturalness, equanimity, spontaneity, and freedom.

From Profound Primordiality to Deviant Belief

The influence of Daoism has waxed and waned throughout Chinese history, but it has almost always played second fiddle to its doppelganger of Confucianism. Daoism emerged in the midst of Confucian civilization, so Daoist jazz has from the beginning been contrasted with the classical music of Confucianism. Whereas Confucians argue that human beings become fully human by becoming social, Daoists say that we become fully human by becoming natural. Because the "pristine Dao" is within us, all we need to do is be ourselves.[16] While this approach may sound thrilling to those among us who feel caged in by society, it has repeatedly sounded alarms of rebellion and anarchy to Chinese rulers. So bureaucrats have typically applauded Confucian philosophers and their prose more than Daoist hermits and their poetry.

Most Chinese, however, see these two traditions as complementary, not contradictory. From the start, Daoists adopted Confucius as one of their own (though his main function in Daoist texts seems to be to exhibit his dullardism and then to bow and scrape before his Daoist betters). Meanwhile, Confucians took up many of Daoism's spiritual disciplines. So throughout Chinese history Confucians and Daoists have not only coexisted but complemented one another—Confucianism's communitarianism and Daoism's individualism, Confucianism's formalism and Daoism's flow, the hard yang of Confucianism and the soft yin of Daoism.

Daoism briefly penetrated corridors of power in the second century B.C.E., but its niche has typically been subjects rather than rulers. Popular support for Daoism rose in the fourth and fifth centuries C.E., about the same time Daoists started to gather their massive corpus of sacred texts into a canon of over 1,200 works divided (after the manner of the Buddhists *Tripitaka*, or "three baskets") into "three caverns." Particularly in the countryside, where Daoism absorbed local festivals and popular deities, Daoists positioned their tradition at the front of the class of the Three Teachings, boldly

portraying the Buddha as a reincarnation of the Daoist sage Laozi and Confucius as his humble (and sometimes bumbling) student.

Daoism's glory years came in the Tang dynasty (618–907) when the imperial family, which shared a surname with Laozi, enhanced their status by enhancing his. Declaring Laozi "Most High August Sovereign of Profound Primordiality," they proclaimed his birthday a national holiday and added the *Daodejing* to their list of required reading for civil-service exams.[17] They also threw so much money at Daoist monasteries and temples that by the middle of the eighth century there were 1,687 Daoist institutions (550 of them for nuns) registered with the state.[18]

The thirteenth century saw the burning of Daoist books. In the seventeenth century, Daoism was denounced by Christian missionaries as "deviant belief," and Chinese officials came to see it as unscientific, superstitious, and hyperritualized.[19] During the Taiping Rebellion (1851–64), led by a visionary who fancied himself the brother of Jesus, Daoist priests were killed and their monasteries destroyed wherever the rebels held power. When communists came to power in 1949, Daoism was suppressed as a degenerate relic of feudalisms past. Under Mao Zedong, ordinations stopped, festivals were forbidden, and temples and monasteries were either shuttered or recommissioned as factories or government offices. Under Deng Xiaoping, who ascended to leadership in 1978, religious persecution was relaxed and Daoism was recognized as one of five official religions.

Today Daoism has fewer religious professionals than any of China's other official religions (Buddhism, Protestantism, Roman Catholicism, and Islam), but ordinations are now going forward once again.[20] Thanks to a combination of spiritually motivated foreign money and tourism-motivated government support, over a thousand Daoist temples have been restored and reopened. Over one hundred thousand worshippers attend the most popular Daoist festivals. Both the Mount Wudang temple complex in Hubei province and the Mount Mao temple in Jiangsu province draw hundreds of thousands of pilgrims and tourists each year. Some of the funds

visitors pumped into the Mount Mao temple were used to build the world's largest bronze statue of Laozi, unveiled at this site in 1998.

Daoism is represented in China today chiefly by two institutions: the earlier Celestial Masters sect popular in the south, and the later Complete Perfection sect popular in the north. Westerners keen on dividing these two sects along Protestant/Catholic lines have ended up tying themselves in knots. While Celestial Masters' leaders have been called "Daoist popes," they do not follow the Catholic practice of requiring clerical celibacy. And while the Complete Perfection sect has followed the Protestants in rebelling against the magical thinking and ritual preoccupations of their Celestial Masters predecessors, they follow Catholics in emphasizing monasticism and requiring their priests to take a vow of celibacy.

Laozi and the Daodejing

Daoists trace their lineage to Laozi and the enigmatic classic attributed to him, the *Daodejing* (*Tao Te Ching*). *Dao* means "way," *de* means power or virtue, and *jing* means "classic." So the *Daodejing* is "The Classic of the Way and Its Power" or "The Classic of the Way and Its Virtue." This text used to be dated to the sixth century B.C.E., which would make Laozi a contemporary of the Buddha. But just as new discoveries have pushed forward the Buddha's dates, the *Daodejing* is now typically dated to the third or fourth century B.C.E., though many of its key concepts are much older. Unlike the Jewish and Christian scriptures, which glory in names and dates and the verisimilitude of historical accuracy, the *Daodejing* "contains no dates and mentions no proper names, nothing that would tie it to history."[21] Its home ground is the timeless aphorism. Its core concept, the Dao, floats above and beyond the vicissitudes of historical time. As for Laozi himself, there is some chance that he never lived, so the *Daodejing* may well be the work of multiple authors. In either case, stories about Laozi sparring with Confucius (and winning) are probably the stuff of

legend. Nonetheless, the legends endure, so at least in this sense Laozi not only lived, but lives on.

The term *Laozi* means "old master," or "old child." Legend has it that, like the title character played by Brad Pitt in the film *The Curious Case of Benjamin Button*, Laozi was born old. As a young man, he worked as an archivist in the state of Zhou. It was a good job, but one day, convinced that civilization was in freefall, he quit. Climbing onto a water buffalo, he followed the advice later immortalized by the American newspaperman Horace Greeley to "Go west, young man." In this case, west meant the border dividing the Chinese from the barbarians. Before he lit out for that *terra incognita*, a border guard aware of his reputation as a sage asked him to write something down before crossing. Laozi responded with a brief book of about five thousand characters known today as the *Daodejing*. He then rambled toward the western mountains, never to be heard from again. Or perhaps he made his way to India, where he was known as the Buddha. Or perhaps he went to Persia where, as Mani, he inspired the Christian heresy of Manichaeism. Or perhaps he ascended to the heavens. In any case, he would eventually come to be worshipped as Lord Lao, an incarnation of the Dao itself.

The eighty-one short chapters of the *Daodejing*, also called the *Laozi* (or the *Lao-Tzu*), can be read on a longish coffee break, but they have delighted and perplexed readers for millennia. This cryptic classic, part poetry and part prose, is divided into two parts: a more mystical opening section on the Dao, and a more political closing section on *de*. Although Confucians have long interpreted the *Daodejing* as a philosophical text, and Western Sinologists have generally followed their lead, a new generation of interpreters is coming to reckon with its spiritual and religious elements, including its roots in ancient Chinese traditions of shamanism and divination.

Usually translated as "the Way," the term *dao* also refers to a "path" or "road." All the great Chinese schools have wrestled with this keyword, but Daoists, as their name suggests, puzzled over its profundities, poking and prodding it to see where it might lead.

And where it led was back to the source, to the subtle force that creates all things, sustains all things, and pervades all things, which is to say to the Dao itself. Both transcendent and immanent, both perfection and potential, the beginningless and endless Dao is at least as theological as it is philosophical. Everything comes out of it (originally) and returns to it (eventually). So while it represents ultimate reality, it also permeates everything, including our blood and bones. "The Tao is not far off," Daoist sages say, "it is here in my body."[22]

According to Laozi (or whoever wrote the *Daodejing*) this impersonal Dao lies beyond ordinary language and the ordinary mind, so it can never be fully understood or fully described. To try to capture it is to feel it slip through your fingers. So while Daoists use language to depict the Dao, they typically do so with humor and humility. The Dao is the way of untamed nature, the way of authentic human life, and the harmonious union of the two. But it is also the social harmony so prized by Confucians, because when everyone acts authentically and without artifice the natural result is social order.

Reversal and Return

The central verb in the *Daodejing*, and the term that gives the text momentum, is *return*. And where Laozi wants us to return is to the primordial unity of the Dao itself. "Tranquility is returning," the *Daodejing* reads, so "return to the state of infancy," "return to the state of the uncarved block."[23] One of the great themes of the Italian Renaissance was to return *ad fontes*—to the fountainhead. In this text the movement is back to nature and to the endlessly fertile waters out of which everything natural first emerged. "The movement of the Tao," writes Laozi, "is to return."[24] And the fruits of this homecoming are revitalization and renewal.

This returning is necessary only because human beings have left behind the natural rhythms of the country for the artificial synco-

pations of civilization. At birth, human beings are in full possession of the Dao. We are, in a famous metaphor from the *Daodejing*, uncarved blocks—simplicity itself. But Confucians and other civilizers insist on carving these blocks into useful parents and subjects, husbands and wives. Laozi sees each cut as a little death, with each shaving stealing from us our natural vitality, wearing us down, and shortening our lives. As Henry David Thoreau and Huck Finn can attest, however, this custom also steals from us our uniqueness. How can we be free to become ourselves if society is forever conspiring to turn us into something else? Must a government's need for good citizens and a family's need for filial children come before our own individual desires to flourish in our own way and on our own terms?

Laozi is responding here to Confucians who are convinced that both humanity and society are at their best when they are most intricately intertwined. For Laozi, however, the rituals and etiquette of polite society are a trap. The way back—and it *is* a returning—is to reverse the socialization process. The way to freedom leads through nature, which far more than society embodies the unity and harmony of the Dao. It is social beings who force things, who fight the way things are, who swim against the tide. Natural beings accept what is. If they find themselves in a riptide, they float with it until it is safe to swim to shore.

Closely related to this theme of return is the theme of reversal. Like a good wander, the Dao will surprise you. In fact, this sometimes seems to be its full-time job. In the New Testament parables of Jesus, the kingdom of God is about reversals—overturning our expectations by putting the rich before the poor and the last before the first. In the *Daodejing* it is the Dao that plays fast and loose with our expectations. We are to yield rather than pursue, to let go rather than grasp. We are to prefer the valley, which safeguards us in a storm; the female, which outlives the male; and the infant, whose freedom and vitality are unbound. Like James Agee, whose *Let Us Now Praise Famous Men* (1941) glories in the everyday lives of "nobodies," Daoism roots for the underdogs. In the endless

dance of the passive yin and the active yang, we are to partner with
the soft and the supple, the weak and the quiet. We are to let things
come to us rather than pursuing what we think we want and need.
And why? Because yielding will make us free, and freedom will
make us flourish.

The goal of human life, therefore, is to merge with the Dao, to
mimic its flourishing, and thereby to flourish ourselves. And the
best metaphor for the Dao, which is ultimately indescribable and
therefore can only be approached via metaphor (and not without
trepidation) is nature itself. So when Laozi wants to know how to
act, he looks at the natural world, which has been neither social-
ized nor acculturated. He looks at the infant, who is innocent of
learning and pretense. He looks at water running from mountain
to valley without a thought in the world of doing otherwise.

Both infant and water embody *wu wei*, another key concept in
the *Daodejing*. *Wu wei* literally means "no action," and in Daoist
writing it can refer to not acting and to reducing one's actions to a
minimum. More often, however, it refers to acting as nature does,
which is to say spontaneously and effortlessly and out of the core
of one's being—to do this or that because it seems right in the
moment, not because it is prescribed by this law or decreed by that
god. So the opposite of *wu wei* is not action but artificial or con-
trived action. To act in the spirit of "noninterference," as *wu wei*
is sometimes translated, is to submit with equanimity to what is
rather than resisting it in the name of what ought to be.

Someone once explained *wu wei* to me in terms of the choices
that present themselves to a surfer. Bobbing up and down in the
ocean, she has three ways to proceed. She can force things by pad-
dling to shore (intentional action). She can sit there and drift (non-
action). Or she can catch a wave (*wu wei*). My colleague David
Eckel tells me that the best metaphor for *wu wei* is water that ef-
fortlessly runs downhill. Falling water exhibits the Daoist virtue of
ziran, which literally means "self-so" but typically refers to acting
spontaneously or letting things take their natural course. The *Dao-
dejing* refers to water as an example of the paradoxical power of

weakness. Laozi admonishes us to be as flexible and yielding as water, which wears down rock not by smashing through it but by flowing around it. "There is nothing in the world more soft and weak than water," writes Laozi, "yet for attacking things that are hard and strong there is nothing that surpasses it."[25]

Ground of Becoming

Passages such as this one may convey the impression that the *Daodejing* is crusading for the superiority of the passive yin over the active yang. "Know the male," Laozi writes, "but keep to the female."[26] However, the goal of all this talk of valley and void, simplicity and tranquility is balance. In Daoist thought, yin and yang are opposing yet complementary (and interpenetrating) principles, with each containing a bit of and forever evolving into the other. So what Daoists seek is a harmonious union of the two. At the time the *Daodejing* was written, however, the yang energy of Confucianism was running amok. So an infusion of yin was needed to balance things out.

The Western monotheisms, drawing on Zoroastrianism, speak of a cosmic battle between two opposing principles and pray for the total victory of light over darkness. Even Hollywood movies drink deep from this well. In the *Daodejing*, however, the Dao is neither good nor bad. Confucians may go to great lengths to distinguish between beautiful and ugly, superior and inferior, strong and weak, but Laozi sees such judgments as both false and dangerous. The *Daodejing* is replete with all sorts of pairs that most of us would regard as opposites. In every case, however, what seem to be opposites are actually complementary pairs, ever melting into one another. So any effort to take sides is both futile and frustrating. The hope instead is for balance, accompanied by acquiescence to the way things are always changing—from day to night, summer to winter, and back again.

The *Daodejing* opens with two enigmatic lines that have vexed

and delighted interpreters for millennia. These lines are typically translated, "The Dao that can be spoken is not the eternal Dao. The name that can be named is not the eternal name." This rendition suggests a mystical reading: the Dao is as ineffable as Allah for Sufis and God for Kabbalists. But my colleague Thomas Michael has suggested a different reading. These two lines are about change and creativity, he says. Rather than an assertion of mysticism, they are an observation about change and justification for creativity. The key to each sentence lies not in its subject but in its object, which is to say that the key words are *not* and *eternal*, or, in Michael's translation *constant*: "Daos can lead, but these are not constant daos. Names can name, but these are not constant names."[27]

The second line is somewhat easier to parse. The name "professor" can name me in one context (when I am teaching a class, for example) but it will not do in other contexts (when I am "coach" of my daughter's soccer team or "son" at my parents' Thanksgiving table). The first line is trickier but can also be made plain. There are many daos in the sense of "ways" to do things. And following them can lead you where you want to go. But these daos do not stay constant, because the circumstances in which they are employed are ever changing. So, to take Michael's example of basketball, there was a dao for playing basketball at the time James Naismith invented the game, and this way could lead you to victory in the 1890s. But it wouldn't do for Michael Jordan or Larry Bird in the National Basketball Association of the 1990s. Why? Because circumstances change. Because players get bigger and faster and (among other things) trade in the set shot for the jump shot and learn to dunk.

The desire to grab onto what does not change is typically only amplified by religious institutions. The *Daodejing*, by contrast, tells us to glory in transformation. The Daoist tradition includes a creation story that reverses the American motto, "E Pluribus Unum," by affirming "out of one, many." In the beginning was the Dao, which is changeless, formless, and indivisible, but also generative, transforming, and fertile—the mother of all that is to come. Out of

this primordial unity comes qi, the life force present in all matter, human and otherwise. This vital energy then gives birth to yin/yang, which gives birth to the three realms of Heaven, Human, and Earth, the Five Phases of water, metal, fire, wood, and earth, and the ten thousand things, which is to say everything else. Everything, including human beings, is made of qi in some combination of yin and yang. The endless interaction of yin qi and yang qi is forever creating new things and transforming the old. So this cosmology of one and two and ten thousand answers not only the question, "How do things come into being?" but also, "How do things change?"

The German theologian Paul Tillich famously defined God as "the ground of being."[28] The impersonal Dao is that, too, but more fundamentally it is the ground of becoming—the natural process undergirding all generativity and change. This creative transformation is on view in the natural world, where every day light yields to darkness, every year courses through spring, summer, fall, and winter, and every life sees both birth and death. And so it goes with wealth and poverty, order and chaos, war and peace. The nature of things is not stasis but change. And the Dao is the ground of this becoming.

Soft Power

If the *Daodejing* is a mystical, metaphysical, and mythological text, it is also a manual for life, including political life. So the second half of this classic is devoted to *de*, or power/virtue. And here Laozi's divergence from his Confucian friends becomes most plain. Confucius had argued that the problem of social chaos would yield to the solution of social harmony only when rulers and subjects alike educated themselves in the classics and cultivated virtues such as ren (benevolence). Laozi's advice is just the opposite. He tells rulers to "throw out knowledge" and "stop benevolence," adding that if they do, "the people will be a hundred times better off."[29] In their

Book of Common Prayer, Anglicans confess sins both done and left undone. For Laozi, things left undone are far less dangerous.

The *Daodejing* is said to have been written as Laozi was withdrawing to the mountains, and it obviously commends the natural life of the recluse he is becoming over the artificial life of the clerk he had been. It is inhuman, Laozi says, to live under the thumb of the dictates of ruler or father or husband; to be human is to be free. Unlike the seventeenth-century Englishman Thomas Hobbes, who famously argued that human life in the state of nature would be "nasty, brutish, and short," Laozi is convinced that human life in a society where everyone acts naturally and spontaneously would be pleasant, humane, and long. But Laozi is no anarchist. His vision favors "soft power" rather than no power. It imagines small-scale, noncompetitive communities that are harmonious because their governments, in keeping with *wu wei*, do as little as possible and leave the rest to nature. The great U.S. Supreme Court justice Louis Brandeis was channeling Laozi when he said of America's highest court that "the most important thing we do is not doing."[30]

Zhuangzi and the Zhuangzi

The next Daoist classic, second in influence only to the *Daodejing*, is the *Zhuangzi* (*Chuang-Tzu*), which takes its name from Zhuangzi (369–286 B.C.E.), a follower of Laozi and contemporary of the Confucian thinker Mencius. Although we know more about Zhuangzi than we do about Laozi, we don't know much. A biographical account from the first or second century B.C.E. portrays him as a writer of anti-Confucian allegories who laughs in the face of an offer to become a prime minister's chief of staff. "I'd rather enjoy myself playing around in a fetid ditch," Zhuangzi says, "than be held in bondage by the ruler of a kingdom."[31]

Widely recognized as a masterpiece of world literature, the *Zhuangzi*, which likely came together between the fourth and second centuries B.C.E., consists of seven "inner chapters" prob-

ably written by Zhuangzi himself plus fifteen "outer chapters" and eleven "miscellaneous chapters" probably written by his followers. This classic had a major impact not only on Daoism but also on Chan Buddhism, which in Japan would come to be known as Zen. Like Zen, the *Zhuangzi* uses language to call language into question. It also shares with Zen the conviction that what matters most can be found wherever we look. A famous Zen exchange goes, "What is the Buddha?" "Dried shit." The *Zhuangzi* informs us that the Dao can be found even in excrement.

As this observation implies, the *Zhuangzi* is a mischievous text. Its reputed author has been described as "a mystic, a satirist, a nihilist, a hedonist, a romantic," and "a profound and brilliant jester who demolishes our confounded seriousness."[32] The words attributed to him run in all these directions, often at the same time. Long before American poet Walt Whitman wrote, "Do I contradict myself? Very well I contradict myself," Zhuangzi was arguing (no doubt with a sly grin) that arguing is a dead end. While his contemporaries in the Confucian, Mohist, and Legalist schools were using logic and rhetoric to advance arguments, Zhuangzi told stories. In the face of a society that championed usefulness, the *Zhuangzi* championed uselessness, singing the praises of a tree so bent and unkempt that it can't be used for anything other than shade for an afternoon nap. Zhuangzi didn't want the Dao to be useful for politics, or even philosophy. He wanted it to be good for nothing. The same goes for each of us. Instead of making ourselves useful, he advised, make yourself useless. Then everyone will leave you alone.

The *Zhuangzi* includes chapter titles such as "Webbed Toes" and a long cast of off-beat characters—"Master Timid Magpie," "Nag the Hump," "Sir Sacrifice," "Uncle Obscure Nobody," "Princely Nag," "Mad Stammerer"—that seem to have sprung full-blown from a Flannery O'Connor short story.[33] If the *Daodejing* is a work of philosophy, this is a work of literature, and of comedy. It uses fables and fantasy in the service of satire and ranks as both the funniest and the most irreverent of the great religions' scriptures. One way to cope with death and degeneration, the *Zhuangzi* suggests,

is to step lively through laughter and play. If there had been knives and forks at the time of Confucius, his starchy followers would have used both to consume their noodles. Not Zhuangzi. He slurps.

Taking up many of the key themes of the *Daodejing*, the *Zhuangzi* underscores the fact of change and the futility of resisting it. It glories in simplicity, spontaneity, flexibility, and freedom. It observes that rules and concepts get in the way of both individual happiness and social harmony. ("Get rid of goodness," reads the *Zhuangzi*, "and you will naturally be good."[34]) Zhuangzi is less interested than Laozi, however, in dispensing political advice. Whereas Laozi had at least one foot in the Confucian problem of social chaos, Zhuangzi frames the human predicament almost entirely in individual terms. The problem is lifelessness, which is brought on by the social customs so prized by Confucians. The solution is a life well lived, which is to say health, longevity, and perhaps even bodily immortality. But none of this is possible without freedom from life-sapping social conventions.

The *Zhuangzi* also differs from the *Daodejing* in its preference for the story over the aphorism. One of its most poignant parables concerns a rare seabird discovered far away from the ocean in the city of Lu. A government official fetes it like an honored guest from some faraway land. A great feast is prepared, music is played, and wine is offered. But the bird is overwhelmed by the fuss and dies after three days.[35]

In *Leaving Church* (2006), memoirist Barbara Brown Taylor writes about giving up a job as an Episcopal priest—a job that was killing her. Along the way, she challenges readers to ask what in their lives is killing them and what is giving them life. Daoism poses the same challenge. In one of the *Zhuangzi's* oft-told tales, a ruler sends his officials to convince Zhuangzi to accept a prestigious government appointment. But Zhuangzi, who is fishing, doesn't even give them a glance. As he continues his casting, he speaks of the dry bones of an ancient tortoise kept by the ruler in a temple and trotted out on special ritual occasions. "What would you say that the tortoise would have preferred: to die and leave its

shell to be venerated or to live and keep on dragging its tail over the mud?" Zhuangzi asks. "It would have preferred to live and drag its tail over the mud," the officials answer. "Go your ways," Zhuangzi says, "I will keep on dragging my tail over the mud."[36]

The *Zhuangzi* speaks of a variety of techniques that can take us from the problem of lifelessness to the solution of flourishing. Each aims to redirect us from social death to natural life. For example, Zhuangzi advocates "sitting and forgetting," a method for emptying the mind of so-called learning. In a passage that upends both the Confucian hierarchy of teacher over student and Confucian confidence in education, Confucius is speaking with his favorite student Yan Hui. Yan Hui proudly reports that he has forgotten all sorts of core Confucian virtues. "I sit and forget everything," Yan Hui says. "I leave behind my body, perception and knowledge. Detached from both material form and mind, I become one with that which penetrates all things."[37] This story ends when Confucius, rather than rebuking Yan Hui, asks to become his student. So while education, so highly prized by Confucians, may help us get ahead in the Chinese bureaucracy, it does not foster life or make us human. Only the spontaneity and surprise of the Dao can do that.

In passages that have captured the attention of Western philosophers of language, the *Zhuangzi* also takes aim at the Confucians' tendency (and our own) to chop up the world into quick-and-easy dualisms. "Out beyond ideas of wrongdoing and rightdoing / there is a field. I'll meet you there," writes the Sufi mystic Rumi.[38] Except for the meeting part, that is vintage Zhuangzi. For him, dichotomies of right and wrong, life and death, large and small work only inside our limited conventions of thought and language. From the wider perspective of the Dao, so-called opposites logically depend on one another and are forever melting into one another. To grasp after any one side of these dualisms is to bring on lifelessness. Why fixate on success when, as Bob Dylan once put it, "there's no success like failure" and "failure's no success at all"?[39]

It is sometimes said that Daoists believe that human beings are

born good. And it is true that Daoists see virtues such as naturalness and simplicity in abundance in infants, who have the additional merit of an equal balance of yin and yang. But from the Daoist perspective human nature is neither inherently good, as Mencius argued, nor inherently evil, as many of his opponents insisted. It is, as the German philosopher Friedrich Nietzsche would later argue, "beyond good and evil."

As in the *Daodejing*, the exemplary human being in the *Zhuangzi* is the sage, described here as a "genuine person." The *Zhuangzi* also includes a tantalizing glimpse into a figure that will become central in later Daoism: the immortal who is indifferent to politics, uninterested in fame, unmoved by profit or loss, and unafraid of death.

Popular Daoism and Superhero Immortals

Around the time of the emergence of Christianity, rabbinic Judaism, devotional Hinduism, and Mahayana Buddhism, which is to say at the dawn of the first millennium, Daoism began to take on many of the characteristics of other organized religions. Spurred by Buddhists, who upon their arrival in China in the first century C.E. organized themselves around monasteries and temples, Daoism took institutional shape. Daoists wrote thousands of scriptures and gathered them into a massive canon. They turned their heroes into gods. They developed a full range of festivals, rituals, and self-cultivation practices. They integrated into their tradition Buddhist notions of karma and rebirth, Confucian commitments to filial piety, and elements from ancient Chinese religion such as shamanism, divination, sacred mountains, pilgrimage, and sacrifice. They institutionalized their tradition, founding new sects and building and maintaining temples and monasteries. They invited a vast pantheon of gods to inhabit these institutions and ordained priests to oversee them. Some Daoist priests followed Laozi's ex-

ample by living apart from society. Others were married with children, performing life-cycle rituals in the midst of the hubbub of social and sexual life.

Drawing on ancient beliefs in ghosts and demons and practices such as ancestor veneration and shamanism, Daoism added to its goal of nourishing life an ambitious corollary: physical immortality. Whereas Laozi and Zhuangzi had cultivated an air of indifference toward life and death alike, Daoists now sought after not only vitality and longevity but also the immortality of the body. As Buddhism gained in popularity, Daoists started to treat Laozi like a religious founder, a revealer, and even a deity who demonstrated that it was possible for ordinary human beings to live forever. While Buddhists sought to become bodhisattvas or Buddhas, Daoists now sought to become immortals (aka "transcendents"[40]), who according to legend distinguished themselves from the rest of us through all sorts of astonishing powers.

In keeping with the Daoist romance of reclusion, these exemplars were said to live on high mountains, in secluded grottoes, or on faraway islands. According to Dutch Sinologist Kristopher Schipper, the Chinese word for immortal (*hsien*, or *xian*) is made out of the characters for "human being" and "mountain," so immortals were human beings who traded in stale society for the vital rhythms of the natural world.[41] As wanderers, they abstained from the five grains of settled agricultural life, on the theory that these grains nourished the "three worms" that sucked life out of the human body. Immortals subsisted instead on a special diet of roots, nuts, herbs, and other foods that could be gathered in the mountains, including resin and needles from pine trees whose evergreen properties were thought to be particularly conducive to immortality. In exceptional cases, immortals existed on no food at all. These exemplars were particularly adept at augmenting and retaining their qi. In a sort of "sexual vampirism," males and females alike would take in qi from their partners and keep their own by steering clear of qi-depleting orgasms.[42] Thanks to their vast storehouses of qi and their ability to balance their bodies' yin and yang

energies, immortals were said to defy not only mortality but also physical degeneration. They enjoyed youthful bodies with jet black hair, perfect teeth, and unblemished complexions. Their breathing was deep. They were impervious not only to heat and cold but also to the ravages of old age.

Stories about Daoist immortals read like superhero comics or tales of the extraordinary *siddhis* (supernatural powers) of Tibetan lamas. Immortals could run great distances at top speeds, disappear, shrink themselves, and shape-shift. They could change one object into another, heal wounds, fix broken bones, neutralize snake venom, exorcise demons, predict the future, and resurrect the dead. Though they exemplified the key Daoist virtue of naturalness, they were able to defy nature too. Water did not make them wet. Ice did not make them cold. Fire could not burn them. They lived in a Harry Potter sort of world, wielding swords of invisibility and able to apparate at will. And like Superman, they could fly. Their bodies were not only youthful, they were as light as birds.

Daoists used many techniques to achieve these powers, including special diets, sexual practices, breathing regimens, and meditative strategies. They avoided foods rich in heavy yin qi and ate foods rich in light yang qi. In a sexual practice called the "art of the bedchamber," men and women exchanged qi during sexual intercourse but tried to avoid qi-depleting orgasms. While Roman Catholic teaching says that the husband should ejaculate only inside his wife's vagina, these Daoists contended that the man should not spill his sperm at all but absorb its energies into his body instead. The point of this sexual practice was neither conception nor sexual stimulation but increased vitality. Meanwhile, women were encouraged to absorb their qi-rich menstrual fluids, and some succeeded in staunching their menstrual flows altogether.

The most controversial technique for immortality was outer alchemy, which sought to mix rare metals into elixirs of eternal life. Daoists believed that cinnabar, a reddish mineral thought to be particularly rich in yang qi, would bring vitality, longevity, and even immortality if mixed and imbibed in just the right manner.

Many of these potions turned out to be dangerous. Cinnabar, which contains high levels of mercury, can kill you, and it doubtless killed many practitioners of outer alchemy, including some emperors. So roughly a millennium ago, Daoists reset their sites to inner alchemy, which sought to purify the body's own flows and fluids into immortality elixirs. Now the body itself, so highly prized in Daoist thought and practice, became the laboratory. Instead of trying to mix an elixir of immortality with mortar and pestle, Daoists sought through a variety of self-cultivation practices to create an "immortal embryo" inside their own bodies.

Of course, few Daoists read immortality stories as blueprints for their own lives. Although the official line was usually that anyone can become an immortal, few ordinary Daoists imagined flying from mountaintop to mountaintop themselves. Rather than the ultimate goal of physical immortality, they hoped for the proximate goal of human flourishing: good health, long life, and vitality. Happily, many of the techniques utilized by aspiring immortals also advanced practitioners toward these more attainable goals. So they were by no means restricted to those who hoped to ride dragons to the moon.

The Jade Emperor and the Queen Mother of the West

Like the pantheon of Yoruba orishas, the society of Daoist deities is fabulously unwieldy, extending to deified human beings and divinized forces of nature who in this case act very much like China's imperial bureaucracy.

Sitting atop this pantheon is a heavenly analog to the Chinese ruler known as the Jade Emperor (aka "Lord Heaven"). There is also a Daoist trinity of sorts that takes on different names in different periods and is associated with the three vital forces and the three vital centers in the human body. The most popular Daoist deities are divinized human beings known as the Eight Immortals, who are remembered today not only in Daoist temples but

also in popular Chinese plays and folk tales. As bringers of good luck, their images are everywhere in China—"on the hems of women's clothes, on bed curtains, on temple gates and roofs, on children's bonnets."[43] They also appear in films, television shows, comic books, and video games. Again like Catholic saints and Yoruba orishas, each of these Eight Immortals is seen as a patron of a different group of people: Iron-Crutch Li, for pharmacists; Cao, for actors; Lan, for florists; Old Man Zhang, for the elderly; Immortal Woman He, for storekeepers; Lu Dongbin, for barbers; Philosopher Han, for musicians; and Zhongli Quan, for soldiers. Also popular are a variety of household gods, many of whom were revered in ancient China. The most important of these, the stove god Zao Jun, was immortalized in the West in *The Kitchen God's Wife* (1991), a novel by the Chinese-American writer Amy Tan.

In sharp contrast to patriarchal Confucianism, this pantheon also includes a range of goddesses matched among the great religions only by Hinduism. Chief among these goddesses is the Queen Mother of the West, who embodies the mysterious feminine so highly prized among Daoists. This goddess assists in creation, mediates between Heaven and Earth, clears the path to immortality, serves as a matchmaker for marriages, aids women and recluses, and is intimate with both creation and destruction. Other goddesses include: Laozi's mother, also known as Holy Mother Goddess; Doumu, who like Guanyin in Buddhism exemplifies and embodies unending compassion; a tenth-century woman later deified into Mazu the patroness of sailors, fishermen, and merchants; and Immortal Woman He, the only female among Daoism's ubiquitous Eight Immortals.

The Orthodox and Unity Way

In the story of the rise of the gods and goddesses of popular Daoism, the key date is 142 C.E., the place is a cave in the Sichuan mountains, and the person is a Confucian named Zhang Daoling

(Chang Tao-ling) (34–156). As a young man Zhang Daoling had read the Confucian classics, but as he grew older he was drawn to study a topic those classics ignored: longevity. So like any self-respecting Daoist, he moved to a mountain, where he immersed himself in the Daoist classics instead. One day Lord Lao, a deification of Laozi and of the Dao itself, appeared to him in a mountain cave. In Islam's iconic cave moment, Allah spoke to Muhammad through an intermediary: the angel Gabriel. Here Lord Lao spoke directly to Zhang Daoling. He taught him the Way of the Celestial Masters, instructed him in morality, meditation, and medicine, and tapped him as the first Celestial Master. This initiation empowered him to heal. It convinced him that virtue is an essential ingredient in the recipe for longevity and that traditional blood sacrifices to ancestral spirits should give way to offerings of vegetables. It prompted him to write his own scripture, a commentary on the *Daodejing*. And it showed him that Laozi was not only divine but the Way itself. In this way the Dao was transformed from an impersonal principle to a personal divinity, and the textual Daoism of Laozi and Zhuangzi began to merge with the gods and goddesses of Chinese popular religion.

Through a series of political and military maneuvers, this sect, which survives today as the Way of Orthodox Unity (*Zhengyi dao*), was officially recognized in 215 C.E. Its traditional headquarters is on Dragon-Tiger Mountain in Jiangxi province, but many of its members have lived in Taiwan since fleeing from the mainland in 1949. Today this group is led by the sixty-fifth Celestial Master, who is sometimes referred to as the "Daoist pope." Although Orthodox Unity Daoists allow female clerics, the role of the Celestial Master is hereditary, passing from male heir to male heir. Because early followers of this sect were required to tithe five pecks of rice, it has also been known as the Five Pecks of Rice sect.

Complete Perfection Sect

The second main branch in this tradition is *Quanzhen* (*Chuan-chen*), which is usually translated as "Complete Perfection" or "Perfect Realization" Daoism. Founded in the twelfth century by a soldier-turned-ascetic named Wang Chongyang (1113–70), this tradition is now the official, state-sponsored monastic order on the mainland and China's largest Daoist school.

Complete Perfection Daoism began when Wang, while wandering around in a drunken stupor at the age of forty-eight, received revelation from two immortals who led him to a new synthesis of Daoism, Chan Buddhism, Neo-Confucianism, and old-fashioned asceticism. Wang styled himself a madman and proved it by digging a grave for himself and living in it for three years. Convinced that family life was a prison and the husband-wife bond a chain, he lived in seclusion for a decade before returning to the world to spread his message. Of all the Daoist ideals, Wang valued simplicity most highly. But he disparaged as foolish both the Daoist quest for physical immortality and the rituals they used to cultivate it. Because Complete Perfection Daoists rejected the magical talismans and laboratory elixirs others hoped would produce physical immortality, they have been compared with the Protestant Reformers of sixteenth-century Europe. The way to spiritual immortality, they argued, was not through the external manipulation of objects but through inner alchemy and self-cultivation.

Wang attracted seven disciples (six men and one woman), also known as the "Seven Immortals," each of whom founded his or her own lineage. One of these followers, a female poet named Sun Buer, is now "the most famous woman Daoist."[44] Another, Qiu Chuji, met with the Mongol warlord Chinggis (Genghis) Khan and convinced him to give Complete Perfection monasteries the imprimatur of tax exemption. All these disciples and their lineages followed Wang in synthesizing Daoism with Chan Buddhism and Neo-Confucianism. They revered Lord Lao as

an ancestor, the Buddha as a pathfinder, and Confucius as a sage. This sect is centered today on the White Cloud Monastery in Beijing. Whereas priests in the older Way of Orthodox Unity perform rituals at home altars, Complete Perfection rituals typically occur in monasteries.

Popular Daoism

Although these two groups have been the main institutional vessels into which Daoism has been poured, this tradition also spread throughout China and Chinese enclaves worldwide through a variety of folk practices. In fact, popular Daoism is so far-reaching that it is difficult to separate it from the folkways of the Chinese people.

Because of their ethic of social withdrawal, Daoists have drawn the ire of Confucians, who accuse them of being selfish, immature, anti-social, and irresponsible. But this same ethic has drawn Daoists for millennia to mountains, which they revere as particularly rich in qi. Some peaks are allied with particular Daoist schools (for example, Mount Longhu with the Celestial Masters and Mount Wutang with various martial arts). But all Daoists, and in fact all Chinese, share the "Five Sacred Peaks" of Mount Tai, Mount Hua, Mount Song, and two different Mount Hengs (one in Shanxi and the other in Hunan province). For millennia, sages-to-be like Laozi would withdraw to the mountains to seek vitality and perhaps immortality. Today, ordinary people make brief pilgrimages to these mountains, where they stop at temples that adorn them to pay homage to Daoist immortals, Buddhist bodhisattvas, and Confucian sages.

Popular Daoism also involves an array of religious practices, including celebrating the birthdays of deities and witnessing the inauguration of temples and the ordination of priests. These priests in turn bless villages and officiate at weddings and funerals. They also manipulate sacred objects, such as talismans and registers of the gods, in an effort to chase away demons or call down divine

power. Daoist rituals vary from sect to sect but often include a combination of singing, chanting, prayers, sacrifices, offerings, and even dance.

Philosophical and Religious Daoism

Scholars have traditionally distinguished between two different Daoisms: the philosophical Daoism (*daojia*) of the *Daodejing* and the *Zhuangzi*, and the religious Daoism (*daojiao*) of the Celestial Masters and the Complete Perfection sects. According to this view, philosophical Daoism, which developed in the Warring States Period (403–221 B.C.E.) is about accepting death, while religious Daoism, which developed in the later Han dynasty (206 B.C.E.–220 C.E.), is about overcoming death via immortality. Unlike philosophical Daoism, religious Daoism borrows heavily from both Confucianism and Buddhism. It also takes on all sorts of trappings of organized religion unknown to Laozi and Zhuangzi and their contemporaries—from prayer to priests to polytheism. Religious Daoists also develop a wide range of spiritual techniques for longevity and immortality, including various contemplative practices and breathing exercises. Like philosophical Hinduism, which is tailor-made for renouncers, philosophical Daoism is for elites—mystics and recluses withdrawn from the exigencies of everyday life. Religious Daoism, by contrast, is for ordinary people.

Unfortunately, this typology is more useful for polemics than for analysis. Christians, Confucians, and communists alike have used this distinction to disparage contemporary Daoism as "superstition" for the illiterate masses. Just as Protestants have caricatured Catholics as corruptors of the true Christianity of the Bible, partisans of philosophical Daoism have caricatured religious Daoists as corruptors of the true Daoism of the ancient classics, bastard children of the *Daodejing* and the *Zhuangzi*.[45]

The other major flaw of this typology is that it misses many continuities between earlier and later Daoism. First, so-called phil-

osophical Daoism is not as secular as it may seem. Its concerns are at least as mystical as they are political. And while the Dao in the *Daodejing* is admittedly impersonal, it is nonetheless deeply spiritual—ineffable, mysterious, nondual, and creative beyond imagining. Second, so-called religious Daoism is not as religious as it may seem. Like philosophical Daoism, it shows almost no interest in what many regard as the religious challenge par excellence—the problem of life after death. Religious Daoism also draws heavily on the early classics. Almost every key concept from philosophical Daoism, including *Dao*, *de*, and *wu wei*, carries over into religious Daoism. Religious Daoists also revere Laozi as both a founder and god—"Saint Ancestor Great Tao Mysterious Primary Emperor"—and regard not only the *Daodejing* but many subsequent Daoist scriptures as revelations from him.[46]

Religious Daoists are often distinguished from philosophical Daoists by their quest for physical immortality. But both the *Daodejing* and the *Zhuangzi* speak of immortals. The first chapter of the *Zhuangzi* tells of mountain-dwelling immortals overflowing with qi, which endows them not only with long life but also with extraordinary powers. One such holy man, as gentle as a virgin, lives on a faraway mountain, possesses the power of healing, eschews the five grains of settled agricultural communities, and drives flying dragons. The *Zhuangzi*'s next chapter tells of an immortal who cannot be burned by fire or chilled by ice, is unfrightened by the most frightful thunder and lightning, and "moves with the clouds, soars above the sun and the moon and wanders beyond the four seas."[47]

Of course, Daoism changes over time. All religions do. It takes on Confucian and Buddhist elements, making peace with Confucian ideals such as filial piety, human-heartedness, and propriety, and adapting Buddhist meditation techniques for its own purposes. All these transformations, however, can be understood as developments inside a religious tradition unafraid of change. In the end, there is far more continuity than discontinuity between earlier and

later Daoism. Throughout its long history, from the *Daodejing* to *The Tao of Pooh*, Daoism has seen lifelessness as its problem and flourishing as its goal.

Change and Disappearance

In my home on Cape Cod there is a small piece of paper taped to the refrigerator with the word "Change." I usually read this sign in the imperative voice—as a command to make life anew. But that isn't very *wu wei* of me—to take aim at this change and to expend all sorts of energy to make it happen. A more Daoist interpretation would read "Change" as an observation. We live as if things are unchanging—our jobs, our families, our loves, our bodies. But in fact all these things are changing every day.

One of the most famous stories in the *Zhuangzi* is also one of the most vexing. It is set just after the death of Zhuangzi's wife. When a friend comes by to console him, he finds Zhuangzi beating a tub and singing with joy. Jewish law explicitly prohibits the making of music for thirty days after the death of a spouse, but Zhuangzi's singing and playing is also an affront to Confucian propriety, and to our own. We don't mourn much in the modern West. The things we cannot control are shrinking every day, but death remains one of them. So we don't want to linger over it. Still, for most of us, the few hours that Zhuangzi gave over to grief seem a trifle. When his friend criticized him, Zhuangzi replied coolly that change is unavoidable and death nothing to fear. As the four seasons progress from spring to summer to fall to winter, transformation comes to all things, he said. Why should any of us be exempt from this natural process? So do not be repelled from death or attracted to life, but treat both with equanimity and indifference.[48] And do not be afraid to respond to sickness and death and fear itself with laughter and music and play.

For some practitioners, Daoism is about grasping after the brass ring of physical immortality. But at the heart of this tradition is

nothing more magical than a life well lived. If we are confused about why such a goal is religious, that is because we are confused about religion, which, as China's traditions teach us, does not cease to be religious when it refuses to promise a changeless afterlife. After Laozi and Zhuangzi, Daoism doubtless drinks deep of the gods and goddesses, scriptures and sects, priests and prayers we recognize as the stuff of organized religion. In fact, it dives into the deep end. But throughout its long evolution it remains committed first and foremost to vitality—to human flourishing.

For Confucius, to be human is to be social. For Daoists, to be human is to be natural. According to many Confucians, being human is not a birthright but a hard-won accomplishment, and it is accomplished by the labors of society. The Confucian thinker Xunzi (Mencius's nemesis) regularly resorted to metaphors from the trades—hammering, steaming, and bending—to describe this arduous process of becoming something other than what we once were. Daoists, by contrast, claim that we are born human and are hammered out of our humanity through education. To return to our true nature, we need only to return to the natural rhythms of the Dao, accepting without resistance the flux and flow of every-day life—summer to fall to winter to spring, morning to evening, mourning to birth.

Every year on Labor Day on Cape Cod visitors pull their boats out of the water, pack up their things, and drive away (often in sweatshirts). I have seen this happen almost every year since I was in kindergarten, but it still has the power to upend me. I go to the ocean. I stay until almost everyone has left, chatting with the locals, pretending it is just another sunset. Before I make for home, I hear a childlike voice inside me wishing I could jump through some magical hoop to the middle of June, skipping over the nostalgia of fall and the slush of winter to another Cape Cod summer. But there is another voice, younger and older at the same time, that also speaks, reminding me that things change, that "the Dao that can be spoken is not the constant Dao," that summer here would not be summer if it did not follow on the bone-chilling bluster of spring.

One of the grand motifs of Daoist stories is disappearance. An immortal known as the Lady of Great Mystery can point at temples and even entire cities and make them disappear. At the end of the biography celebrating her life—a Daoist analog to the hagiographies of Catholic saints—she is said to have ascended, Christlike, to the heavens in broad daylight, never to be seen again.[49] Laozi goes by land rather than air, but he, too, wanders off. After depositing his wisdom with the border guard, he enters into the undiscovered country, and, his biographer tells us, "No one knows what became of him."[50]

Daoism can be distilled into stories of the human problem and its solution—stories of how lifelessness threatens but flourishing triumphs. Its heart can be heard beating in exemplars known as sages and immortals who have mastered techniques to nourish life and "roam in company with the Dao."[51] But more than any other of the great religions, Daoism possesses the power to vanish before our eyes, to get up and wander west, drift high into the mountains, and disappear into the clouds.

A Brief Coda on Atheism

THE WAY OF REASON

Atheism is not a great religion. It has always been for elites rather than ordinary folk. And until the twentieth century, its influence on world history was as nonexistent as Woody Allen's god. Even today, the impact of atheism outside of Europe is inconsequential. A recent Gallup poll found that 9 percent of adults in Western Europe (where the currency does *not* trust in God) described themselves as "convinced atheists." That figure fell to 4 percent in Eastern and Central Europe, 3 percent in Latin America, 2 percent in the Middle East, and 1 percent in North America and Africa.[1] Most Americans say they would not vote for an atheist for president.[2]

Nonetheless, atheism stands in a venerable tradition reaching back to ancient Greece, where Diagoras was kicked out of Athens for impiety, and ancient India, where Buddhists, Jains, and some Hindus also denied a personal god. Some of the greatest minds in the modern world (Friedrich Nietzsche, Karl Marx, Sigmund Freud, Jean-Paul Sartre) were atheists. So were some of modernity's most brutal dictators (Mao Zedong, Joseph Stalin, Vladimir Lenin, Pol Pot, Slobodan Milosevic).

A few years ago I wrote that, in staunchly unsecular America, atheists had "gone the way of the freak show."[3] I was wrong. For much of the last decade, books on atheism have crowded U.S. bestseller lists. And in his 2009 inaugural address President Barack Obama called the United States a "nation of Christians and Mus-

lims, Jews and Hindus, and nonbelievers."[4] In both Europe and the
United States today there is a vibrant conversation about the virtues
and vices of Godtalk. So while atheism is not a great religion, it
deserves some attention here.

After all, atheism is a religion of sorts, or can be. Many atheists
are quite religious, holding their views about God with the convic-
tion of zealots and evangelizing with verve. Atheists take aim at
organized religion, miracles, and groupthink. They defend reason
over revelation, logic over faith, and scientific experimentation
over magical thinking. Echoing Confucius and Laozi, they focus
on life before death. As the term implies, however, *atheism* is first
and foremost about denying the God proposition. Theoretically,
atheists deny the existence of all deities, but as a practical matter
they can deny only the gods they know. Freud rejected the Jewish
and Christian conceptions of God swirling around him in late-
nineteenth-century Vienna. Most of today's "New Atheists" know
little about the gods and goddesses of Hinduism, for example, so
when they take aim at the idol of "God," it is the deities of the
Western monotheisms they are hunting.

Atheists argue that the human problem cannot be solved by
religion, because religion itself is the problem. Religious belief is
man-made and murderous—irrational, superstitious, and hazard-
ous to our health. The solution is to flush this poison out of our
system—to follow the courageous examples of heroic unbelievers
from Diagoras to Freud to the patron saints of the New Athe-
ism: American writer Sam Harris, American philosopher Daniel
Dennett, British evolutionary biologist Richard Dawkins, British-
American journalist Christopher Hitchens, and French philoso-
pher Michel Onfray. And where will this cleansing lead? To a
postreligious utopia. Without the foolishness of faith, all will be
well, and all manner of things will be well.

Angry Atheists

Of course, not all atheists are created equal. Some describe themselves as secularists, humanists, naturalists, freethinkers, skeptics, or rationalists. Others do not. Because of the stigma attached to the term *atheist*, some have suggested alternatives such as "bright." An online group calling itself The Brights' Net claims close to fifty thousand members in 185 different countries, including Harvard psychology professor Steven Pinker, comedy duo Penn and Teller, and New Atheists Dennett and Dawkins.[5]

Some distinguish between strong atheists (who actively deny God) and weak atheists (who simply do not affirm God), but the distinction between angry and friendly atheism is more useful. New Atheists exemplify the angry type. Their atheism is aggressive and evangelistic—on the attack and courting converts. Even the titles of their books (*The God Delusion*, *The End of Faith*) and chapters ("Jesus at Hiroshima," "Down with Foreskins!") are provocations.[6] These militants see the contest between religion and reason as a zero-sum game, but their favorite metaphors come from war rather than sports, and their rhetoric takes no prisoners. According to Dawkins, "faith is one of the world's great evils, comparable to the smallpox virus but harder to eradicate."[7] According to Harris, theology is "ignorance with wings."[8] According to Hitchens, organized religion is "violent, irrational, intolerant, allied to racism and tribalism and bigotry, invested in ignorance and hostile to free inquiry, contemptuous of women and coercive toward children."[9] At least in Europe, these New Atheists are not above hitting below the belt. Michel Onfray, the popular French philosopher and *enfant terrible* whose *Atheist Manifesto* (2007) has sold hundreds of thousands of copies in Europe, attacks circumcision as barbaric and, in perhaps the unkindest cut (at least for a Frenchman), reports that the apostle Paul was impotent and "unable to lead a sex life worthy of the name."[10]

Earlier skeptics such as Mark Twain and H. L. Mencken took

aim at fundamentalists and revivalists. And Hitchens, who thrills to the chase of "foam-flecked hell-and-damnation preachers," was on the air only hours after the death of televangelist Jerry Falwell, remarking that "if you gave Falwell an enema, he could be buried in a matchbox."[11] But the New Atheist complaint is more comprehensive—against the sins and wickedness of Western monotheism, which Hitchens describes as "a plagiarism of a plagiarism of a hearsay of a hearsay," and, more broadly, against religion in general, which, Hitchens adds, derives in East as well as West "from the bawling and fearful infancy of our species."[12]

This is an old lament, itself a plagiarism of Freud (who got it from Marx, who got it from Ludwig Feuerbach, among others), updated largely by the New Atheists' trademark indignation and rhetorical excess. In decades past, Western intellectuals honored a gentleman's agreement of sorts to keep their faith, or lack thereof, largely to themselves. Three things blew that agreement up. First, the U.S. Religious Right began in the late 1970s to put God to partisan political purposes, prompting atheists with different political views to go public with their criticisms of Godthink. Second, Muslims began to pour into Europe, edging toward 10 percent of the population in France and topping 5 percent in the Netherlands. Finally, Quran-quoting terrorists hijacked four jets and steered themselves and thousands of others to their deaths on September 11, 2001.

This confluence of events led many to worry about the public power of religion. Was U.S. president George W. Bush's born-again faith sending soldiers to their deaths in Iraq? Was British prime minister Tony Blair's Catholicism behind his decision to stand by Bush? And so the gloves came off. Resurrecting the nineteenth-century metaphor of a war between science and religion, the New Atheists came to see themselves as pugilists for reason, logic, and common sense. As increasing numbers of atheists became convinced that religion was a real and present danger, more and more of them came to believe that putting the wrecking ball to it was a personal duty and a public good.

These wrecking-ball atheists soon came to question even the cherished ideal of religious tolerance. In a *Guardian* essay published shortly after 9/11, Dawkins laid down the gauntlet, identifying the horror of that day as a tipping point between the old atheism and the new:

> *Many of us saw religion as harmless nonsense. Beliefs might lack all supporting evidence but, we thought, if people needed a crutch for consolation, where's the harm? September 11th changed all that. Revealed faith is not harmless nonsense, it can be lethally dangerous nonsense. Dangerous because it gives people unshake-able confidence in their own righteousness. Dangerous because it gives them false courage to kill themselves, which automatically removes normal barriers to killing others. . . . And dangerous because we have all bought into a weird respect, which uniquely protects religion from normal criticism. Let's now stop being so damned respectful!*[13]

Harris then attacked the ideal of religious tolerance as "one of the principal forces driving us toward the abyss."[14] "Some propositions are so dangerous," he wrote in a chilling passage, "that it may even be ethical to kill people for believing them."[15] For Harris, religious tolerance is almost as dangerous as religion itself. Belief in God is not an opinion that must be respected; it is an evil that must be confronted.

For these New Atheists and their acolytes, the problem is not religious fanaticism. The problem is religion itself. So-called moderates only spread the "mind viruses" of religion by making them appear to be less authoritarian, misogynistic, and irrational than they actually are.[16] "The teachings of 'moderate' religion, though not extremist in themselves," writes Dawkins, "are an open invitation to extremism."[17] The only solution is to get out the disinfectant and wipe your hands clean.

Fundamentalism by Another Name

Critics have accused these evangelistic atheists of aping the dogma-
tism of their fundamentalist foes. Chris Hedges, a former Middle
East bureau chief for the *New York Times*, describes the New Athe-
ism as "a secular version of the Religious Right," which portrays
the Muslim world "in language that is as racist, crude and intoler-
ant as that used by Pat Robertson or Jerry Falwell."[18] The New
Atheists' broadsides against bigotry are bigoted, and their speeches
against hatred are full of hate, Hedges argues. Is it so hard to see
that human beings are as capable of killing in the name of progress
and the proletariat as they are in the name of tradition and God?

One of history's most dangerous games begins with dividing the
world into the good guys and the bad guys and ends with using
any means necessary to take the villains out. New Atheists play this
game with brio, demonizing Muslims, denouncing Christians and
Jews as dupes, and baptizing their fellow "brights" into their own
communion of the smarter-than-thou saints. Like fundamentalists
and cowboys, they live in a Manichaean world in which the forces
of light are engaged in a great apocalyptic battle against the forces
of darkness. They, too, are dogmatic and uncurious and every bit
as useful to neoconservative policymakers as right-wing televange-
lists. Franklin Graham says that Islam is "a very evil and wicked
religion."[19] Harris says that Islam "has all the makings of a thor-
oughgoing cult of death."[20]

New Atheists also fume against the anti-intellectualism of reli-
gion. Yet when it comes to making their own case, these "brights"
don't just mimic their fundamentalist opponents; they go them
one better. Most people of faith harbor some doubt. But the sup-
posedly open minds of New Atheists are so settled and sure that
there is nary an opening in their invective for genuine conversa-
tion. Every refusal of a person of faith to come over to the atheist
side is viewed not as a principled disagreement but as evidence of

stupidity or malice or worse. Apparently the axioms of atheism are so obvious to any properly functioning human intelligence that it is not even worth arguing for them. And so, aside from outrage, the main emotion in these books is smug exasperation. Why isn't the rest of the world exactly like us?

But Is It a Religion?

Some atheists, including attorney Michael Newdow, who took his complaint against the inclusion of God in the Pledge of Allegiance all the way to the U.S. Supreme Court, believe that atheism is, in the words of novelist David Foster Wallace, an "anti-religious religion, which worships reason, skepticism, intellect, empirical proof, human autonomy, and self-determination."[21] Most atheists, however, are offended by the suggestion that they, too, might be religious.[22] For them, exhibit A is as simple and powerful as their denial of God. But all sorts of religious people deny God, including many Buddhists, Confucians, and Jews. And the history of atheism has featured some undeniably religious moments. During the Furies of the French Revolution, the *ancien régime* that married Catholicism to the French state got the guillotine. What followed, however, was not irreligion but the Cult of Reason. This religion—and it *was* a religion—was as ritualized as French Catholicism. It worshipped Voltaire as a secular saint and revered martyrs of the revolutionary cause. It renamed Notre Dame the Temple of Reason, lauded the Goddess of Reason, and celebrated a Festival of Liberty. Soon the French were baptizing their children in the name of the holy trinity of *liberté, égalité, fraternité*, confessing their faith in the French republic, and marking the year with holy days commemorating reason, virtue, and the French Revolution itself.[23] Closer to our time, both socialism and communism have proven that secular religions are as prone to fanaticism and fundamentalism as Christianity and Islam. In his doctoral dissertation, Marx wrote, "I hate the

pack of gods," but that didn't prevent his followers from worshipping Lenin and Stalin.[24]

Whether atheism is a religion depends, of course, on what actual atheists believe and do. So the answer to this question will vary from person to person, and group to group. It will also depend on what we mean by religion. Religion is now widely defined, by scholars and judges alike, in functional rather than substantive terms. Instead of focusing on some creedal criterion such as belief in God, we look for family resemblances. Do the works of Ayn Rand function like scripture for atheists? Do the various humanist manifestos function like creeds? According to one common formula, members of the family of religions typically exhibit Four *C*s: creed, cultus, code, and community. In other words, they have statements of beliefs and values (creeds); ritual activities (cultus); standards for ethical conduct (codes); and institutions (communities). How does atheism stack up on this score?

Atheists obviously have a creed. Some atheists deny that they believe anything. Is bald a hair color, they ask? But this denial is disingenuous. In fact, atheism is more doctrinal than any of the great religions. By definition, atheists agree on the dogma that there is no god, just as monotheists agree on the dogma that there is one. Belief is their preoccupation, as anyone who has read even one book on the subject can attest.

Cultus is trickier. Years ago I received a letter from a Boston-area chaplains group accompanying an interfaith calendar. The letter urged professors to be broad-minded enough to excuse students from class for religious holidays, and the calendar indicated when such broad-mindedness might be called for. Among the holy days was the birthday of British philosopher Bertrand Russell (May 18). More recently, the Albany, New York–based Institute for Humanist Studies published a Secular Seasons calendar with a more thorough accounting of atheists' High Holy Days, including Thomas Paine Day (January 29) and Darwin Day (February 12). There is not much evidence, however, that atheists celebrate these days with any gusto or actually regard these exemplars as saints.

Most atheists do have a code of ethical conduct. In fact, one of the most frequent claims of the New Atheists is that they are the moral superiors of the old theists. One dissenter here is Onfray, a self-described hedonist who after suffering a heart attack famously told a dietician urging a better diet on him that he "preferred to die eating butter than to economize my existence with margarine."[25] Following Nietzsche, who argued that God's death would free true atheists from the shackles of conventional morality, Onfray is convinced that Anglo-American atheists such as Hitchens and Dawkins are still in the thrall of Christian ethics. So he urges them to trade in their "Christian atheism" for his "atheistic atheism"—to convert from Christian values centered on compassion to "ethical hedonism" focused on pleasure. "To enjoy and make others enjoy without doing ill to yourself or to others," he writes, "this is the foundation of all morality."[26]

Although most atheists go it alone, some gather into communities. There is a network of summer camps for atheist children called Camp Quest. Other prominent atheist organizations include Atheist Alliance International, American Atheists, British Humanist Association, Humanist Association of Canada, and the Germany-based National Council of Ex-Muslims. In the Boston area, over a dozen different humanist, atheist, and secularist groups sit under the umbrella of the Boston Area Coalition of Reason. A U.S. group known as the United Coalition of Reason ran a billboard and bus campaign with ads that read, "Don't Believe in God? You Are Not Alone." Though intended to raise the visibility of atheists in the American public square, this campaign also trumpeted the availability of atheist communities, not least the United Coalition of Reason itself.

Using this functional approach, the U.S. Supreme Court concluded in 1961 that secular humanism functions like a religion, so secular humanists merit the same sorts of First Amendment protections that religious practitioners enjoy.[27] In 2005, in a decision that irked atheists and Christians alike, a lower U.S. court held that, because atheism walked and talked like a religion, judges should treat it like one.[28]

Onfray, the most radical and, after Hitchens, the most gifted New Atheist writer, detects the stench of religion in much atheism today, and he wishes for a stiff breeze to blow it away. "The tactics of some secular figures seem contaminated by the enemy's ideology: many militants in the secular cause look astonishingly like clergy. Worse: like caricatures of clergy," he writes. "Unfortunately, contemporary freethinking often carries a waft of incense; it sprinkles itself shamelessly with holy water."[29] Here Onfray seems to be channeling at least some of the spirit of German philosopher Arnold Ruge, a friend of Marx who refused to jump on the atheism bandwagon not because it was too radical but because it was too traditional: "Atheism is just as religious as was Jacob wrestling with God: the atheist is no freer than a Jew who eats pork or a Mohammedan who drinks wine."[30]

Are human beings *homo religiosus*? Is it human nature to grasp after the sacred? Yes, say those biologists who find evolutionary advantages in religious beliefs and practices. If they are right, if religion is an inescapable part of being human, then atheism would seem fated to take on the form of religion. But not all atheists are religious. Some take their atheist creed with a shrug, steering clear of the cultus, codes, and communities of their atheist kin. For others, however, atheism is, in the words of German theologian Paul Tillich, an "ultimate concern."[31] It stands at the center of their lives, defining who they are, how they think, and with whom they associate. The question of God is never far from their minds, and they would never even consider marrying someone outside of their fold. They are, in short, no more free from the clutches of religion than adherents of the Cult of Reason in eighteenth-century France. For these people at least, atheism may be the solution to the problem of religion. But that solution is religious nonetheless.

Friendly Atheists

One of the mistakes observers of religion often make is imagining that all religious people are hard core. We pay far too little attention to ordinary Christians who read their Bibles with a shrug (or never crack them at all). And so it goes for atheism. The village atheist was a gadfly, not a bomb thrower, and most atheists today are far less dogmatic than the high priests of the New Atheism.

A Web site called "Friendly Atheist" defines this kinder, gentler type as someone who "can talk to a religious person without invoking an argument," "questions his/her own beliefs as much as others' beliefs," and "does not think someone is inferior for believing in God."[32] In a book called *Losing My Religion* (2009), William Lobdell, a former *Los Angeles Times* religion writer, tells of his journey from evangelicalism to Catholicism to atheism. It's a deconversion narrative, but this "reluctant atheist" isn't trying to deconvert anyone else, and his tone is more wistful than angry. Of the New Atheists, Lobdell writes that "their disbelief has a religious quality to it that I'm not ready to take on." "With all that's happened to me," he adds, "I don't feel qualified to judge anyone else."[33] *Letting Go of God* by the former *Saturday Night Live* comic Julia Sweeney is a similar project. This one-woman play also proceeds via storytelling rather than argument and steers clear of New Atheist vitriol. Another friendly atheist is Nica Lalli, a Brooklyn-based writer and self-proclaimed "pink atheist" who observes in an essay called "Atheists Don't Speak With Just One Voice" that atheists come in all shapes and sizes. Most of the angry and argumentative atheists are men, she writes, and their old-boys network doesn't speak for her.[34]

At an atheism rally I attended at Harvard University in 2009, I heard two very different arguments. The first was the old line of the New Atheists: Religious people are stupid and religion is poison, so the only way forward is to end the idiocy and flush away the poison. The second was less controversial and less utopian. Ad-

vocates of this perspective present atheism not as the infallible truth but as a valid point of view deserving of a fair hearing. Their goal is not a world without religion but a world in which believers and nonbelievers coexist in a spirit of mutual toleration.

These competing approaches could not be further apart. One is an invitation to a duel. The other is a fair-minded appeal for recognition and respect. Or, to put it in terms of the gay rights movement: One is like trying to turn everyone gay and the other is like trying to secure equal rights for homosexuals.

This Harvard rally included a series of white male speakers preaching to the choir, taking potshots at Christians as their congregation snickered on cue. There was one female speaker, however, and she spoke in a very different voice. Amanda Gulledge is a self-described "Alabama mom" who got on her first plane and took her first subway ride in order to attend this event. Although Gulledge stood up on behalf of logic and reason, she spoke from the heart. Instead of arguing, she told stories of the "natural goodness" of her two sons who somehow manage to be moral without believing in God. But the key turn in her talk, and in the event itself, came when Gulledge mentioned, in passing, how some neighborhood children refuse to play with her boys because they have not accepted Jesus as their Savior.

The New Atheism stands at a crossroads. Until now it has been spearheaded by the sort of white, male firebrands that led the charge for evangelicalism during the Second Great Awakening of the early nineteenth century. But there is a different voice emerging—call it the *new* New Atheism—and with it a very different agenda from the "Four Horsemen" of the angry atheist apocalypse (Hitchens, Harris, Dawkins, and Dennett). This friendlier atheism sounds more like a civil rights movement than a crusade, and it is far more likely to issue from the lips of friendly women than from the spittle of angry men.

If the hope is to pummel into submission every theist from Salt Lake City to São Paulo to Sydney, then the atheist movement has about as much of a chance as an evangelical revival in the National

Assembly of France. But if the hope is for a world in which children can play with other children without regard for the religious (or non-religious) beliefs of their parents, then this is a wave that many Christians and Muslims, Jews and Hindus would happily catch. I wouldn't walk around the block to hear Christopher Hitchens take cheap shots at Christians. But I'd get on the subway, and maybe even a plane, to hear Amanda Gulledge tell me why her kids are good people too.

It is easy to imagine that the task of the great religions is to transport and transform us. The world is not our true home; being human is not our true calling. We are stuck in the muck and mire of sin or suffering or illusion, so it is religion's job to convey us to heaven or nirvana or moksha. Along the way we will be transformed from caterpillar to cocoon to butterfly: Christianity will transfigure us into saints, Buddhism into bodhisattvas, Hinduism into gods.

The world's religions do promise the magic of metamorphosis, but the metamorphosis on offer is often less dramatic than spinning golden gods out of human straw. Even in traditions of escape from the sin and suffering of this world, religion works not so much to help us flee from our humanity as to bring us home to it. "The glory of God," wrote the second-century Catholic bishop Irenaeus of Lyons, "is a human being fully alive."[1] Or, as a contemporary Confucian puts it, "We need not depart from our selfhood and our humanity to become fully realized."[2]

Of course, we are in a sense born human beings, but only in the most trivial sense of genus and phylum and DNA. Often our humanity lies out ahead of us—as achievement rather than inheritance, and a far from trivial achievement at that. Yes, Christianity tells us we are sinners and calls us to be something else, but Jesus did not take on a human body just to save us from our sins. Among the purposes of the Christian doctrine of the Incarnation is to show us how to inhabit a human body and to demonstrate along the way that being human can be sacred too. Other religions can also be understood in this light. In Islam, the fact that Muhammad is emphatically *not* divine does not

prevent him from serving as the model for humanity. In Daoism, the sages show us how to act as we really are, which is natural, spontaneous, and free.

One of the greatest stories ever told is also one of the oldest: the ancient Mesopotamian epic of Gilgamesh and his friend Enkidu. Gilgamesh is a god/man, king of Uruk, a city dweller and guardian of civilization. Enkidu is an animal/man, a forest dweller and threat to civilization who dresses in animal skins and runs with wild beasts. The story of these two men—a sort of *On the Road* for the third millennium B.C.E.—gets going when, during their initial encounter, they wrestle to a draw and become fast friends. Soon they are casting themselves onto the sorts of adventures virile young men have forever imagined that only forests and monsters can bring. And when one of those monsters comes bearing death, Gilgamesh goes on a quest for immortality.

Like any classic, Gilgamesh is many tales tucked into one, but it is preeminently a meditation on how to become a human being. As the story opens, Gilgamesh the god/man thinks himself superior to other humans, while Enkidu the animal/man thinks himself inferior. As the story progresses, each becomes a human being. Enkidu seems to become human by having sex with a woman, who then washes and shaves his hairy body, while Gilgamesh seems to become human by watching his friend die and grieving his passing. Eros and thanatos, as Freud might say: the sex urge and the death urge—two sides of being human.

A few years ago, when "What Would Jesus Do?" bracelets were colonizing evangelical wrists across America, a friend started making "What Would You Do?" bracelets. Forget what Jesus would do. What would Joseph or Katie do? Inside the packing boxes for these bracelets she tucked sayings from various thinkers about finding and following your own path. In almost all religions there is at least the intimation that what God or Heaven wants for us is simply to become ourselves:

*When the eighteenth-century Hasidic rabbi Zusya reaches
the next world, God will not ask him, "Why were you
not Moses?" but "Why were you not Zusya?"* [3]

*'"The Tao has ten thousand gates,' say the masters,
and it is up to each of us to find our own."* [4]

To explore the great religions is to wander through these ten
thousand gates. It is to enter into Hindu conversations on the logic
of karma and rebirth, Christian conversations on the mechanics of
sin and resurrection, and Daoist conversations on flourishing here
and now (and perhaps forever). It is also to encounter rivalries be-
tween Hindus and Muslims in India, between Jews and Muslims
in Israel, and between Christians and Yoruba practitioners in Nige-
ria. Each of these rivals offers a different vision of "a human being
fully alive." Each offers its own diagnosis of the human problem
and its own prescription for a cure. Each offers its own techniques
for reaching its religious goal, and its own exemplars for emula-
tion. Muslims say pride is the problem; Christians say salvation is
the solution; education and ritual are key Confucian techniques;
and Buddhism's exemplars are the arhat (for Theravadins), the bo-
dhisattva (for Mahayanists), and the lama (for Tibetan Buddhists).

These differences can be overemphasized, of course, and the
world's religions do converge at points. Because these religions *are*
a family of sorts, some of the questions they ask overlap, as do some
of the answers. All their adherents are human beings with human
bodies and human failings, so each of these religions attends to our
embodiment and to the human predicament, not least by defining
what it is to be fully alive.

Religious folk go about this task in very different ways, however.
Confucians believe we become fully human by entwining our-
selves in intricate networks of social relations. Daoists believe we
become fully human by disentangling ourselves from social rela-
tions. For Muslims, Muhammad's three core human qualities are

piety, combativeness, and magnanimity.[5] The Buddha may have been magnanimous, but he was far from pious. In fact, he did not even believe in God. And Jesus may have been magnanimous, too, but when combat called, he turned the other cheek. If the Dao has ten thousand gates, so do the great religions. And it is up to each of us to find our own.

For those who find such a path, it is tempting to lapse into the sort of naive Godthink that lumps all other religious paths into either opposites or mirror images of your own. The New Atheists see all religions (except their own "anti-religious religion") as the same idiocy, the same poison. The perennial philosophers see all religions as the same truth, the same compassion. What both camps fail to see is religious diversity. Rather than ten thousand gates, they see only one.

Godthink is ideological rather than analytical—it starts in the dense clouds of desire rather than with a clear-eyed vision of how things are on the ground. In the case of Hitchens and the New Atheists, it begins with the desire to denounce the evil in religion. In the case of Huston Smith and the perennialists, it begins with the desire to praise the good in religion. Neither of these desires serves our understanding of a world in which religious traditions are at least as diverse as our political, economic, and social arrangements—where religious people make war and peace in the name of their gods, Buddhas, and orishas. It does not serve diplomats or entrepreneurs working in India or China to be told that all Hindus and all Confucians are equally idiotic. It does not serve soldiers in the Middle East to be told that the Shia Islam of Iran is essentially the same as the Sunni Islam of Saudi Arabia, or that Muslims, Christians, and Jews in Israel do not disagree fundamentally on matters of faith or practice.

Of course, there are people who stress the difference between, say, Islam and Christianity in order to make the theological point that Islam is the one true path or that Jesus is the only way, the only truth, and the only life. More dangerously, others stress religious differences in order to make the political point that religious

civilizations are fated to clash. Most dangerously, there are people who stress religious differences in order to justify going to war against their theological enemies. And holy war is precisely what both the New Atheists and the perennialists are, to their credit, trying to avoid.

I too hope for a world in which human beings can get along with their religious rivals. I am convinced, however, that we need to pursue this goal through new means. Rather than beginning with the sort of Godthink that lumps all religions together in one trash can or treasure chest, we must start with a clear-eyed understanding of the fundamental differences in both belief and practice between Islam and Christianity, Confucianism and Hinduism.

Some people are sure that the only foundation on which interreligious civility can be constructed is the dogma that all religions are one. I am not one of them. Every day across the world, human beings coexist peacefully and even joyfully with family members who are very different from themselves. In New York, Mets fans and Yankees fans have learned to live and work alongside one another, as have partisans of Real Madrid and FC Barcelona in football-loving Spain. And who is so naïve as to imagine that the success of a relationship depends on the partners being essentially the same? Isn't it the differences that make things interesting? What is required in any relationship is knowing who the other person really is. And this requirement is only frustrated by the naïve hope that somehow you and your partner are magically the same. In relationships and religions, denying differences is a recipe for disaster. What works is understanding the differences and then coming to accept, and perhaps even to revel in, them. After all, it is not possible to agree to disagree until you see just what the disagreements might be.

Until quite recently, interfaith dialogue proceeded only among those for whom the doctrines and narratives of their traditions ran far behind the ethical imperative to get along with their neighbors. In other words, it was a game for religious liberals; religious conservatives need not apply. Today, however, young people are forging a

new path—Interfaith Dialogue 2.0—that is open to traditional believers, and to nonbelievers as well, precisely because it recognizes that genuine dialogue across religious boundaries must recognize the existence of these boundaries and the fundamental difference between the lands they bisect.

At the Chicago-based Interfaith Youth Core run by Eboo Patel, there is no requirement that participants bargain to agreement. In fact, Patel actively discourages IFYC participants from discussing politics and theology. Instead, he sets them to work on community-based projects, encouraging them to discuss instead how their very different traditions impel them toward a shared commitment to service. As a result, Patel (who is Muslim himself) is able to get Orthodox Jews, conservative Catholics, and born-again Christians to work side-by-side. "Religion is a force in the world," Patel says. "Whether it divides or unites is up to us."[6] Whether religion divides or unites also depends on whether we can learn to talk about it with some measure of empathetic understanding.

Among the casualties of the late, great culture wars is the recognition that there are two ways to talk about religion. There is the religious way of synagogue prayers and church sermons—the way that religious people preach *their* creeds, *their* gods, *their* rituals. But there is also a secular way to talk about religion. This second way does not assume that religion in general, or any religion in particular, is either true or false, because to make such an assumption is to be talking about religion religiously. It aims instead simply to observe and to report, as objectively as possible, on this thing human beings do, for good or for ill (or both).

There is a difference between doing art history and making art. Art historians can be artists, of course, but creating art and interpreting it are two very different projects. And so it goes with doing and interpreting religion. Some scholars of religion are religious, of course, but there is no faith requirement for the job, just as it is not necessary to be a sculptor or painter to be an art historian. Of course, scholars of religion often allow their own theological biases to slip into their work, speaking about religion in

two ways at once. The problem with Godthink of either the New Atheist or the perennial philosophy variety is that each camp fails to see what should be obvious to any outsider—that theirs are theological positions too. When Richard Dawkins calls religion delusional, he is speaking as a theologian (or atheologian), not as an objective reporter. When Huston Smith calls all religions one, he is doing theology too.

If religion did not matter, this collective confusion would not cloud our understanding of the world. If human beings acted in their families, communities, and nations purely on the basis of greed and power, then economists and political scientists could do a decent job of describing the world. But people act every day on the basis of religious beliefs and behaviors that outsiders see as foolish or dangerous or worse. Allah tells them to blow themselves up or to give to the poor, so they do. Jesus tells them to bomb an abortion clinic or to build a Habitat for Humanity house, so they do. Because God said so, Jews, Christians, and Muslims believe that this land is their land, so they fight for it in the name of G-d or Jesus or Allah. Call this good news or bad news, but by any name it is the way things are. So if we want to live in the real world rather than down a rabbit hole of our own imagining then we need to reckon with it.

To reckon with the world as it is, we need religious literacy. We need to know something about the basic beliefs and practices of the world's religions. This book has tried to offer this literacy. It has outlined how the eight rival religions wrestle with the human predicament—their problems, solutions, techniques, and exemplars. It has demonstrated how different religions emphasize different dimensions of religion—the ethical and ritual dimensions in Confucianism, for example, and the legal and narrative dimensions in Judaism. Along the way it has ranked these religions from the greatest of the great on down—from Islam to Christianity to Confucianism to Hinduism to Buddhism to Yoruba religion to Judaism to Daoism. But religious literacy of this sort is not enough.

Today we have plenty of Christians doing Christian theology

in public, plenty of atheists doing atheology in public, and plenty of perennial philosophers telling the public that all religions are one. Our airwaves and bookstores are clogged with angry arguments for this religion and against that religion. On *Hardball* and other television shows that sound like they were named by adolescent boys, producers routinely pit ideologues on the Secular Left against ideologues on the Religious Right. So there is no shortage of religious (and antireligious) name-calling. What is missing is this second way of talking about religion—a voice that sounds more like the old-fashioned news gathering of CBS and the BBC than like the contemporary vituperations of Fox News and MSNBC. This book has tried to speak in this different voice, offering new ways to enter into the ten thousand gates of human religiosity.

There is a famous folk tale about blind men examining an elephant. It likely originated in India before the Common Era, but it eventually spread to East and Southeast Asia and then around the world. According to this folk tale, blind men are examining an elephant. One feels his trunk and declares it to be a snake. Another feels his tail and declares it a rope. Others determine that the elephant is a wall, pillar, spear, or fan, depending on where they are touching it. But each insists he is right, so much quarreling ensues.

Among true believers of the perennial philosophy sort, this story is gospel. In their eyes, the elephant is God and the blind men are Christians and Muslims and Jews who mistake their particular (and partial) perspectives on divinity for the reality of divinity itself. Because God is beyond human imagining, we are forever groping around for God in the dark. It is foolish to say that your religion alone is true and all other religions are false. No one has the whole truth, but each is touching the elephant. So, concludes the Hindu teacher (and inspiration for many perennialists) Ramakrishna, "one can realize God through all religions."[7]

But this folk tale also demonstrates how different religions are, since it has been told in various ways and put to various uses by

various religious groups. Among Buddhists, it shows that specula-
tion on abstract metaphysical questions causes suffering. Among
Sufis, it shows that God can be seen through the heart but not
the senses. Hindus read it as a parable about how "God can be
reached by different paths."[8] Finally, modern Western writers
such as the British poet John Godfrey Saxe turn it into a tale of
the stupidity of theology:

> *So oft in theologic wars,*
> *The disputants, I ween,*
> *Rail on in utter ignorance*
> *Of what each other mean,*
> *And prate about an Elephant*
> *Not one of them has seen!*[9]

For me, this story is a reminder not of the unity of the world's
religions (as Ramakrishna and the perennialists would have us be-
lieve), or of their shared stupidity (as Saxe and the New Atheists
would argue), but of the limits of human knowledge. It is com-
monplace to think of religions as unchanging dogmas demand-
ing unqualified assent. And there are no doubt fundamentalists
inside most religions who see things just this way. But one function
of the transcendent is to humble us, remind us that our thoughts
are not the thoughts of God or the Great Goddess—to remind us
that, at least for the time being, we see through a glass, darkly. Yes,
religious people offer solutions to the human predicament as they
see it. Yet these solutions inevitably open up more questions than
they close down. This is definitely true of Confucius and Hillel,
who, perhaps more than any of the figures discussed in this book,
followed Rilke's admonition to "love the questions themselves."[10]
But it is also true of Muhammad, who once said, "Asking good
questions is half of learning," and of Jesus, whose parables seem
designed less to teach us a lesson than to move us to scratch our
heads.[11]

When it comes to safeguarding the world from the evils of

religion, including violence by proxy from the hand of God, the claim that all religions are one is no more effective than the claim that all religions are poison. Far more powerful is the reminder that any genuine belief in what we call God should humble us, remind us that, if there really is a god or goddess worthy of the name, He or She or It must surely know more than we do about the things that matter most. This much, at least, is shared across the great religions.

ACKNOWLEDGMENTS

This book is informed throughout by the generosity of colleagues, the writings of other scholars, the encouragement of friends and family, and the provocations of students.

At Boston University, I benefited from the support of my Chair, Deeana Klepper, and my deans, Jeffrey Henderson and Virginia Sapiro. A dozen or more graduate students in BU's Division of Religious and Theological Studies lent me their expertise. BU colleagues who pushed this project forward by brainstorming with me, reading chapters, or answering frantic emails on this phrase or that date include Kecia Ali, Nancy Ammerman, David Eckel, Paula Fredriksen, Donna Freitas, Scott Girdner, Catherine Hudak, Jonathan Klawans, Jennifer Knust, Frank Korom, Christopher Lehrich, Robert Hefner, Tom Michael, Dana Robert, Adam Seligman, Onaje Woodbine, Wesley Wildman, and Michael Zank. John Berthrong and Diana Lobel were extraordinarily generous, commenting on multiple chapters and encouraging me along the way.

From outside of my home university came expert assistance from Juhn Ahn, Heather Burns, David Chappell, Yvonne Chireau, Lesleigh Cushing, Yvonne Daniel, Alice Frank, Georgia Frank, Seth Handy, Leah Hochman, Paul Johnson, Ashley Makar, Kathryn McClymond, Joseph Murphy, Jacob Olupona, Robert Ross, Nora Rubel, Ken Serbin, Kristin Swenson, Robert Farris Thompson, Scot Thumma, Robert Thurman, Thomas Tweed, Duncan Williams, Jeff Wilson, and Lauren Winner.

I also want to acknowledge Nicholas Jagdeo and David Neuhaus, who guided me through their respective Jerusalems, and

Laode Arham and Meghan Hynson, who took me into the homes of Muslims in Java and Hindus in Bali.

As always, I am extraordinarily grateful to have my extraordinary agent, Sandy Dijkstra, and her hard-working staff at the Sandra Dijkstra Literary Agency, in my corner. At HarperOne, my publisher, Mark Tauber, and my publicist, Julie Burton, are both first rate, as is my indefatigable editor, Roger Freet, who provided a wonderful sounding board for this project from proposal to publication and beyond.

I am also extraordinarily lucky to be blessed with two daughters who feign interest in my work.

Finally, I must thank my students, to whom this book is dedicated. Some, such as the multi-talented Shari Rabin, engaged me in thought-provoking discussions about this project. Others advanced my thinking through less direct but no less powerful means, not least a brimming curiosity about the great religions of the world. My students are Muslims and Christians, Confucians and Hindus, and non-believers. They practice Buddhism, Yoruba religions, Judaism, and Daoism. So they provide for me a living laboratory of religious difference and a model for how to coexist amiably alongside adherents of rival religions.

I view teaching and learning as conversation and conversation as provocation. I am happy to report that the conversations my students have had with me, and with one another, in my classrooms over the years have been all the provocation any professor could desire. I thank them above all else for asking big questions—the sorts of questions that no one book, and no one religion, can exhaust.

NOTES

Introduction

1. The sole surviving copy of this book can be found at the Huntington Library and Art Gallery in San Marino, California. See it online at: http://www.blakearchive.org/exist/blake/archive/work.xq?workid=aro&java=yes. Blake wrote, "As all men are alike (tho infinitely various), so all religions . . . have one source," which he referred to as "the Poetic Genius."

2. Huston Smith, *The World's Religions: Our Great Wisdom Traditions* (New York: HarperSanFrancisco, 1991), 73.

3. Dalai Lama, *An Open Heart: Practicing Compassion in Everyday Life* (Boston: Little, Brown, 2001), 8–9.

4. Smith, *World's Religions*, 73. "Those who circle the mountain, trying to bring others around to their paths, are not climbing," Smith adds.

5. Swami Sivananda, "The Unity That Underlies All Religions," http://www.dlshq.org/religions/unirel.htm.

6. See Reuven Firestone, "Argue, for God's Sake—or, a Jewish Argument for Argument," *Journal of Ecumenical Studies* 39, no. 1–2 (2002): 47–57.

7. Adam B. Seligman, "Tolerance, Tradition and Modernity," *Cardozo Law Review* 24, no. 4 (2003): 1645–56. In addition to writing sociological works on this topic, Seligman runs The Tolerance Project and the International Summer School on Religion and Public Life (http://www.issrpl.org).

8. Smith, *World's Religions*, 5, 388–89.

9. Sivananda, "Unity That Underlies All Religions."

10. Hans Küng, *On Being a Christian*, trans. Edward Quinn (Garden City, NY: Doubleday, 1976), 98.

11. Tracy McNicoll, "Courting Islamic Cash in France," *Newsweek*, September 21, 2009, 12.

12. W. E. B. DuBois, *The Souls of Black Folk: Etches and Sketches* (Chicago: A. C. McClurg, 1903), 23. I first heard this argument from Eboo Patel of the Interfaith Youth Core.

13. Ninian Smart, *Dimensions of the Sacred: An Anatomy of the World's Beliefs* (Berkeley: Univ. of California Press, 1996).

14. Abraham Joshua Heschel, "No Religion Is an Island," in *No Reli-*

gion Is an Island: Abraham Joshua Heschel and Interreligious Dialogue, eds. Harold Kasimow and Byron L. Sherwin (Maryknoll, NY: Orbis Books, 1991), 3–22. "Parochialism has become untenable," Heschel writes. "There was a time when you could not pry out of a Boston man that the Boston state house is not the hub of the solar system or that one's own denomination has not the monopoly of the holy spirit. Today we know that even the solar system is not the hub of the universe" (5–6).

15. Quoted in Eric J. Sharpe, *Comparative Religion: A History* (London: Duckworth, 1975), 36.

16. I hope it is clear that I am not trying to revive the shopworn division of the world's religions into orthodox "great traditions" of the lettered and heterodox "little traditions" of the unlettered. On this division, see, e.g., Clifford Wilcox, *Robert Redfield and the Development of American Anthropology*, 2nd ed. (Lanham, MD: Lexington Books, 2006).

17. World Religion Database, http://www.worldreligiondatabase.org. Unless otherwise noted, the demographic data on the world's religions in this book comes from this resource.

18. "The List: The World's Fastest-Growing Religions," *Foreign Policy*, May 2007, http://www.foreignpolicy.com/story/cms.php?story_id= 3835. Islam's growth rate is 1.84 percent. Christianity, which is benefiting from both high birth rates and mass conversions in the Global South, is growing 1.38 percent per year.

19. Christopher Hitchens, *God Is Not Great: How Religion Poisons Everything* (New York: Twelve Books, 2007).

20. Max Hastings, "Mohammed Is Now the Third Most Popular Boy's Name in England," MailOnline, September 10, 2009, http://www .tiny.cc/8ET3Y.

21. David Masci, "An Uncertain Road: Muslims and the Future of Europe," The Pew Forum on Religion and Public Life, October 2005, http://pewforum.org/docs/?DocID=60.

22. The index to Axel Michaels, *Hinduism: Past and Present*, trans. Barbara Harshav (Princeton: Princeton Univ. Press, 2004) has ten separate entries on "salvation," and Michaels refers throughout to "sin" (see, e.g., p. 16). In the Buddhist context, Ninian Smart refers to "salvation" in his *Religions of Asia* (Englewood Cliffs, NJ: Prentice Hall, 1993), 107; and D. T. Suzuki refers to "sin" in his *Essays in Zen Buddhism: (Second Series)* (London: Luzac, 1933), 243. Even Daoism is routinely enlisted into the "sin" and "salvation" camp. See, e.g., Julia Ching, "East Asian Religions," in *World Religions: Eastern Traditions*, 2nd ed., ed. Willard G. Oxtoby (New York: Oxford Univ. Press, 2001), 392.

23. Smith, *World's Religions,* 73.

24. James Fadiman and Robert Frager, eds., *Essential Sufism* (New York: HarperCollins, 1999), 82.

25. Rainer Maria Rilke, *Rilke on Love and Other Difficulties*, trans. John J. L. Mood (New York: Norton, 1975), 25; Walt Whitman, "The Wound-Dresser," in his *Leaves of Grass* (Philadelphia: David McKay, 1891–92), 242.

26. Richard Rorty, "Religion as a Conversation Stopper," *Common Knowledge* 3, no. 1 (1994): 1–6. Here Rorty is taking on Stephen L. Carter, *The Culture of Disbelief: How American Law and Politics Trivialize Religious Devotion* (New York: Basic Books, 1993).

27. Augustine, *Confessions*, 10.33.50 in *Augustine of Hippo: Selected Writings*, trans. Mary T. Clark (New York: Paulist Press, 1984), 150.

Chapter One: Islam: The Way of Submission

1. "Public Expresses Mixed Views of Islam, Mormonism," The Pew Forum on Religion and Public Life, September 25, 2007, http://pew forum.org/surveys/religionviews07. The top ten single words associated with Islam (in order) were: "devout/devoted," "fanatic/fanatical," "different," "peace/peaceful," "confused/confusing," "radical," "strict," "terror/terrorism," "dedicated," "violence/violent."

2. "The Great Divide: How Westerners and Muslims View Each Other," Pew Global Attitudes Project, June 22, 2006, http://pewglobal.org/reports/display.php?ReportID=253.

3. Laurie Goodstein, "Top Evangelicals Critical of Colleagues over Islam," *New York Times*, May 8, 2003, http://www.nytimes.com/2003/05/08/us/top-evangelicals-critical-of-colleagues-over-islam.html.

4. All quotations from the Quran are, unless otherwise noted, from A. J. Arberry, *The Koran Interpreted* (New York: Touchstone, 1996).

5. World Religion Database, http://www.worldreligiondatabase.org. China is not typically listed in the top ten, largely because it is notoriously difficult to gather data on religious affiliation there, but China could well be one of the most populous countries in the Muslim world.

6. "Islamic Extremism: Common Concern for Muslim and Western Publics, Pew Global Attitudes Project, July 14, 2005, http://pewglobal.org/reports/display.php?PageID=809; "Islam and the West: Searching for Common Ground," Pew Global Attitudes Project, July 18, 2006, http://pewglobal.org/commentary/display.php?AnalysisID=1009; "Great Divide: How Westerners and Muslims View Each Other," Pew Global Attitudes Project, June 22, 2006, http://pewglobal.org/reports/display.php?ReportID=253.

7. See Jack Shaheen, *Reel Bad Arabs: How Hollywood Vilifies a People* (New York: Olive Branch Press, 2003).

8. William C. Chittick, *The Sufi Doctrine of Rumi* (Bloomington, IN: World Wisdom, 2005), 82.

9. Seyyed Hossein Nasr, *Ideals and Realities of Islam* (London: George Allen & Unwin, 1985), 22.

10. Some Western critics claim that Islam has six pillars rather than five, and that jihad is that sixth pillar. Some contemporary Islamist groups, most notably al-Qaeda and the Taliban, also hold this view. But the overwhelming majority of Muslims, both past and present, restrict these practices to five.

11. Some Muslim countries pay for their citizens to make the hajj. In 2008, Nigerian states sent 84,878 Muslims to Mecca, at a total cost of $127 million. After arguing that their pilgrimages to Jerusalem were at least as worthy of government subsidies as the hajj of Muslims, 17,000 Nigerian Christians received subsidies of $17 million that same year to become "JPs," or Jerusalem pilgrims. See Gabriel Omoh, "Nigeria: Citizens Spend N35 Billion on Pilgrimages," *Vanguard*, January 5, 2009, http://allafrica.com/stories/200901051100.html.

12. It should be noted that few Muslims read the Quran through the *sola scriptura* (scripture alone) strategy of Protestants. More like rabbinic Jews and Roman Catholics, they read this text through a long tradition of interpretation that in many cases softens the hard edges of difficult passages not only on war but also on other controversial topics such as women's rights.

13. "A Rising Tide Lifts Mood in the Developing World," Pew Global Attitudes Project, July 24, 2007, http://pewglobal.org/reports/display.php?ReportID=257. American Muslims are far less likely to support al-Qaeda than Muslims in other countries, but even in the United States one in twenty Muslims has a favorable view of that organization. Equally troublingly, only 40 percent of American Muslims believe that Arabs were responsible for the 9/11 attacks. The rest either said they did not know or put the blame on Israel or the United States. See "Muslim Americans: Middle Class and Mostly Mainstream," Pew Research Center, May 22, 2007, http://pewresearch.org/pubs/483/muslim-americans.

14. Michael H. Hart, *The 100: A Ranking of the Most Influential Persons in History* (New York: Citadel Press, 1992).

15. S. H. Pasha pamphlet, undated, but handed out on the streets of Atlanta in the 1990s (personal collection of author).

16. Wilfred Cantwell Smith, *Islam in Modern History* (New York: New American Library, 1959), 26. Continuing in this line of thinking, the parallel to the Bible in Islam is not the Quran but the Hadith.

17. Arberry translation, modified from "man" to "the human being" because in the original Arabic the noun is gender neutral.

18. Abraham J. Heschel, *The Prophets* (New York: Harper & Row, 1962), 12. "The threat of punishment is one of the most prominent themes of the prophetic orations," Heschel added (187).

19. See also: "Let not the believers take the unbelievers for friends, rather than the believers" (3:28); "O believers, take not the unbelievers as

friends instead of the believers" (4:144); and "O believers, take not My enemy and your enemy for friends" (60:1). I am grateful to Omid Safi and Kecia Ali for email exchanges on this matter.

20. I once heard a renowned calligrapher of the Quran asked about an infamous Hadith, quoted in the Hamas charter, proclaiming that the Day of Judgment will not come until the Muslims kill the Jews. He dismissed it out of hand as inauthentic because it contradicts Quranic teachings that embrace Jews as fellow "people of the book." This hadith comes from the Muslim collection, 41:6985, http://www.usc.edu/schools/college/crcc/engagement/resources/texts/muslim/hadith/muslim/041.smt.html.

21. The four are: the Hanafi school, named after Abu Hanifa (d. 767); the Maliki school, named after Malik ibn Anas (d. 795); the Shafii school, named after Muhammad ibn Idris al-Shafii (d. 820); and the Hanbali school, named after Ahmad ibn Hanbal (d. 855). South Asia is largely Hanafi. The Shafii school predominates in Indonesia, the Maliki school in North Africa, and the Hanbali school in Saudi Arabia.

22. "Al Qaeda's Fatwa," The Online NewsHour, February 23, 1998, http://www.pbs.org/newshour/terrorism/international/fatwa_1998.html.

23. "La Comisión Islámica de España Emite una Fatua Condenando el Terrorismo y al Grupo Al Qaida," March 10, 2005, http://www.webislam.com/?idn=399. Translation by the author.

24. Danièle Hervieu-Léger, *Religion as a Chain of Memory*, trans. Simon Lee (New Brunswick, NJ: Rutgers Univ. Press, 2000).

25. Omid Safi, "Progressive Islam in America," in *A Nation of Religions: The Politics of Pluralism in Multireligious America*, ed. Stephen Prothero (Raleigh: Univ. of North Carolina Press, 1996), 52–53.

26. Safi, "Progressive Islam in America," in Prothero, *Nation of Religions*, 54.

27. Fadiman and Frager, *Essential Sufism*, 102.

28. Fadiman and Frager, *Essential Sufism*, 111. Rumi made a similar point: "For them that have attained (to union with God) there is nothing (necessary) except the eye (of the spirit) and the lamp (of intuitive faith): they have no concern with indications (to guide them) or with a road (to travel by)." Quoted in Chittick, *Sufi Doctrine of Rumi*, 20.

29. Quoted in Kecia Ali, "Virtue and Danger: Sexuality and Prophetic Norms in Muslim Life and Thought," *Interreligious Dialogue*, September 30, 2009, http://irdialogue.org/wp-content/uploads/2009/10/Ali-JIRD-Oct-2009.pdf. As Ali notes, a parallel Hadith states, "There is no monkery in Islam."

30. Coleman Barks, trans., *The Essential Rumi* (New York: Harper-Collins, 1995), 242, 129.

31. Barks, *Essential Rumi*, 193.

32. Fadiman and Frager, *Essential Sufism*, 58.

33. Fadiman and Frager, *Essential Sufism*, 115.

34. Jalâl al-Dîn Rûmî, *Selected Poems from the Dîv̄ani Shamsi Tabrîz*, trans. Reynold A. Nicholson (Richmond, UK: Routledge Curzon Press, 1999), 135.

35. Ignac Goldziher, *Mohammed and Islam*, trans. Kate Chambers Seelye (New Haven: Yale Univ. Press, 1917), 183. Sufi scholar Seyyed Hossein Nasr is equally irenic: "To have lived any religion fully is to have lived all religions" (*Ideals and Realities of Islam*, 16).

36. William Wordsworth, *The Poetical Works of William Wordsworth*, eds. Ernest de Selincourt and Helen Darbishire (Oxford: Oxford Univ. Press, 1949), 4.57.

37. Barks, *Essential Rumi*, 178.

38. Quoted in Naila Minai, *Women in Islam: Tradition and Transition in the Middle East* (New York: Seaview Books, 1981), 40.

39. Mohammed El Qorchi, "Islamic Finance Gears Up," *Finance and Development* 42, no. 4 (2005), http://imf.org/external/pubs/ft/fandd/2005/12/qorchi.htm.

Chapter Two: Christianity: The Way of Salvation

1. Harvey Cox, *The Future of Faith* (New York: HarperOne, 2009), 174.

2. Make that 1082 languages as of December 2009, according to The Jesus Film Project web site (http://www.jesusfilm.org/film-and-media/statistics/languages-completed). On this same site, megachurch pastor Rick Warren refers to this movie as "the most effective evangelistic tool ever invented."

3. J. C. Hallman, *The Devil Is a Gentleman: Exploring America's Religious Fringe* (New York: Random House, 2006), xv.

4. See Stephen Prothero, *American Jesus: How the Son of God Became a National Icon* (New York: Farrar, Straus & Giroux, 2003).

5. David B. Barrett, Todd M. Johnson, and Peter F. Crossing, "Missiometrics 2008: Reality Checks for Christian World Communions," *International Bulletin of Missionary Research* 32, no. 1 (2008): 29.

6. John R. W. Stott, *Basic Christianity*, 2nd ed. (London: InterVarsity Press, 1971), 81.

7. David B. Barrett, George T. Kurian, and Todd M. Johnson, *World Christian Encyclopedia*, 2nd ed. (New York: Oxford Univ. Press, 2001), 22.

8. Diana L. Eck, *A New Religious America: How a "Christian Country" Has Become the World's Most Religiously Diverse Nation* (New York: HarperSanFrancisco, 2001).

9. In a seminar on the history of the Bible in the United States, I assigned *Revolve*. After reading the whole thing, one of my students concluded it was an *Onion*-style parody of evangelicalism, not an expression of

evangelicalism itself. See *Revolve: The Complete New Testament* (Nashville: Thomas Nelson, 2003).

10. John Henson, *Good as New: A Radical Retelling of the Scriptures* (Winchester, UK: O Books, 2004), 23, 335.

11. Carter Lindberg, *The European Reformations*, 2nd ed. (Malden, MA: Wiley-Blackwell, 2010), 64.

12. Régis Debray, *God: An Itinerary*, trans. Jeffrey Mehlman (London: Verso, 2004), 62.

13. George E. Ganss, ed., *Ignatius of Loyola: Spiritual Exercises and Selected Works* (New York: Paulist Press, 1991), 213. This was number thirteen in Ignatius's "Rules for Thinking, Judging, and Feeling with the Church."

14. Mark A. Noll, *The New Shape of World Christianity: How American Experience Reflects Global Faith* (Downers Grove, IL: InterVarsity Press, 2009), 191.

15. Here Anglicans, or Episcopalians as they are known in the United States, split the difference between Protestants and Catholics, relying on a "three-legged stool" of scripture, reason, and tradition.

16. World Christian Database, http://www.worldchristiandatabase.org. This database divides the world's Christians into six "mega-blocs": Anglicans, Catholics, Independents, Marginals, Orthodox, and Protestant. It defines Marginals, which include in addition to the Mormons such groups as Unitarians and Swedenborgians, as groups that revere Jesus yet reject traditional Christian creeds and councils and in some cases employ new revelation beyond the Bible. Here I have read Anglicans and Independents as Protestants. All demographic data in this chapter derives from this database, unless otherwise noted.

17. Sally Atkinson, "America's Next Top Mormon," *Newsweek*, May 6, 2008, http://www.newsweek.com/id/135758.

18. Philip Jenkins, *The Next Christendom: The Coming of Global Christianity* (New York: Oxford Univ. Press, 2002), 66. For a provocative argument that Mormonism is well on its way to becoming the first new world religion since Islam, see Rodney Stark, *The Rise of Mormonism*, ed. Reid L. Neilson (New York: Columbia Univ. Press, 2005). According to Stark, the LDS Church could have as many as 267 million members by 2080 (22).

19. "There is not a young man now living in the U.S.," wrote Jefferson in a letter to physicist Benjamin Waterhouse, "who will not die an Unitarian" (Dickinson W. Adams, ed., *Jefferson's Extracts from the Gospels: The Philosophy of Jesus and the Life and Morals of Jesus* [Princeton: Princeton Univ. Press, 1983], 406).

20. David W. Bebbington, *Evangelicalism in Modern Britain: A History from the 1730s to the 1980s* (London: Unwin Hyman, 1989), 2–17.

21. Noll, *New Shape of World Christianity*, 111.

22. August Comte, *System of Positive Polity*, trans. John Henry Bridges (London: Longmans, Green, 1875), 1.600.

23. George M. Marsden, *Understanding Fundamentalism and Evangelicalism* (Grand Rapids: Eerdmans, 1991), 1.

24. For 1900 data on Caucasians (which includes "Caucasian, Germanic, Slav"), and on Christians in Europe (68 percent of all Christians) and North America (14 percent), see Todd M. Johnson, "Christianity in Global Context: Trends and Statistics," Pew Forum on Religion and Public Life, http://pewforum.org/events/051805/global-christianity.pdf.

25. Hilaire Belloc, *Europe and the Faith* (New York: Paulist Pres, 1920), ix.

26. Todd M. Johnson and Sun Young Chung, "Tracking Global Christianity's Statistical Centre of Gravity, A.D. 33–A.D. 2100," *International Review of Mission* 93.369 (April 2004): 166–81.

27. Rufus Rockwell Wilson, ed., *Intimate Memories of Lincoln* (Elmira, NY: Primavera Press, 1945), 243.

28. "Weird Babel of Tongues," *Los Angeles Daily Times*, April 18, 1906, reprinted in Judith Mitchell Buddenbaum and Debra L. Mason, eds., *Readings on Religion as News* (Malden, MA: Wiley-Blackwell, 2000), 175.

29. "Annual Statistical Table on Global Mission: 2009," Center for the Study of Global Christianity, Gordon-Conwell Theological Seminary, http://www.gcts.edu/sites/default/files/IBMR2009.pdf.

30. "Spirit and Power: A 10-Country Survey of Pentecostals," Pew Forum on Religion and Public Life, October 2006, http://pewforum.org/surveys/pentecostal/.

31. On what he calls the "primitivism" and "pragmatism" of Pentecostalism, see Grant Wacker, *Heaven Below: Early Pentecostals and American Culture* (Cambridge: Harvard Univ. Press, 2001).

32. Cox, *Future of Faith*, 204.

33. "Moved by the Spirit: Pentecostal Power & Politics After 100 Years," Pew Forum on Religion & Public Life, April 24, 2006, http://pewforum.org/events/?EventID=109.

34. Donald E. Miller and Tetsunao Yamamori, *Global Pentecostalism: The New Face of Christian Social Engagement* (Berkeley: Univ. of California Press, 2007), 39–67.

35. "Annual Statistical Table on Global Mission: 2009," Center for the Study of Global Christianity, Gordon-Conwell Theological Seminary, http://www.gcts.edu/sites/default/files/IBMR2009.pdf.

36. "Christianity in all Regions," World Christian Database, http://www.worldchristiandatabase.org.

37. Noll, *New Shape of World Christianity*, 20.

38. *Deseret News 2009 Church Almanac* (Salt Lake City: Deseret News, n.d.), http://www.deseretbook.com/item/5018625/2009_Deseret_News_

Church_Almanac). See also "World LDS Membership," Rickety Blog, http://www.rickety.us/lds/world/.

39. "Social Values, Science & Technology," Special Eurobarometer 225, European Commission, June 2005, 9, http://ec.europa.eu/public_opinion/archives/ebs/ebs_225_report_en.pdf.

40. Jenkins, *Next Christendom*, 24. "At the time of the Magna Carta or the Crusades," writes Jenkins, "if we imagine a typical Christian, we should be thinking not of a French artisan, but of a Syrian peasant or Mesopotamian town-dweller, an Asian not a European."

41. Jenkins, *Next Christendom*.

42. The Hartford Institute for Religious Research maintains a database for all American Protestant churches "with a sustained average weekly attendance of 2000 persons or more in its worship services." See http://hirr.hartsem.edu/megachurch/definition.html.

43. Dana L. Robert, "Shifting Southward: Global Christianity Since 1945," *International Bulletin of Missionary Research* 24, no. 2 (2000): 50. See also Dana L. Robert, "World Christianity as a Women's Movement," *International Bulletin of Missionary Research* 30, no. 4 (2006): 180–88. How easy it is to forget this history was brought home to me during a conversation a few years ago among friends from Europe and India. After it became clear that the German Protestant in the conversation was assuming that the Indian was Hindu, she corrected him. "I'm a Mar Thomas Christian from Kerala," she said, adding that her church, which claims the biblical Thomas as its founder, had been professing Christ for centuries before Luther was even born.

44. Cox, *Future of Faith*, 222, 1, 20.

45. Noll, *New Shape of World Christianity*, 111.

46. "Annual Statistical Table on Global Mission: 2009," Status of Global Mission, Center for the Study of Global Christianity, Gordon-Conwell Theological Seminary, http://www.gcts.edu/sites/default/files/IBMR2009.pdf.

47. According to Episcopal bishop John Shelby Spong, Christians would do well to examine their own history of violence and anti-intellectualism before criticizing Muslims for the same. The Bible, Spong writes, has been used "to oppose the Magna Carta and support the divine right of kings, to condemn the insights of Galileo and Charles Darwin, . . . to support slavery and later apartheid and segregation . . . to justify the Crusades and their unspeakable horrors against Muslim peoples, as well as the murderous behavior of the Inquisition and the virulent anti-Semitism of the Holocaust." See his *The Sins of Scripture: Exposing the Bible's Texts of Hate to Reveal the God of Love* (New York: HarperSanFrancisco, 2005), dust jacket.

48. Quoted in Debray, *God: An Itinerary*, 264.

Chapter Three: Confucianism: The Way of Propriety

1. Analects 15:24, 15:23, 4:16; Miles Menander Dawson, ed. *The Ethics of Confucius: The Sayings of the Master and His Disciples on the Conduct of "The Superior Man"* (New York: G. P. Putnam's Sons, 1915), 76; Analects 15:6. These and subsequent quotes from the Analects are from Confucius, *The Analects*, trans. D. C. Lau (New York: Penguin, 1979).

2. Max Weber advances this argument in both *The Protestant Ethic and the Spirit of Capitalism* and *The Religion of China: Confucianism and Taoism*, which first appeared in German in 1904–05 and 1915, respectively. The key observation is that capitalism failed to emerge in China as it had in Protestant countries in Europe.

3. There are competing systems for transliterating Chinese characters into English. Until recently, the most common was Wade-Giles, which rendered China's capital as Peking and the most popular Chinese scripture in the West as the *Tao Te Ching*. Here I use the increasingly popular Pinyin system (used by the United Nations), which spells that capital as Beijing and that scripture as the *Daodejing*. So the I Ching (in Wade-Giles) is Yijing (in Pinyin).

4. The first Confucian canon actually included Six Classics, the current five plus the lost Book of Music. The Five Classics then swelled into the Thirteen Classics by the Song dynasty (960–1279 C.E.). Tu Weiming sees in the Five Classics five different visions that constitute the Confucian way: the poetic, social, historical, political, and metaphysical. Human beings, he argues, are multiple. To understand them, and ourselves, we need sight lines from a wide variety of perspectives. See his "Confucianism," in *Our Religions: The Seven World Religions Introduced by Preeminent Scholars from Each Tradition*, ed. Arvind Sharma (New York: HarperSanFrancisco, 1993), 195–97.

5. J. J. Clarke, *The Tao of the West: Western Transformations of Taoist Thought* (London: Routledge, 2000), 22.

6. Grace Jantzen, *Becoming Divine: Towards a Feminist Philosophy of Religion* (Manchester: Manchester Univ. Press, 1998), esp. 128–70.

7. James Fieser and John Powers, eds., *Scriptures of the East* (Boston: McGraw Hill, 1998), 158.

8. Tu Wei-ming, "Confucianism," in Sharma, *Our Religions*, 147.

9. Tu Wei-ming, "Confucianism," in Sharma, *Our Religions*, 214. Some leading Confucian scholars, including David L. Hall and Roger T. Ames, contend that through the Han dynasty there was no sense of transcendence in Confucianism. Transcendence, immanent or otherwise, comes later, and is a product of foreign influence. See their *Thinking Through Confucius* (Albany: State Univ. of New York Press, 1987) and their *Thinking from the Han: Self, Truth, and Transcendence in Chinese and Western Culture* (Albany: State Univ. of New York Press, 1998).

10. Tu Wei-ming, "Confucianism," in Sharma, *Our Religions*, 207. See also Herbert Fingarette, *Confucius: The Sacred as Secular* (New York: Harper & Row, 1972).

11. Gordon Haber, "The False Science," Killing the Buddha Blog, http://killingthebuddha.com/mag/exegesis/the-false-science.

12. Tu Wei-Ming, *Confucian Thought: Selfhood as Creative Transformation* (Albany: State Univ. of New York Press, 1985), 15.

13. A thorough discussion of this term appears in Hall and Ames, *Thinking Through Confucius*, 176–92.

14. John Winthrop, "A Model of Christian Charity," in Kirsten Fischer and Eric Hinderaker, eds., *Colonial American History* (Malden, MA: Blackwell, 2002), 85, 87.

15. Analects 12:11.

16. James Legge, *The Chinese Classics* (Oxford: Clarendon Press, 1893), I.87.

17. Analects 7:1, quoted in *The Analects of Confucius*, trans. Arthur Waley (New York: Vintage, 1989), 23.

18. Confucius, *The Sacred Books of China: The Texts of Confucianism*, trans. James Legge (New York: Charles Scribner's Sons, 1899), 5.353.

19. Fieser and Powers, *Scriptures of the East*, 148.

20. Analects 1:2.

21. Analects 2:5.

22. Analects 12:1.

23. See Fingarette, *Confucius: The Sacred as Secular*.

24. Tu Wei-ming, "Confucianism," in Sharma, *Our Religions*, 206.

25. Analects 2:17, in *The Analects*, trans. Waley, 91.

26. Analects 17:19, in Philip Novak, *The World's Wisdom: Sacred Texts of the World's Religions* (New York: HarperCollins, 1995), 116. This passage is often read as a denial of revelation, but it can also be read as an affirmation of a sort of mysticism.

27. Personal interview with John Berthrong, May 27, 2009.

28. Fieser and Powers, *Scriptures of the East*, 156.

29. Tu Wei-ming, "Confucianism," in Sharma, *Our Religions*, 175.

30. Jennifer Oldstone-Moore, "Confucianism," in Coogan, ed., *Eastern Religions*, 329.

31. Michael Nylan, *The Five "Confucian" Classics* (New Haven: Yale Univ. Press, 2001), 330.

32. Analects 1:12.

33. John Naish, "Why Confucius Matters Now," Times Online, April 25, 2009, http://women.timesonline.co.uk/tol/life_and_style/women/relationships/article6160664.ece.

34. Personal interview with John Berthrong, May 27, 2009.

35. Chenyang Li, ed., *The Sage and the Second Sex: Confucianism, Ethics, and Gender* (Chicago: Open Court, 2000).

36. Lu Xun, "A Madman's Diary," http://www.chinarice.org/madmans
-diary.pdf.

37. Personal interview with John Berthrong, May 27, 2009.

38. Confucius, *Confucian Analects: The Great Learning, and the Doctrine of
the Mean*, trans. James Legge (New York: Dover, 1971), 67–68.

39. Analects 2:11.

40. Novak, *World's Wisdom*, 129.

41. *The Doctrine of the Mean* 13, quoted in Tu Wei-ming, *Confucian
Thought*, 59. See also Analects 14:28.

42. Wendell Berry, "Writer and Region," in his *What Are People For?:
Essays* (San Francisco: North Point Press, 1990), 85, 78.

Chapter Four: Hinduism: The Way of Devotion

1. F. Max Müller, *Chips from a German Workshop* (London: Longmans,
Green, 1867), 2.300.

2. "Hindu Demographics," Hindu American Foundation, http://www
.hinduamericanfoundation.org/resources/hinduism_101/hinduism_
demographics.

3. The Oxford English Dictionary traces "Hindooism" back to 1829,
more specifically to Henry Barkley Henderson, *The Bengalee: Or,
Sketches of Society and Manners in the East* (London: Smith, Elder,
1829), 46. Hinduism scholars typically trace this term to roughly the
same period. In *An Introduction to Hinduism* (Cambridge: Cambridge
Univ. Press, 1996), Gavin Flood reports that "the 'ism' was added to
'Hindu' around 1830" (6). But an online search turns up two usages of
"Hindooism" (both religiously inflected) in the 1790s. The earliest, a
reference to "the superstitions of Hindooism," occurs in Robert Nares,
ed., *The British Critic* (London: F. and C. Rivington, 1793), 18. The
other comes in *The Wesleyan-Methodist Magazine* (1798): 516, edited by
the famed evangelist George Whitefield. "Hindooism" occurs dozens
of times in the first decade of the 1800s, and over a hundred times be-
tween 1810 and 1819. Although the gestation of this term has usually
been foisted on Orientalists, all four of these publications are religious
rather than philological. This term seems to be a coinage not of Orien-
talists but of Christian missionaries.

4. Emerson to Elizabeth Hoar, June 17, 1845, in Ralph L. Rusk, ed., *The
Letters of Ralph Waldo Emerson*, 6 vols., (New York: Columbia Univ.
Press, 1939), 3:290.

5. Erlendur Haraldsson, "Popular Psychology, Belief in Life After
Death and Reincarnation in the Nordic Countries, Western and East-
ern Europe," *Nordic Psychology* 58, no. 2 (2006): 171–80; Humphrey
Taylor, "The Religious and Other Beliefs of Americans," Harris Inter-
active, February 26, 2003, http://www.harrisinteractive.com/harris_
poll/index.asp?pid=359.

6. Highly regarded books that mistakenly refer to moksha as salvation include Flood, *Introduction to Hinduism* 13; Michaels, *Hinduism: Past and Present*, 24; and Carl Olson, *The Many Colors of Hinduism: A Thematic-Historical Introduction* (Piscataway, NJ: Rutgers Univ. Press, 2007), 8. Unfortunately, scholars also refer to sin in the Hindu context, often as a translation for the Sanskrit term *papa*. In *The Origins of Evil in Hindu Mythology* (Berkeley: Univ. of California Press, 1976), Wendy Doniger O'Flaherty states that she will translate *papa* as "evil" rather than "sin" (7), but she and others use the term *sin* routinely nonetheless. This category is too freighted with Christian theological assumptions about creation, the Fall, and redemption to be usable in this way.

7. J. A. Dubois, *Description of the Character, Manners, and Customs of the People of India* (London: Longman, Hurst, Rees, Orme, and Brown, 1817), 331.

8. December 11, 2000. Dozens of other *New Yorker* cartoons explore the humorous possibilities of life as a Hindu holy man. In one, a mountaintop guru tells a backpacker, "You do the hokey pokey and turn yourself around—that's what it's all about" (November 22, 1999).

9. The Brahmanas lie closer to the Vedas and the Aranyakas to the Upanishads. Like the Vedas, the Brahmanas are ritual texts, though their preoccupation is how to do ritual in general rather than how to perform a specific sacrifice. The Aranyakas are far more philosophical, devoting scant attention to the ritual dimension.

10. Siân Miles, ed., *Simone Weil: An Anthology* (New York: Grove Press, 2000), 92.

11. Sunil Sehgal, *Encyclopedia of Hinduism* (New Delhi: Sarup & Sons, 1999), 2.477.

12. Shankara, *Crest-Jewel of Discrimination*, trans. Swami Prabhavananda and Christopher Isherwood (Hollywood: Vedanta Press, 1978), 41.

13. Robert E. Van Voorst, *Anthology of Asian Scriptures* (Belmont, CA: Wadsworth, 2000), 34.

14. Another story in the Upanishads—from Patrick Olivelle, trans., *Upanishads* (Oxford: Oxford Univ. Press, 1996), 46—gives voice to the preference of philosophical Hindus for the one over the many, and to the wider Hindu tendency to see unity in diversity. In the Brhadaranyaka Upanishad, a student named Vidagdha Sakalya inquires of the great sage Yajnavalkya about the mathematics of divinity:

> *"Tell me, Yajnavalkya—how many gods are there?"*
> *"Three and three hundred, and three and three thousand."*
> *"Yes, of course," he said, "but really, Yajnavalkya, how many gods are there?"*
> *"Thirty-three."*

> *"Yes, of course," he said, "but really, Yajnavalkya, how many gods are there?"*
>
> *"Six."*
>
> *"Yes, of course," he said, "but really, Yajnavalkya, how many gods are there?"*
>
> *"Three."*
>
> *"Yes, of course," he said, "but really, Yajnavalkya, how many gods are there?"*
>
> *"Two."*
>
> *"Yes, of course," he said, "but really, Yajnavalkya, how many gods are there?"*
>
> *"One and a half."*
>
> *"Yes, of course," he said, "but really, Yajnavalkya, how many gods are there?"*
>
> *"One."*

And when he is asked what this One is, Yajnavalkya says breath, and Brahman and beyond.

15. J. N. Fraser and K. B. Marathe, *The Poems of Tukaram* (Madras: Christian Literature Society, 1909), 114–15.

16. Wendy Doniger O'Flaherty, *Shiva: The Erotic Ascetic* (Oxford: Oxford Univ. Press, 1981), 262-63, 268-69.

17. For a spirited argument that Tantrism stands at the center of Hindu life rather than its periphery, see David Gordon White, *Kiss of the Yogini: "Tantric Sex" in Its South Asian Contexts* (Chicago: Univ. of Chicago Press, 2006).

18. Diana L. Eck, *Darśan: Seeing the Divine Image in India*, 3rd ed. (New York: Columbia Univ. Press, 1998), 3. The centrality of sight in devotional Hinduism, and of *darshan* in puja, is underscored by the way in which an inanimate image of a god is transformed ritually into a living god itself. This happens when the priest either places the eyes (almost always impossibly large) into the statue or paints them onto its face. From this moment onward, the deity is considered to be alive, and in need of round-the-clock attention—waking, washing, clothing, and feeding—from the priest.

19. *"Sita Sings the Blues,"* Reel 13 Blog, http://www.thirteen.org/sites/reel13/blog/watch-sita-sings-the-blues-online/347/.

20. "The Ramayana: The Legend of Prince Rama," National Theatre, http://www.nationaltheatre.org.uk/?lid=1217.

21. Mark Twain, *Following the Equator: A Journey Around the World* (Hartford, CT: American Publishing Company, 1898), chapter 52, Project Gutenberg EBook, http://www.gutenberg.org/files/2895/2895-h/p6.htm.

22. This epithet is common. One early source is David A. Curtis, "The Martin Luther of India," *Frank Leslie's Sunday Magazine* 4, no. 6 (1878), 657–61.

23. Prema Kurien, "Mr. President, Why Do You Exclude Us from Your Prayers?: Hindus Challenge American Pluralism," in Prothero, *Nation of Religions*, 119–38.

Chapter Five: Buddhism: The Way of Awakening

1. *Majjhima-nikaya*, quoted in Walpola Rahula, *What the Buddha Taught* (New York: Grove Press, 1974), 109.

2. Jack Kerouac, *Wake Up: A Life of the Buddha* (New York: Viking, 2008), 58.

3. This phrase is used in "The Power of Ideas," the second episode in the BBC television series "The Story of India" (http://www.pbs.org/ thestoryofindia/), which first aired in the United States in January 2009.

4. *Majjhima-nikaya*, quoted in Rahula, *What the Buddha Taught*, 12.

5. Only about three million Americans self-identify as Buddhists, but a recent survey found that about 12 percent of U.S. citizens—roughly 25 million people—say that Buddhism has had a significant influence on their religious or spiritual lives. See Robert Wuthnow and Wendy Cadge, "Buddhists and Buddhism in the United States: The Scope of Influence," *Journal for the Scientific Study of Religion* 43, no. 3 (2004): 361–78.

6. Friedrich Nietzsche, *The Anti-Christ, Ecce Homo, Twilight of the Idols, and Other Writings*, trans. Judith Norman (Cambridge: Cambridge Univ. Press, 2005), 16; Jack Kerouac, *The Dharma Bums* (New York: Penguin, 2006), 83.

7. Unfortunately, many scholars continue to refer to both "sin" and "salvation" in a Buddhist context. In a particularly egregious example, the *Encyclopedia of Living Faiths* (New York: Hawthorn Books, 1959) refers to Buddhism as "the gospel of salvation" ("The Buddha," 216).

8. This practice is sometimes referred to as *anapanasati*, or "breath mindfulness." For an elegantly simple description see, Ajahn Sumedho, "Watching the Breath (Ânâpânasati)" and "Effort and Relaxation," in his *Mindfulness, The Path to the Deathless: The Meditation Teaching of Venerable Ajahn Sumedho* (Morristown, NJ: Yin Shun Foundation, 1999), 23–24, 28–32. My colleague Diana Lobel reminds me that a Christian parallel to the body breathing on its own can be found in the nineteenth-century Russian book *The Way of a Pilgrim*, whose anonymous author finds the Jesus prayer starting to pray itself through him, even in his sleep.

9. Rainer Maria Rilke, *Rilke's Book of Hours: Love Poems to God*, trans. Anita Barrows and Joanna Macy (New York: Riverhead, 2005), 119.

10. Novak, *World's Wisdom*, 74.

11. Kerouac, *Wake Up*, 30. I refer here to the Buddhist term *tanha* (which literally means "thirst") as "craving" rather than "desire," in part because I have been convinced by the American Buddhist and psychotherapist Mark Epstein that what Buddhism is trying to overcome has less to do with wanting than with wanting in a desperate sort of way. "The problem is not desire," writes Epstein in *Open to Desire: The Truth About What the Buddha Taught* (New York: Gotham Books, 2006), "it is clinging to, or craving a particular outcome" (41). Epstein is most creative in reinterpreting the Middle Path as cutting between "the right-handed path of renunciation and monasticism in which sensory desires are avoided and the left-handed path of passion and relationship in which sensory desires are not avoided but are made into objects of meditation" (40). Desire, in short, can be a teacher. And its core instruction that there is always a gap between longing and satisfaction.

12. Cheri Huber, *Trying to Be Human: Zen Talks*, ed. Sara Jenkins (Murphys, CA: Keep It Simple Books, 2006), 17.

13. Kerouac, *Wake Up*, 7.

14. Sumedho, *Mindfulness*, 15, 40.

15. Haraldsson, "Popular Psychology," 171–80. Figures are higher in Iceland (41 percent) and lower in Italy (18 percent), while 27 percent of Americans believe in reincarnation. See, e.g., Taylor, "Religious and Other Beliefs of Americans," http://www.harrisinteractive.com/harris_poll/index.asp?pid=359.

16. Rahula, *What the Buddha Taught*, 45.

17. i, *F.O.A.: Full on Arrival* (n.p.: n.p., n.d.), 24.

18. Edward B. Tylor, *Primitive Culture* (London: John Murray, 1891), 1.424.

19. Robert A. F. Thurman, "Tibetan Buddhism in America: Reinforcing the Pluralism of the Sacred Canopy," in Prothero, *Nation of Religions*, 94.

20. Quoted in Dalai Lama, *Essential Teachings*, trans. Zélie Pollon (Berkeley, CA: North Atlantic Books, 1995), 52.

21. Daisetz Teitaro Suzuki, *The Training of the Zen Buddhist Monk* (New York: Cosimo Classics, 2004), 103. During their life together, the Beat poet Allen Ginsberg and his lover Peter Orlovsky made a promise that Ginsberg described as "a mutual Bodhisattva's vow." According to Ginsberg, they promised "that neither of us would go into heaven unless we could get the other one in" (Winston Leyland, ed., *Gay Sunshine Interviews* [San Francisco: Gay Sunshine Press, 1978], 1.109–13).

22. Epstein, *Open to Desire*, 188.

23. Pat Byrnes, *New Yorker* cartoon, January 15, 2001, http://www.cartoonbank.com/2001/Are-you-not-thinking-what-Im-not-thinking/invt/120275.

24. Nagarjuna quoted in Nancy McCagney, *Nâgârjuna and the Philosophy of Openness* (Lanham, MD: Rowman & Littlefield, 1997), 34.

25. Donald S. Lopez, Jr., *The Heart Sûtra Explained: Indian and Tibetan Commentaries* (Albany: State University of New York Press, 1988), 57.

26. Pema Chodron, *The Pema Chodron Audio Collection: Pure Meditation, Good Medicine, From Fear to Fearlessness* (Louisville, CO: Sounds True, 2005).

27. i, *F.O.A.: Full on Arrival*, 47.

28. Sogyal Rinpoche, *The Tibetan Book of Living and Dying*, ed. Patrick Gaffney and Andrew Harvey (New York: HarperSanFrancisco, 1993), 83.

29. Thurman, "Tibetan Buddhism in America," in Prothero, *Nation of Religions*, 105. In this same essay, Thurman makes a persuasive argument against equating the Tibetan situation with the church/state marriages of medieval Europe (97–99).

30. Thurman, "Tibetan Buddhism in America," in Prothero, *Nation of Religions*, 114–16.

31. On Western (mis)interpretations of this text, see Bryan J. Cuevas, *The Hidden History of the Tibetan Book of the Dead* (New York: Oxford Univ. Press, 2003), esp. 5–14.

32. I am borrowing here from my colleague David Eckel, who has lectured on these themes in my courses.

33. Novak, *World's Wisdom*, 103.

34. Daisetz Teitaro Suzuki, *An Introduction to Zen Buddhism* (New York: Grove Press, 1991), 46.

35. Dalai Lama, *Essence of the Heart Sutra: The Dalai Lama's Heart of Wisdom Teachings*, trans. Thupten Jinpa (Boston: Wisdom, 2005), 126.

36. Nagarjuna quoted in *The Central Philosophy of Tibet: a Study and Translation of Jey Tsong Khapa's Essence of True Eloquence*, trans. Robert A.F. Thurman (Princeton: Princeton Univ. Press, 1991), 152.

37. John Updike, *The Early Stories: 1953–1975* (New York: Knopf, 2003), xv. Updike is speaking here not of Buddhism but of his own writing.

Chapter Six: Yoruba Religion: The Way of Connection

1. I am grateful to my colleague David Eckel, who came up with core concepts for this course, and to my teaching assistant Kevin Taylor, who helped to bring these concepts alive in the classroom.

2. Keywords in Yoruba religion change from country to country and language to language. Here I use Yoruba terms (minus diacritical marks) unless I am referring to a specifically Brazilian or Cuban symbol.

3. Proverb quoted in Joseph M. Murphy, "Òrìṣà Traditions and the Internet Diaspora," in Jacob K. Olupona and Terry Rey, eds., *Òrìṣà Devotion as World Religion: The Globalization of Yorùbá Religious Culture* (Madison: Univ. of Wisconsin Press, 2008), 482.

4. On Yoruba-derived traditions as "rhizomes," see James Lorand Matory, *Black Atlantic Religion: Tradition, Transnationalism, and Matriarchy in the Afro-Brazilian Candomblé* (Princeton: Princeton Univ. Press, 2005), 274–80. Note, however, how closely the roots and shoots of rhizomes (such as ginger) are connected to one another—so close that even Matory compares the Yoruba and Candomble traditions to "Siamese Twins" (72).

5. Quoted in Wole Soyinka, *Myth, Literature and the African World* (Cambridge: Cambridge Univ. Press, 1976), 10.

6. Debray, *God: An Itinerary*, 57.

7. Robert Farris Thompson, *Flash of the Spirit: African and Afro-American Art and Philosophy* (New York: Random House, 1983), 5.

8. Karen McCarthy Brown, *Mama Lola: A Vodou Priestess in Brooklyn* (Berkeley: University of California Press, 2001), 6.

9. Paul Christopher Johnson, *Secrets, Gossip, and Gods: The Transformation of Brazilian Candomblé* (Oxford: Oxford Univ. Press, 2002), 38. Of course, this is not an exact comparison. As Jacob Olupona reminds me, Oshun by no means relies (as Ginger does) on her male friends to make things happen, and our plans succeed only with her blessing.

10. Are orishas gods? Some resist referring to orishas as divinities, perhaps because they do not want to taint Yoruba religion with the stigma of polytheism. I see nothing wrong with polytheism, but I refer here to orishas as orishas, leaving open the question, contested among the Yoruba themselves, of whether this tradition is monotheistic or polytheistic.

11. Here I call the orishas by their most popular Yoruba names. The messenger god Eshu, who is known in Brazil as Exu, Cuba as Elegba, and Haiti as Legba, I refer to here simply as Eshu, unless I am invoking specifically Brazilian, Cuban, or Haitian circumstances.

12. Thompson, *Flash of the Spirit*, 5. There is also some controversy about the ways and means of Olodumare. In *Olodumare, God in Yoruba Belief* (London: Longmans, 1962), E. Bolaji Idowu argues that this High God is anything but remote. Convinced that orishas are manifestations of Olodumare, Idowu describes Yoruba religion as "diffused monotheism." Idowu, an ordained minister who led the Methodist Church Nigeria for over a decade in the 1970s and 1980s, has been criticized, however, for reading too much of Christianity and its monotheistic imperative into Yoruba religious traditions. For a concise discussion of Idowu, his "highly theological" Ibadan School of interpretation, and his supporters and detractors, see Jacob K. Olupona, "The Study of Yoruba Religious Tradition in Historical Perspective," *Numen* 40, no. 3 (1993): 246–47.

13. Wande Abimbola, "Gods Versus Anti-Gods: Conflict and Resolution in the Yoruba Cosmos," *Dialogue & Alliance* 8, no. 2 (1994): 76.

14. BioDun J. Ogundayo, "Ifa," in *Encyclopedia of African Religion*, eds. Molefi Kete Asante and Ama Mazama (Thousand Oaks, CA: Sage, 2009), 1.331.

15. William Bascom, *The Yoruba of Southwestern Nigeria* (Prospect Heights, IL: Waveland Press, 1969), 90. On Oshun, see also Joseph M. Murphy and Mei-Mei Sanford, eds., *Ọṣun Across the Waters: A Yoruba Goddess in Africa and the Americas* (Bloomington: Indiana Univ. Press, 2001).

16. Jacob K. Olupona, "Imagining the Goddess: Gender in Yorùbâ Religious Traditions and Modernity," in *Dialogue and Alliance* 18, no. 2 (Fall/Winter, 2004/05): 71–86. See also Diedre Bádéjo, *Osun Seegesi: The Elegant Deity of Wealth, Power and Femininity* (Trenton, NJ: Africa World Press, 1996).

17. Soyinka, *Myth, Literature and the African World*, 13.

18. On this incident, which the Cuban newspaper *Diario de la Marina* called "an act of Providence," see Miguel A. De La Torre, *Santería: The Beliefs and Rituals of a Growing Religion in America* (Grand Rapids: Eerdmans, 2004), 197.

19. Wole Soyinka, "The Tolerant Gods," in Olupona and Rey, *Òrìṣà Devotion*, 43; Soyinka, *Myth, Literature and the African World*, 141, 145. Soyinka is a devotee of Ogun. See also Sandra T. Barnes, ed., *Africa's Ogun: Old World and New*, 2nd ed. (Bloomington: Indiana Univ. Press, 1997).

20. Soyinka, *Myth, Literature and the African World*, 26.

21. Thompson, *Flash of the Spirit*, 85.

22. William Bascom, *Sixteen Cowries: Yoruba Divination from Africa to the New World* (Bloomington: Indiana Univ. Press, 1980), 45.

23. Thompson, *Flash of the Spirit*, 5.

24. Mikelle Smith Omari-Tunkara, *Manipulating the Sacred: Yorùbá Art, Ritual, and Resistance in Brazilian Candomblé* (Detroit: Wayne State Univ. Press, 2006), 35.

25. Johnson, *Secrets, Gossip, and Gods*, 56.

26. For a spirited, book-length critique of the tendency of scholars to divide religious phenomenon into a "venerable East," which "preserves history" and a "progressive West," which "creates history," see Tomoko Masuzawa, *The Invention of World Religions: Or, How European Universalism Was Preserved in the Language of Pluralism* (Chicago: Univ. of Chicago Press, 2005), 4. Although I agree with Masuzawa's skepticism about the still widespread assumption that "all religions are everywhere the same in essence" (9), I do not agree with her claim that the concept of "world religion" (however invented and sooted up in colonial desires) is beyond redeeming. I, too, am uncomfortable in the face of the inevitable value judgments that seem to follow from this phrase (e.g., Christianity the "universal" religion is better than Juda-

ism the "ethnic" religion). But like the term *religion*, *world religion* has taken on a life of its own outside academe, so killing it is not an option. All scholars can do is bend it, which I hope to do here by joining many scholars and practitioners of Yoruba religion in arguing for the way of the orishas as one of the great religions.

27. I have been influenced on this point especially by Olupona and Rey, *Òrìṣà Devotion*, and by conversations with my friend Onaje Woodbine, a PhD candidate in the Division of Religious and Theological Studies at Boston University. I am also grateful to my former Boston University colleague Wande Abimbola for subtly awakening me to the importance of this tradition. In addition to being a scholar, Abimbola is a Yoruba priest and babalawo who was installed in 1981 by the *ooni* of Ife as Awise Awo Agbaye (World Spokesperson for Ifa and Yoruba Religion). Finally, I am grateful to an Akan woman, initiated years ago by Abimbola, who challenged me at a public talk in Louisville, Kentucky, in 2009 to attend to African religions with the seriousness they deserve.

28. Olupona and Rey, "Introduction," in their *Òrìṣà Devotion*, 4. Other estimates for West Africa's Yoruba population run from 20 million to 50 million.

29. Bascom, *Yoruba of Southwestern Nigeria*, 1.

30. Soyinka, "The Tolerant Gods," in Olupona and Rey, *Òrìṣà Devotion*, 44.

31. As Miguel A. De La Torre argues in *Santería*, orisha devotion also found common cause with Protestantism—"in the Jamaican groups *Revival* and *Pocomania*," and "in the Trinidadian group known as Spiritual Baptists or Shouters" (xiv). Other Protestant carriers of Yoruba culture include "the Cumina and Convince in Jamaica, the Big Drum in Grenada, and Carriacou and Kele in St. Lucia" (Leslie G. Desmangles, "Caribbean, African-Derived Religion," in *Encyclopedia of African and African-American Religions*, ed. Stephen D. Glazier [New York: Routledge, 2001], 78).

32. Private communication with Joseph Murphy, July 21, 2009. According to a 1954 study, one quarter of Cuban Catholics went to a santero or santera at least occasionally. See Agrupación Católica Universitaria, *Encuesta Nacional sobre el Sentimiento Religioso del Pueblo de Cuba* (Habana: Buró de Información y Propaganda de la ACU, 1954), 37, cited in De La Torre, *Santería*, 170–71.

33. Akintunde Akinade, "Macumba," in Glazier, *Encyclopedia of African and African-American Religions*, 177.

34. "Brazil: International Religious Freedom Report 2007," Bureau of Democracy, Human Rights, and Labor, U.S. Department of State, http://www.state.gov/g/drl/rls/irf/2007/90244.htm.

35. Johnson, *Secrets, Gossip, and Gods*, 198.

36. Murphy, "Òrìṣà Traditions," in Olupona and Rey, Òrìṣà Devotion, 472.

37. Many who toss out the 100 million figure claim that there are that many practitioners in the New World alone. See, e.g., Migene González-Wippler, Santería: the Religion: Faith, Rites, Magic, 2nd ed. (Saint Paul, MN: Llewellyn, 1994), 9; and De La Torre, Santería, xiv. The more modest estimate of 100 million worldwide appears in Kólá Abímbólá, Yorùbá Culture: A Philosophical Account (Birmingham, UK: Iroko Academic, 2005), 24. At the Congress of Orisa Tradition and Culture, held in Havana in 2003, Wande Abimbola also claimed 100 million Yoruba practitioners worldwide. See John Rice, "African Religious Leaders Pay Homage to Cuba," Associated Press, July 8, 2003.

38. Thompson, Flash of the Spirit, xv.

39. George Volsky, "Religion from Cuba Stirs Row in Miami," New York Times, June 29, 1987.

40. Quoted in Johnson, Secrets, Gossip, and Gods, 71.

41. See Carl Hunt, Oyotunji Village: The Yoruba Movement in America (Washington, DC: Univ. Press of America, 1979); and Kamari Maxine Clarke, Mapping Yoruba Networks: Power and Agency in the Making of Transnational Communities (Durham, NC: Duke Univ. Press, 2004). For more recent treatments, see, e.g., Ikulomi Djisovi Eason, "Historicizing Ifá Culture in Ọ̀yọ́túnjí African Village," 278–85; Kamari Maxine Clarke, "Ritual Change and the Changing Canon: Divinatory Legitimization of Yorùbá Ancestral Roots in Ọ̀yọ́túnjí African Village," 286–319; and Tracey E. Hucks, "From Cuban Santería to African Yorùbá: Evolutions in African American Orisa History, 1959–1970), 337–54, all in Olupona and Rey, Òrìṣà Devotion. Oyotunji Village seems to be a classic example of "the invention of tradition"—in this case the invention of an ancient African tradition by a twentieth-century American. See Eric Hobsbawm and Terence Ranger, eds., The Invention of Tradition (Cambridge: Cambridge Univ. Press, 1983).

42. Bob Cohn and David A. Kaplan, "A Chicken on Every Altar?" Newsweek, November 9, 1992, 79, http://www.newsweek.com/id/147404.

43. The Oxford English Dictionary, 2nd ed. (New York: Oxford Univ. Press, 1989) traces Yoruba back to 1843, and the term does seem to become fairly common in that decade, but an Internet search turns up scattered references in French and English in the 1820s.

44. Ulli Beier, The Return of the Gods: The Sacred Art of Susanne Wenger (Cambridge: Cambridge Univ. Press, 1975), 44.

45. Mother B., quoted in Johnson, Secrets, Gossip, and Gods, 12. For all these reasons, I disagree with Miguel A. De La Torre's characterization of Santeria as a "faith system" (in his Santería, 189).

46. Soyinka, "Tolerant Gods," in Olupona and Rey, Òrìṣà Devotion, 41.

47. Soyinka, "Tolerant Gods," in Olupona and Rey, *Òrìṣà Devotion*, 41.
48. Soyinka, "Tolerant Gods," in Olupona and Rey, *Òrìṣà Devotion*, 36.
49. Soyinka, "Tolerant Gods," in Olupona and Rey, *Òrìṣà Devotion*, 35. Later in this same article, Soyinka adds that the orisha are neither evangelistic nor jealous gods. "The *òrìṣà* do not proselytize," he writes. "They are content to be, or to be regarded as, non-existent" (47).
50. Quoted in Olupona, "Study of Yoruba Religious Tradition," 245.
51. Baba Ifa Karade, *The Handbook of Yoruba Religious Concepts* (York Beach, ME: Weiser Books, 1994), 112. Yet Ernesto Pichardo, co-founder of the Church of the Lukumi Babalu Aye in Hialeah, Florida, claims that only about 2 percent of the sacrifices he has participated in have involved animals (Steven G. Vegh, "Santeria Worship May Be Behind Animal Killings: Macabre Evidence Found in Norfolk Beach," *The Virginian-Pilot*, November 8, 2001, quoted in De La Torre, *Santería*, 127). Wande Abimbola observes that animal sacrifice is far more common in the New World than in Africa. "In Africa, a *babaláwo* may have attended to 20 clients in a day without prescribing one animal or fowl," he writes in his *Ifá Will Mend Our Broken World: Thoughts on Yoruba Religion and Culture in Africa and the Diaspora* (Roxbury, MA: Aim Books, 1997), 84.
52. Karade, *Handbook of Yoruba Religious Concepts*, 13. Matory claims in his *Black Atlantic Religion* that the rise of priestesses in Yoruba-derived religions in the New World can be traced to the influence of feminist anthropologists such as Ruth Landes (188–223).
53. Yvonne Daniel, *Dancing Wisdom: Embodied Knowledge in Haitian Vodou, Cuban Yoruba, and Bahian Candomblé* (Urbana: Univ. of Illinois Press, 2005), 75–79.
54. Daniel, *Dancing Wisdom*, 49, 267, 138-140. In his *Santería*, De La Torre refers to Santeria as a "dance religion" (118). In his book, also called *Santería*, Joseph Murphy calls it "danced religion," adding that "the *orishas* are better understood as rhythms than as personalities" (Boston: Beacon Press, 1988), 131, 165.
55. Abimbola, *Ifá Will Mend Our Broken World*, 152–53.
56. The classic text is Oyèrónké Oyěwùmí, *The Invention of Women: Making an African Sense of Western Gender Discourses* (Minneapolis: Univ. of Minnesota Press, 1997), which claims that before colonialism Yoruba culture was essentially gender blind. Classic responses include Olupona, "Imagining the Goddess," 71–86; and J. Lorand Matory, "Is There Gender in Yorùbá Culture?" in Olupona and Rey, *Òrìṣà Devotion*, 513–58.
57. Rowland Abiodun, "Hidden Power: Òsun, the Seventeenth Odù," in Murphy and Sanford, *Ọsun Across the Waters*, 150.
58. Olabiyi Babalola Yai, "Yorùbá Religion and Globalization: Some Reflections," in Olupona and Rey, *Òrìṣà Devotion*, 241.

59. I am influenced here by the "theology of flourishing" of the feminist philosopher of religion Grace Jantzen, who was brought to my attention by my BU colleague Donna Freitas. See Grace M. Jantzen, *Becoming Divine: Towards a Feminist Philosophy of Religion* (Bloomington: Indiana Univ. Press, 1999).

Chapter Seven: Judaism: The Way of Exile and Return

1. Midrash Tehillim 5.5, quoted in Joseph L. Baron, *A Treasury of Jewish Quotations* (Lanham, MD: Rowman & Littlefield, 2004), 66.

2. Mary Douglas, *In the Wilderness: The Doctrine of Defilement in the Book of Numbers* (Sheffield, UK: JSOT Press, 1993), 101.

3. This and all subsequent quotations from the *Tanakh* come, unless otherwise noted, from *The Holy Scriptures According to the Masoretic Text: A New Translation* (Philadelphia: Jewish Publication Society of America, 1917).

4. This is, of course, a subject of considerable debate among Religious Studies scholars, but F. Max Müller makes this connection in his *Natural Religion: The Gifford Lectures Delivered before the University of Glasgow in 1888* (London: Longmans, Green, 1889), 33–35.

5. Rilke, *Rilke on Love*, 25.

6. This teacher is Rabbi Yeshoshua ben Levi. See Elie Wiesel, *Wise Men and Their Tales: Portraits of Biblical, Talmudic, and Hasidic Masters* (New York: Schocken, 2003), 233.

7. *Sefer Hasidim* 13C, quoted in Baron, *Treasury of Jewish Quotations*, 14.

8. Wiesel, *Wise Men and Their Tales*, 298.

9. The classic expression is Horace M. Kallen, "Democracy Versus the Melting-Pot: A Study of American Nationality," *The Nation*, February 25, 1915, 18–25. Kallen first uses the phrase "cultural pluralism" in his *Culture and Democracy in the United States* (New York: Boni and Liveright, 1924), 11. See also Sidney Ratner, "Horace M. Kallen and Cultural Pluralism," *Modern Judaism* 4, no. 2 (1984): 185–200.

10. Babylonian Talmud, Tractate Aboth, 5.22, quoted in Wiesel, *Wise Men and Their Tales*, 279. This saying was also quoted by U.S. Supreme Court Justice Scalia in his dissenting opinion in *Caperton v. A.T. Massey Coal Co.* on June 8, 2009, http://www.supremecourtus.gov/opinions/08pdf/08-22.pdf, 40.

11. Joseph Telushkin, *Jewish Literacy: The Most Important Things to Know About the Jewish Religion, Its People, and Its History* (New York: William Morrow, 1991), 120.

12. Hanina Ben-Menahem, Neil S. Hecht, and Shai Wosner, *Controversy and Dialogue in the Jewish Tradition: A Reader* (New York: Routledge, 2005), 71.

13. Richard Ellmann, ed., *The Artist as Critic: Critical Writings of Oscar Wilde* (Chicago: University of Chicago Press, 1982), 433.

14. e. e. cummings, *100 Selected Poems* (New York: Grove Press, 1994), 119.
15. One reason Jews discourage conversion is because they have long been the objects of efforts at conversion by Christians and Muslims. Another reason is because being Jewish is hard. While Jews are to follow 613 *mitzvot*, there are only seven for Gentiles: not to worship false gods, not to murder, not to steal, not to engage in illicit sex (including incest, adultery, bestiality, and male homosexuality), not to blaspheme against God, not to eat meat from a living animal, and to establish courts to enforce the other six laws (Babylonian Talmud, Sanhedrin 56a). Because these were given to Noah, who was not Jewish, they are referred to as the Seven Laws of Noah. Any Gentile who follows them is assured entrance to the world to come.
16. There are laws in Judaism for excommunication, which actually functions more like Amish-style shunning. *Herem* is the term, and the most notorious case concerned Baruch Spinoza (1632–77), a Dutch rationalist who holds the dubious distinction of not only being excommunicated from the Jewish community but also finding his books on the *Index Liborum Prohibitorum* of the Roman Catholic Church. Spinoza was cursed and cast out of Judaism for "abominable heresies," on such topics as revelation, angels, and the immortality of the soul, all of which he denied (Lewis S. Feuer, *Spinoza and the Rise of Liberalism* [New Brunswick, NJ: Rutgers Univ. Press, 1987], 1).
17. The "Thirteen Principles" of Maimonides affirm: the existence, unity and incorporeality of God; that God is eternal; that God alone is to be worshipped; that God speaks through prophets; that Moses was the greatest prophet; that the Torah is divine; that the Torah is unchanging; that God knows human thoughts and actions; that the obedient will be rewarded and the disobedient punished; that the messiah is coming; and that the dead will be raised.
18. My colleague Diana Lobel informs me that in the two biblical versions of the "Ten Words" (Ten Commandments), one says to "observe" (Deuteronomy 5:12) and the other to "remember" (Exodus 20:8).
19. Debray, *God: An Itinerary*, 47.
20. Jacob Neusner, "Judaism," in Arvind Sharma, *Our Religions*, 314.
21. *Textual Sources for the Study of Judaism*, ed. and trans. Philip S. Alexander (Manchester: Manchester Univ. Press, 1984), 164.
22. For a popular discussion of what historian Salo Baron referred to as "the lachrymose conception of Jewish history," see Theodore Stanger and Hannah Brow, "Rethinking Jewish History," *Newsweek*, May 18, 1992, 38. A scholarly discussion appears in Robert Liberles, "Epilogue: Beyond the Lachrymose Conception," in his *Salo Wittmayer Baron: Architect of Jewish History* (New York: New York Univ. Press, 1995), 338–59.

NOTES 367

23. Shalom Auslander, "Exodus Complexidus," *Jewish Quarterly* (Spring 2008), http://heroic-media.com/jq/issuearchive/article8230.html?articleid=355.

24. Babylonian Talmud, Shabbat 31a.

25. Mary Douglas, *Purity and Danger: An Analysis of Concept of Pollution and Taboo* (London: Routledge & Kegan Paul, 1966), especially the chapter on "The Abominations of Leviticus" (51–71).

26. Calvin Trillin, "Drawing the Line," *The New Yorker*, December 12, 1994, 50.

27. The question of Judaism's origins is of course contested. If Judaism is about monotheism, it goes back to Abraham. If it is about law, it goes back to Sinai. Some insist that Judaism emerges only after the destruction of the Second Temple in 70 C.E. According to literary critic Harold Bloom, Judaism is "a younger religion" than Christianity (Michael Kress, "A Year-End Chat with Harold Bloom," http://www.jbooks.com/interviews/index/IP_Kress_Bloom.htm).

28. Wiesel, *Wise Men and Their Tales*, 278.

29. Neusner, "Judaism," in Sharma, *Our Religions*, 321.

30. According to the United Jewish Communities' "National Jewish Population Survey 2000–01," January 2004, 77 percent of Americans say they either hold or attend a Passover Seder, while only 72 percent report lighting Hanukkah candles and only 59 percent fasting on Yom Kippur (7). See http://www.ujc.org/local_includes/downloads/3905.pdf.

31. More than fifty million copies of the Maxwell House Haggadah are in print. See Carole B. Balin, " 'Good to the Last Drop': The Proliferation of the Maxwell House Haggadah," in *My People's Passover Haggadah: Traditional Texts, Modern Commentaries*, eds. Lawrence A. Hoffman and David Arnow (Woodstock, VT: Jewish Lights, 2008), 85–90.

32. For different views on this important topic, see Alan F. Segal, *Life After Death: A History of the Afterlife in Western Religions* (New York: Doubleday, 2004) and Jon D. Levenson, *Resurrection and the Restoration of Israel: The Ultimate Victory of the God of Life* (New Haven: Yale Univ. Press, 2006).

33. Hagigah 2:1, quoted in Jacob Neusner, *The Mishnah: A New Translation* (New Haven: Yale Univ. Press, 1991), 330.

34. "The National Jewish Population Survey 2000–2001" United Jewish Communities, January 2004, http://www.ujc.org/local_includes/downloads/4606.pdf.

35. "The Pittsburgh Platform, 1885" in Alexander, *Textual Sources for the Study of Judaism*, 136–38.

36. Sanhedrin 106b.

37. "Judaism: The Atheist Rabbi," *Time* (January 29, 1965), http://www.time.com/time/magazine/article/0,9171,839200,00.html.

38. On the United States, see Barry Kosmin, "The Changing Population Profile of American Jews, 1990–2008" (paper presented at the Fifteenth World Congress of Jewish Studies, Jerusalem, August 2009). According to this study, 37 percent of American Jews see themselves as not religious. In 2008 a study by the Israel Democratic Institute found that 51 percent of Israelis were secular. See "Study: 51 percent of Israelis Secular," *Jewish World*, http://www.ynetnews.com/articles/0,7340,L-3514242,00.html.

39. The key expression is Phyllis Trible, *Texts of Terror: Literary-Feminist Readings of Biblical Narratives* (Philadelphia: Fortress Press, 1984).

40. Bara Batra 16b, quoted in Denise Lardner Carmody, *Women and World Religions*, 2nd ed. (Englewood Cliffs, NJ: Prentice-Hall, 1989), 147.

41. Richard Rodriguez, "The God of the Desert: Jerusalem and the Ecology of Monotheism," *Harper's,* January 2008, 45.

Chapter Eight: Daoism: The Way of Flourishing

1. Victor H. Mair, trans., *Wandering on the Way: Early Taoist Tales and Parables of Chuang Tzu* (Honolulu: Univ. of Hawaii Press, 1998), 33.

2. Again, I am forgoing the older Wade-Giles transliterations scheme, which rendered the subject of this chapter as Taoism and its most famous text as the *Tao Te Ching*, for the newer Pinyin system, which renders these terms as Daoism and the *Daodejing*.

3. *Huainanzi* 1, quoted in Thomas Michael, *The Pristine Dao: Metaphysics in Early Daoist Discourse* (Albany: State Univ. of New York Press, 2005), 130.

4. Mair, *Wandering on the Way*, 5, 7, 9, 21, 385, 35. Elsewhere, Mair writes that the *Zhuangzi* could be called *"In Praise of Wandering."* See Victor H. Mair, "Chuang-tzu and Erasmus: Kindred Wits," in *Experimental Essays on Chuang-tzu*, ed. Victor H. Mair (Honolulu: Univ. of Hawaii Press, 1983), 86.

5. Mair, *Wandering on the Way*, xiii. Over a hundred different English-language translations of the first chapter of the Daodejing can be found at http://www.bopsecrets.org/gateway/passages/tao-te-ching.htm.

6. Russell Kirkland, *Taoism: The Enduring Tradition* (New York: Routledge, 2004), 43.

7. Benjamin Hoff, *The Tao of Pooh* (New York: Penguin Books, 1982), 1–7. *The Tao of Pooh* is a favorite target of Daoist scholars, who dismiss its teachings as "New Age Daoism" and "Pooh Bear Daoism." Coming from scholars deeply committed, both professionally and personally, to ancient Daoist texts, this criticism is understandable, but it ignores Daoist observations about the inevitability of change. Scholars' determination to make Daoism serious seems to spring more from

academic culture than from Daoism itself. Zhuangzi, whose sense of humor is well attested, would have loved *The Tao of Pooh*.

8. Kristofer Schipper, *The Taoist Body*, trans. Karen C. Duval (Berkeley: Univ. of California Press, 1993), 1.

9. Cheng-tian Kuo, *Religion and Democracy in Taiwan* (Albany: State Univ. of New York Press, 2008), 56.

10. Sheng-chi Liu, "Religious Development in Mainland China in the Reform Era," *Studies on Mainland China* 44, no. 12 (2001): 79.

11. See Jantzen, *Becoming Divine*.

12. Michael, *Pristine Dao*, 77.

13. *Huainanzi* 7, quoted in Michael, *Pristine Dao*, 134.

14. Mair, *Wandering on the Way*, 145.

15. Schipper, *Taoist Body*, 126.

16. Or, as my colleague Thomas Michael puts it in *Pristine Dao*, "human beings are not a kind of projectile attempting to shoot clear of their ontological reality in the effort to identify with an absolute principle standing somewhere outside and beyond" (35).

17. Alan K. L. Chan, "The *Daodejing* and its Tradition," in *Daoism Handbook*, ed. Livia Kohn (Leiden, the Netherlands: Brill, 2000), 4.

18. Livia Kohn, *The Daoist Monastic Manual: A Translation of the Fengdao Kejie* (New York: Oxford Univ. Press, 2004), 12.

19. Schipper, *Taoist Body*, 16.

20. Julian F. Pas, "Introduction: Chinese Religion in Transition," in *The Turning of the Tide: Religion in China Today*, ed. Julian F. Pas (New York and Hong Kong: Hong Kong Branch of the Royal Asiatic Society in association with Oxford Univ. Press, 1989), 8–9.

21. Schipper, *Taoist Body*, 5.

22. Schipper, *Taoist Body*, 4.

23. Michael, *Pristine Dao*, 47; Fieser and Powers, *Scriptures of the East*, 186.

24. Schipper, *Taoist Body*, 158.

25. Lao Tzu, *The Sayings of Lao Tzu*, trans. Lionel Giles (Radford, VA: Wilder, 2008), 31.

26. Livia Kohn, ed., *The Taoist Experience: An Anthology* (Albany: State Univ. of New York Press 1993), 288.

27. Thomas Michael, *Shadows of the Pristine Dao* (Albany: SUNY Press, forthcoming). According to Michael, "The first line of the Daodejing is arguably the most famous line in the entire tradition of East Asian religion and philosophy, but also the most widely mistranslated line in the entire tradition of Western sinology" (1).

28. Paul Tillich, *Systematic Theology* (Chicago: Univ. of Chicago Press, 1951), 1.238.

29. Schipper, *Taoist Body*, 188.

30. Alexander M. Bickel, *The Least Dangerous Branch: The Supreme Court at the Bar of Politics*, 2nd ed. (New Haven: Yale Univ. Press, 1986), 71.

31. Victor Mair, "The *Zhuangzi* and Its Impact," in Kohn, *Daoism Handbook*, 32.
32. Mair, "Chuang-tzu and Erasmus," in Mair, *Experimental Essays on Chuang-tzu*, 86.
33. Mair, *Wandering on the Way*, 75, 21, 46, 57, 44, 42, 211.
34. Mair, *Wandering on the Way*, 274.
35. Zhuangzi, *Zhuangzi,* trans. Hyun Höchsmann and Yang Guorong (New York: Pearson Longman, 2007), 194. A later Daoist work, by "the Master-Who-Embraces-Simplicity," tells of a fit women who had lived by foraging in the mountains for over two hundred years when she was captured, brought back to the city, and force-fed an urban diet. Her hair fell out, she aged rapidly, and died after two years (retold in Schipper, *Taoist Body*, 169).
36. Zhuangzi, *Zhuangzi*, trans. Höchsmann and Guorong, 188–89.
37. Zhuangzi, *Zhuangzi*, trans. Höchsmann and Guorong, 123.
38. Rumi, *The Book of Love: Poems of Ecstasy and Longing*, trans. Coleman Barks (New York: HarperCollins, 2003), 123.
39. Bob Dylan, "Love Minus Zero/No Limit," *Bringing It All Back Home*, Columbia Records, March 1965, http://www.bobdylan.com/#/songs/love-minus-zerono-limit.
40. Mair, *Wandering on the Way*, 376.
41. Schipper, *Taoist Body*, 164.
42. Catherine Despeux, "Women in Daoism," in Kohn, *Daoism Handbook*, 405.
43. Schipper, *Taoist Body*, 160.
44. James Miller, *Daoism: A Short Introduction* (Oxford: OneWorld, 2005), 115.
45. See Russell Kirkland, T. H. Barrett and Livia Kohn, "Introduction" in Kohn, *Daoism Handbook*, xiii-xiv.
46. Liu Xiaogan, "Taoism," in Sharma, *Our Religions*, 238.
47. Zhuangzi, *Zhuangzi*, trans. Höchsmann and Guorong, 95.
48. Zhuangzi, *Zhuangzi*, trans. Höchsmann and Guorong, 195.
49. See Kohn, *Taoist Experience*, 291–92.
50. Sima Qian, *Shiji*, 63.2142, quoted in Fieser and Powers, *Scriptures of the East*, 179.
51. *Huainanzi* 1, quoted in Michael, *Pristine Dao*, 130.

Chapter Nine: A Brief Coda on Atheism: The Way of Reason

1. "Voice of the People 2005: Religiosity Around the World," Gallup International, http://extranet.gallup-international.com/uploads/internet/Religiosity%20around%20the%20world%20VoP%2005%20press%20release.pdf.
2. See, e.g., Jeffrey M. Jones, "Some Americans Reluctant to Vote for Mormon, 72-Year-Old Presidential Candidates," Gallup News Ser-

vice, February 20, 2007, http://www.gallup.com/poll/26611/some-americans-reluctant-vote-mormon-72yearold-presidential-candidates.aspx.

3. Stephen Prothero, *Religious Literacy: What Every American Needs to Know—And Doesn't* (New York: HarperOne, 2007), 40.

4. President Barack Obama, "Inaugural Address," January 21, 2009, http://www.whitehouse.gov/blog/inaugural-address/.

5. See http://the-brights.net. To his credit, Hitchens refuses to drink the "bright" Kool-Aid. In his *God Is Not Great*, he calls bright-ism "a cringe-making proposal" (5).

6. Richard Dawkins, *The God Delusion* (Boston: Houghton Mifflin, 2006); Sam Harris, *The End of Faith: Religion, Terror, and the Future of Reason* (New York: W. W. Norton, 2004). The chapter titles are from Michel Onfray, *The Atheist Manifesto: The Case Against Christianity, Judaism, and Islam*, trans. Jeremy Legatt (New York: Arcade, 2007). Onfray's book first appeared as *Traité d'athéologie* in France in 2005 and then as *In Defence of Atheism* in the United Kingdom in 2007.

7. Richard Dawkins, "Is Science a Religion?" *Humanist* 57, no. 1 (1997), http://www.thehumanist.org/humanist/articles/dawkins.html.

8. Harris, *End of Faith*, 173.

9. Hitchens, *God Is Not Great*, 56.

10. Onfray, *Atheist Manifesto*, 134.

11. Hitchens, *God Is Not Great*, 58; interview with Christopher Hitchens and Ralph Reed, *Hannity & Colmes*, Fox News, May 16, 2007.

12. Hitchens, *God Is Not Great*, 280, 64.

13. "Has the World Changed?—Part Two," *The Guardian*, October 11, 2001, http://www.guardian.co.uk/world/2001/oct/11/afghanistan.terrorism2.

14. Harris, *End of Faith*, 15.

15. Harris, *End of Faith*, 52–53. Harris insists that this sentence has been widely misconstrued. See his "Response to Controversy," http://www.samharris.org/site/full_text/response-to-controversy2/.

16. Richard Dawkins, *A Devil's Chaplain: Reflections on Hope, Lies, Science, and Love* (New York: Houghton Mifflin, 2003), 117.

17. Dawkins, *God Delusion*, 306.

18. Chris Hedges, *I Don't Believe in Atheists* (New York: Free Press, 2008), 6.

19. Quoted in Gustav Niebuhr, "A Nation Challenged: The Evangelist," *New York Times*, November 20, 2001, B5. Graham first made this comment a few days earlier on NBC's "Nightly News" on November 16.

20. Harris, *End of Faith*, 123. See, too, Martin Amis's denunciation of "Thanatism" in his "9/11 and the Cult of Death," Times Online, September 11, 2007, http://tiny.cc/wnlRw.

21. David Foster Wallace, "All That," *The New Yorker*, December 14, 2009, 79.

22. In *The Atheists Are Revolting!* (n.p.: Lulu.com, 2007), Nick Gisburne contends that asking whether atheism is a religion is "the silliest question of all." "You won't find atheists praying to gravity, or to evolution," he writes. "Atheism is simply not a religion by any recognizable definition of the word" (56).

23. Some of these practices emerged during the more Deistic Cult of the Supreme Being, which replaced the Cult of Reason under Robespierre in 1794. See Nigel Aston, *Religion and Revolution in France, 1780–1804* (Washington, DC: Catholic Univ. of America Press, 2000); and John McManners, *Church and Society in Eighteenth-Century France* (New York: Oxford Univ. Press, 1998).

24. Karl Marx, "The Difference Between the Democritean and Epicurean Philosophy of Nature," in *Marx/Engels Collected Works* (London: Lawrence and Wishart, 1975), 1.30, http://www.marxists.org/archive/marx/works/1841/dr-theses/foreword.htm.

25. Brad Spurgeon, "Agent Provocateur," *The Star* (Toronto), December 17, 2006, http://www.thestar.com/printArticle/157872.

26. Onfray, *Atheist Manifesto*, 57; Onfray (citing the eighteenth-century French aphorist Nicolas Chamfort) quoted in Andrew Higgins, "As Religious Strife Grows, Europe's Atheists Seize Pulpit," *Wall Street Journal*, April 12, 2007, A1.

27. *Torcaso v. Watkins*, 367 U.S. 488 (1961). Footnote 11 reads: "Among religions in this country which do not teach what would generally be considered a belief in the existence of God are Buddhism, Taoism, Ethical Culture, Secular Humanism."

28. *Kaufman v. McCaughtry*, 419 F.3d 867 (8th Cir. 2005). This case concerned a prisoner who asserted a First Amendment right to create an atheism group. See Derek H. Davis, "Is Atheism a Religion? Recent Judicial Perspectives on the Constitutional Meaning of 'Religion,'" *Journal of Church and State* 47, no. 4 (2005): 707–23. A sustained legal argument for atheism as a religion is presented in Douglas Laycock, "Religious Liberty as Liberty," *Journal of Contemporary Legal Issues* 7 (1996): 313–356. Kent Greenawalt refutes Laycock in "Saying What Counts as Religious," in his *Religion and the Constitution,* vol. 1: *Free Exercise and Fairness* (Princeton: Princeton Univ. Press, 2006), 124–56.

29. Onfray, *Atheist Manifesto*, 215.

30. Quoted in Sidney Hook, *From Hegel to Marx: Studies in the Intellectual Development of Karl Marx* (New York: Columbia Univ. Press, 1994), 154. See also David Sloan Wilson, "Atheism as a Stealth Religion," Huffington Post Blog, December 14, 2007, http://www.huffington-post.com/david-sloan-wilson/atheism-as-a-stealth-reli_b_76901.html.

31. Tillich, *Systematic Theology,* 1.11–12.

32. "FAQ," Friendly Atheist Blog, http://friendlyatheist.com/faq/.

33. William Lobdell, *Losing My Religion: How I Lost My Faith Reporting on Religion in America—And Found Unexpected Peace* (New York: HarperCollins, 2009), 269, 271.

34. Nica Lalli, "Atheists Don't Speak With Just One Voice," *USA Today*, October 8, 2007, http://blogs.usatoday.com/oped/2007/10/atheists-dont-s.html. Another possible candidate for "friendly atheist" status is literary critic Harold Bloom. Shortly after the appearance of his book, *Jesus and Yahweh: The Names Divine* (New York: Riverhead, 2005), he was telling an interviewer about his dislike for Yahweh—"He's as good an explanation for why everything goes wrong all the time as we could want"—when his wife interrupted and said that he was an atheist. "No, I'm not an atheist," he replied. "It's no fun being an atheist." So what is the alternative, his interviewer asked. "Well, the alternative is to entertain all of these fictions" (Laura Quinney, "An Interview with Harold Bloom," http://www.rc.umd.edu/praxis/bloom_hartman/bloom/bloom.html).

Conclusion

1. Irenaeus, *Against Heresies*, 4.20.7.

2. Tu Wei-ming, *Confucian Thought*, 63.

3. Lucy S. Dawidowicz, ed., *The Golden Tradition: Jewish Life and Thought in Eastern Europe* (Syracuse, NY: Syracuse Univ. Press, 1996), 93.

4. Schipper, *Taoist Body*, 158.

5. Nasr, *Ideals and Realities of Islam*, 73–74.

6. "Our Movement, Our Stories," Interfaith Youth Core, http://www.ifyc.org/donate

7. Swami Nikhilananda, trans., *The Gospel of Sri Ramakrishna* (New York: Ramakrishna-Vivekananda Center, 1942), 191.

8. Nikhilananda, *Gospel of Sri Ramakrishna*, 191.

9. John Godfrey Saxe, *The Poetical Works of John Godfrey Saxe* (Boston: Houghton, Mifflin, 1882), 112. This story has also been put to use by Leo Tolstoy and Nikos Kazantzakis, and by recent children's book authors. For a thorough review of this literature, and an intriguing application of this story to the world of computer science, see Edith Feistner and Alfred Holl, *Mono-perspective Views of Multi-perspectivity: Information Systems Modeling and "The Blind Men and the Elephant"* (Växjö, Sweden: Växjö Univ. Press 2006), http://www.informatik.fh-nuernberg.de/professors/Holl/Personal/Elefant_Acta.pdf.

10. Rilke, *Rilke on Love*, 25.

11. Fadiman and Frager, *Essential Sufism*, 82.

INDEX

Abraham: biblical story of, 73, 255; as Jew by adoption, 262; Judeo-Christian-Islamic sharing of, 26–27; Kabah shrine (Mecca) built by, 34

Absolute Truth (Mahayana Buddhism), 195, 200–201

Abu Bakr, 51

Adam and Eve story, 71, 72–73, 243, 246, 255, 279

Adefunmi, Efuntola Oseijeman Adelabu, 227–28

Adefunmi, Oba, II, 228

Ade, King Sunny, 229

adhan (call to prayer) [Islam], 27–28, 30–31

Advaita Vedanta (Hindu philosophy), 166

Africa: estimates of Yoruba practitioners in, 220–22; Yoruba religion spread by slaves from, 222–23. *See also* Nigeria; Yoruba religion

Agee, James, 294

Agnes, St., 82

Agni (Vedic god), 142

ahimsa (noninjury) principle, 10

Ali (Muhammad's son-in-law), 51

Allah: *adhan* (call to prayer) to, 27–28, 30–31; as author of Quran, 40–41; description, names, and nature of, 36–37, 45–46; total submission to, 31–32. *See also* God

Alliance for Jewish Renewal, 276

All Religions Are One (Blake), 1

"all religions are one" belief, 3, 4, 8

al-Qaeda, 19, 52–54

American Atheists, 325

American Idol (TV show), 84

American Muslims: Nation of Islam (NOI) and, 29; popular culture influence of, 29–30

American politics: American Jewish influence in, 246; Bible used in, 18; growing influence of U.S. Muslims in, 20; Religious Right impact on, 8, 320, 338; role of religion in, 6–11, 18. *See also* United States

American popular culture: American Muslims' influence on, 29–30; Buddhism influence on, 176–77; Daoism revival through, 281–85; Jewish influence on, 246–47; Yoruba religion adopted by, 229. *See also* United States

Amida Buddha, 191

Anabaptists, 79

Analects (Confucius), 102, 104, 106, 113, 114, 115, 116, 117–18, 119, 121, 128, 281

anatta (no soul) [Buddhism], 184–85

Anglican Church in North America, 96

Anglican Communion, 79

Ansari of Herat, 58

Aristotle, 98, 123

Armstrong, Karen, 2, 6, 166

Arnaz, Desi, 229

Aryans ("Noble Ones"), 143

asceticism, 66

ashe (orisha power) [Yoruba religion], 88, 156, 205–6, 207, 209, 212, 219–20, 234, 235

Ashkenazi Jews, 247

Ashoka (Emperor of India), 175

Asian-American "model minority," 105, 133

atheism: crossroad facing New Atheists, 328–29; debate over creed of, 323–26; ethics of, 325; Friendly Atheists, 327–28; Harvard University atheism rally (2009), 327–28; historic tradition of, 317; New Atheists attacks on religion, 9, 66, 317–26

Atheist Alliance International, 325

Atheist Manifesto (Onfray), 319

Atman (self/soul) [Hinduism], 149, 150, 151

Augustine, St., 24, 92–93, 98

Auslander, Shalom, 258

Autobiography of a Yogi (Swami Yogananda), 168

Avalokiteshvara, 190–91

babalawo (father of secrets), 204, 205, 206, 235

Babylonian exile of Jews, 254–55, 261

Baha'i faith, 15

Barks, Coleman, 60